Lofts DesignSource

Lofts DesignSource

Ana G. Cañizares

COLLINS | DESIGN

An Imprint of HarperCollinsPublishers

LOFTS DESIGNSOURCE
Copyright © 2006 COLLINS DESIGN and LOFT Publications

HarperCollins books may be purchased for educational, business, or sales promotional use.
For information, please write: Special Markets Department, HarperCollins Publishers Inc.,
10 East 53rd Street, New York, NY 10022

First Edition published in 2004 by:
Collins Design
An Imprint of HarperCollins*Publishers*
10 East 53rd Street
New York, NY 10022
Tel.: (212) 207-7000
Fax: (212) 207-7654
collinsdesign@harpercollins.com
www.harpercollins.com

Distributed throughout the world by:
HarperCollins*Publishers*
10 East 53rd Street
New York, NY 10022
Fax: (212) 207-7654

Packaged by
LOFT Publications
Via Laietana, 32 4.º Of. 92
08003 Barcelona, Spain
Tel.: +34 932 688 088
Fax: +34 932 687 073
loft@loftpublications.com
www.loftpublications.com

Publisher:
Paco Asensio
Editor:
Ana G. Cañizares
Art Director:
Mireia Casanovas Soley
Layout:
Cris Tarradas Dulcet
Cover photo:
© **Björg Photography**

Library of Congress Cataloging-in-Publication Data

Cañizares, Ana Cristina G.
Lofts designsource / Ana G. Cañizares.--1st ed.
 p. cm.
 ISBN-13: (ppk. with flaps)
 ISBN-10: 0-06-074975-X (ppk. with flaps)
 1. Lofts. 2. Interior decoration. 3. Interior architecture.
 I. Title: Lofts design source. II. Title.
 NK2117.L63C36 2005
 747'.88314--dc22

 2004024742

Second Printing, 2006

Introduction

Loft living began in Manhattan as part of the social urban development during the 1960s. It immediately generated an entire movement devoted to the recovery of old, industrial spaces. Today, loft living has been transformed into a product of careful architectural elaboration that few people can acquire. In the 1960s, warehouses and abandoned factories in New York City were converted into residences for a certain intellectual elite, signifying a change of direction in the migration towards suburban zones and a resurgence inside the city that had gone into full decline after industrial development. The first residents of these recovered spaces were artists and students with little acquisition power and a great need for space. They occupied the spaces illegally and became activists and defenders of architectural spaces declared obsolete by the industrial sector, representing a lifestyle in which the creation and appreciation of art formed part of the daily routine. Soon thereafter, promoters discovered and commercialized the image and the ambience of the artists in order to create an attractive and competitive new product in the real estate market. The loft ceased to be merely a space for artistic production and took on a provocative meaning as an emblem of the freedom of new generations.

The contemporary notion of the loft has given way to flexible and varied interpretations of this unique living space. Most loft owners are clients who buy shell spaces and have the interior professionally designed, built, and furnished. Architects who design loft conversions are particularly sensitive to the function and materials of the original building, and search for a marriage between old and new that adapts to the needs and tastes of the owners. Although minimalism might still be considered the prevailing style, there is a growing diversity of loft interiors and interpretive treatments of the characteristic whitewashed walls, exposed metal, glass screens, and expansive hard floors. The loft has also become more accessible to the general public. Its original definition has been stretched to include a mass of open-plan living spaces, both old and new. As *Lofts DesignSource* illustrates, individual expression is the key; experimentation with distribution, color, texture, materials, and finishes can result in highly personalized spaces and urban sanctuaries in the heart of the city.

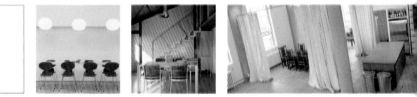

Smith Loft

Cho Slade Architects | © Jordi Miralles | New York, NY, United States

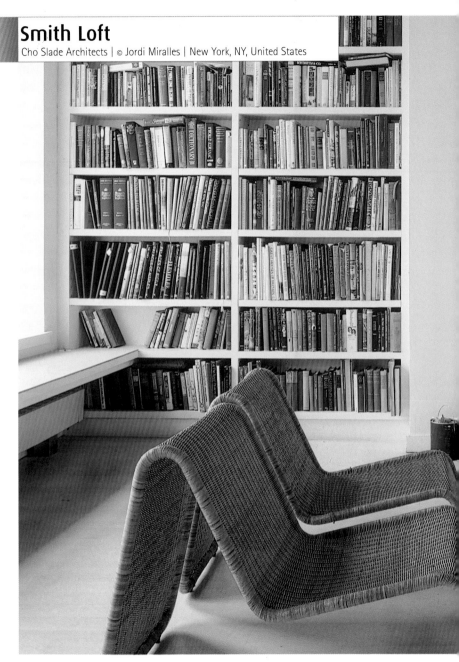

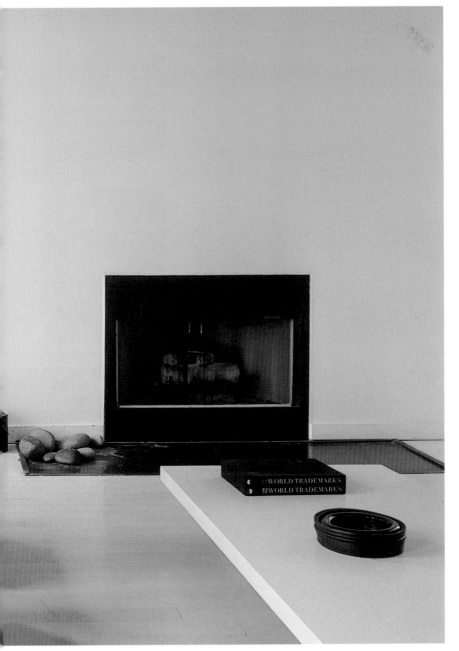

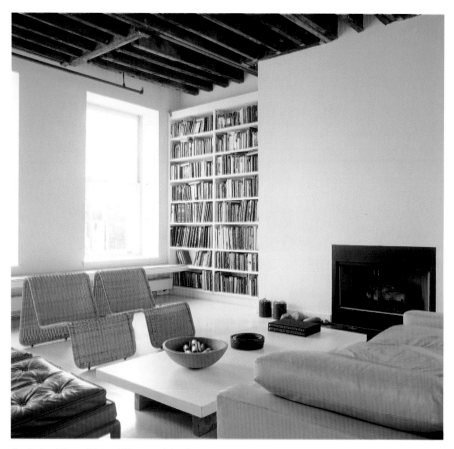

The clients, a father and his two children, commissioned
Cho Slade studio to remodel their Manhattan apartment.
One of the main requirements was that it be characterized
by an open distribution of space.

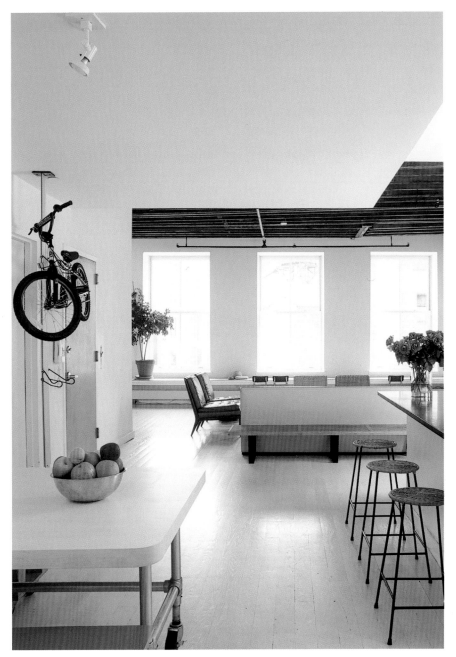

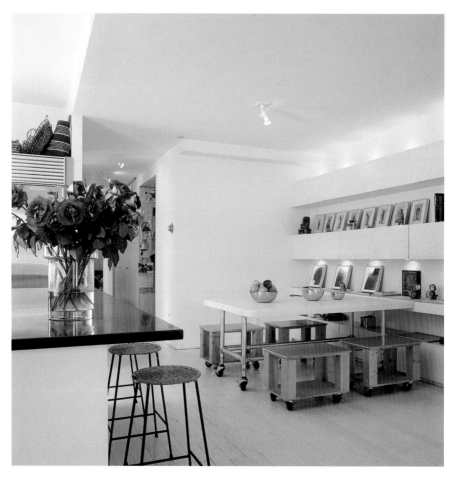

The common element of these three areas is a broad
corridor that connects the spaces, emphasizing the
sensation of movement between the two ends of the floor.

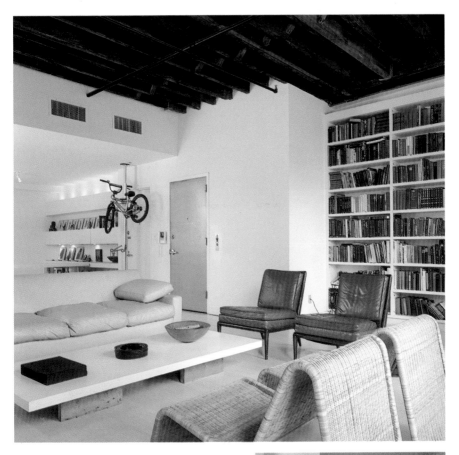

Cortés Loft

Pepe Cortés Asociados | © Eugeni Pons | Barcelona, Spain

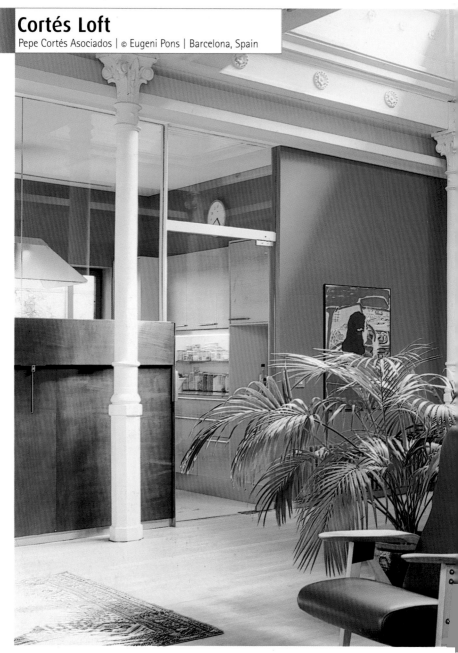

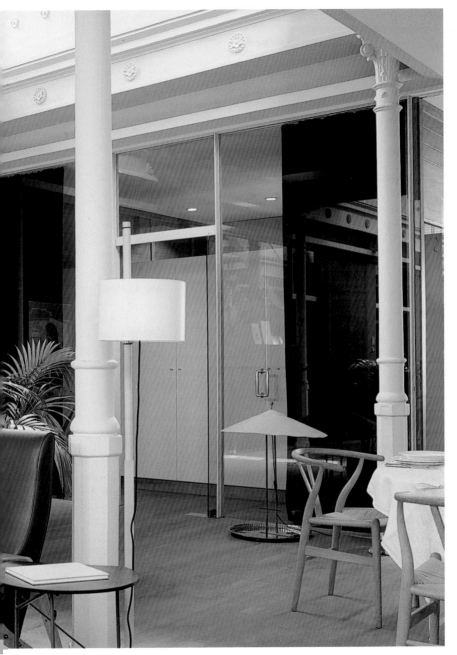

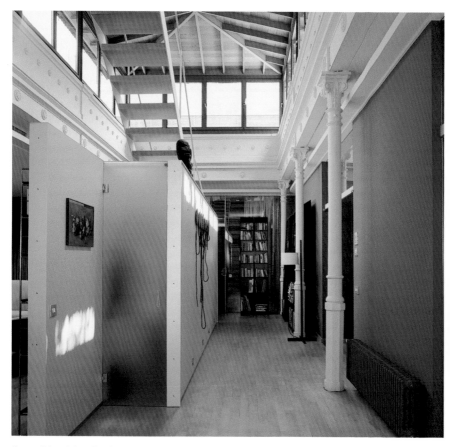

The prestigious designer Pepe Cortés converted this old
textile warehouse into his own home. Despite being
situated in the center of a busy, Barcelona
neighborhood, this unusual residence enjoys peace and
silence, which are uncommon in this city.

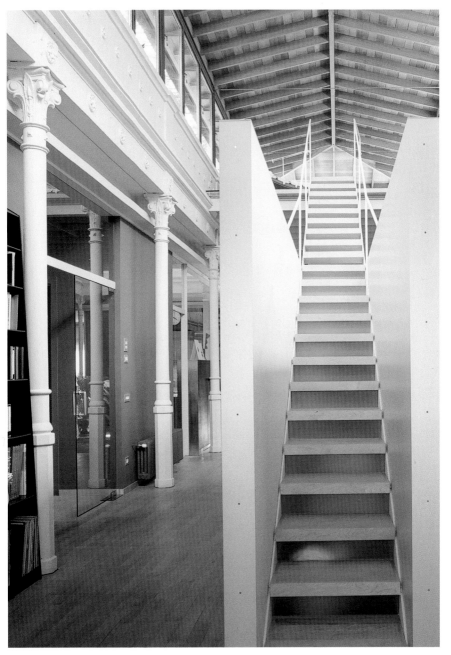

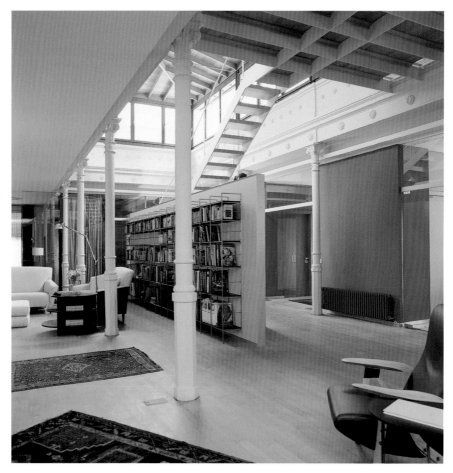

The elements used to distinguish spaces in this loft include
sliding doors, curtains, and perforated partitions that allow
light to flow in, affording privacy when necessary.

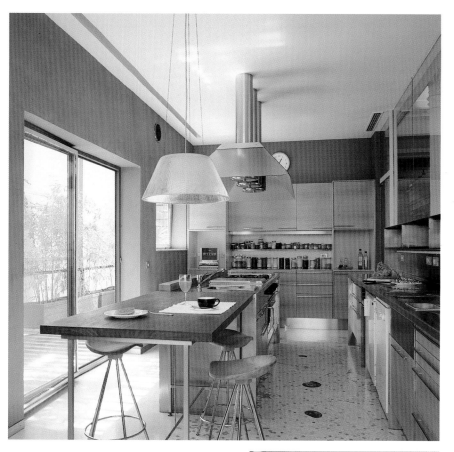

Tous Loft

Josep Maria Esquius i Prat | © Eugeni Pons | Igualada, Spain

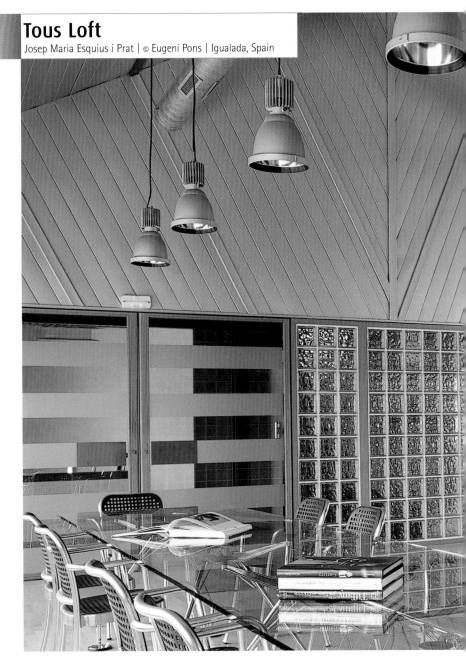

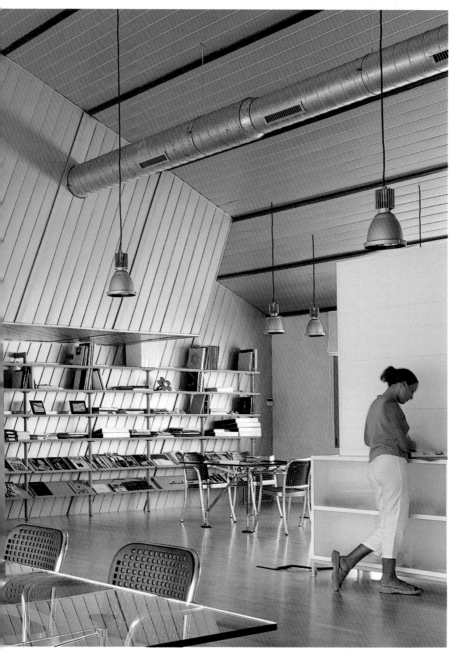

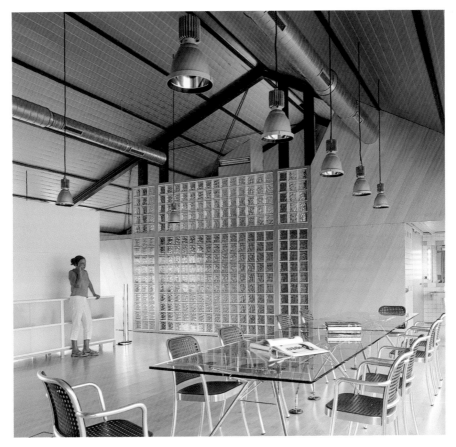

This project occupies the top floors of a building that consists of offices and workshops and is owned by an important jewelry company. It was conceived as a versatile area where the owners of the company could meet with clients and fellow collaborators.

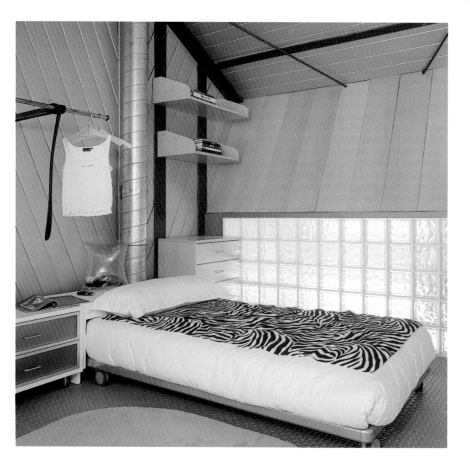

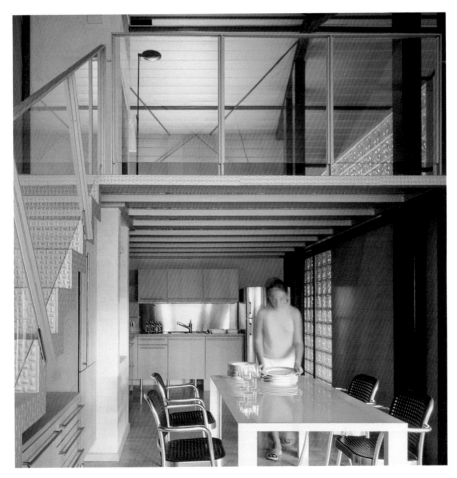

The architects took care to preserve the
building's original design, which conveyed a
strong industrial atmosphere.

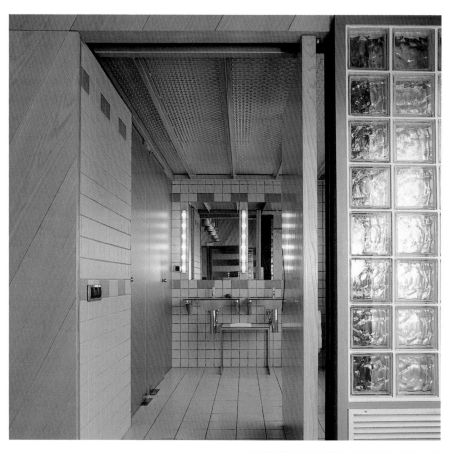

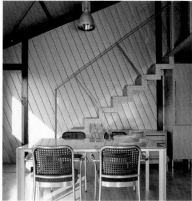

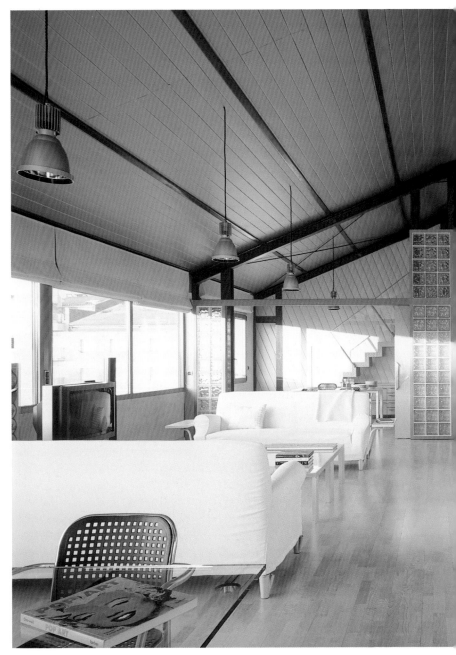

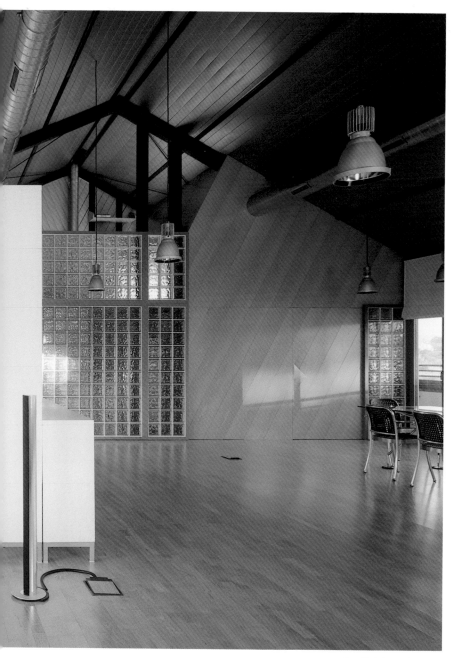

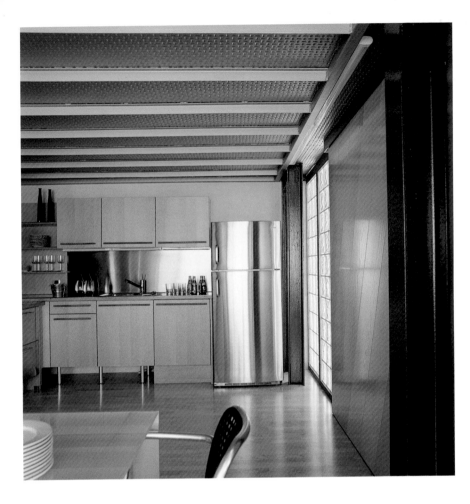

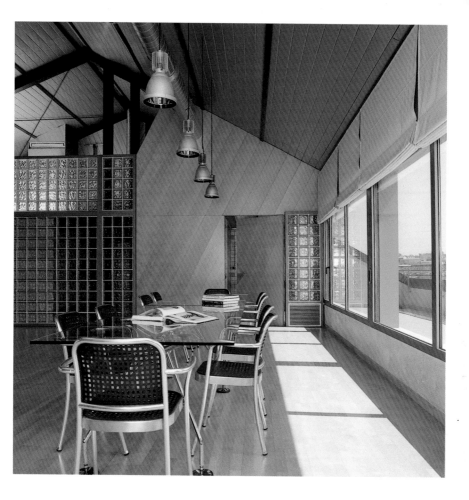

Frank + Amy

Resolution: 4 Architecture | © Eduard Hueber | New York, NY, United States

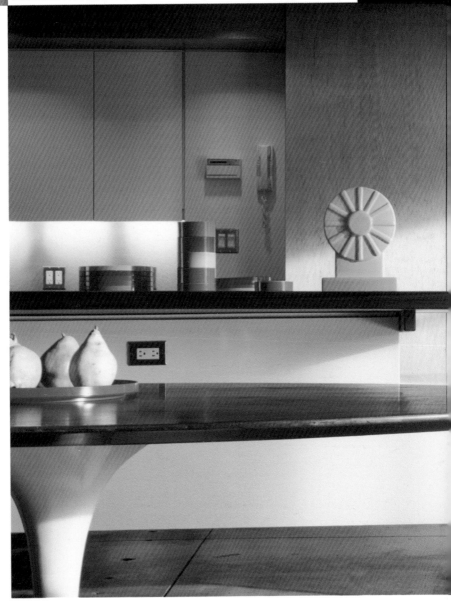

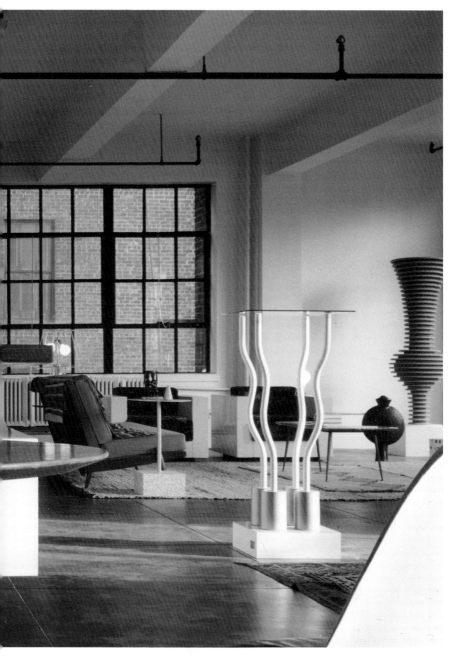

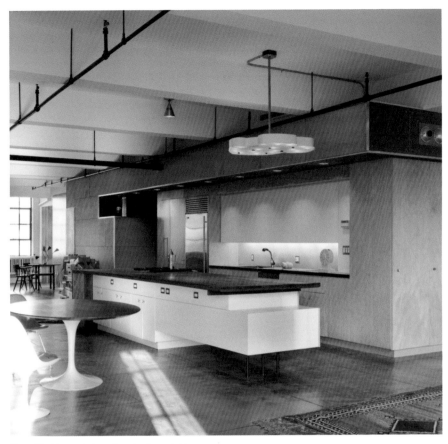

The architects' conceptual use of construction materials
increased the industrial atmosphere of the loft's design.
The cube is the structural axis of the space, separating
the public and private atmospheres.

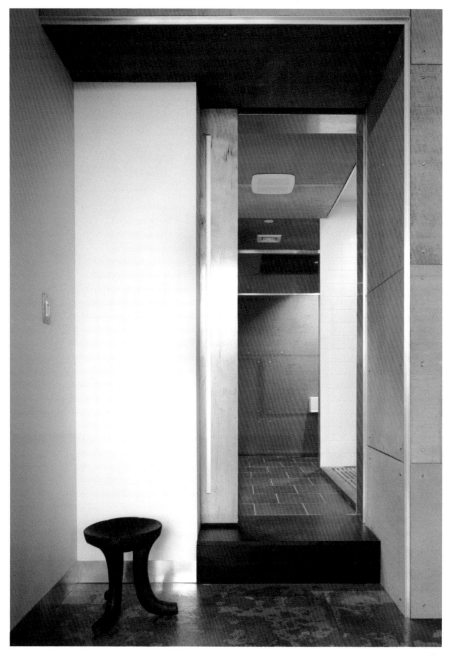

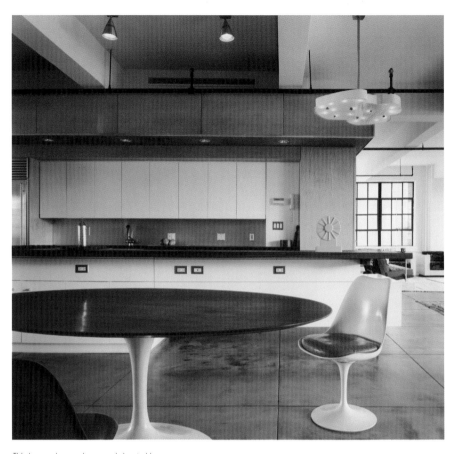

This bare and expansive space is located in an area
called Hell's Kitchen, in New York, and occupies an
entire floor of an old, industrial building. Its very large
windows are fundamental to the division of the space.

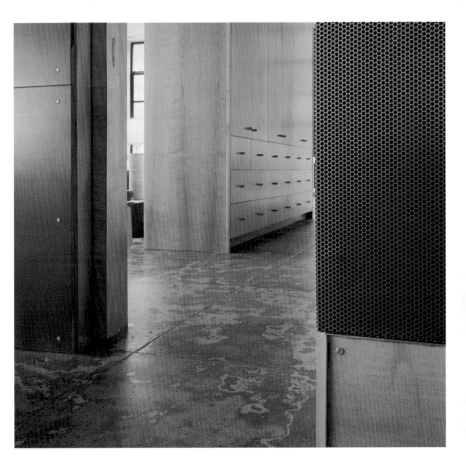

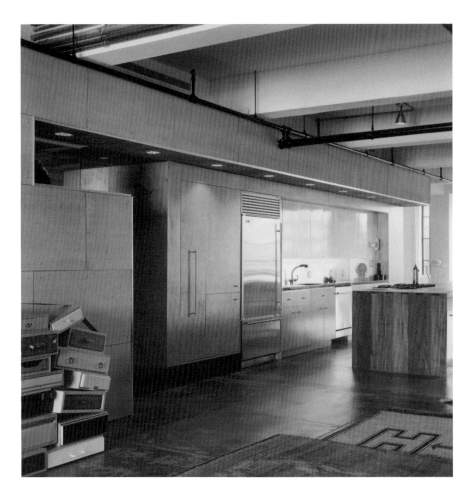

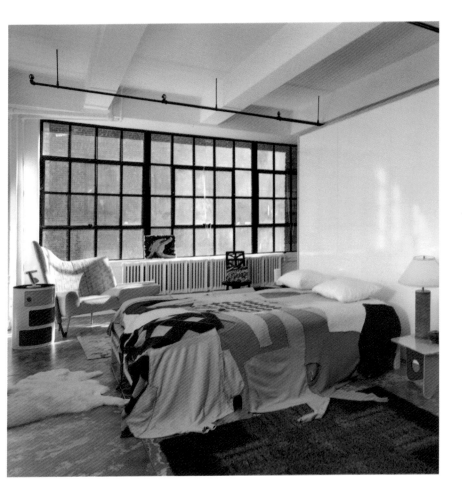

Loft A
Carlo Donati | © Matteo Piazza | Milan, Italy

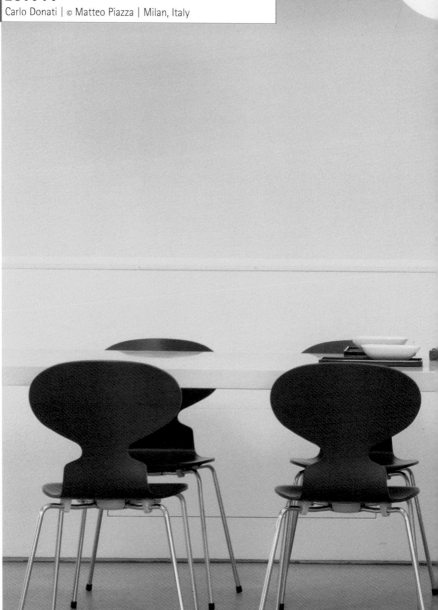

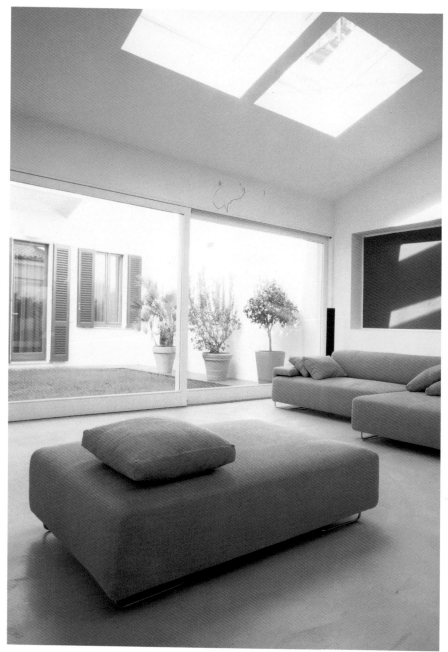

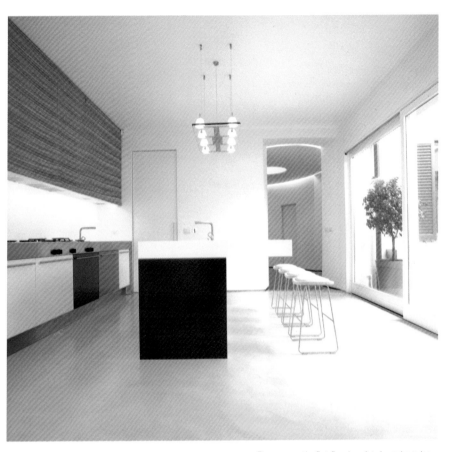

The rooms on the first floor have interior and exterior spaces that receive direct natural light. Among them is the kitchen, which acts as a kind of filter between the entrance and the rest of the house.

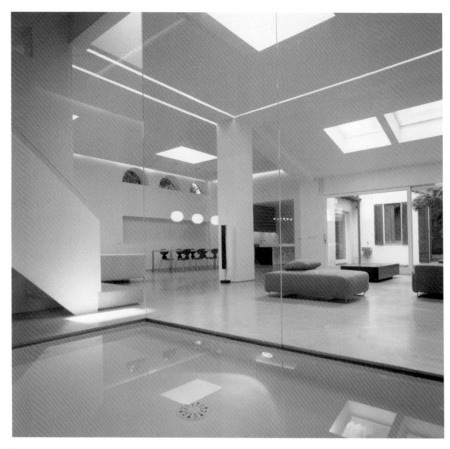

The basis for this project was the typical, traditional Milanese house with a balustrade. The concept behind the space is the union of the three units which comprise it. The entrance hall was transformed into an area where two geometrically pure bodies insert themselves into each other, thus creating different paths into the loft.

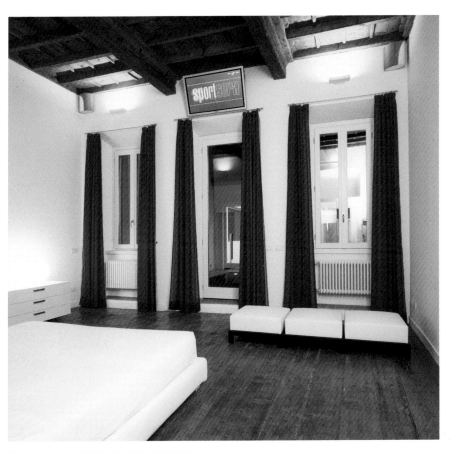

Samarcanda stone is used in the design of the
bathroom, which is part of the relaxation area designed
to be integrated into the living room area.

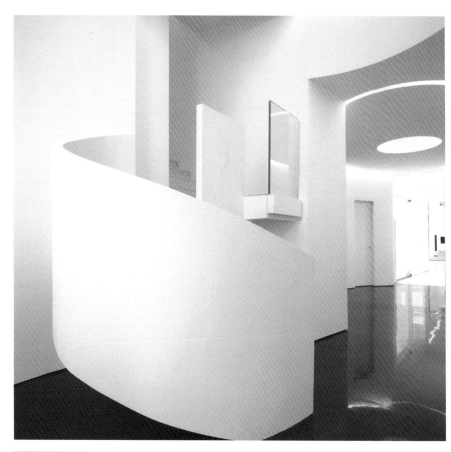

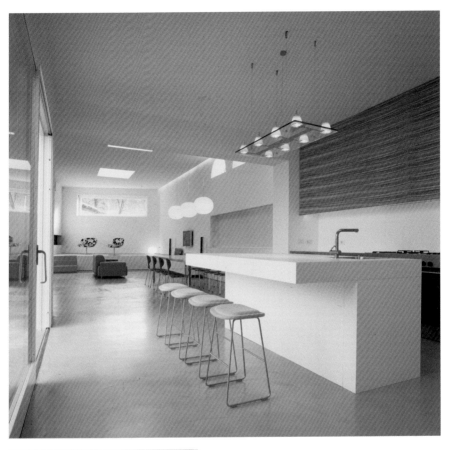

Oriol Loft

Oriol Roselló and Lucía Feu | © Jordi Miralles | Barcelona, Spain

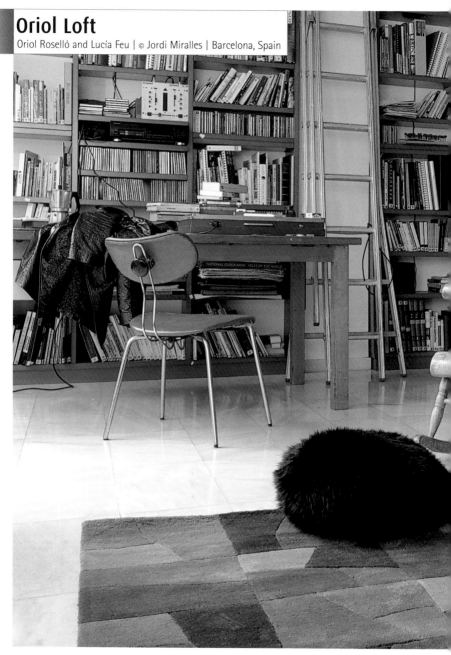

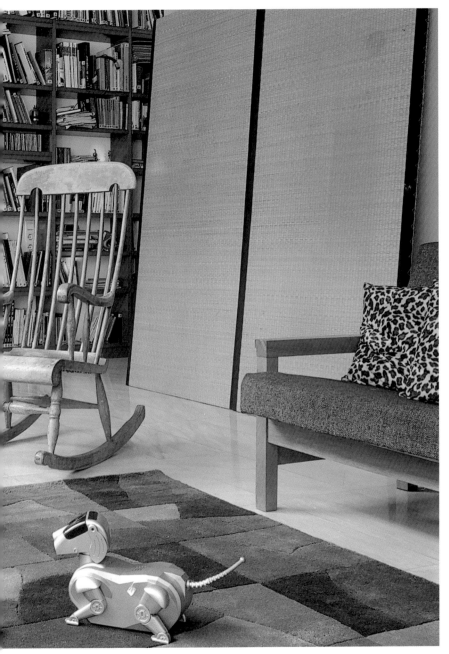

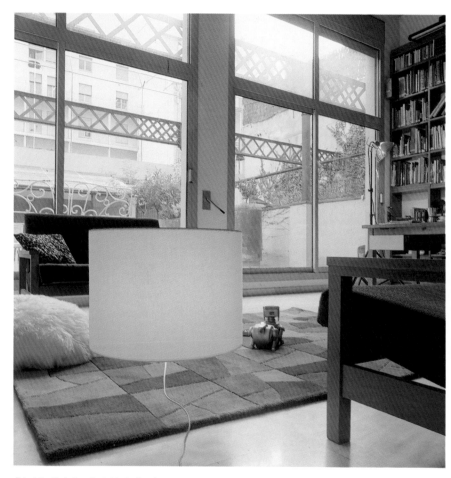

This old textile factory situated in the Barcelona Eixample district was converted into a block of flats. The architect, Oriol Roselló, kept the ground floor of the building, the only part that preserved the original industrial past of the building—the forged, trellis-iron beams, for example.

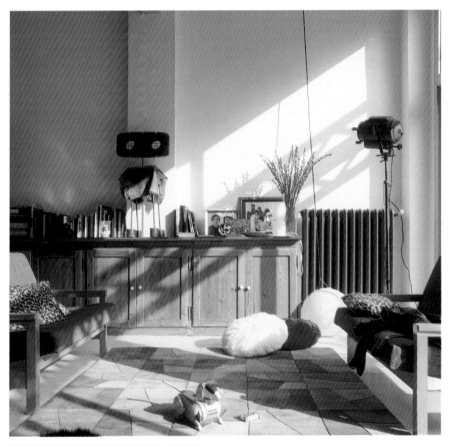

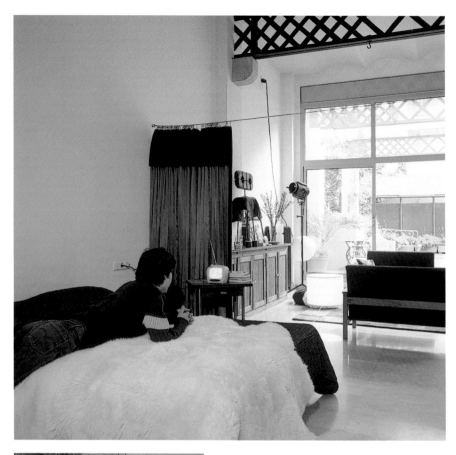

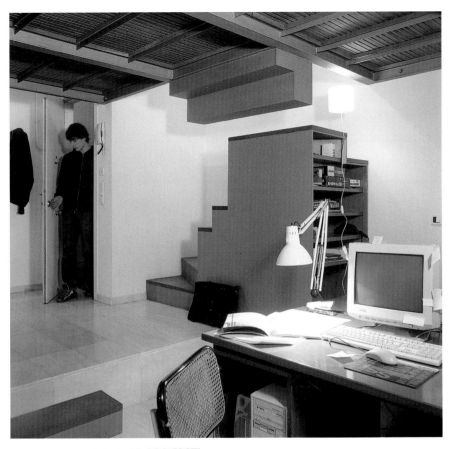

The system of beams that used to hold up the roof is visible on the terrace, which is a reminder of the continuity between the original project and the new.

Taffer Loft

Audrey Matlock Architects | © Catherine Tighe | New York, NY, United States

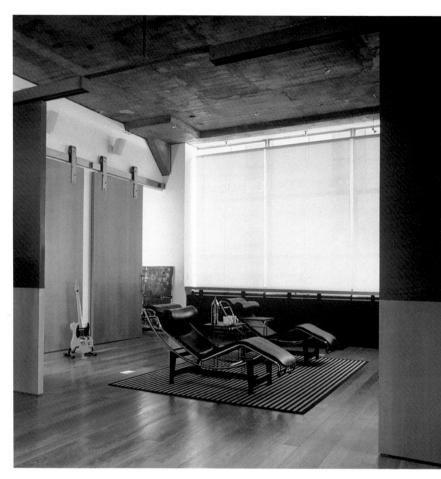

This loft sits in an old factory on the shore of the
Hudson River, beside the Holland Tunnel, in a part of
southern Manhattan that has undergone considerable
transformation over the course of the last 50 years.
Industrial buildings, wharves, and warehouses gradually
have become spaces for homes, parks, and office blocks.
The majority of these alterations to the urban
landscape have influenced structural preservations in
the original edifice and its adaptation for new uses.

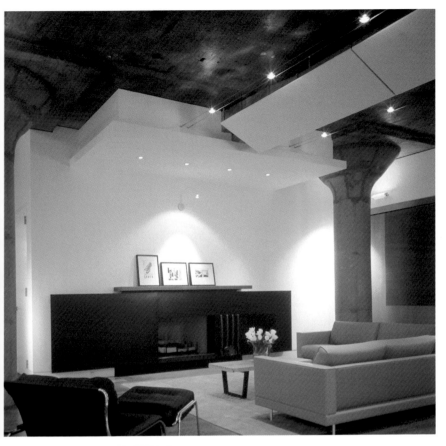

This project envisioned a house with open-layout spaces. While in some instances compartmentalized, the different areas always maintain an open spacial relationship with one another.

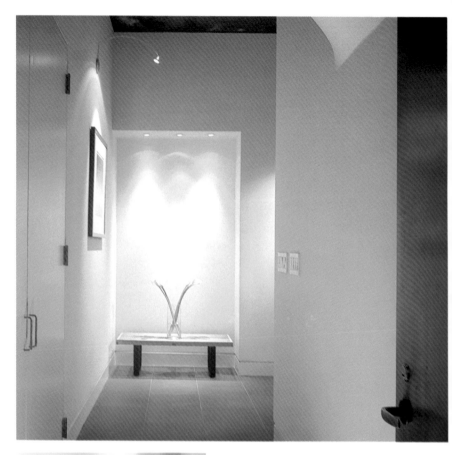

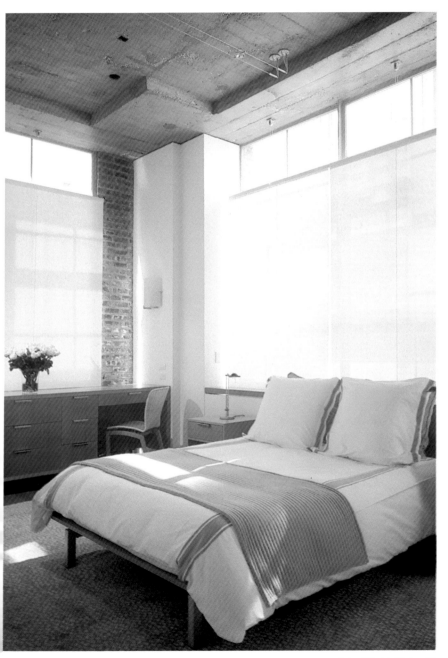

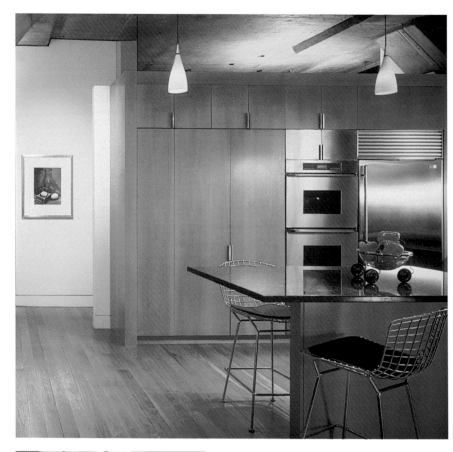

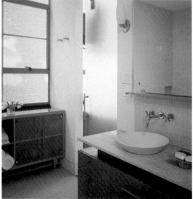

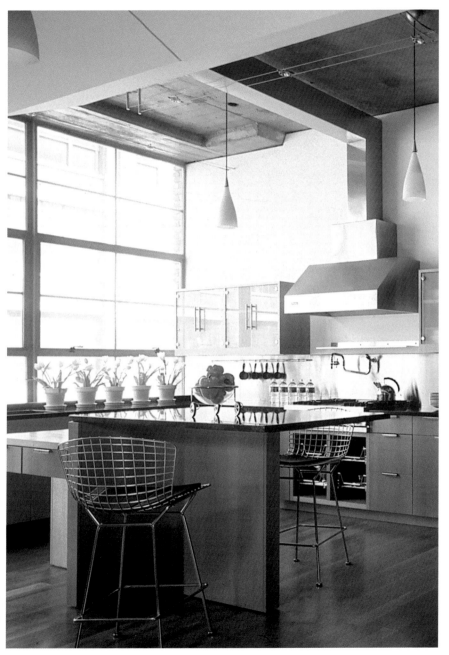

Boesky Loft

Gluckman Mayner Architects | © Mark Arbeit | New York, NY, United States

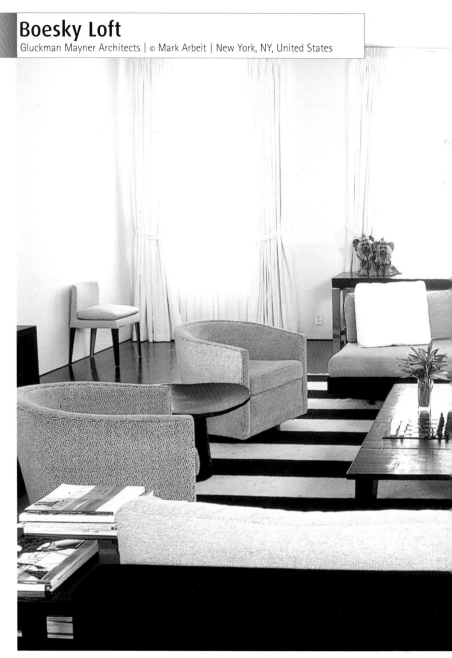

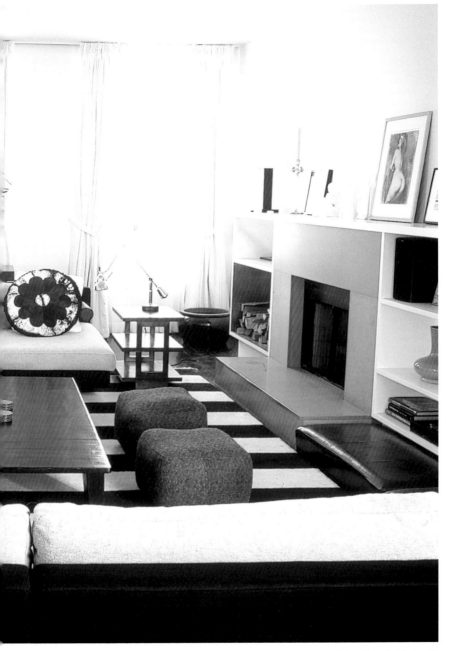

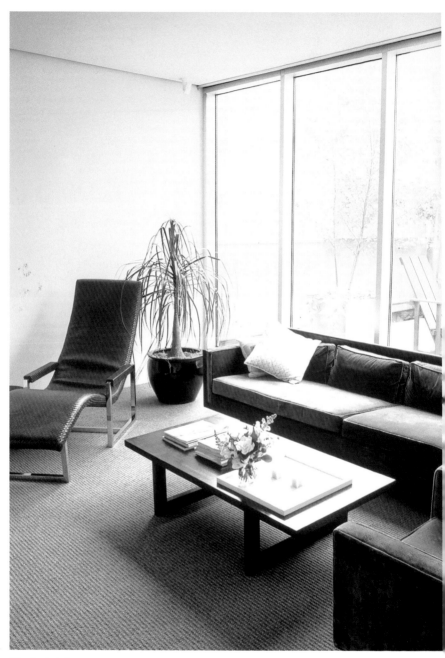

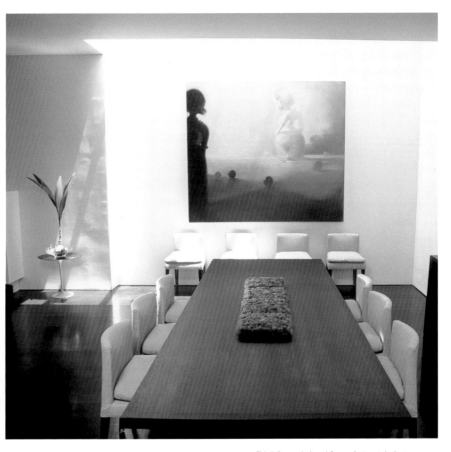

This loft was designed for a private art dealer to accommodate the display of her art collection. Vertical axes of light penetrate deeply into the space, illuminating white planes of plastic and sheetrock. Skylights were created at various points in the loft to highlight specific areas or objects.

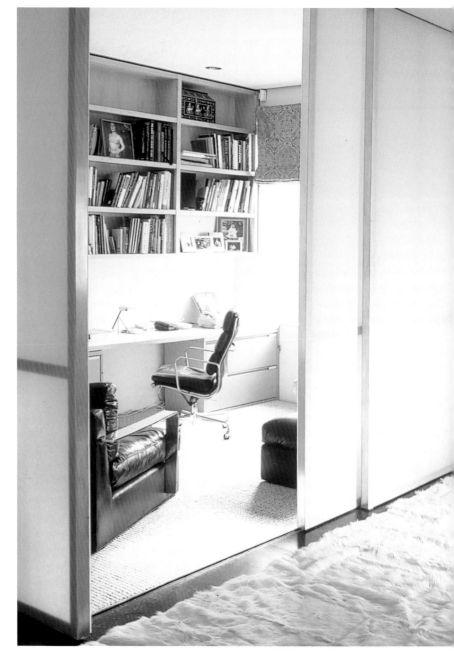

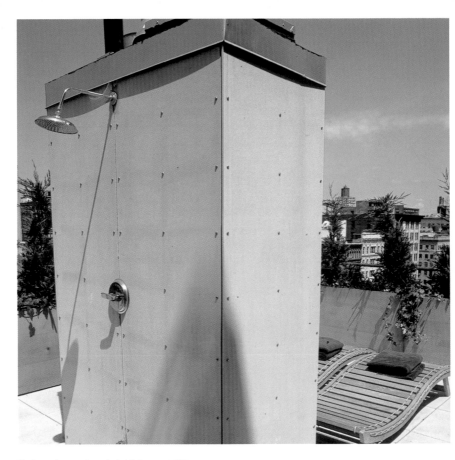

The terrace incorporates a shaded dining area and its
own shower, opening up the loft's dining possibilities.

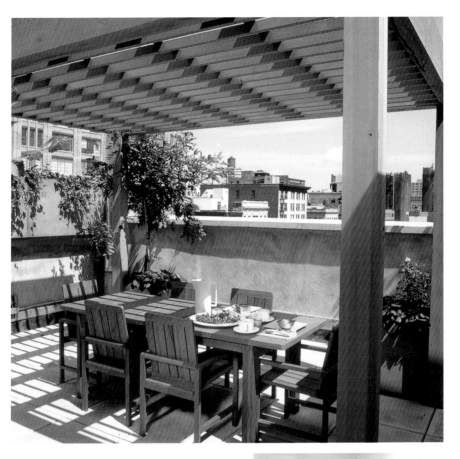

Baron Loft

Deborah Berke | © Fabien Baron | New York, NY, United States

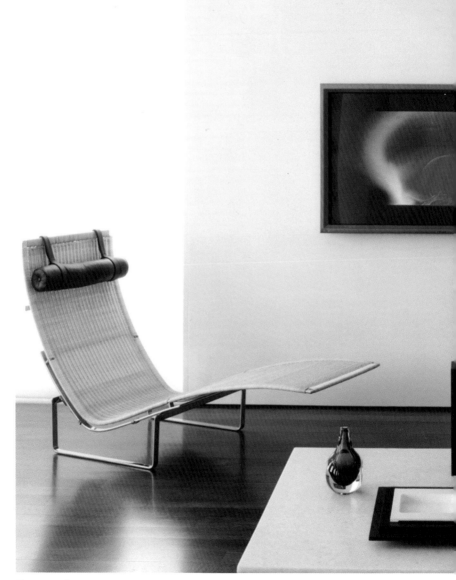

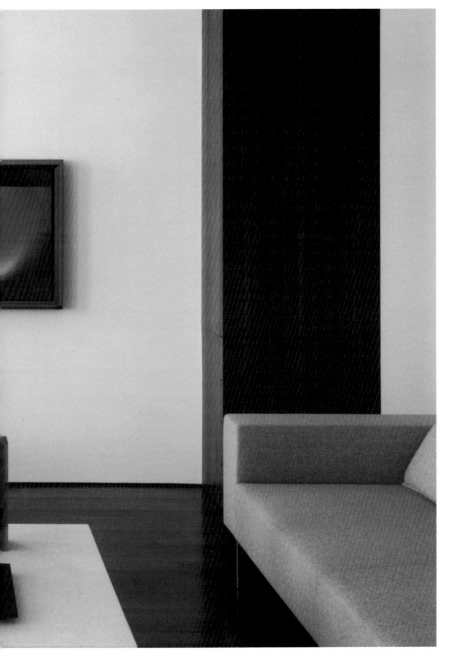

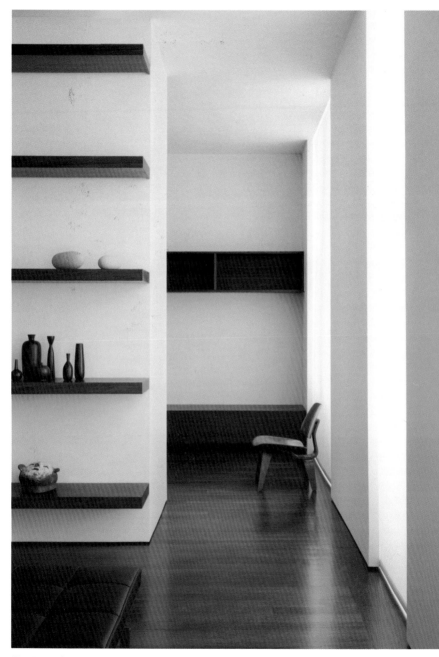

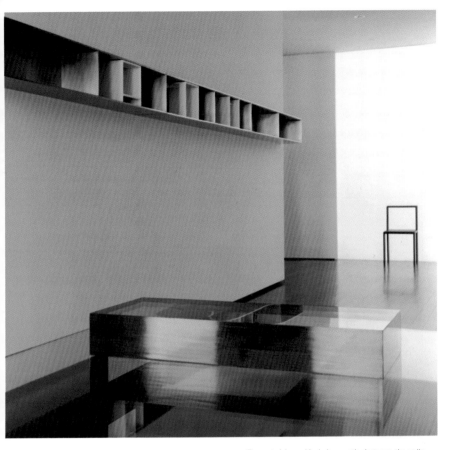

The materials used include smooth plaster on the walls, ebonized oak floors, polished schist blocks in the bathroom, oiled walnut slabs, brushed stainless steel, white glass, and white window scrims. Each of these is detailed in the most unobtrusive manner possible.

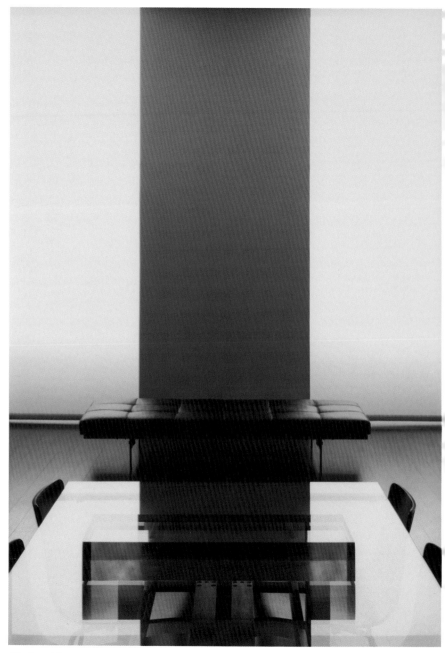

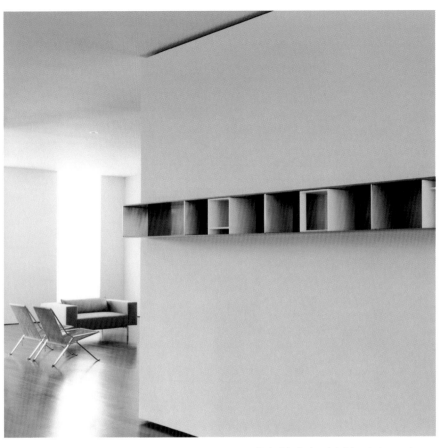

Much of the furniture is built into the home and
displays the owner's extensive art collection.
A strict color palette gives way to a sober design
sprinkled with subtle doses of warm tones.
The kitchen is hidden behind walnut doors, while a
translucent glass wall conceals the master bedroom.

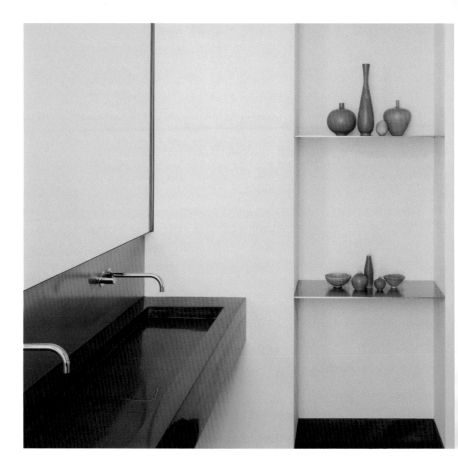

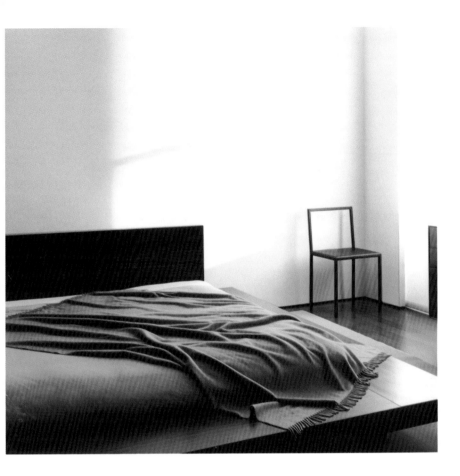

Barbieri Loft

Simon Conder Associates | © Peter Warren | London, United Kingdom

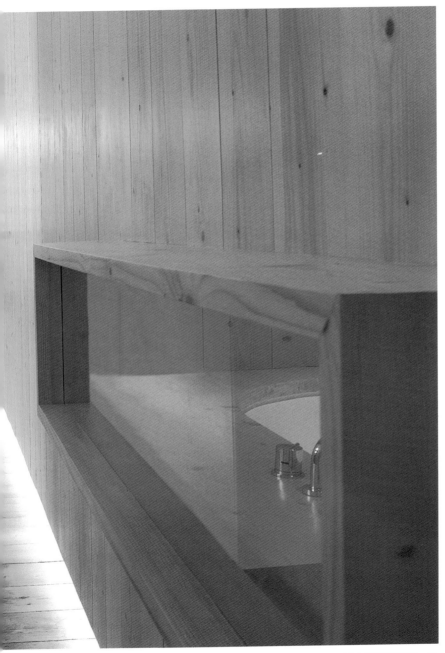

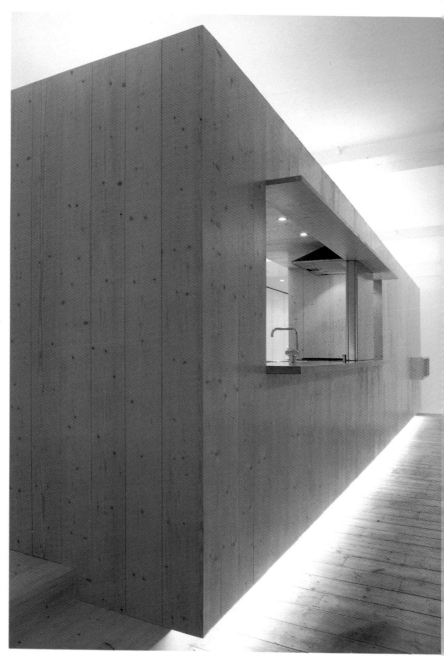

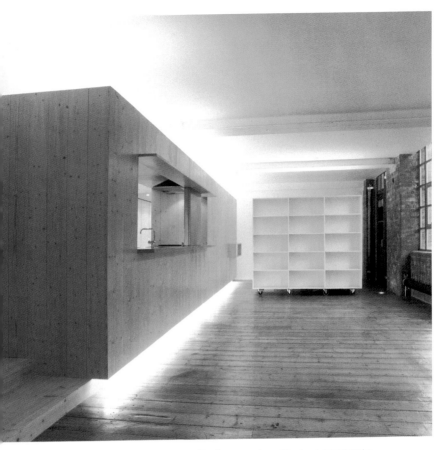

The clients were a journalist and a photographer who acquired this locale on the second floor of a nineteenth century industrial building. The objective was to create spacious and bright ambiences that also communicate well with each other. This was especially important between the kitchen and the living room in order to facilitate the conversation between those cooking and the guests.

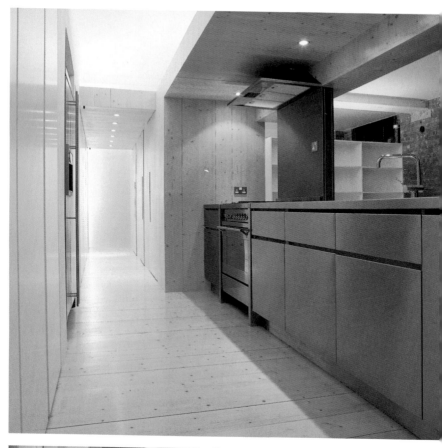

Given the limited surface area, the key decision was made not to subdivide the space into different rooms but, rather, to have one all-enveloping atmosphere organized by movable partitions.

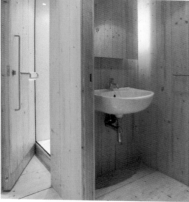

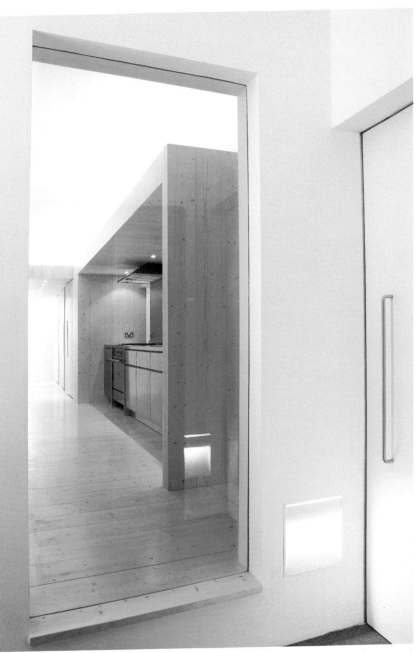

Surrey Loft
Detail Architects | © Jonathan Moore | Surrey, United Kingdom

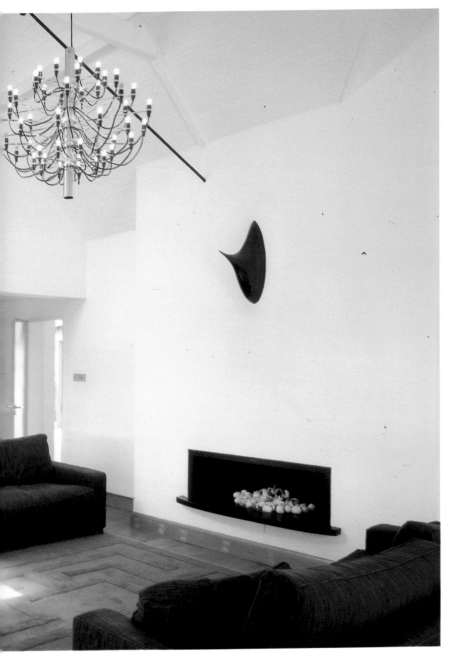

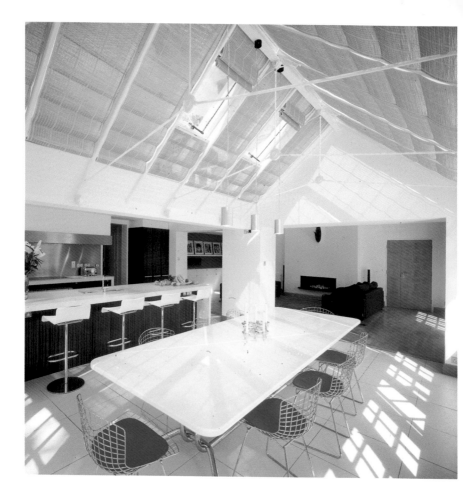

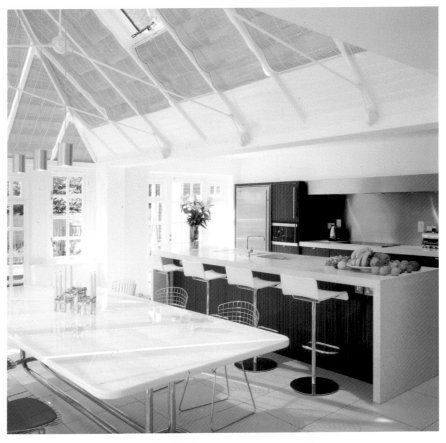

This project is based on the rehabilitation of a stable that was part of an Edwardian-style country estate in Surrey, England, and entailed the demolition of interior walls in order to create open spaces. The plan called for a dining room and a kitchen, and the dwelling needed to be outfitted with the common comforts of a home, such as electrical installations, pipes and drains, walls, new flooring, and furniture.

Atrium Loft

Nancy Robbins + Blau-Centre de la Llar | © José Luis Hausmann | Barcelona, Spain

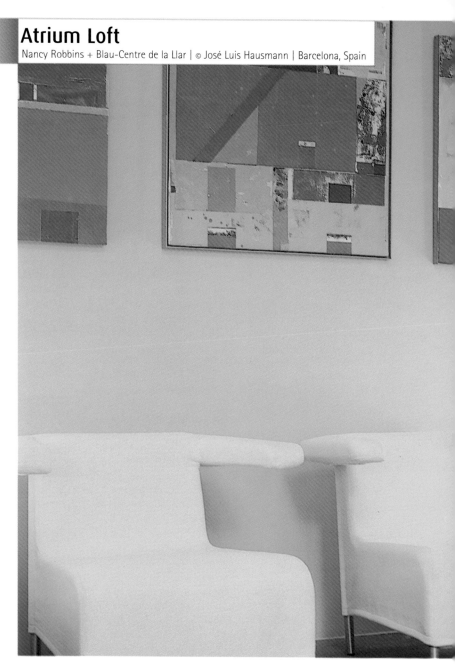

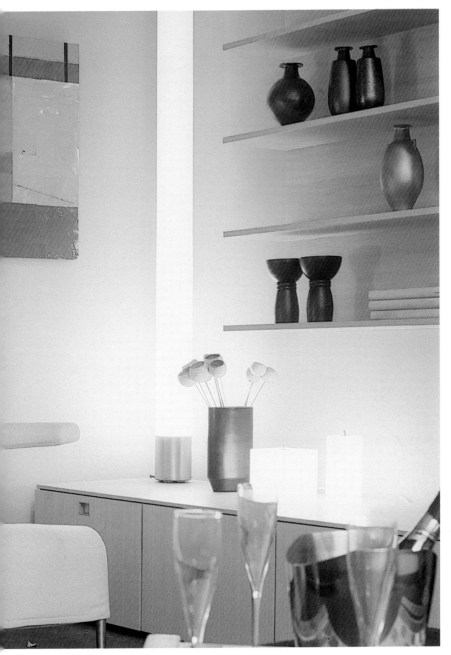

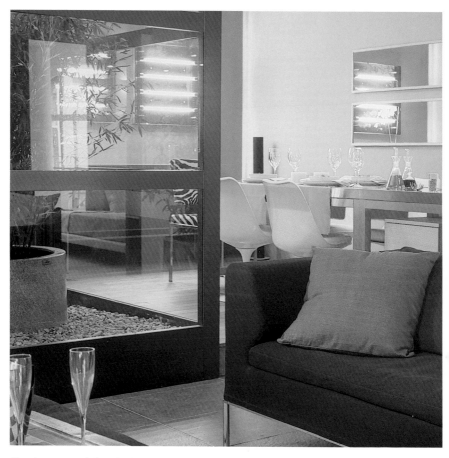

Given the narrow area designated as the kitchen and dining areas, the stainless steel island was simply extended for use as a dining table. The island makes room for mobile storage units underneath the service area, and a raised level on the floor indicates the eating area. A skylight just above the dining area was draped with white fabric to diffuse the natural light.

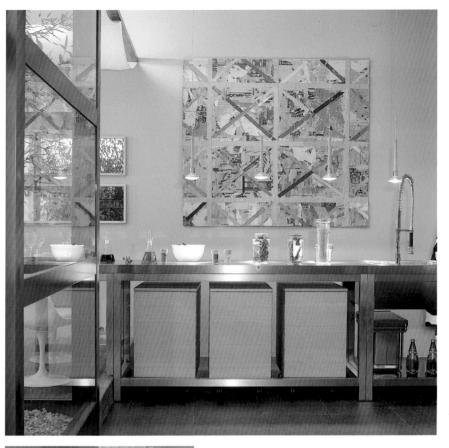

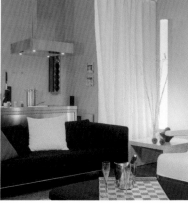

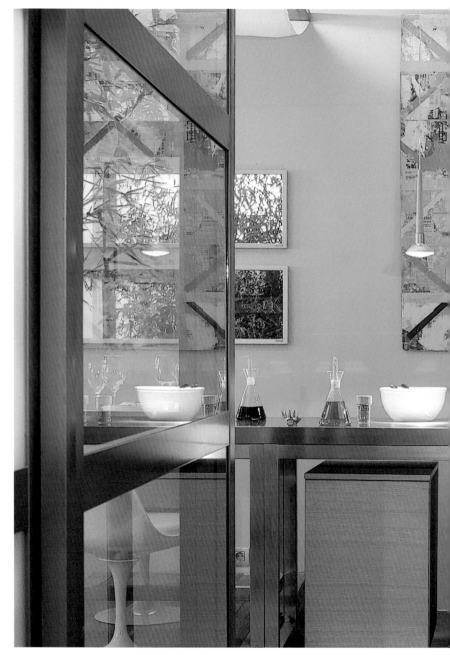

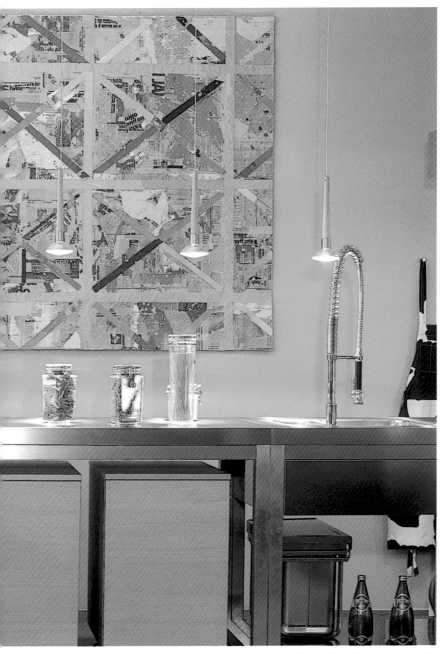

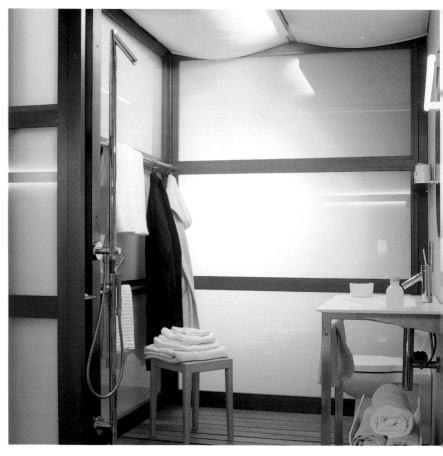

The en suite bathroom is wrapped in translucent glass and
features an integrated shower on a wooden deck surface.

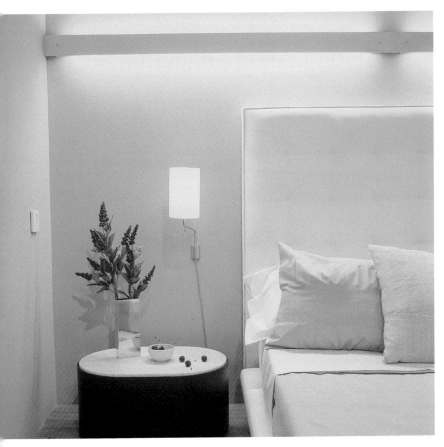

The bedroom was placed on the other side of the atrium, farthest from the day area. The lighting plays an important role in setting a serene mood, both in the bedroom and the bathroom.

Flower District Loft

Desai / Chia Studio | © Joshua McHugh | New York, NY, United States

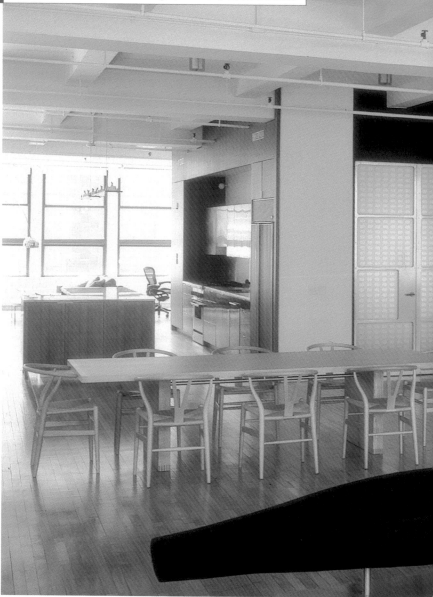

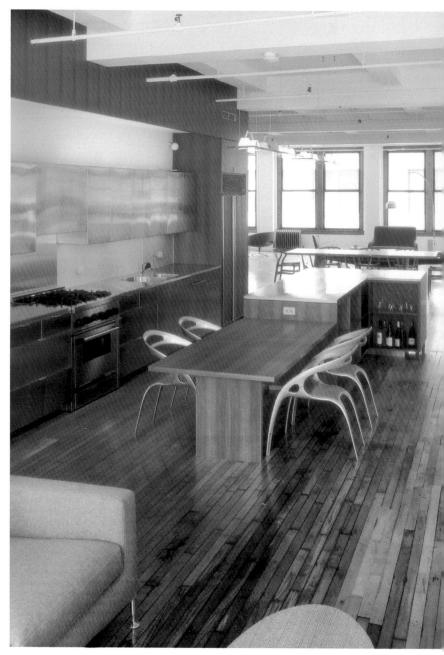

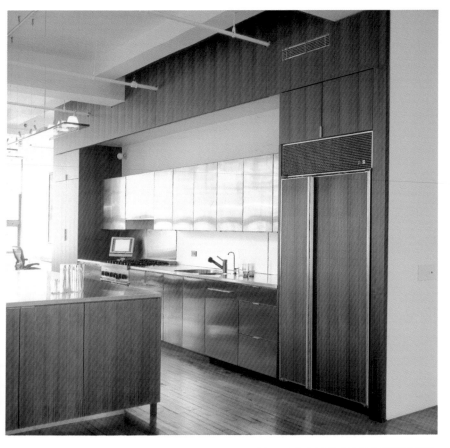

This compact volume of private space contains a guest bedroom, a gym, a powder room, and two bathrooms. The design concentrates the center of the public area at the kitchen, which becomes the focal point of the loft.

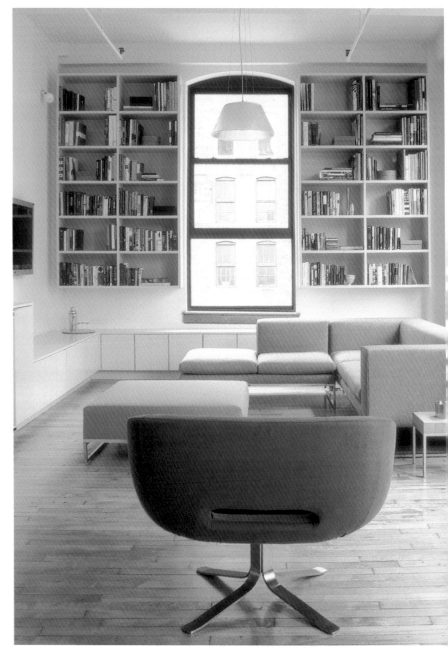

The loft's open public areas are visually choreographed so that they can merge, compress, and expand, depending upon the client's needs. Its elasticity allows it to expand for a large, crowded party or to contract into separate zones for more intimate gatherings and events.

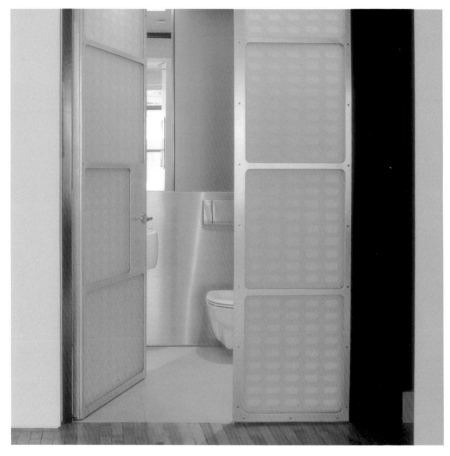

Translucent screen doors mounted on aluminum frames
allow the passage of light from the private core to the
public areas. Their pattern, inspired by the traditional
Indian jali, creates a shifting pattern of translucency,
depending upon the direction in which the light passes
through the sandwiched materials.

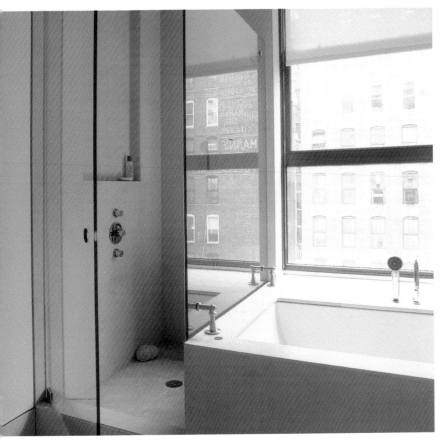

Campins Loft

Luis Felipe Infiesta Architect | © Jordi Sarrá | Barcelona, Spain

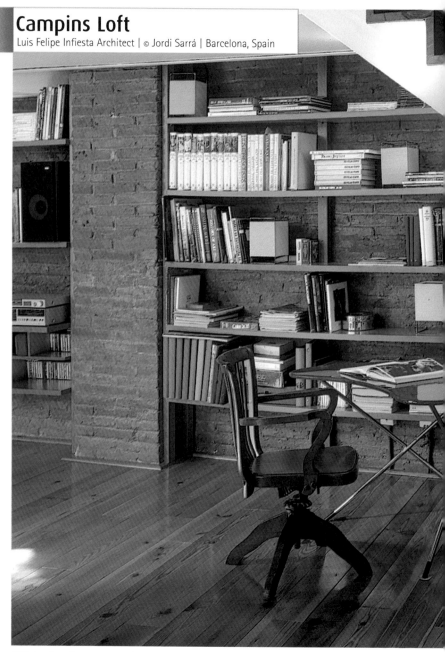

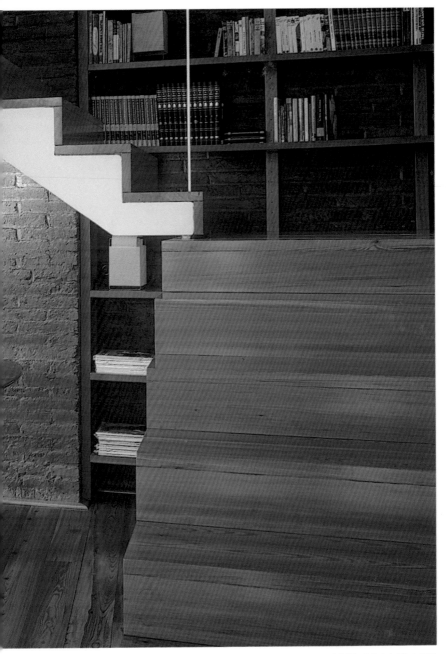

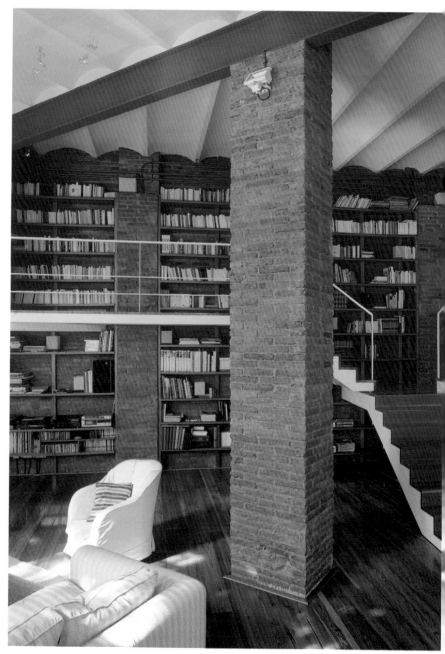

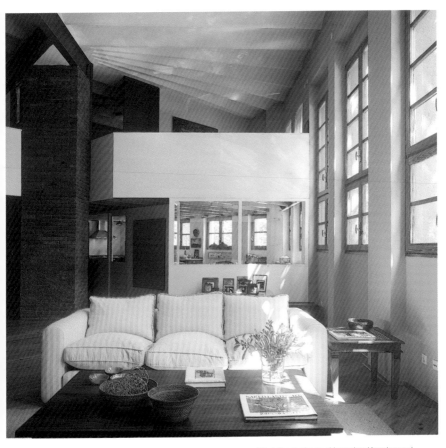

This loft occupies an old metalworking shop and combines a photographic studio and a dwelling. The design sought to combine these two functions in the same volume while maintaining the independence of each. To achieve this, the ceiling height of 16 feet was maintained. A loft was built to house the master suite-style bedroom and another room that is attached at one end to the façade of the double-height living room.

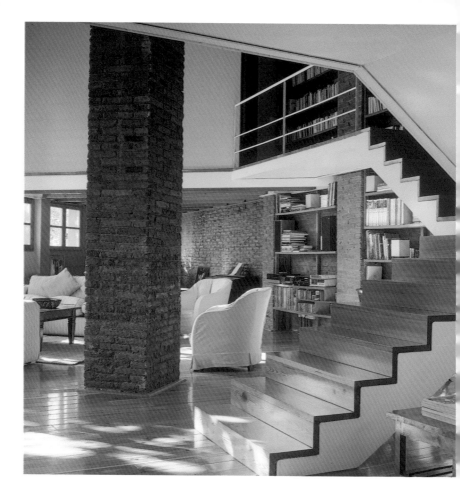

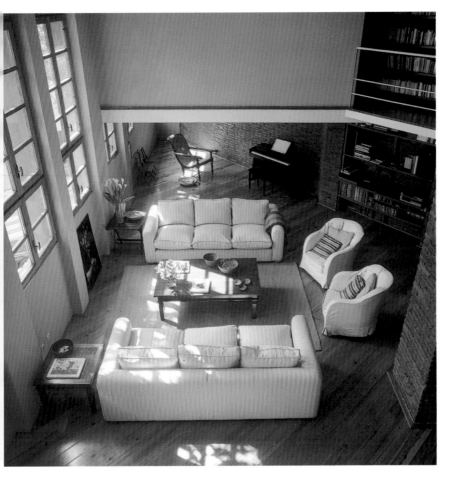

The linear distribution of this space is organized around a wide central aisle in order to make it less tubelike. In the central axis of the floor, the preexisting brick columns dictated leaving this zone as uncluttered as possible to achieve the most diaphanous space possible.

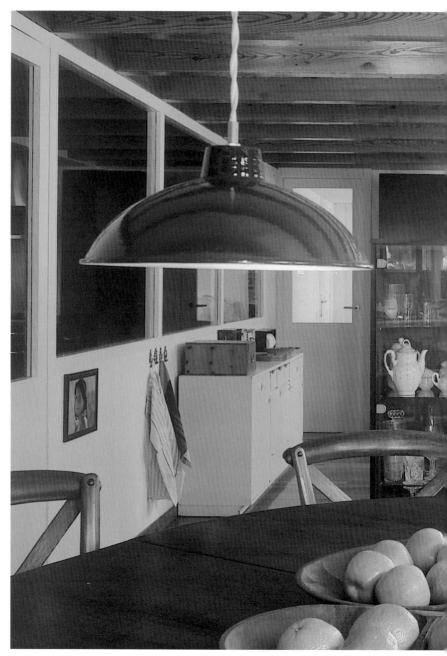

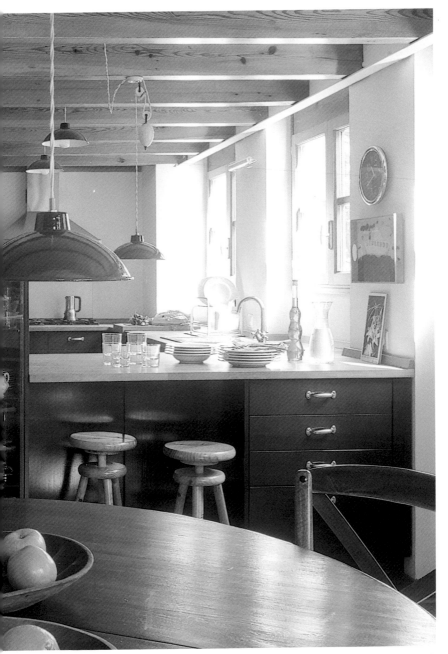

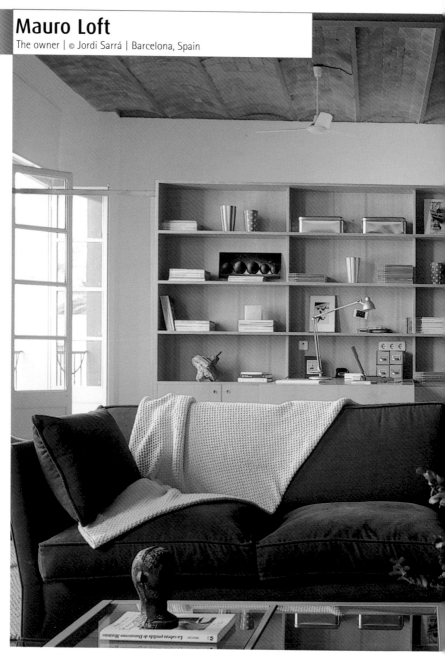

Mauro Loft

The owner | © Jordi Sarrá | Barcelona, Spain

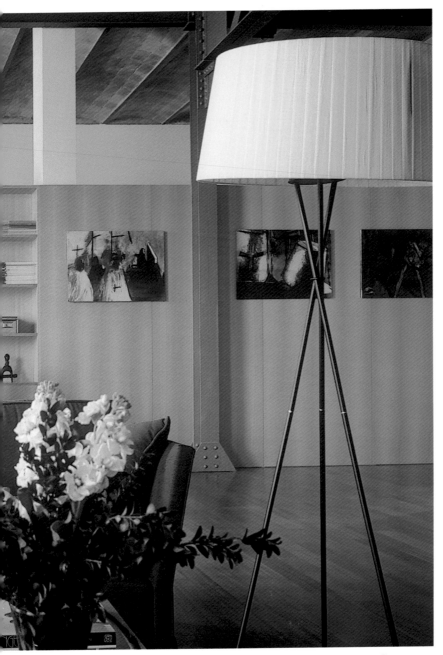

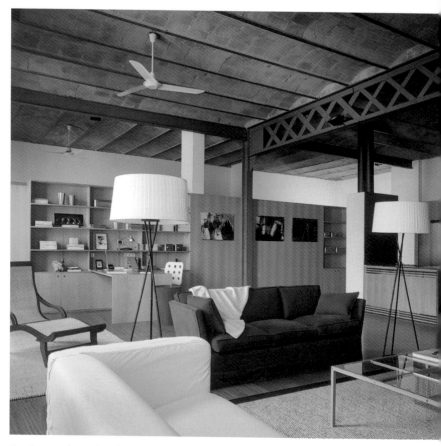

From the outset, the proprietor of this old industrial space envisioned its aesthetic and functional possibilities and so dared to design the project on his own. The project's development was guided by the decision to preserve the space's identity, defined by wrought iron beams, trusses and pillars with rivets, and ceilings consisting of joists and bare jack arch bricks.

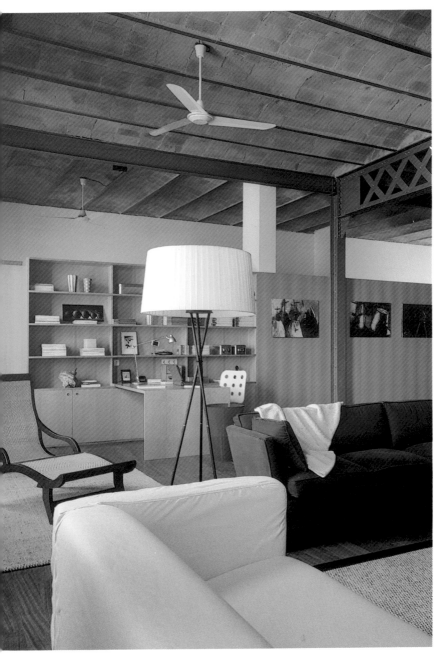

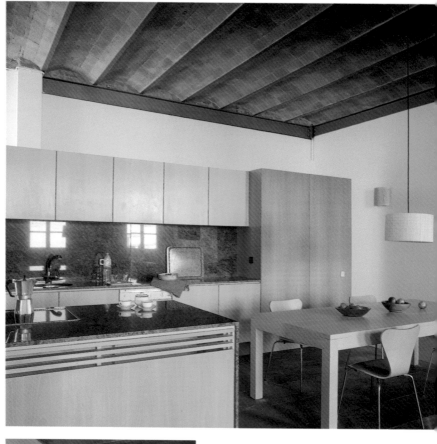

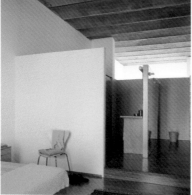

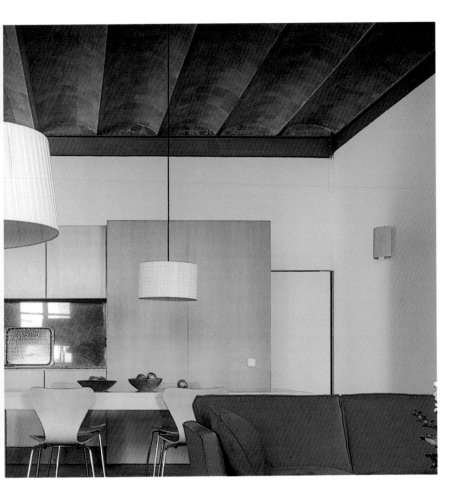

Flinders Lane

Staughton Architects | © Shannon Mcrath | Melbourne, Australia

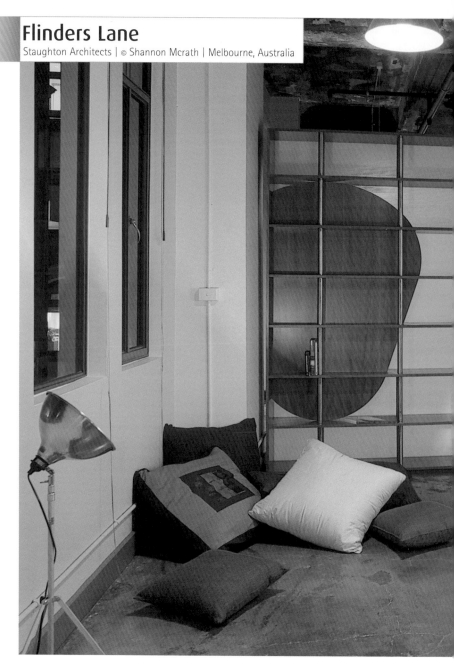

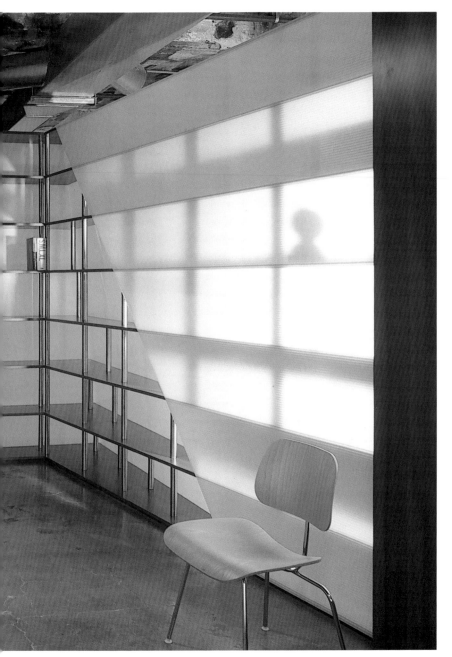

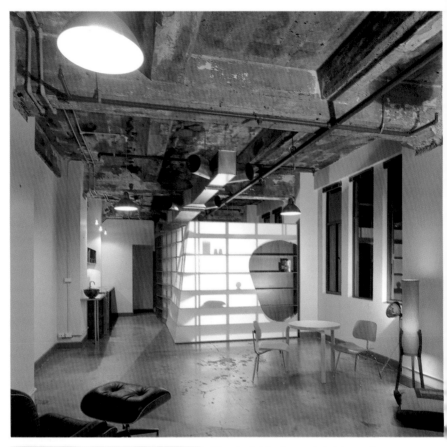

This project is defined by two principal elements. The first is a multifunctional, freestanding, wood-framed unit that encloses the sleeping area, provides storage space, serves as an auxiliary dining room, includes bookshelves, and is a sculptural element in itself. The second element is the set of patterns sandblasted onto the original cement floor.

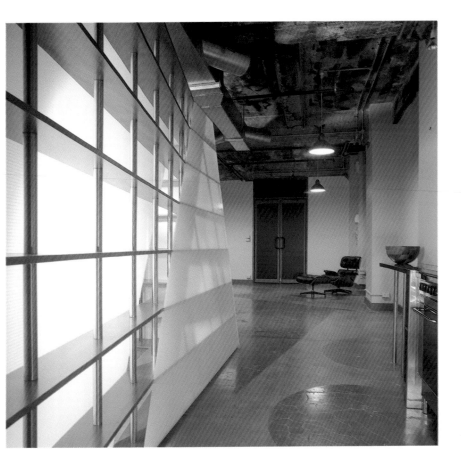

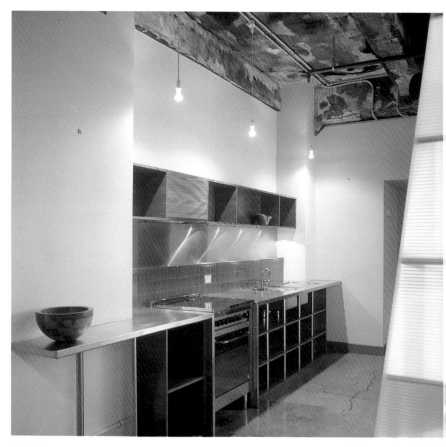

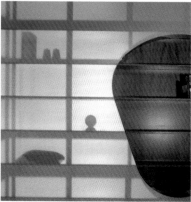

While the wood and polycarbonate unit separates the space into bedroom and living room, it also delimits the kitchen and guides traffic to the narrow entrance of the bedroom and bathroom. In addition to performing multiple functions, the polycarbonate and wood unit also acts as a lamp against which shadows are visible.

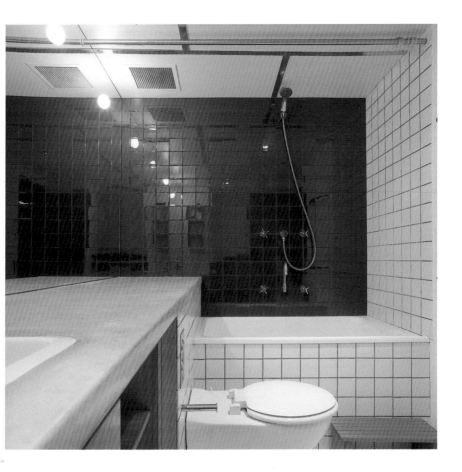

White Loft

Anne Bugugnani and Diego Fortunato | © Eugeni Pons | Barcelona, Spain

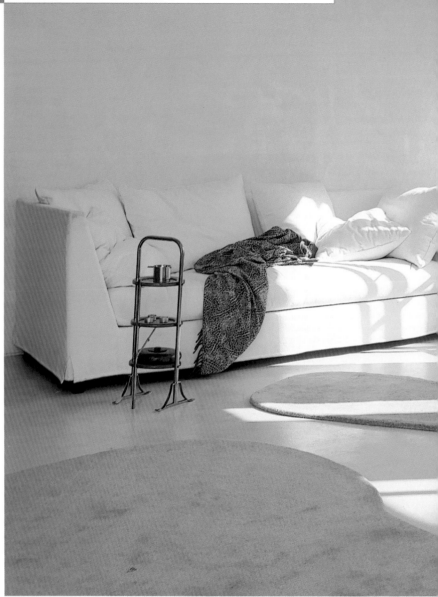

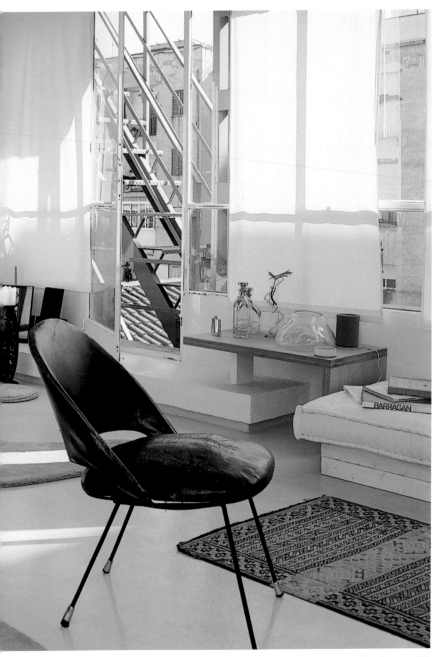

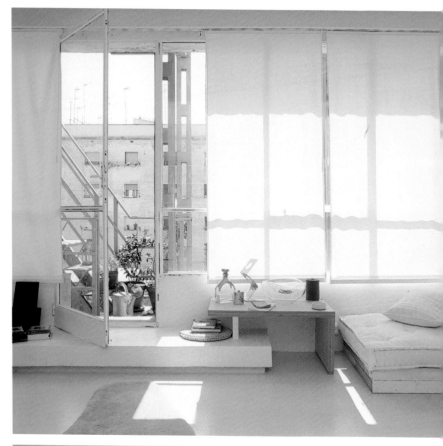

The concept for this space revolved around the marriage between contrasting elements: the visually chaotic interior patio; the mathematic collection of volumes; the cool metallic emergency stairwell; and the soft white stucco that enfolds the loft.

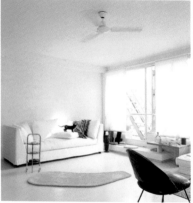

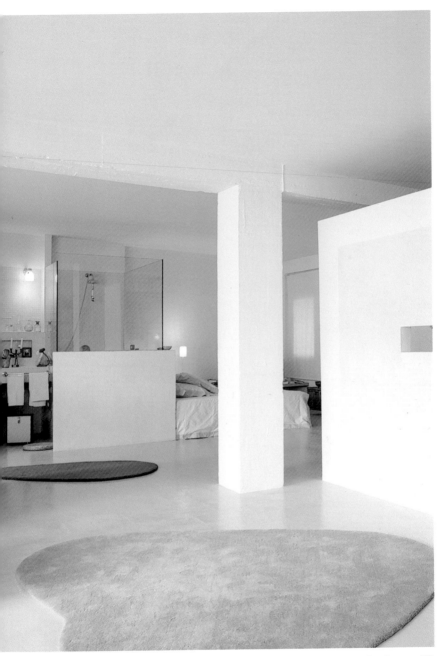

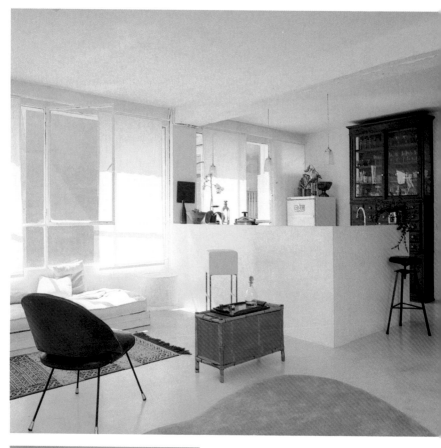

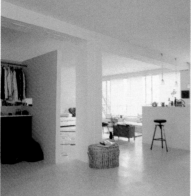

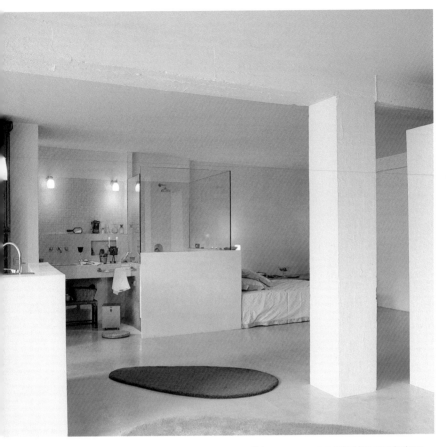

This square space was sustained by a central column and a transversal beam, which act as invisible boundaries between public and private areas. The loft's functions are characterized by freestanding structural elements, such as those that define the kitchen, wardrobe, and bathroom.

Loft in Saarbrücken

Guenther Lellé | © Angelika Klein / Artur | Saarbrücken, Germany

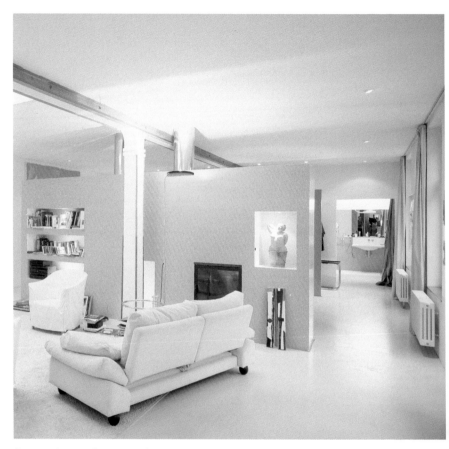

Recent years have seen the emergence of owners who, rather than transforming an old factory into a loft, design a conventional dwelling using a loft approach. A fine example of this flourishing trend is this home in Saarbrücken, which does not occupy a former industrial space but instead makes use of a common, conventional dwelling in an ordinary block of apartments.

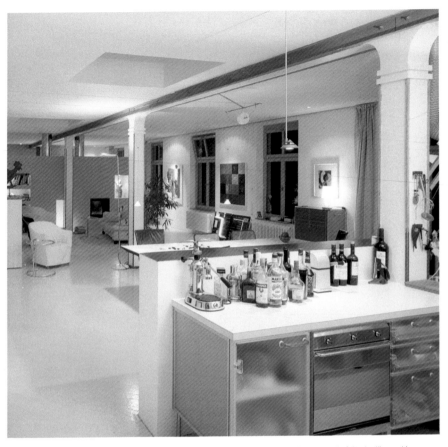

The kitchen is at one end of the dwelling and is separated from the dining room by a low furniture piece that serves as a bar.

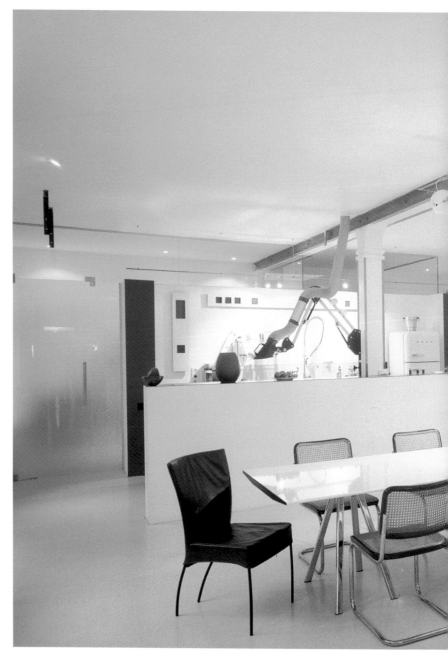

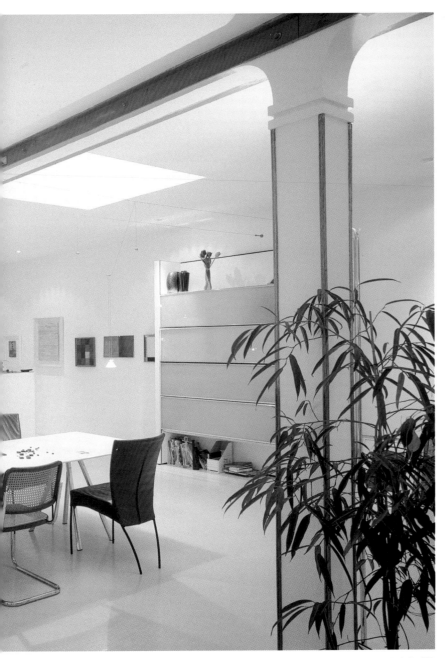

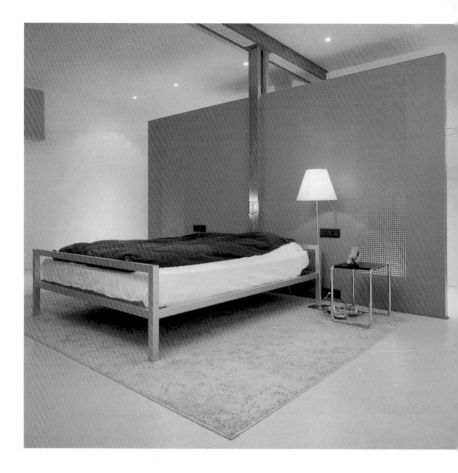

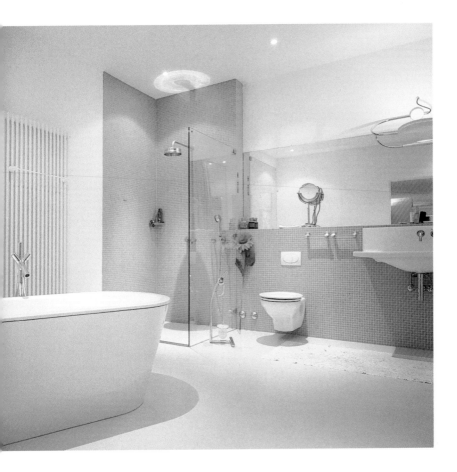

Rue Volta Loft

Christophe Ponceau | © Alejandro Bahamón | Paris, France

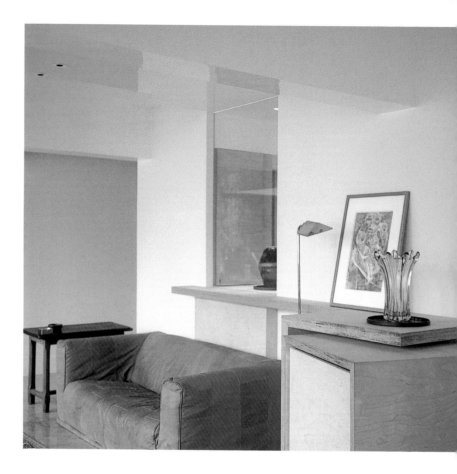

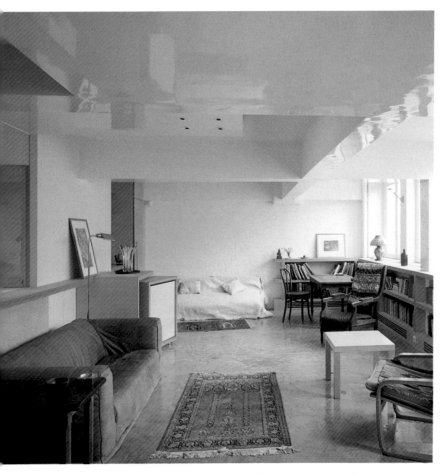

A fine layer of white cement with earth-colored particles was poured all over the floor of this dwelling, except for the bathroom, and then varnished over and polished. The seamless use of this material in the home strengthened its feeling of spaciousness.

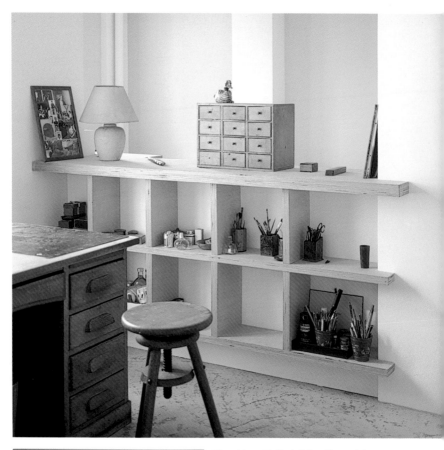

Situated in an old office building, this commission was faced with two important restrictions: the strong, reticulated, and reinforced concrete structure, which could not be modified in any way, and the scarce height of the ceilings, which in places scarcely reached 6 feet. From the beginning, the objective was to minimize these limitations so that they did not interfere with the comfort of the dwelling.

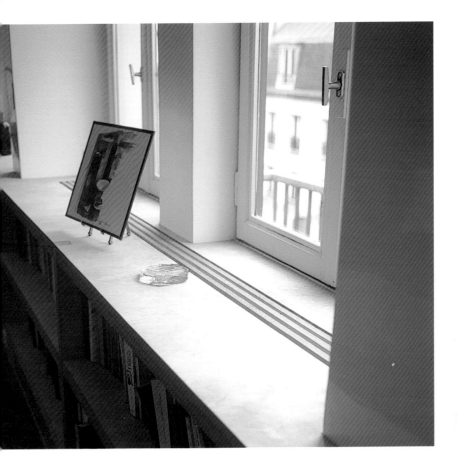

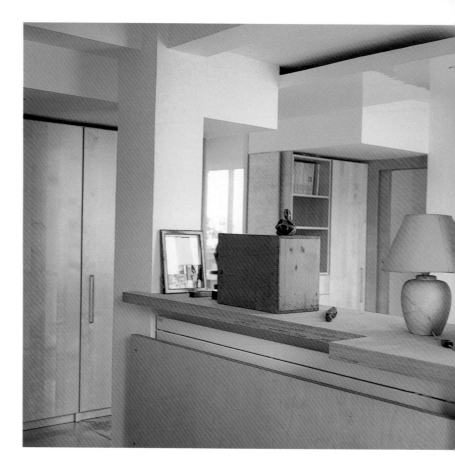

Brown Loft

Deborah Berke | © Catherine Tighe | New York, NY, United States

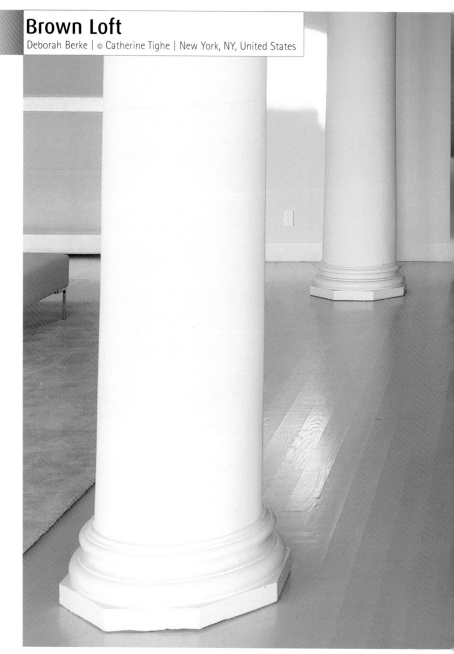

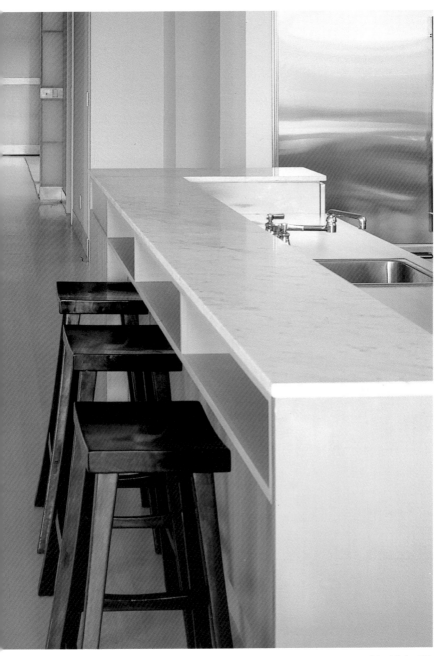

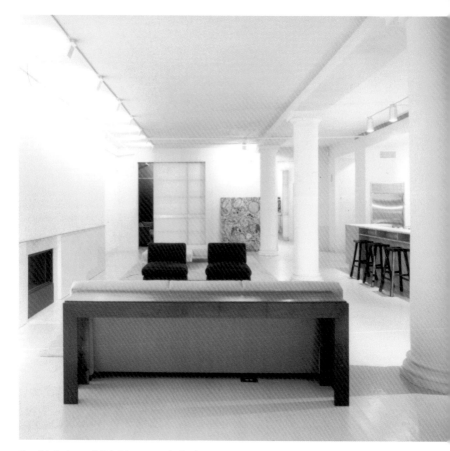

The original columns of this building were retained and restored, acting as a polished foil for the modernity of the renovation. Their presence creates an invisible line between the kitchen and living areas. Translucent acrylic and aluminum partitions allow for flexible divisions between the major spaces, and disappear discreetly into pockets inside the wall.

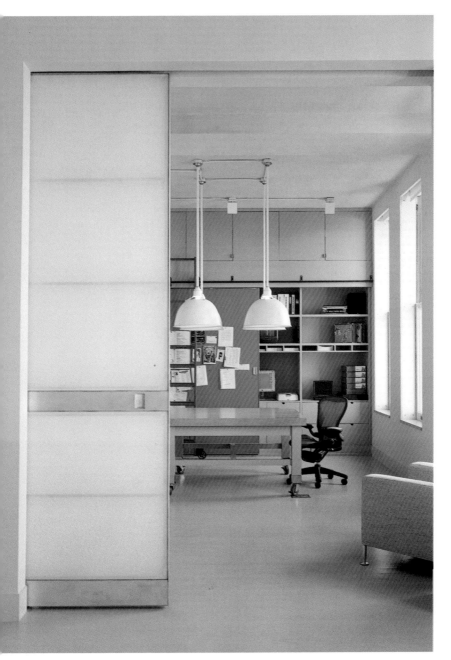

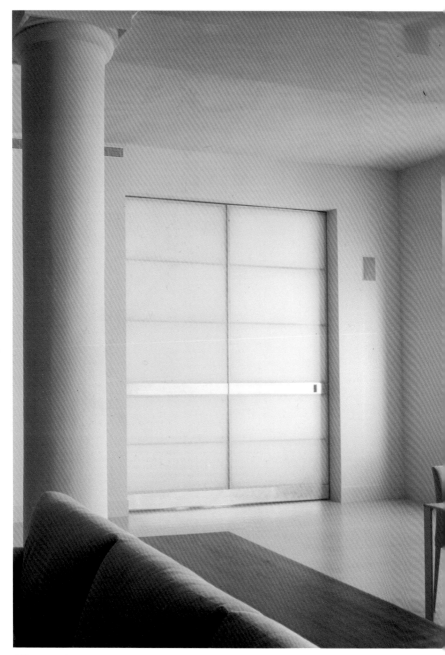

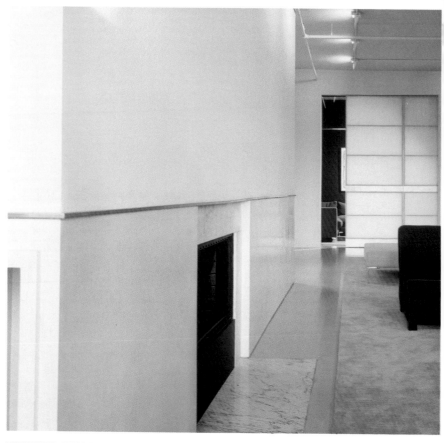

Industrial attributes, such as the sprinkler pipes along the ceiling, were restored and kept exposed as a reminder of the building's original state.

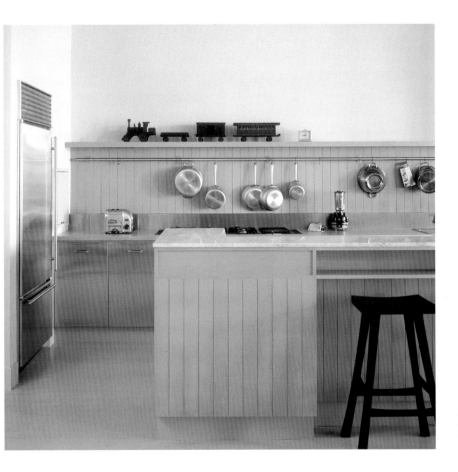

Loft in San Juan Avenue

William Adams Architects | © Tom Bonner | Venice, CA, United States

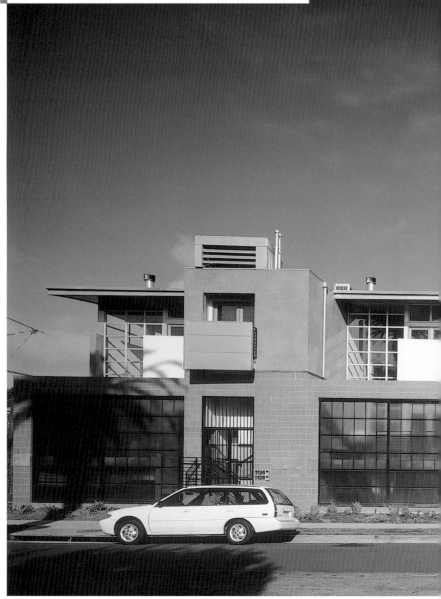

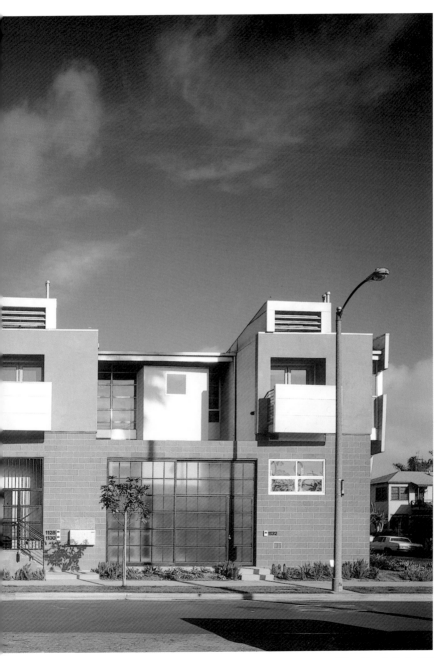

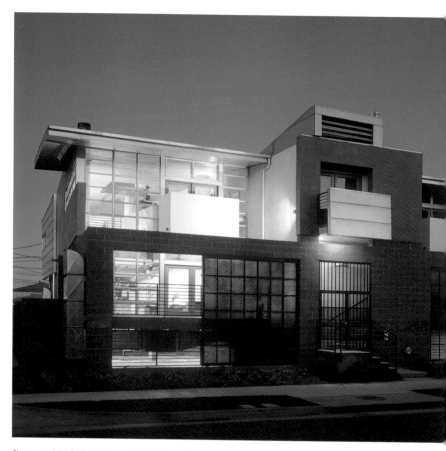

The center of the Californian town of Venice is home to
numerous workshops for artists. Not surprisingly, new urban
development reflects this functional duality that
accommodates both domestic and professional undertakings.
This project called for a building with six dwellings, each
with space set aside for workshops and offices.

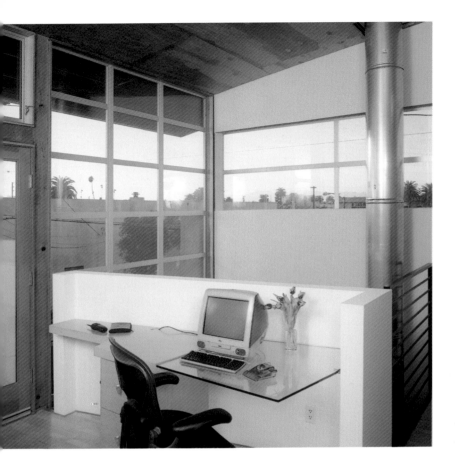

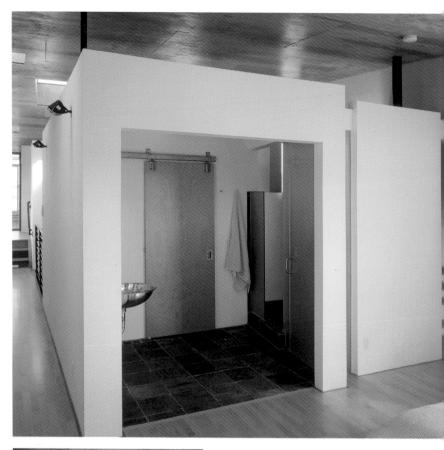

The interior design of this space features the roughness of the concrete structural walls contrasted with the warmth of the wood used for the stairs and the lofts.

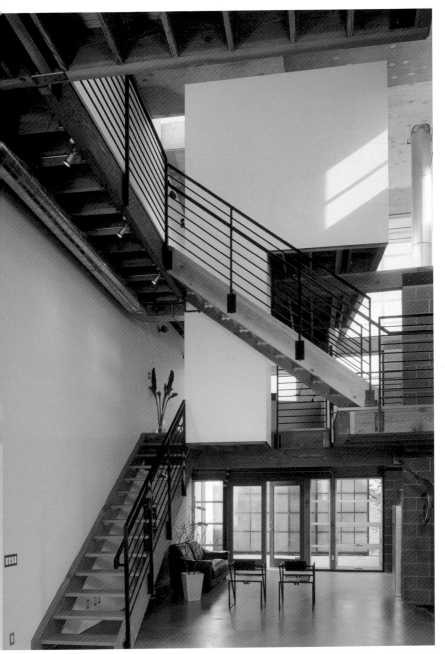

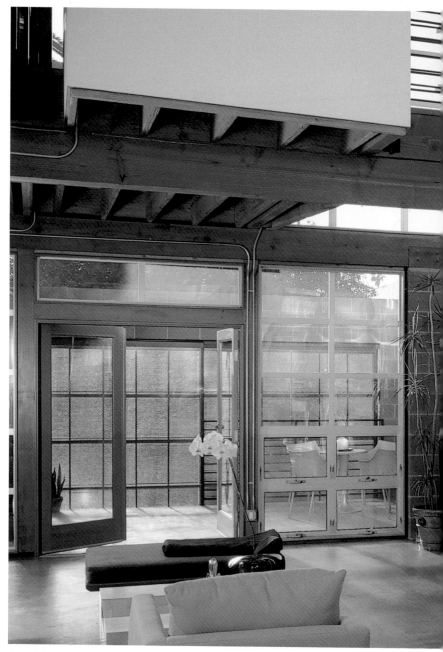

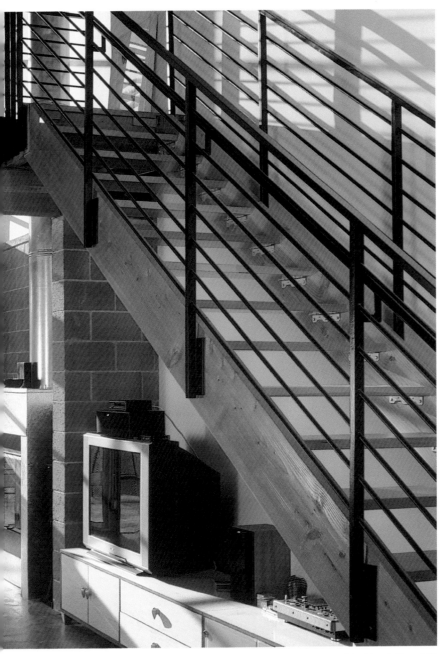

Inspired by Ice

Marie Veronique de Hoop Scheffer | © Virginia del Guidice | Buenos Aires, Argentina

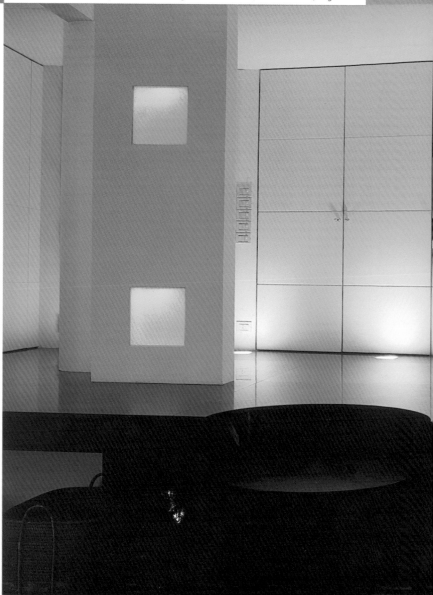

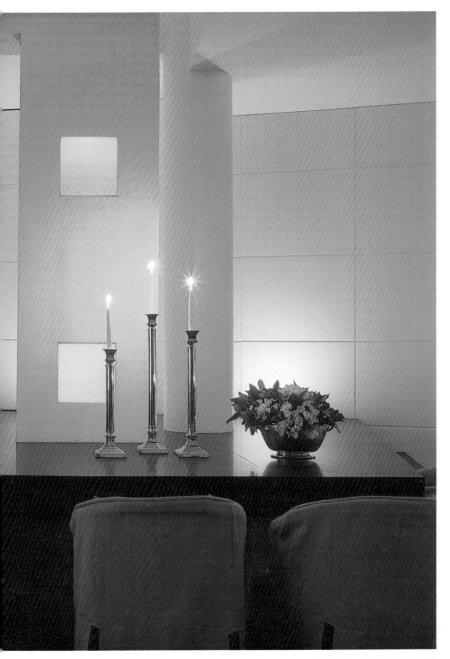

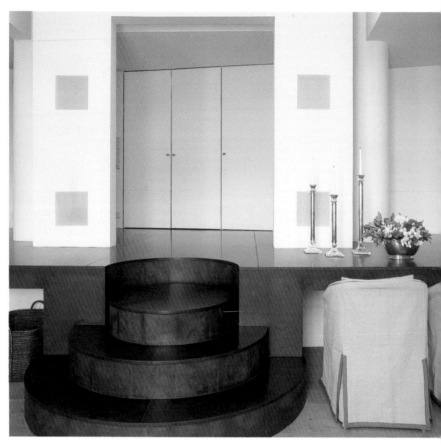

A grand entrance announces the way into the loft. The
glacierlike platform penetrates the living area and
simultaneously functions as a dining table. Its similarity
to a stage creates a theatrical effect, especially at night
when illuminated artificially.

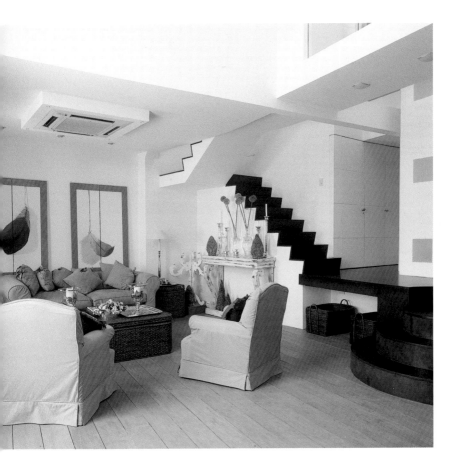

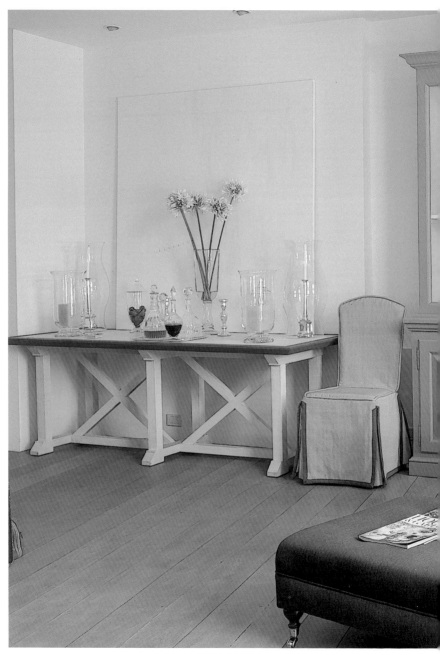

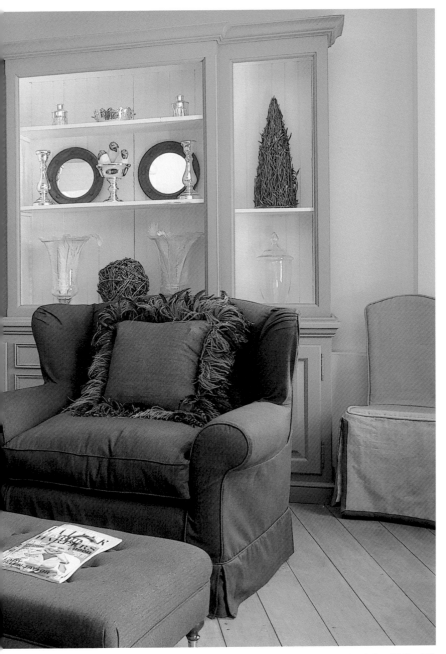

A staircase, designed by Marie Veronique, leads to the upper level where a small lounge and two bedrooms are situated. Linked by a glass walkway, the two bedrooms enjoy a great deal of privacy.

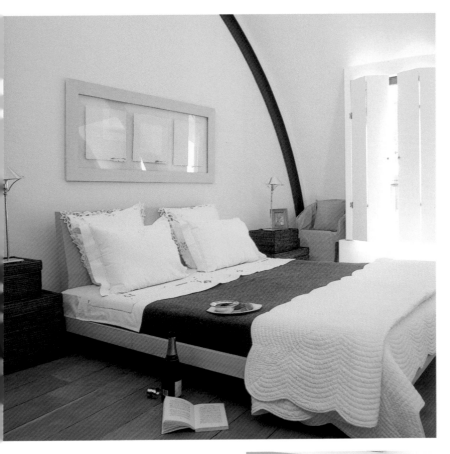

Pearl Residence

Thompson Architects | © Doug Baz | New York, NY, United States

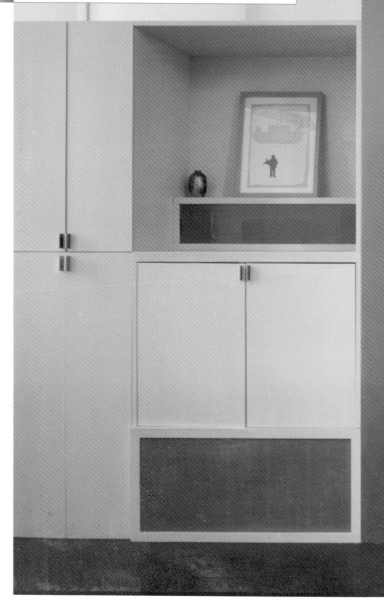

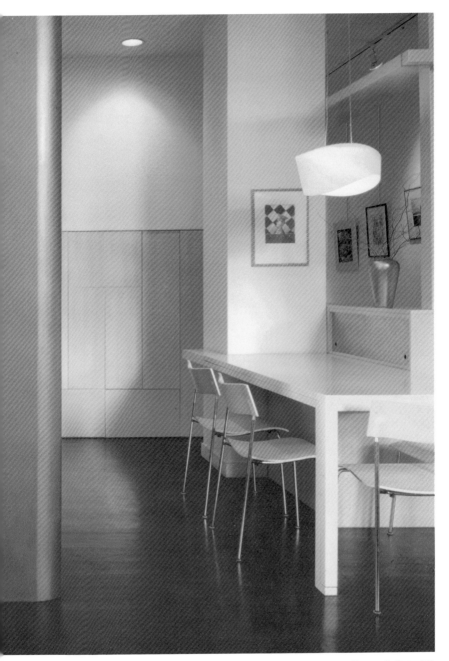

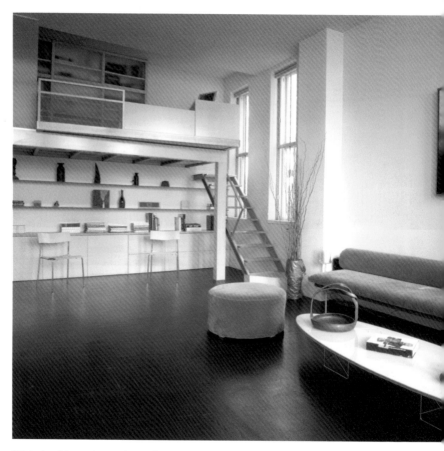

This spacious living area incorporates a small
mezzanine level that serves as a study and a guest
room. Tall ceilings make this a comfortable space, and
the use of Plexiglas on the stairs and platform lessens
the obstruction of light from the large windows.

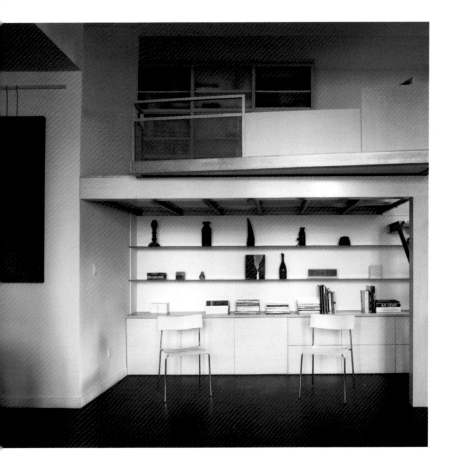

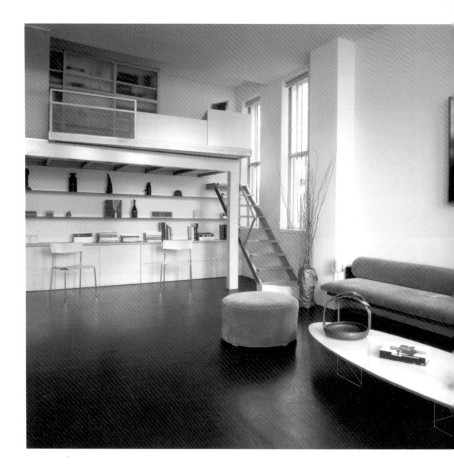

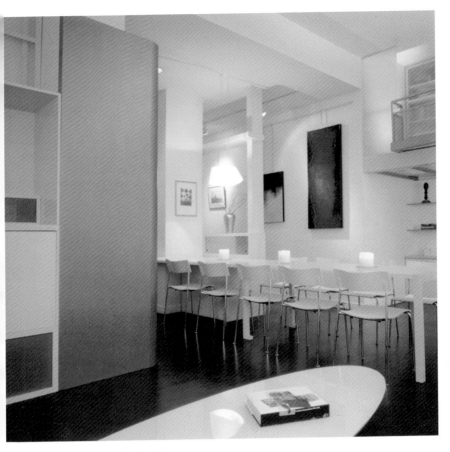

The color palette of this space is light, with copper
highlights and metallic finishes above an ebonized
wood floor.

Home for an Actress

Franc Fernández | © Joan Mundó | Barcelona, Spain

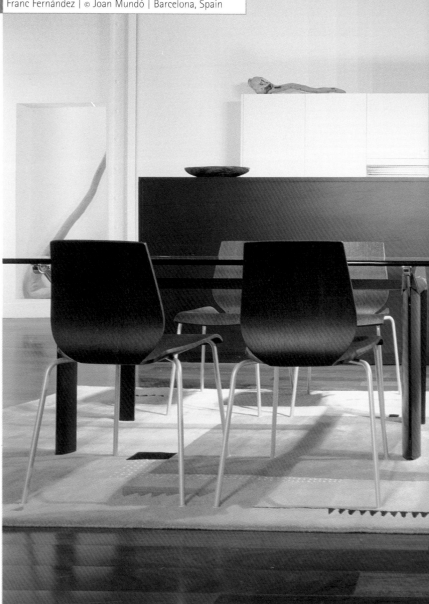

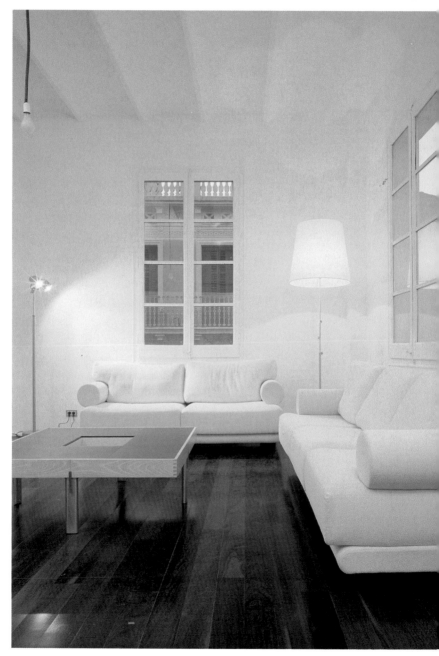

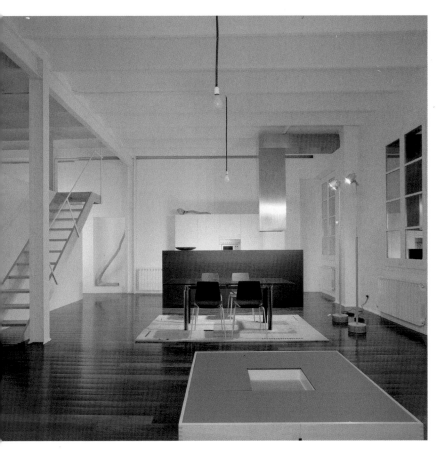

This project transformed a factory-warehouse into a residential building. While the architect left the 14.7-foot-high original ceilings intact in order to preserve the building's industrial character, the new dwellings have their own definite personality. Each floor was divided into four areas of 1,606 square feet. This apartment resulted from subdividing one these areas into two.

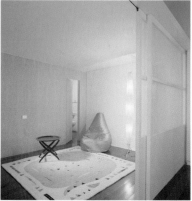

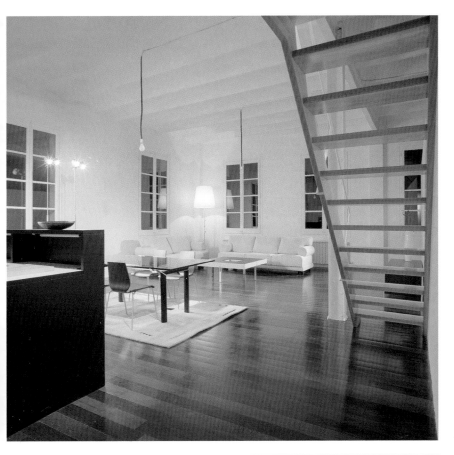

Renovated Attic

Marco Savorelli | © Matteo Piazza | Milan, Italy

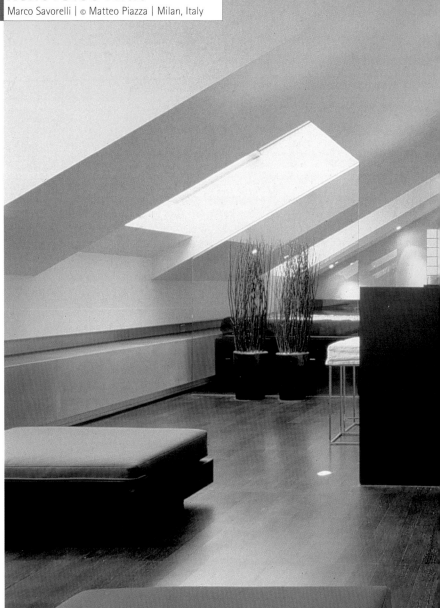

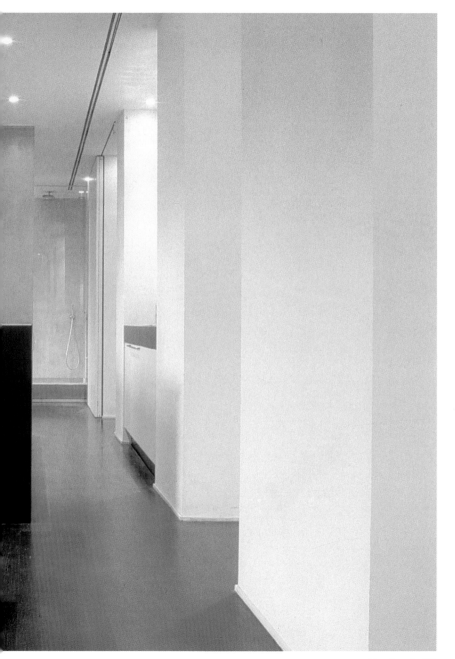

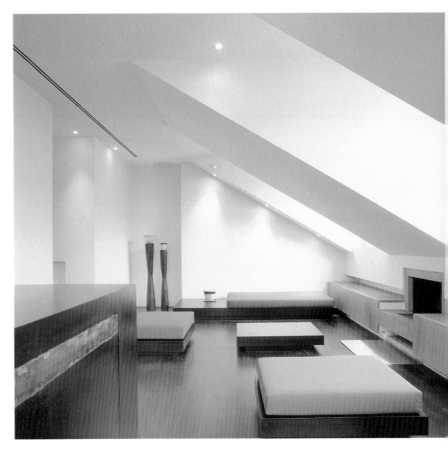

The sofas were designed to create floating wooden bodies
and cushions covered in a light-colored cloth that merges
with the surroundings decorated in the same tones.

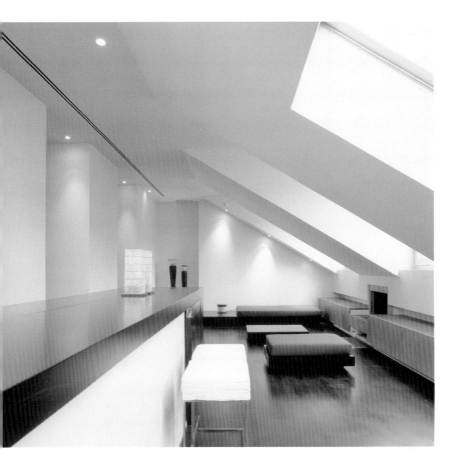

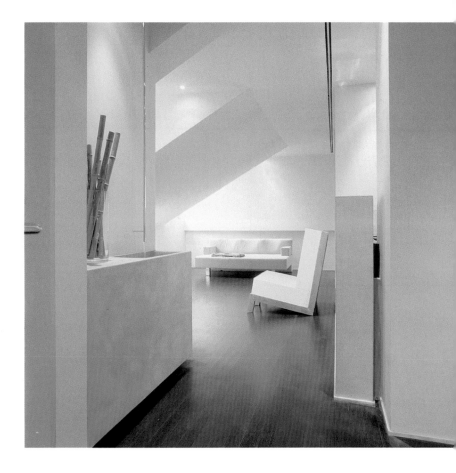

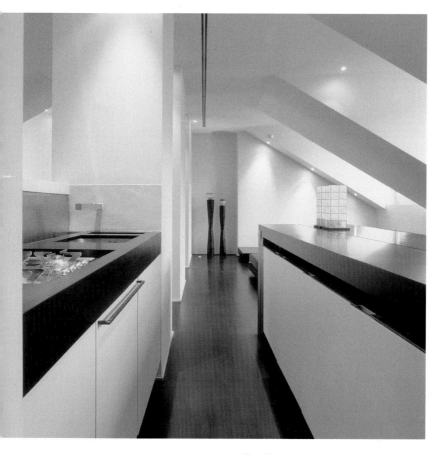

Like all the rooms in this home, the kitchen is open and connected to the living room. The kitchen includes two cabinets, one of which contains the installations and is placed against two structural pillars that conceal the water pipes.

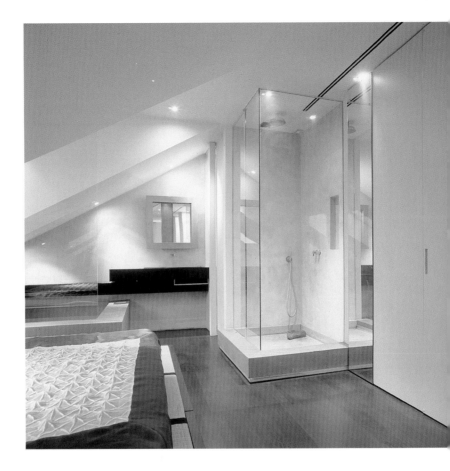

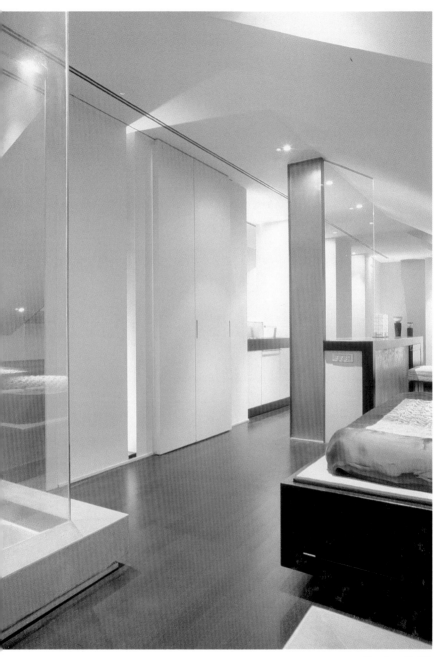

Decorator's Loft

Dorotea Oliva | © Virginia del Guidice | Buenos Aires, Argentina

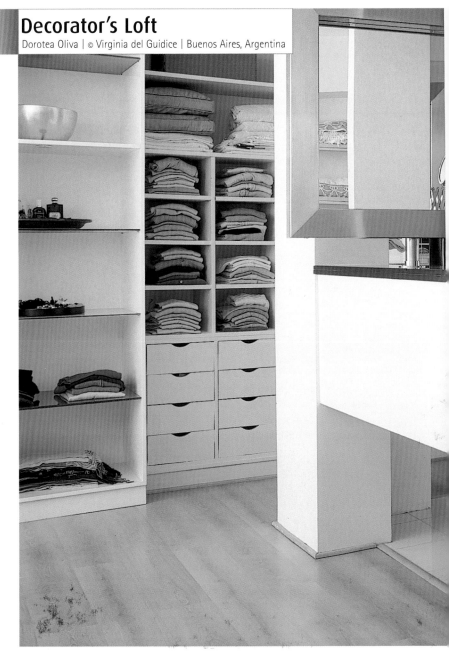

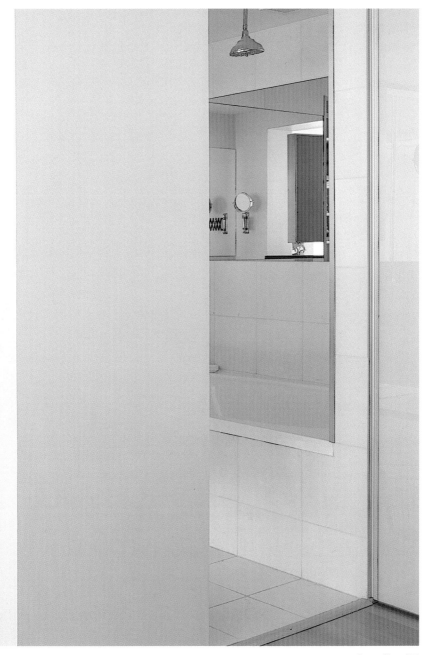

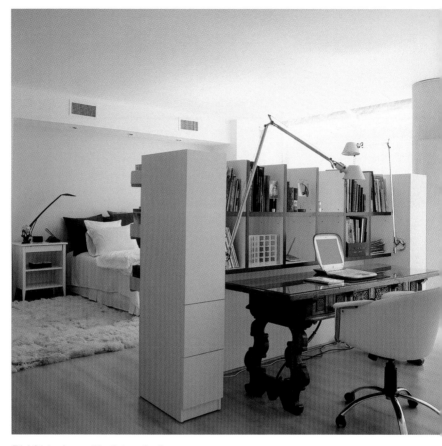

This loft integrates a partition that organizes the functions of the home. The side facing the bed holds aluminum shelves for the entertainment equipment, while the other side is a library that incorporates two extendable light fixtures that shed light on the antique desk.

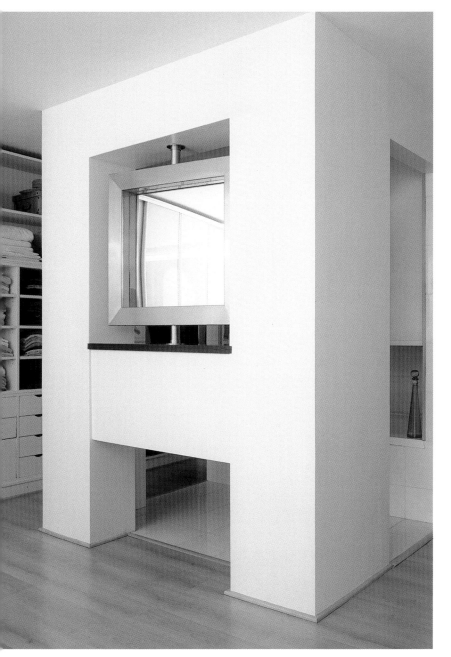

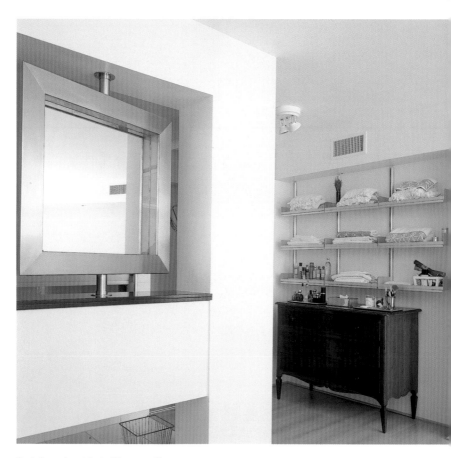

The bathroom is contained within a canopylike
structure consisting of white walls and a rotating
mirror designed by Dorotea Oliva. The design takes
advantage of the adjacent wall by providing storage in
the form of an antique chest of drawers, and shelves
for towels and toiletries.

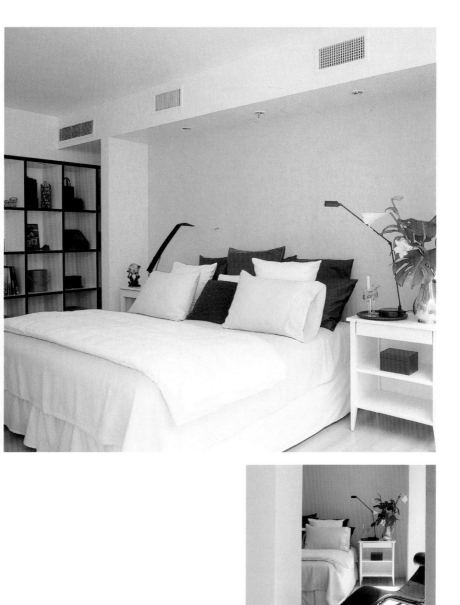

Shane Cooper Loft

1100 Architect | © Michael Moran | New York, NY, United States

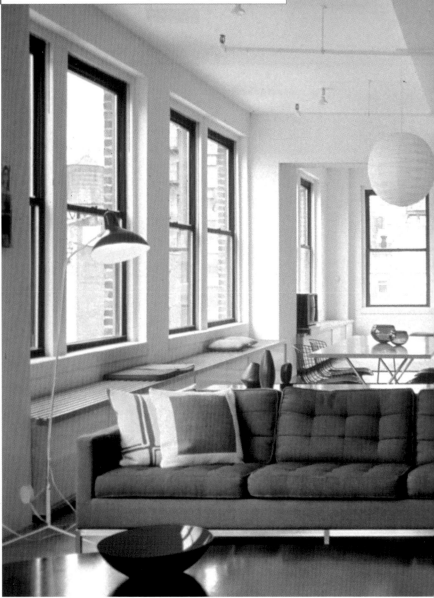

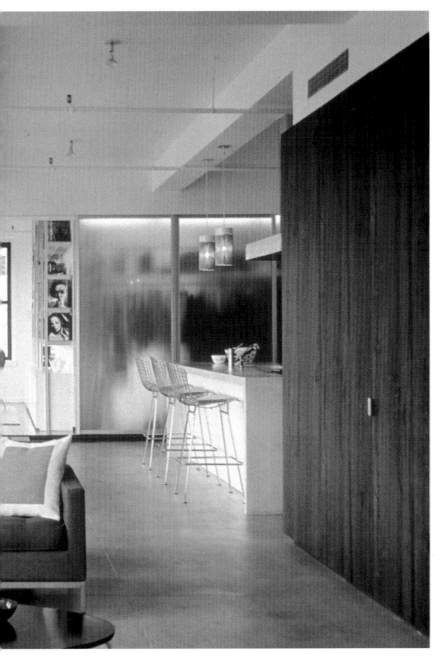

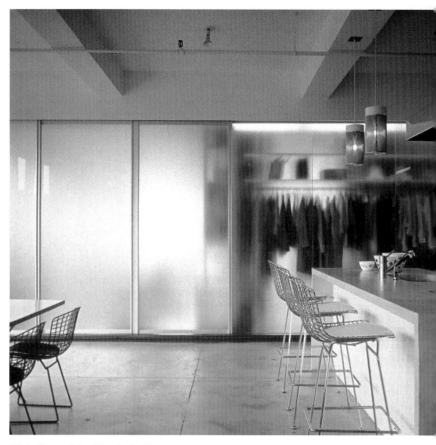

This dwelling was designed for a family of four,
consisting of a couple and their two children. The goal
of the design was to achieve the spacious feeling of a
loft and still maintain a certain degree of privacy.

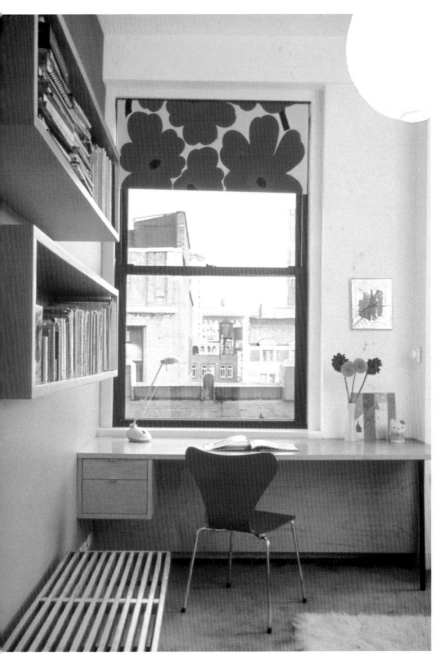

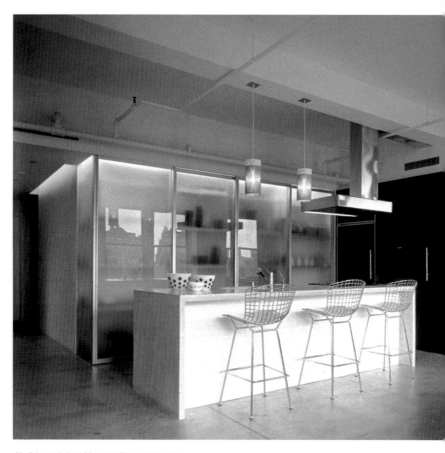

All of the vertical partitions, mobile wooden panels, translucent doors, and plaster walls are inserted into the great envelope like independent elements.

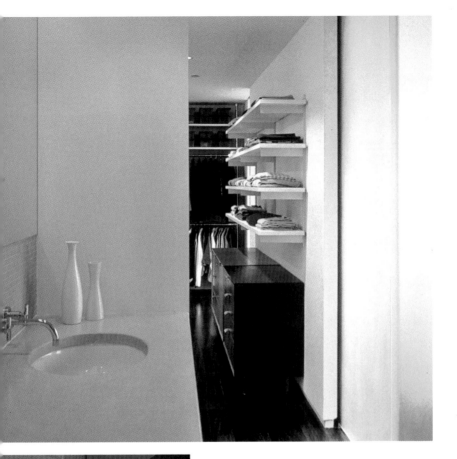

Hill Loft

Resolution: 4 Architecture | © Eduard Hueber | New York, NY, United States

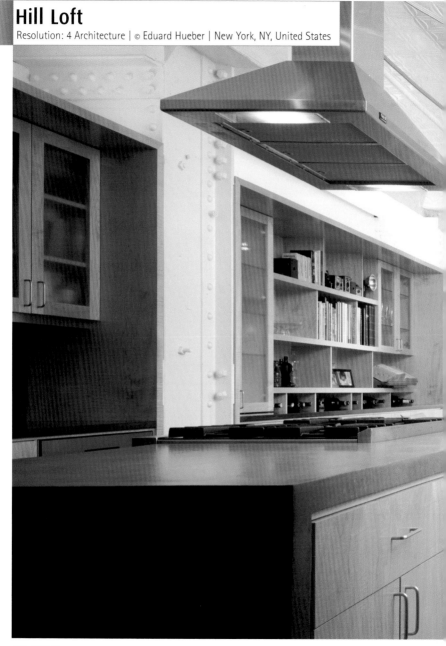

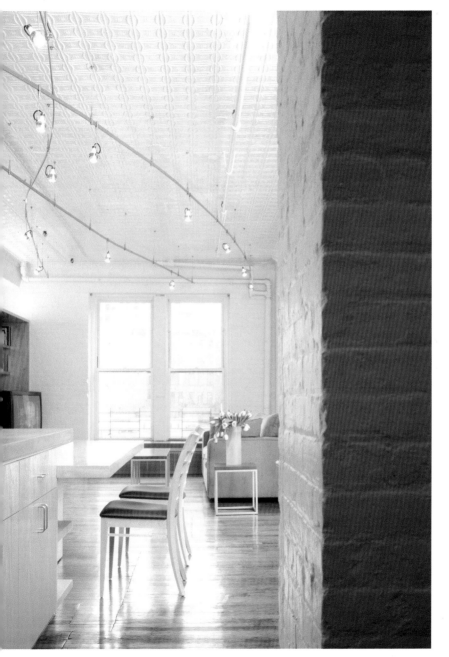

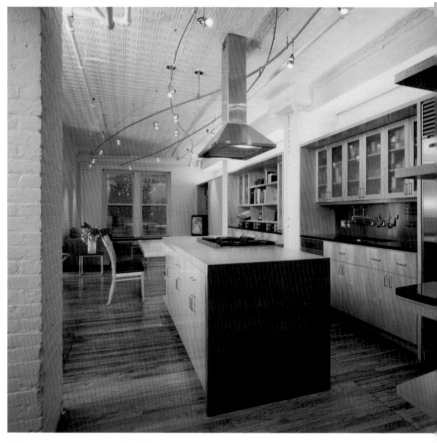

Different steel columns are inserted to visually separate
the three areas and to differentiate the three zones:
bedroom, kitchen-dining room, and living room.

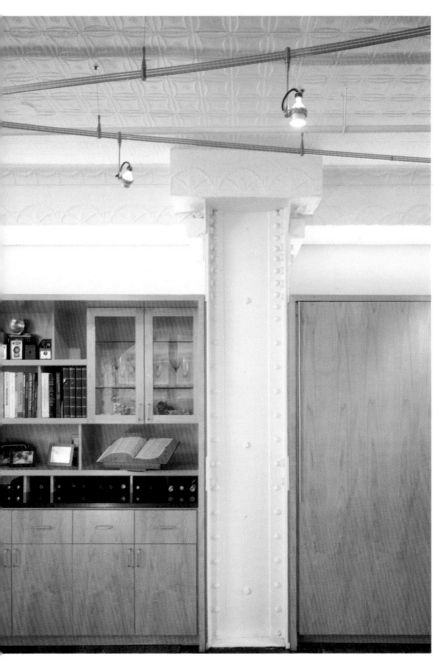

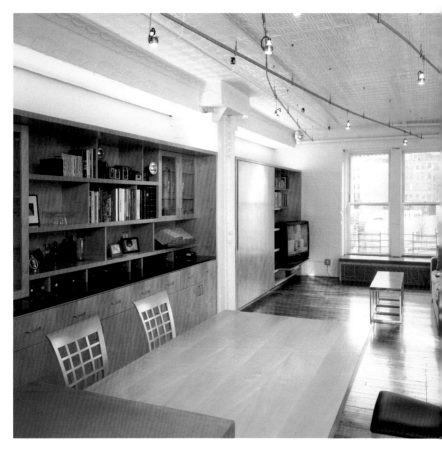

This loft is situated in a former industrial building in
New York's Tribeca neighborhood, serving as an
example of a proficient response to the requirements of
space. One of the walls that runs the length of the
kitchen, living room, dining room, and bedroom was
completely outfitted with built-in closets and shelves,
which reflect their three respective ambiences.

Stewart Loft

James Gauer | © Catherine Tighe | New York, NY, United States

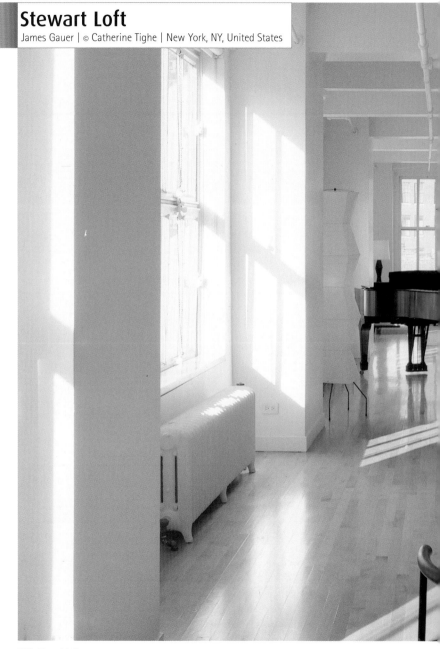

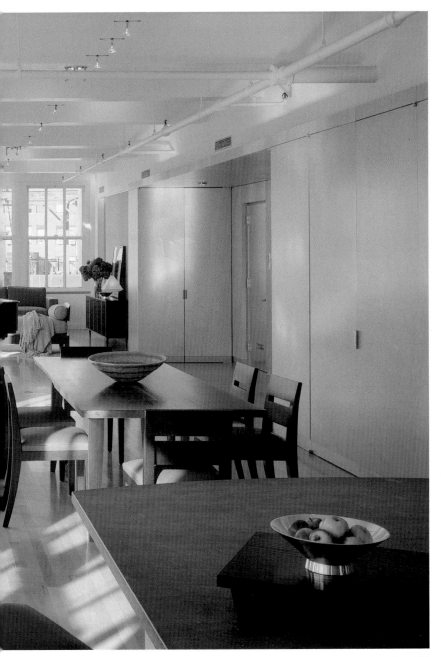

Thick storage walls separate the perimeter rooms,
which are covered in silver dusted brown paper and
flanked by translucent glass doors in aluminum frames.

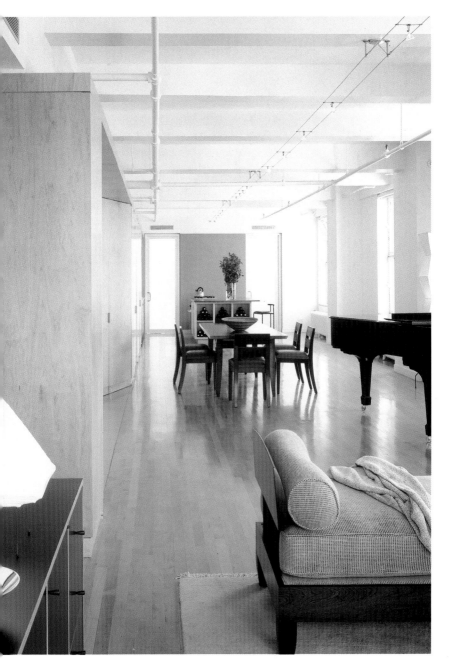

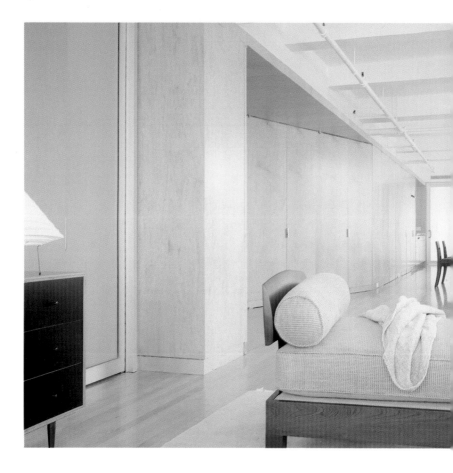

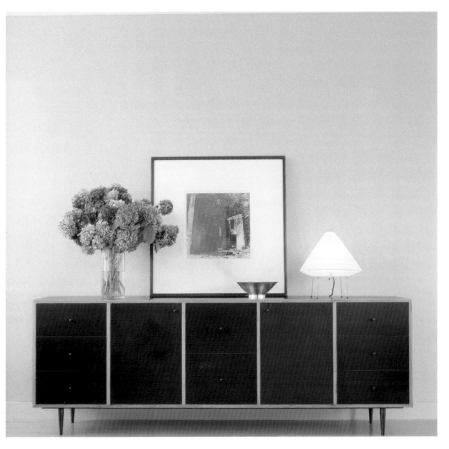

Lighting was also used to reinforce the distinction between the core and the perimeter. A small, recessed fixture lights the core, and a cable system suspended below the exposed ceiling beams and sprinkler pipes underscores the linear nature of the perimeter spaces.

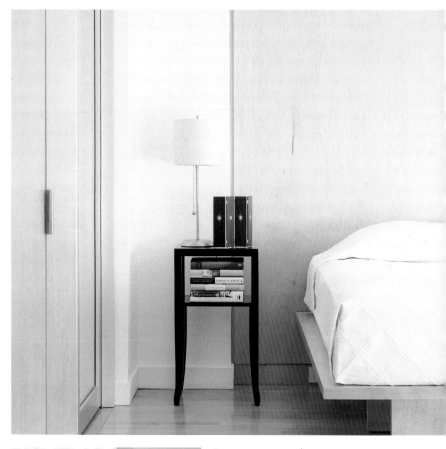

The master suite and study/guest room are situated at the far end of the loft beyond the translucent glass doors.

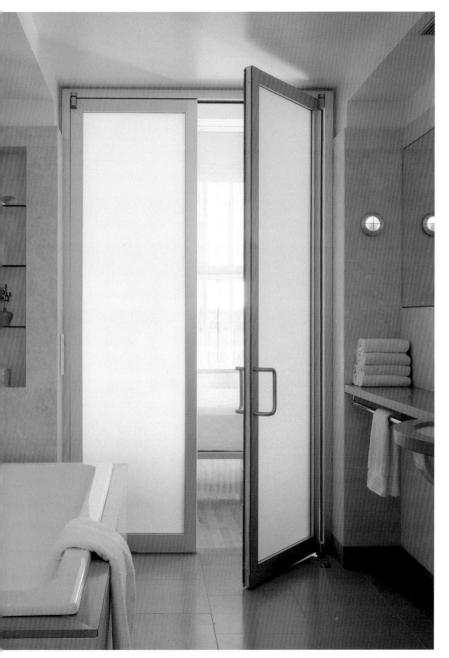

Wooster Street

Lynch / Eisinger / Design | © Albert Vecerka | New York, NY, United States

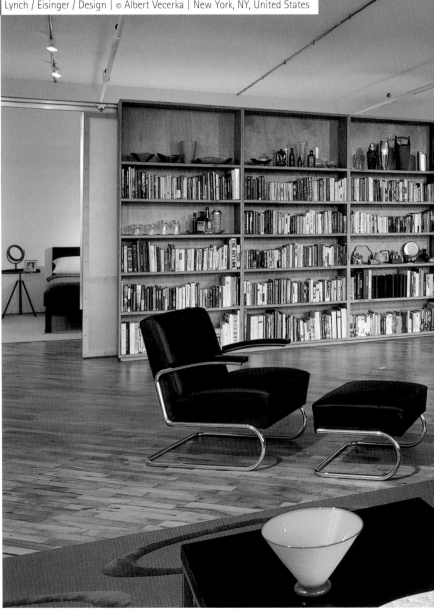

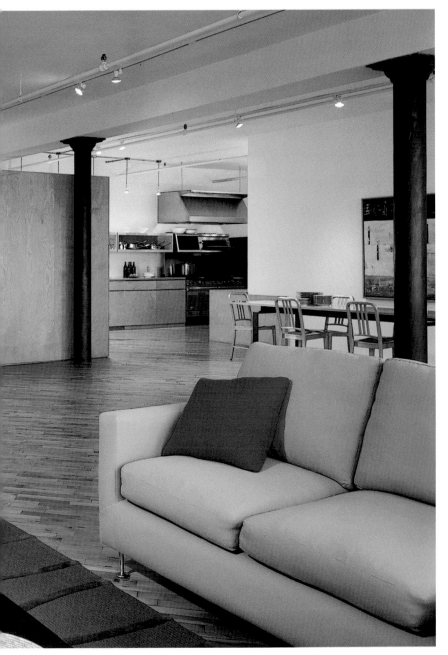

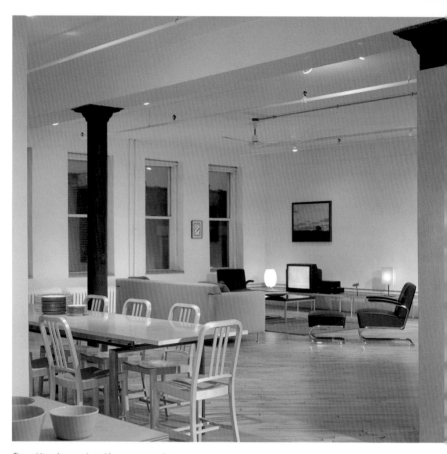

The architects' approach to this space was to clear
away all existing partitions and concentrate the new
construction—kitchen, bath, bedroom, and dressing
room—along a single wall. The new elements are
treated as an insertion of cabinetry distinct from the
enclosing volume.

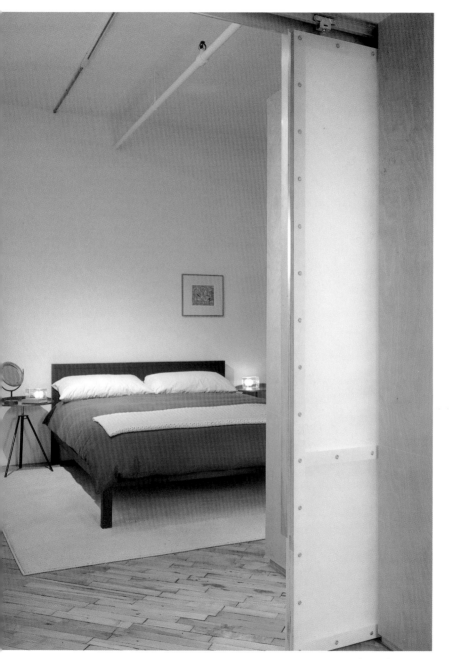

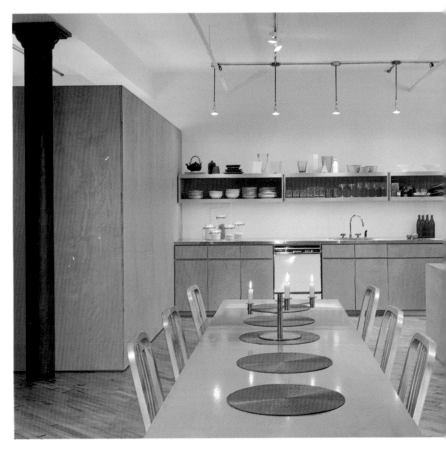

Humble materials, such as birch, plywood, and acrylic, were used to highlight the original character of the space. Walls and ceilings were restored with smooth, white plaster and contrast with the new wood cabinetry, which blends into the restored maple floors.

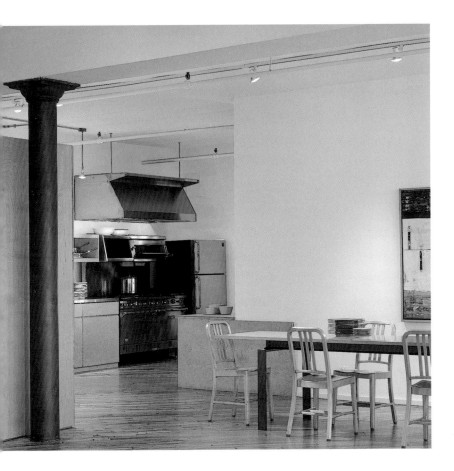

Flex Loft

Archikubik | © Eugeni Pons | Barcelona, Spain

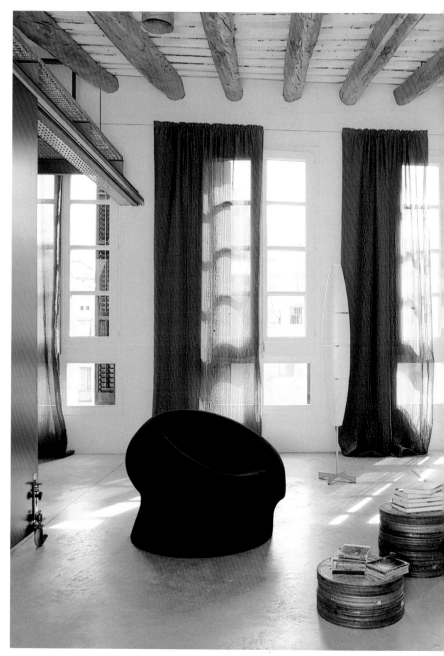

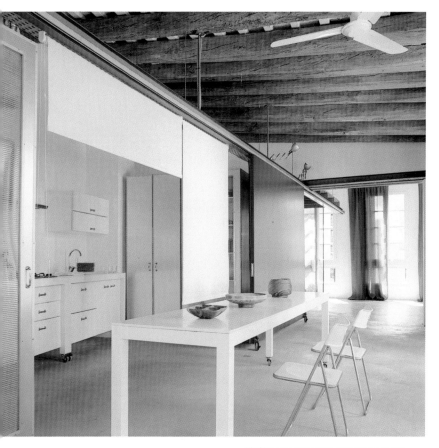

All of the main components, including the kitchen, cupboards, and storage units, can fit into a container, facilitating transportation to another location and making the space a cost-effective investment.

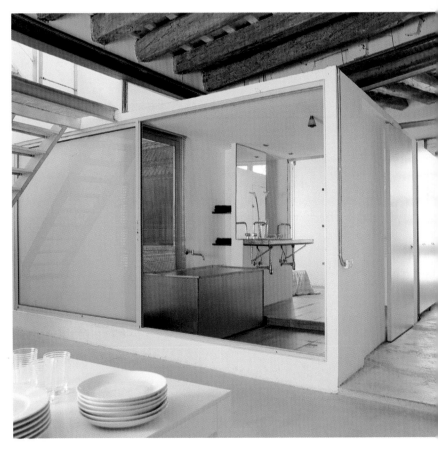

Light materials and mobile structures afford flexibility
within an original space. Floors were laid in concrete to
create spatial continuity.

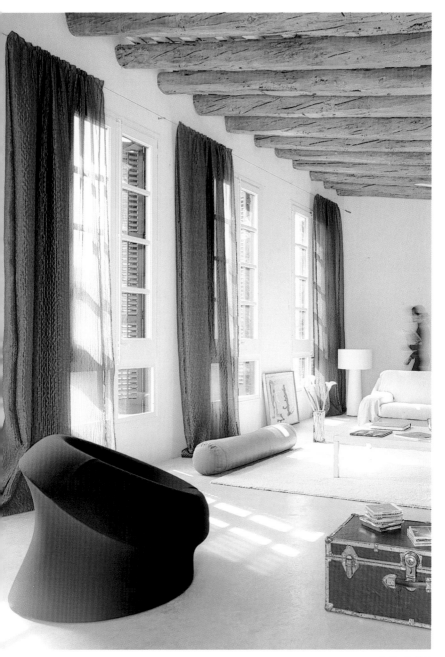

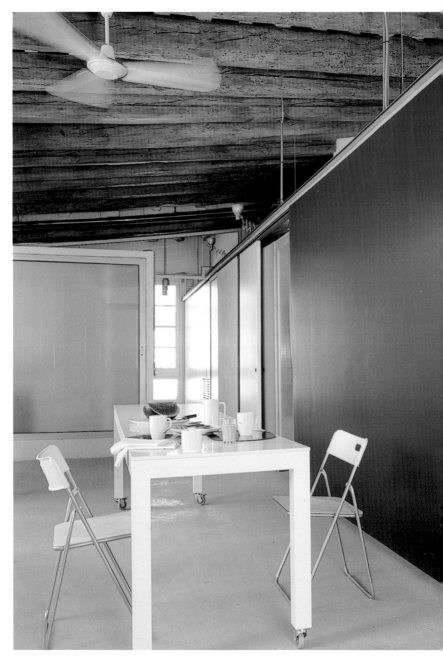

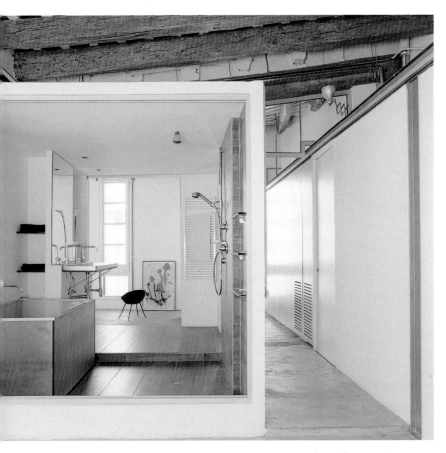

A red panel hangs from a railing system that runs through the space longitudinally, varying the configuration of functional areas and the aesthetic perception of the design.

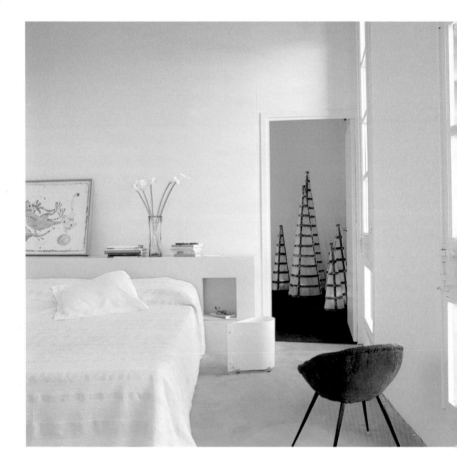

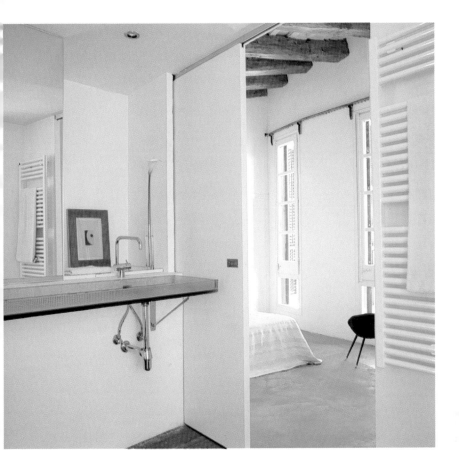

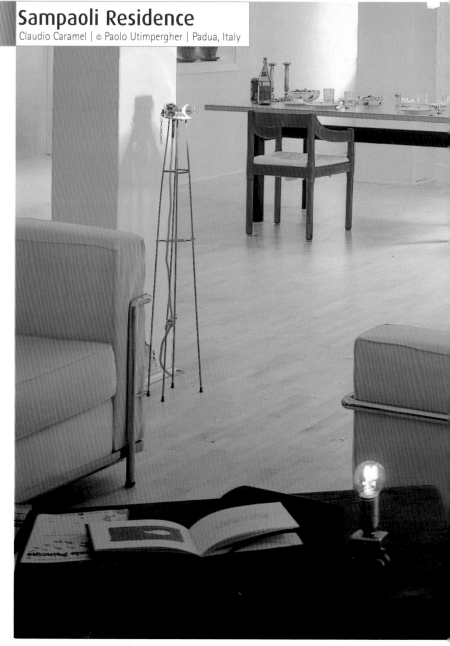

Sampaoli Residence

Claudio Caramel | © Paolo Utimpergher | Padua, Italy

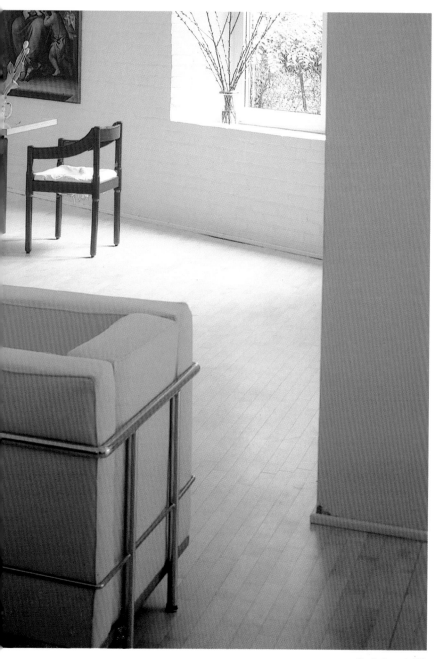

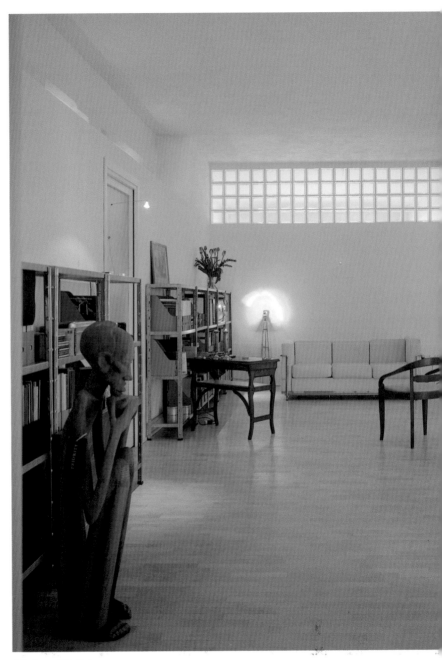

Though the space maintains its original character, the architect created an atmosphere that more closely matches the typology of a traditional residence. The private spaces are defined by independent bedrooms, but the area that dominates the interior is a large room that blends the functions of living room, dining room, and kitchen.

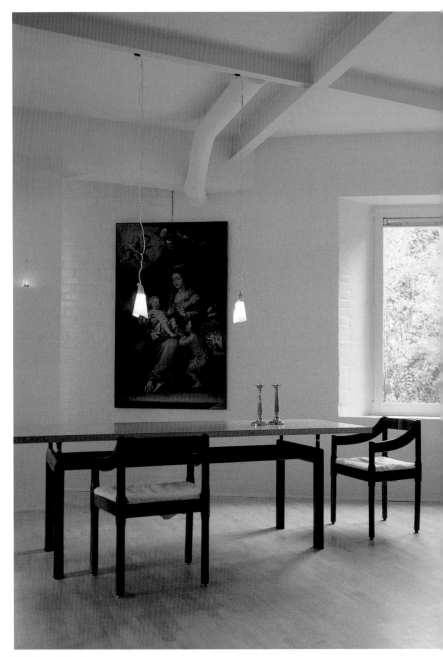

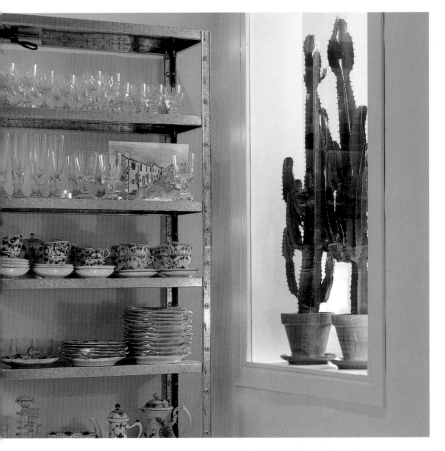

The atmosphere of this space is a well-balanced mix of technology and creativity. The result is subtle elegance.

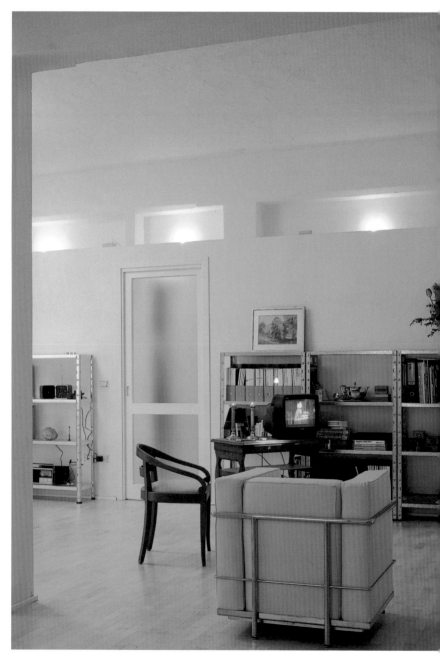

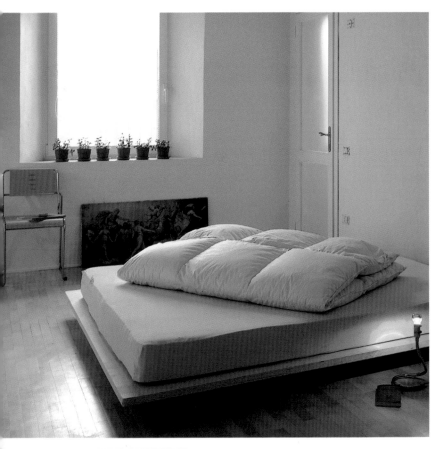

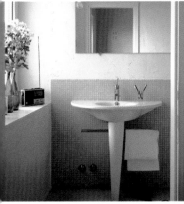

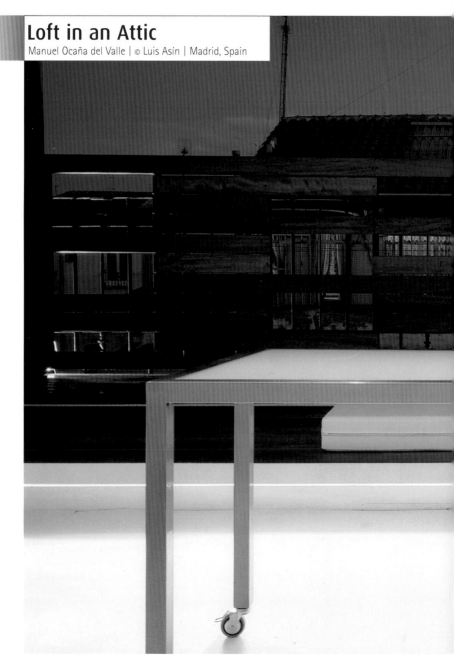

Loft in an Attic
Manuel Ocaña del Valle | © Luis Asín | Madrid, Spain

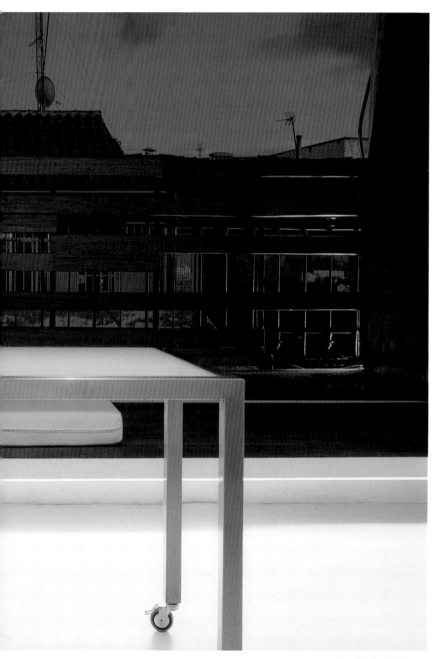

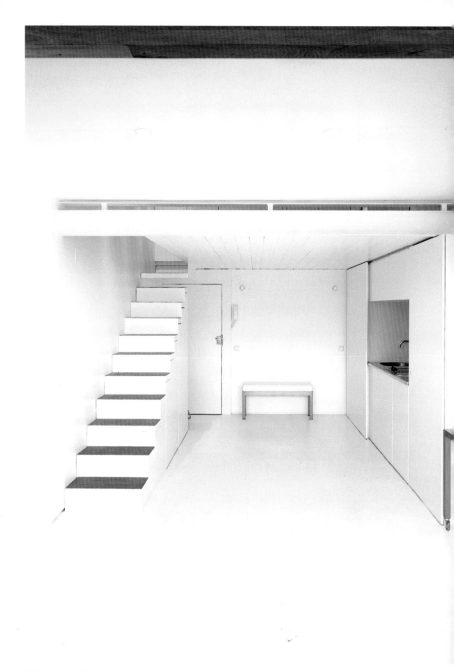

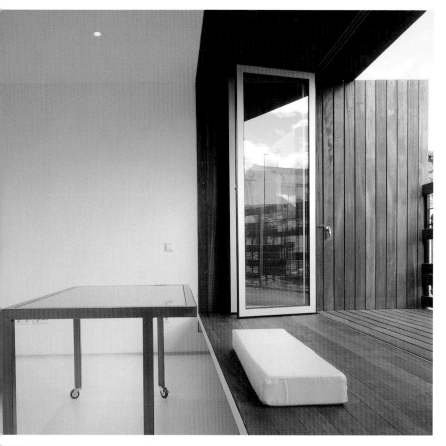

What is now a comfortable, modern residence was once a small, 323-square-foot space, unsuitable for living. Located in a 150-year-old building in the up-and-coming Madrid neighborhood of Chueca, this loft provides many uses resolved in unitary and flexible spaces. The furnishings were designed as part of the architecture itself, to make the most of the available space.

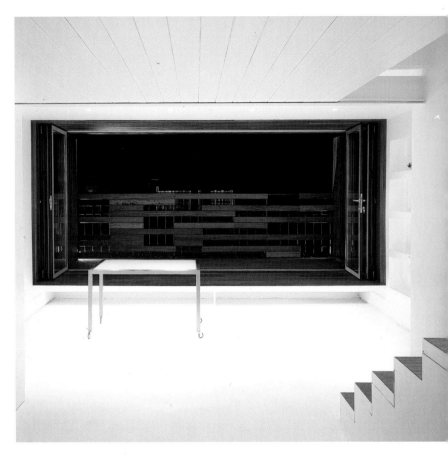

The lower floor includes a dressing room, a living room, a dining room, a kitchen, a bathroom, and the terrace, while the loft contains a bedroom, a bathroom, a dressing room, and a laundry room.

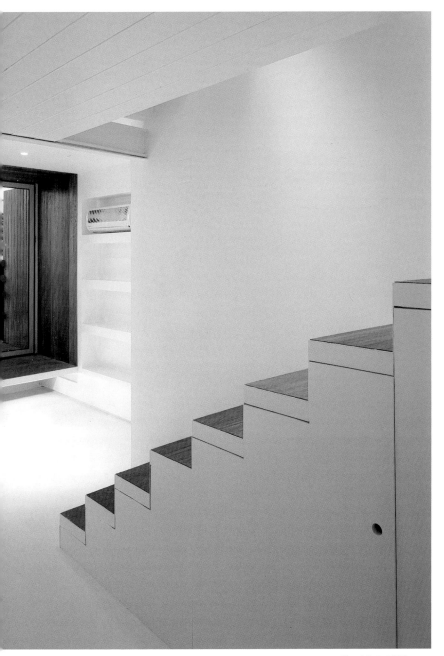

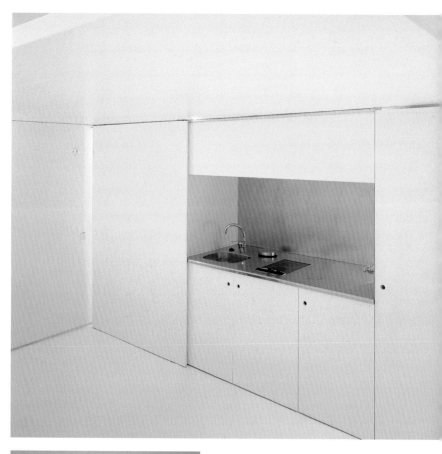

250 Loft in an Attic

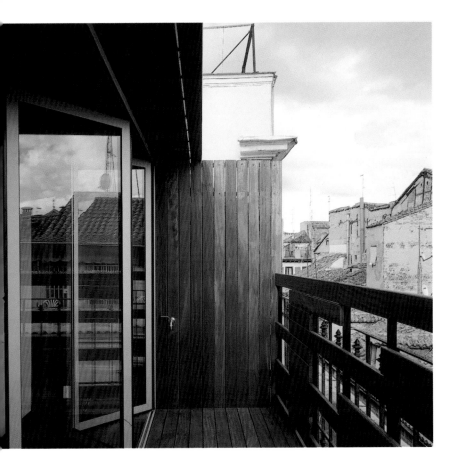

Playful and Intimate

Gary Chang / EDGE (HK) LTD. | © Almond Chu | Hong Kong, China

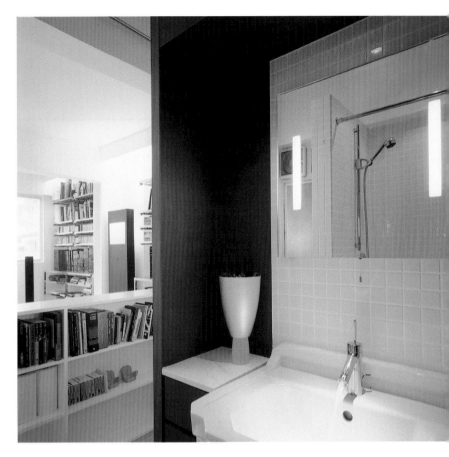

This loft, located on the east island of Hong Kong, was designed by Gary Chang as his personal residence. Located in a popular neighborhood, this old flat was previously the home of a large family. The goal of the project was to create a space that, despite its reduced proportions, contains all of the necessary residential functions and has flexibility for rest and leisure.

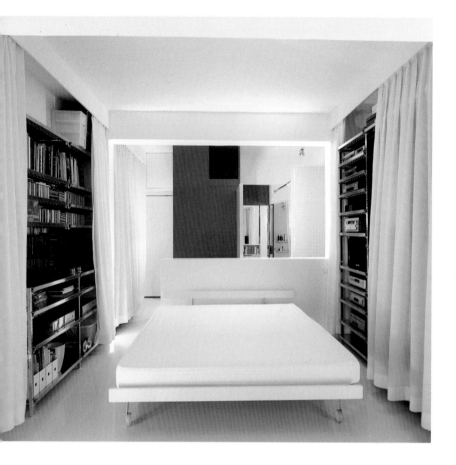

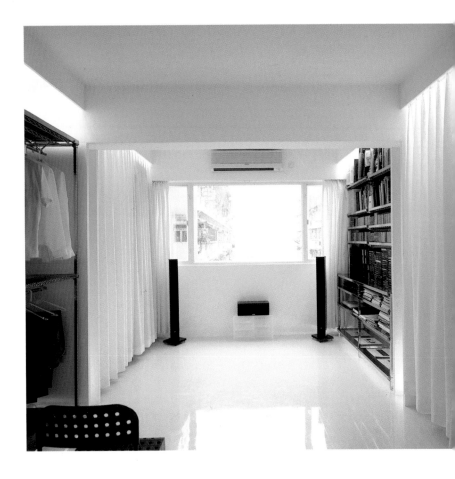

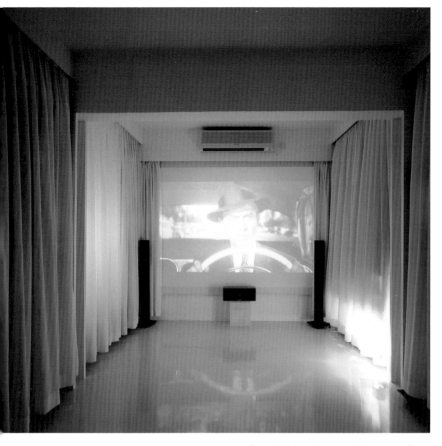

The main window, when covered with a screen, offers the option of watching TV or using the Internet. Each detail was carefully thought out and designed with the objective of making the most of every corner of this 323-square-foot space. In this single atmosphere, the architect managed to group residential neccesities in a simple and elegant way. The lights and the convertible elements alter the apartment for different circumstances, adding a playful yet relaxed spirit.

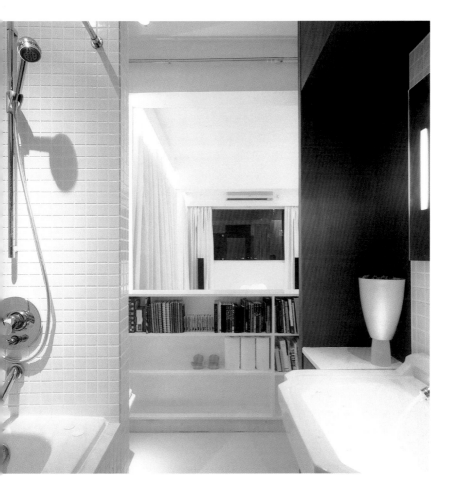

Formal Unity

Guillermo Arias | © Eduardo Consuegra, Pablo Rojas | Bogotá, Colombia

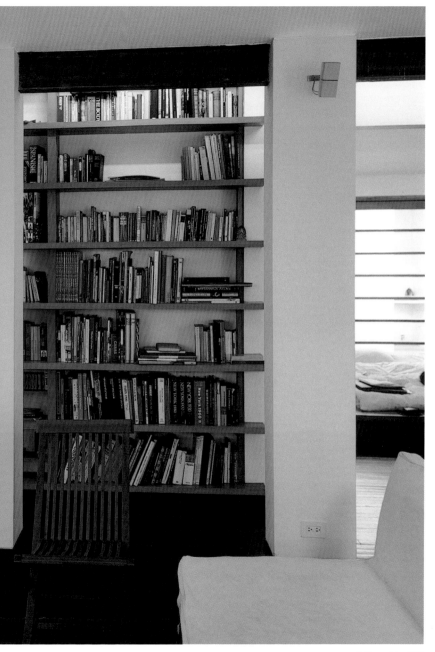

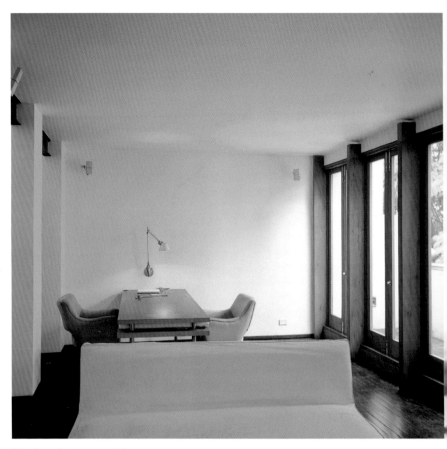

This loft occupies a large part of what was once a
traditional residence in a 1930s building in Bogotá.

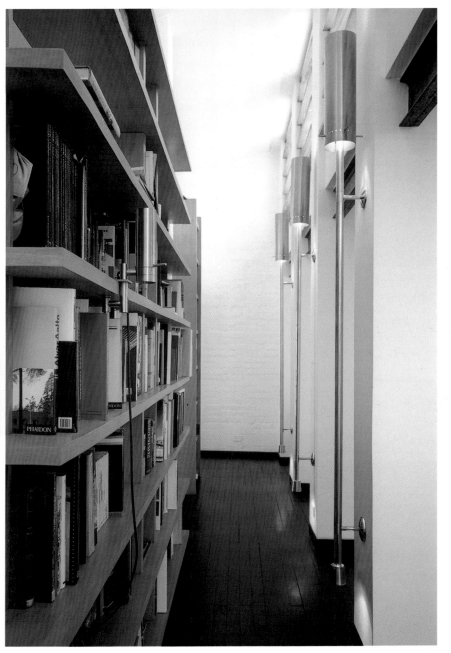

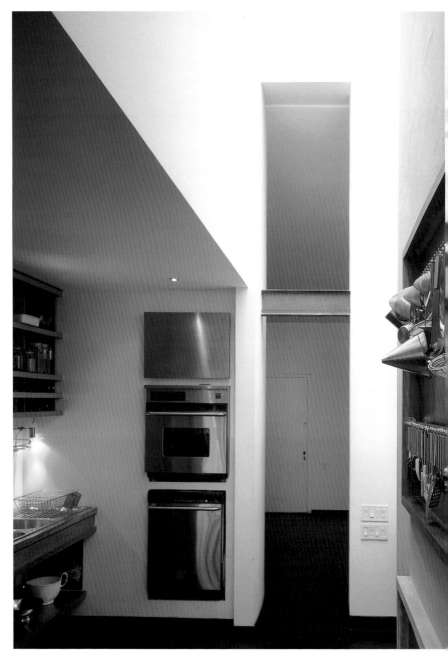

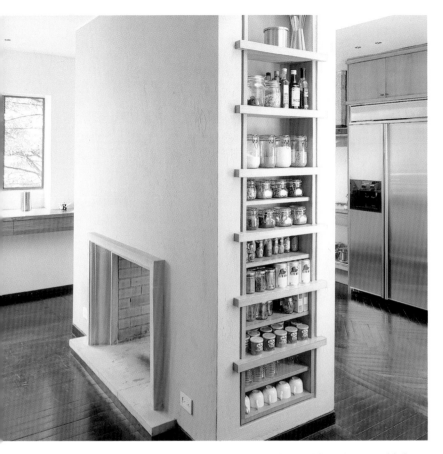

Architect Guillermo Arias's residence was originally
made up of several rooms, but it was structurally
possible to clear the space in order to create only one
room with ample proportions.

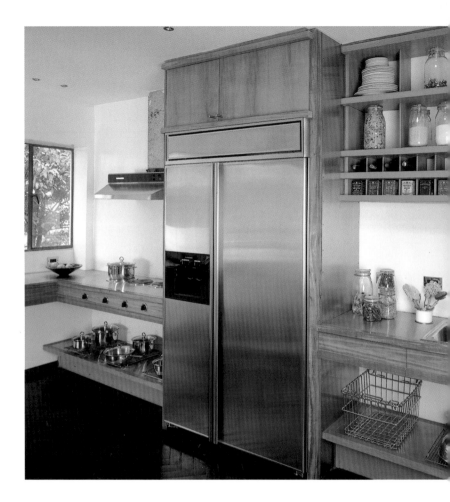

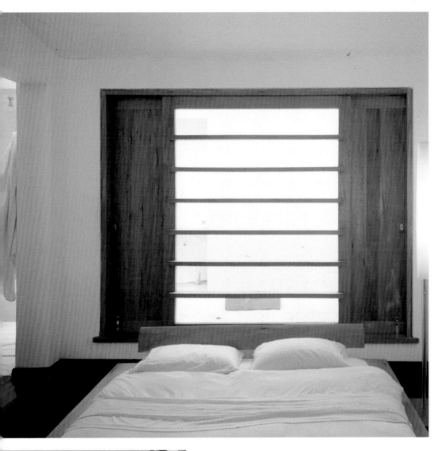

A Continuous Path

Luis Cuartas | © Eduardo Consuegra | Bogotá, Colombia

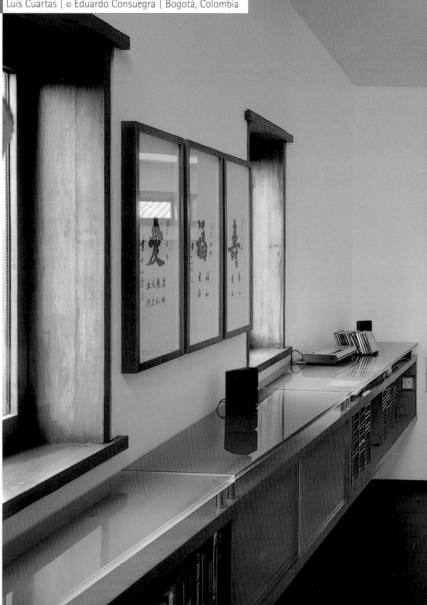

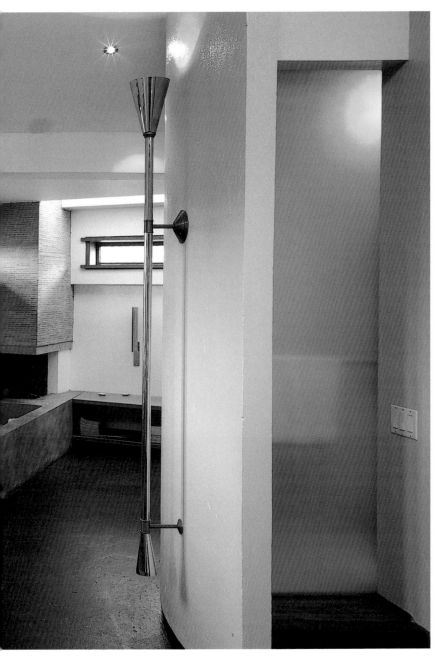

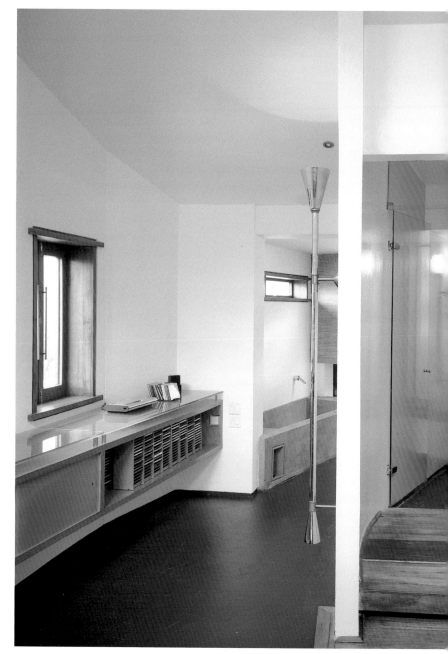

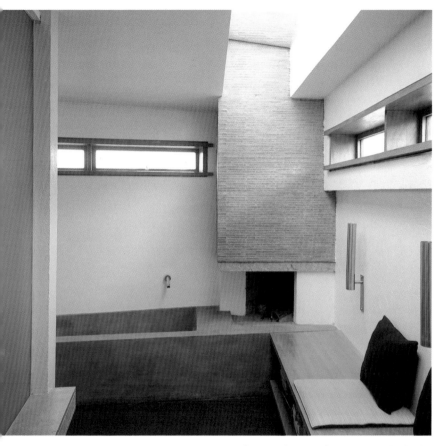

This project forms part of an integral renovation that the
two architects carried out on an old building in the
center of Bogotá. The architects transformed the space
into their personal residences. This particular project
occupies the part of the building that previously
contained the kitchen, the services, and the dining room.

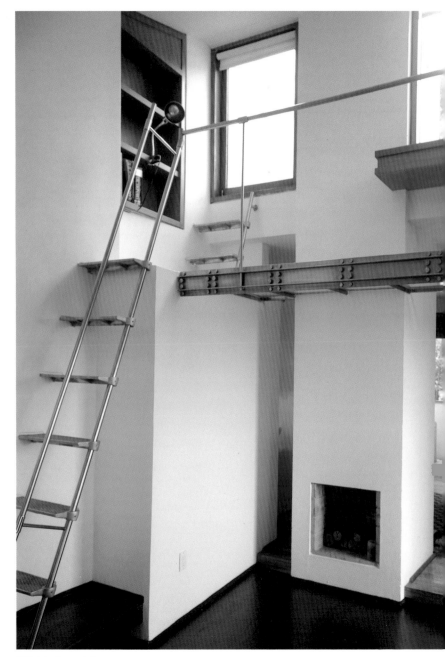

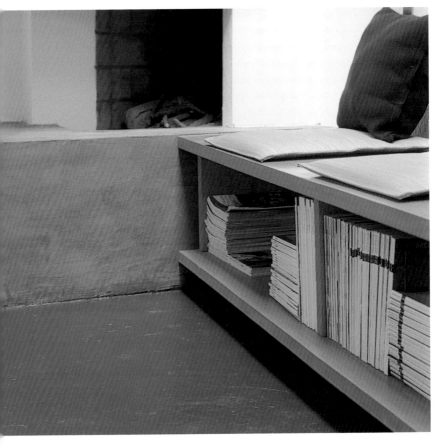

The steel and glass structure of the walkway creates an aspect of lightness, while the walls that make up the interior volumes give a sensation of solidity. The mixture of textures and surfaces makes this residence a rich space.

Zartoshty Loft

Stephen Chung | © Eric Roth | Boston, MA, United States

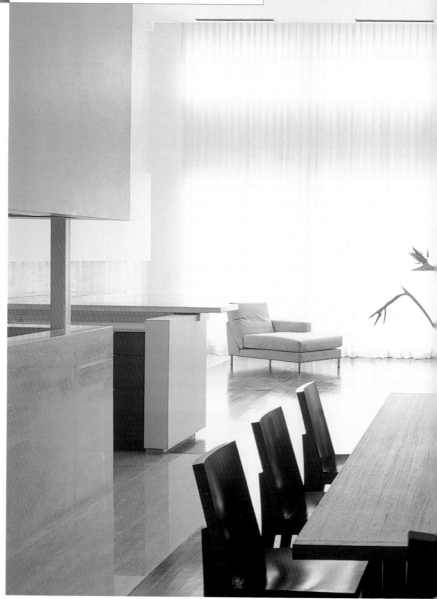

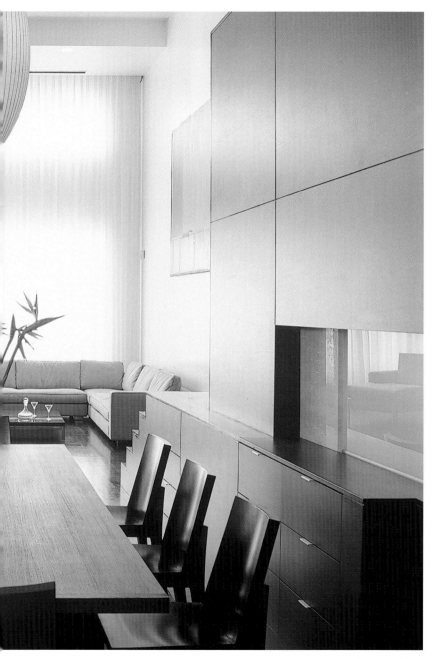

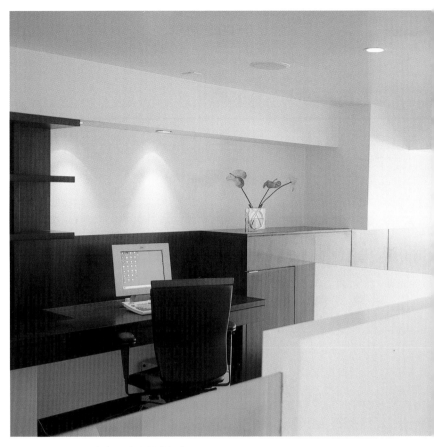

Located on the top floor of a new artist loft building in downtown Boston, this project involved the conversion of a 2,400-square-foot shell into a primary residence. At the owner's request, the architect designed a two-story living/dining area, an open kitchen, a wet bar, and a media room. A staircase, partly concealed behind a tall cupboard unit, leads to the upper mezzanine, which contains the master bedroom, the bathroom, and the study.

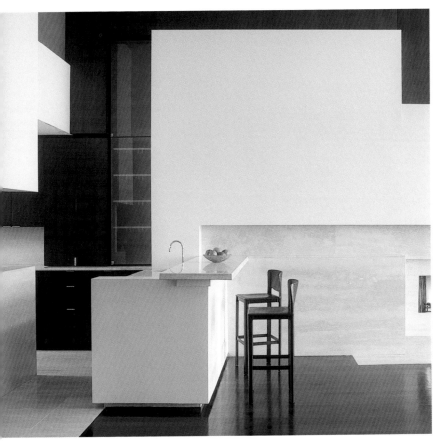

A limited palette of materials was used to blur the distinction between different elements and functional areas. The cabinetry, doors, trim, and most of the flooring are dark walnut wood with a matte finish that contrasts with the walls, counters, and doors that are sandblasted glass. The remaining space is rendered in veneer plaster with a semigloss surface.

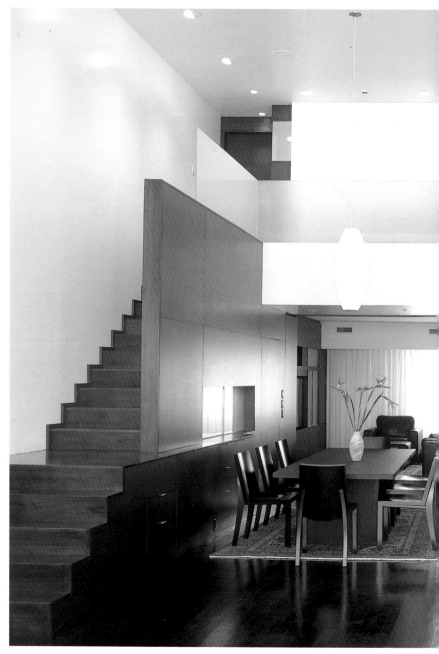

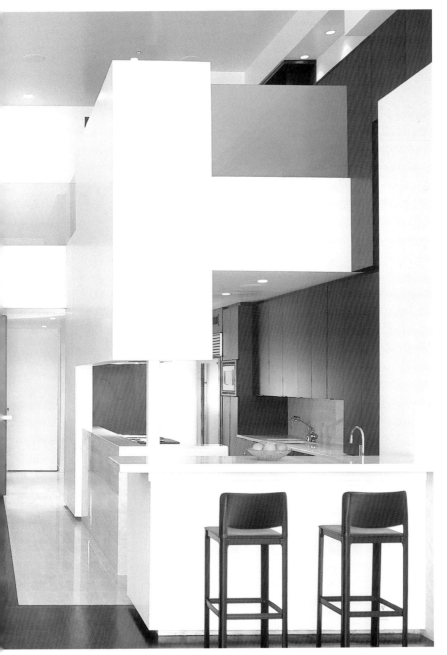

Photographer's Loft

Leddy Maytum Stacy Architects | © Stan Musilek, Sharon Reisdorph | San Francisco, CA, United States

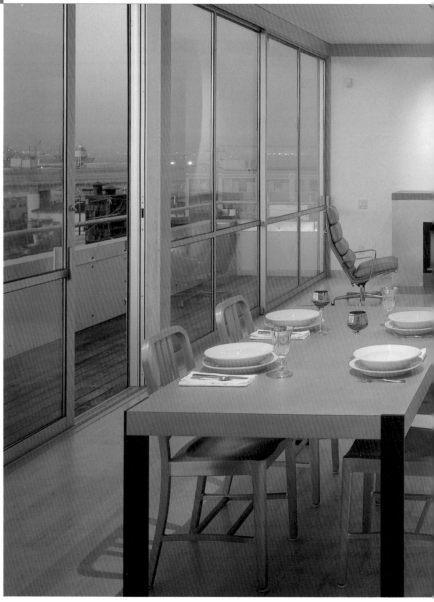

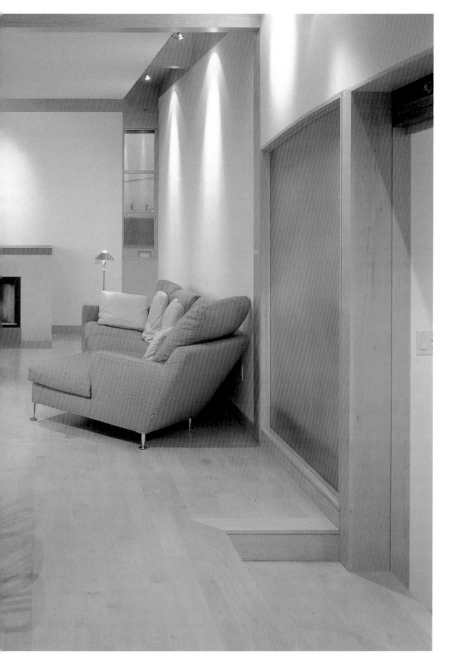

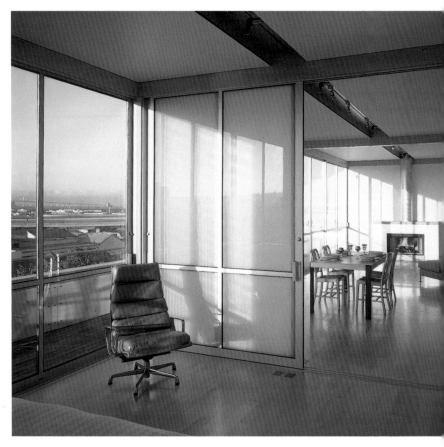

This loft is laid out in a series of consecutive spaces. The studio is located on the ground floor, followed by a mezzanine and the upper floor, where the living space is located and where the roof serves as an outdoor terrace.

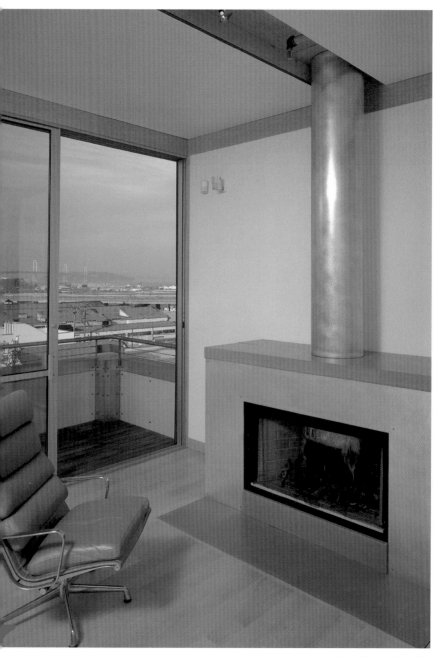

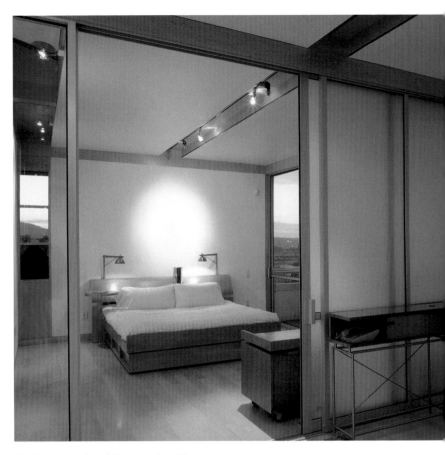

The living areas contain no divisions except for a sliding glass door that partitions off the bedroom. Huge windows integrate the interior with the exterior views. The kitchen and bathroom are situated on a level slightly below the main space
 yet also maintain a generous view of the bay.

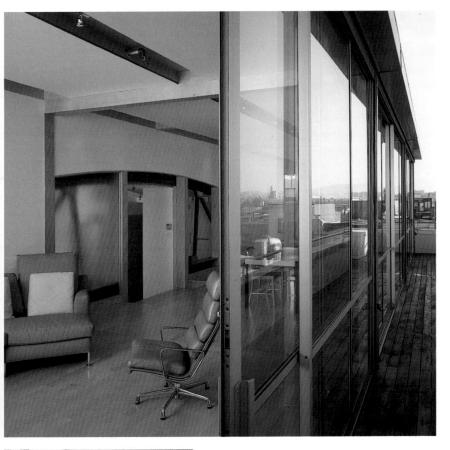

Loft in Islington

Caruso + St John Architects | © Hélène Binet | London, United Kingdom

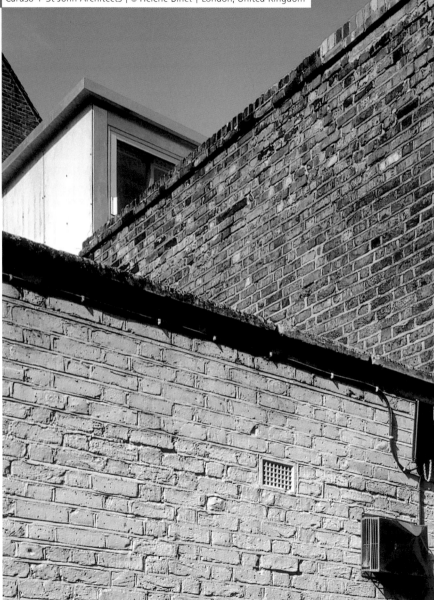

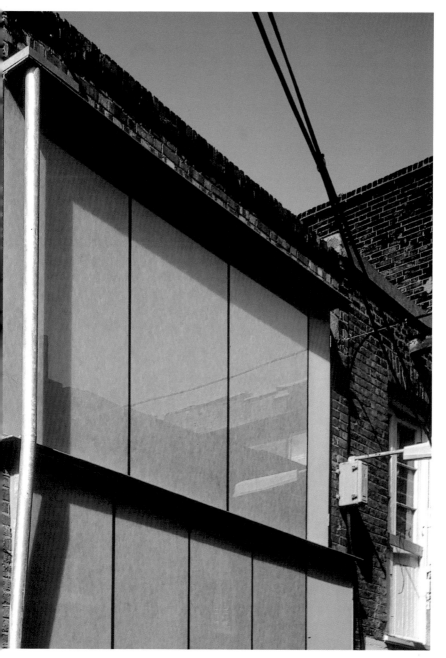

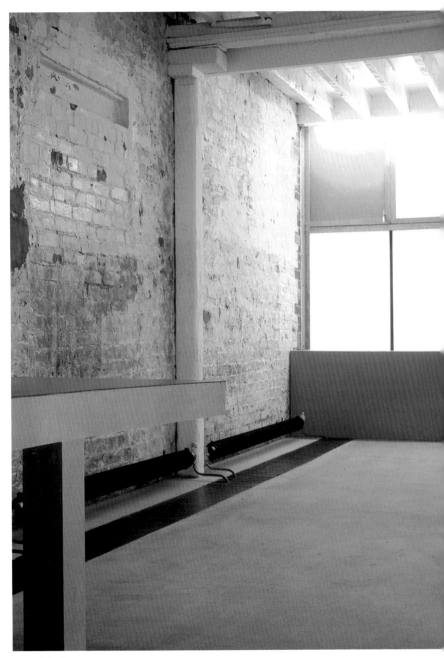

This house and studio are located in the neighborhood of Islington, in the northern part of London. Though the neighborhood is traditionally residential, the loft is situated in an old, two-story warehouse. The building was constructed in different eras and suffered from the various additions and renovations. The project's starting point was the formal unification of the structure through a single "skin." Another task was to appreciate and revive the space's constructional and functional past.

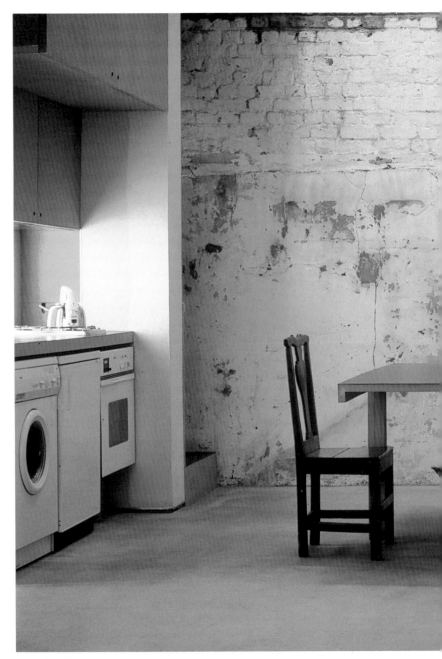

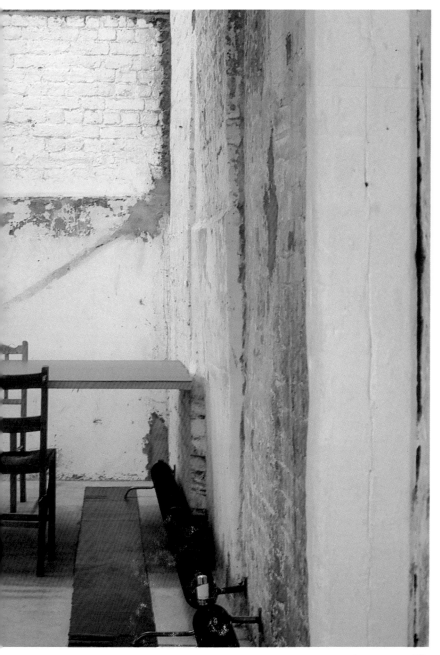

Spatial Relations

McDonnell Associates Ltd. | © Carlos Domínguez | London, United Kingdom

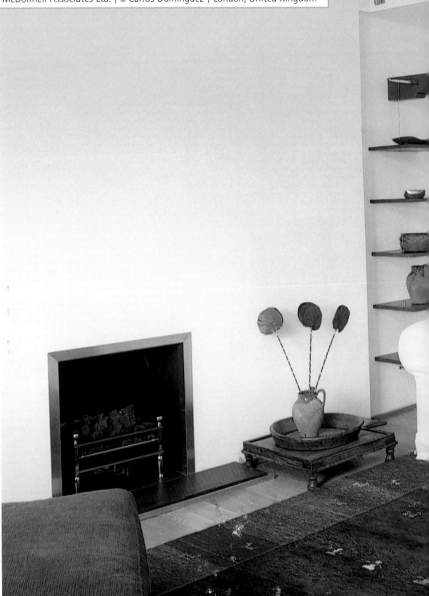

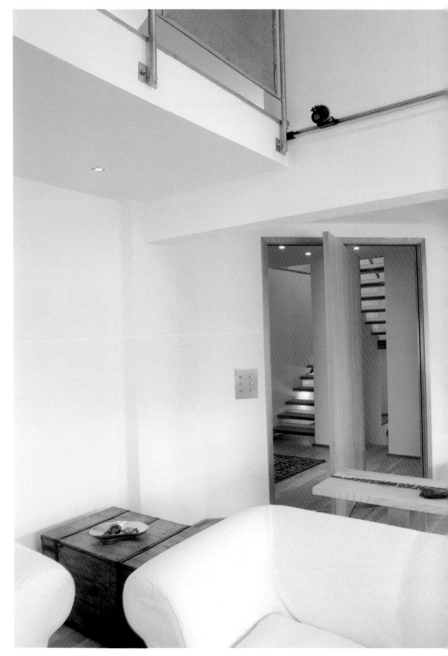

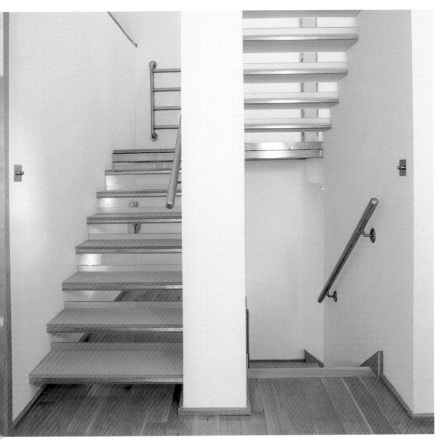

This apartment, located in the center of London, was originally a structure without a ceiling that the owner wanted to remodel into an escape from the hustle and bustle of the city. The best features of the space, natural light and splendid views, are emphasized in this renovation.

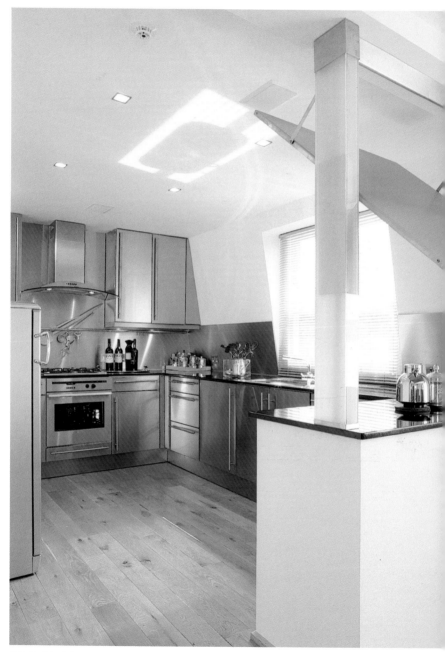

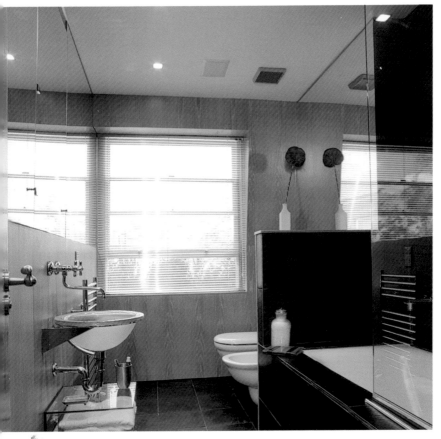

Union Square Loft

James Dart | © Catherine Tighe | New York, NY, United States

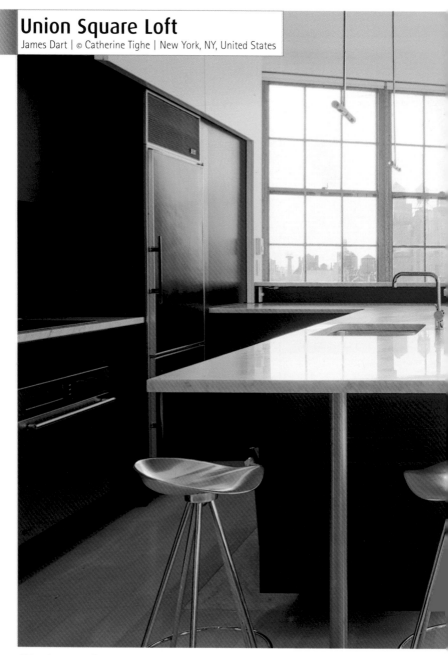

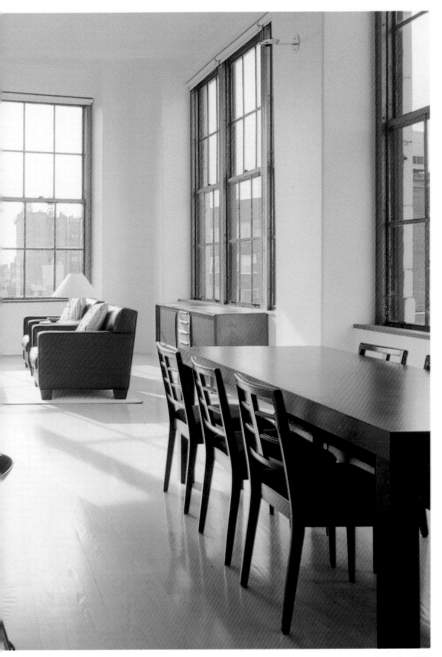

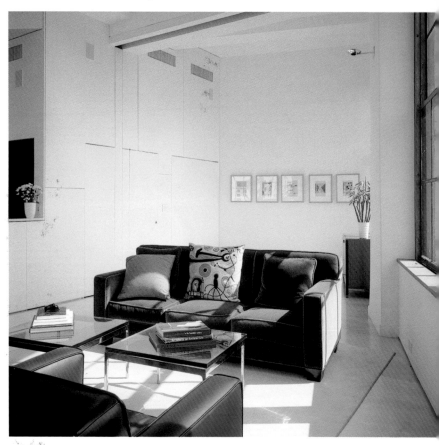

Occupying the oblique corner of 4th Avenue and 12th Street, this loft plays off of the irregular geometry of the plan to create a series of framed views of the city. The decoration is restrained, though not minimalist, and favors the use of symmetry and neutral colors.

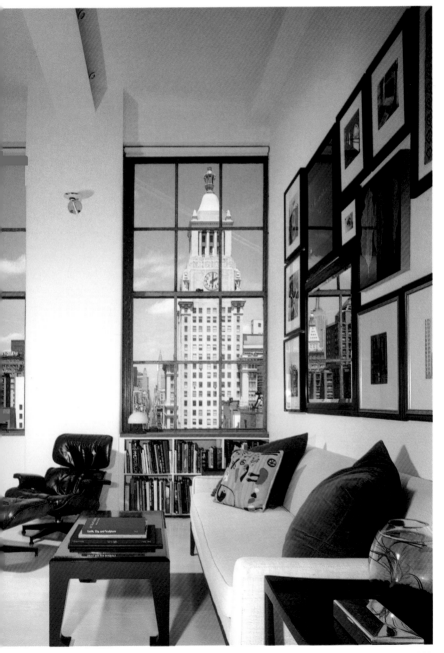

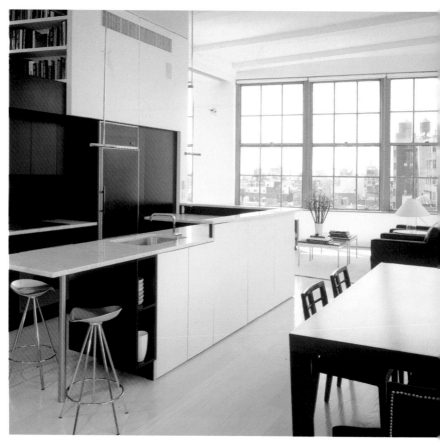

The new design incorporates a central core composed
of the kitchen and bathroom, in order to provide
uninterrupted views of the exterior through the
perimeter windows. The stairs along the side lead to the
mezzanine level, which houses a small library and the
master bedroom beyond.

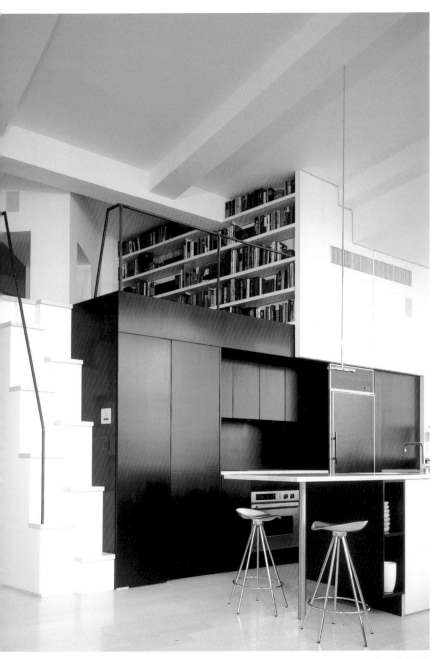

Rectangular Loft

Pablo Chiaporri | © Virginia del Guidice | Buenos Aires, Argentina

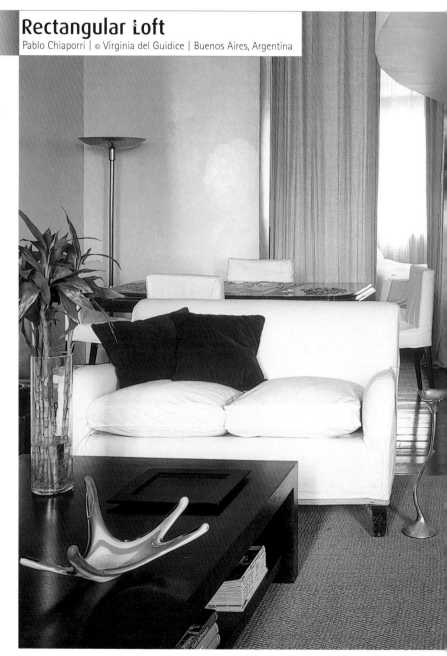

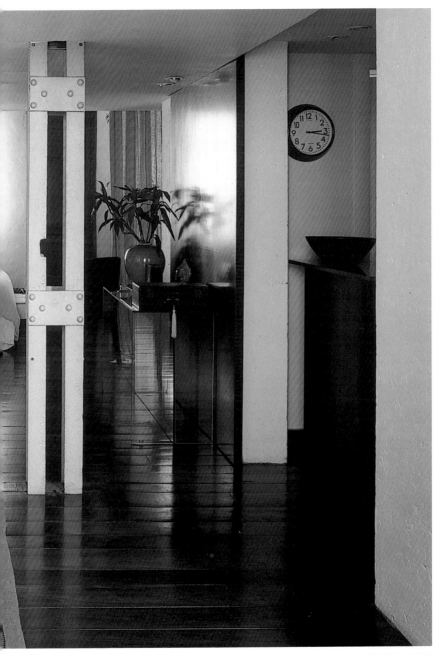

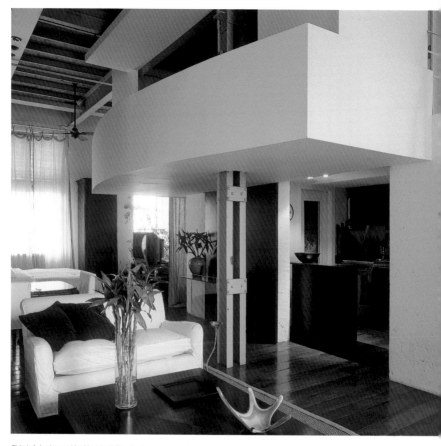

This loft is situated inside a building that was once part of the Molinos Minetti warehouses in Buenos Aires. Underneath this staircase, the kitchen is integrated across from the living room, behind a partition laminated in Caoba wood.

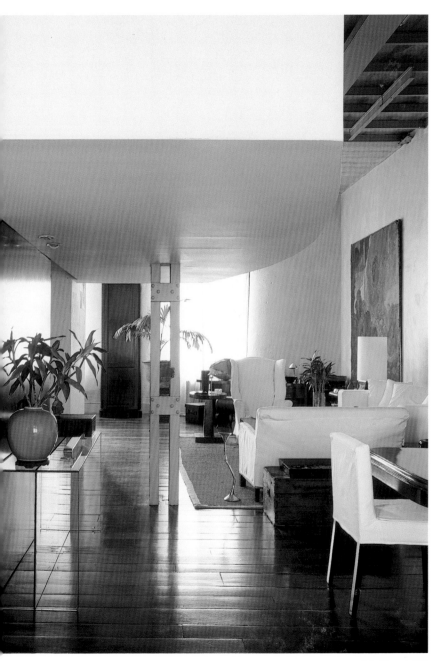

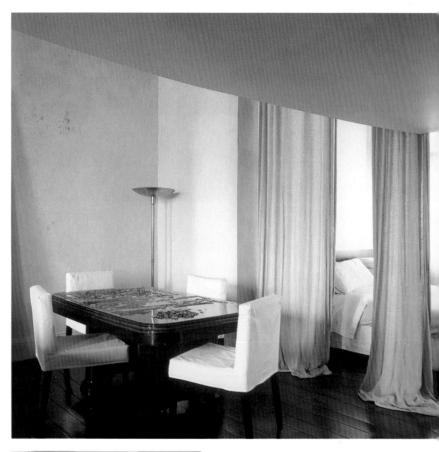

Characterized by contemporary lines and its careful selection of furniture and objects, the space follows a simple L-shaped plan in which public and private is divided by the use of a full-length translucent fabric. White and dark wood compose the color scheme of the space, and contemporary objects are interspersed with furniture from the 1940s and 1950s.

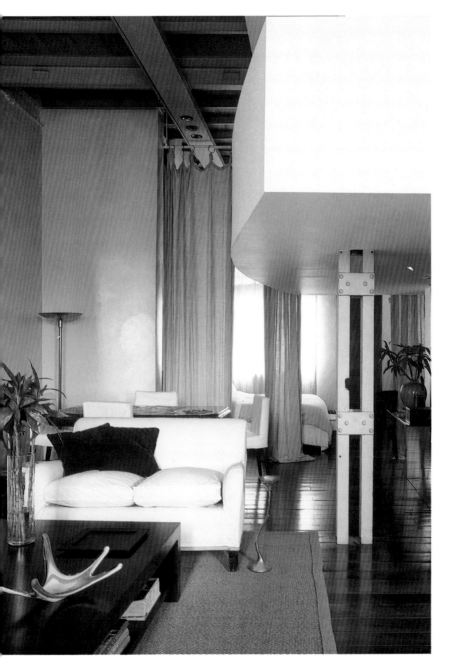

Four Atmospheres in One

Hugh Broughton Architects | © Carlos Domínguez | Gloucestershire, United Kingdom

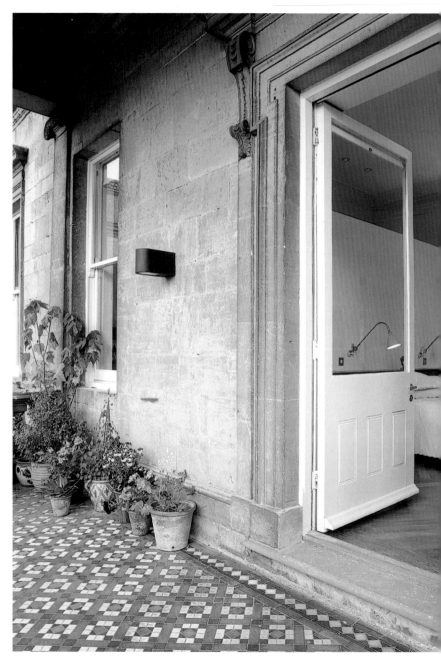

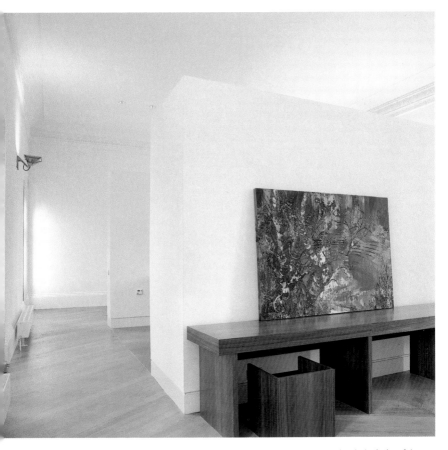

This home was constructed at the beginning of the 20th century, and its 18th-century Palladian façade (style created by Andrea Palladio) was transported on roads specially constructed for the project. The former dance hall, located at the southern part of the space was divided in the 1920s to create a series of smaller rooms with low ceilings.

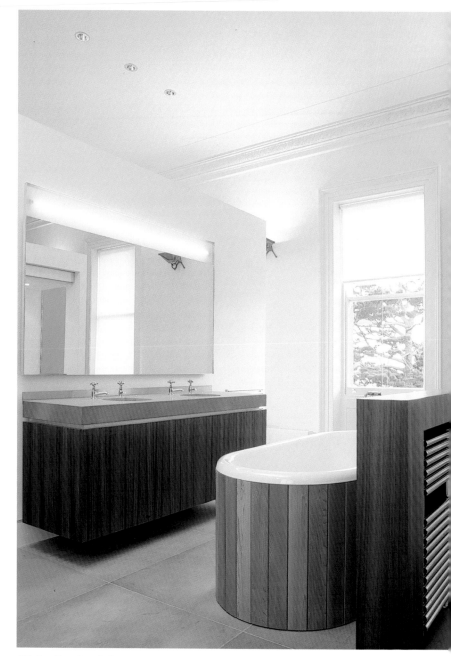

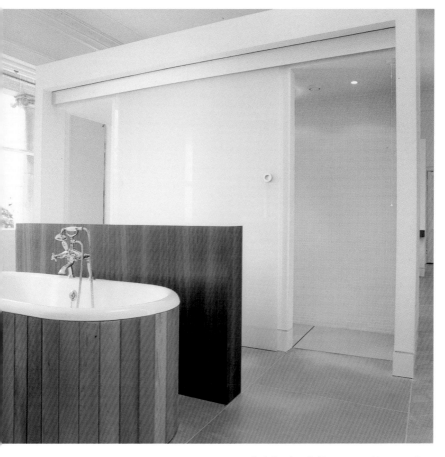

Hugh Broughton Architects renovated these rooms by restoring their original characteristics and adding new, contemporary components.

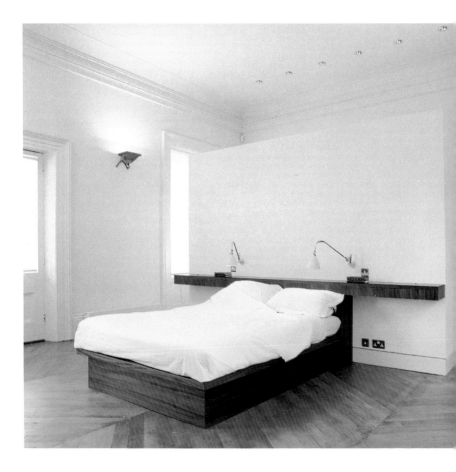

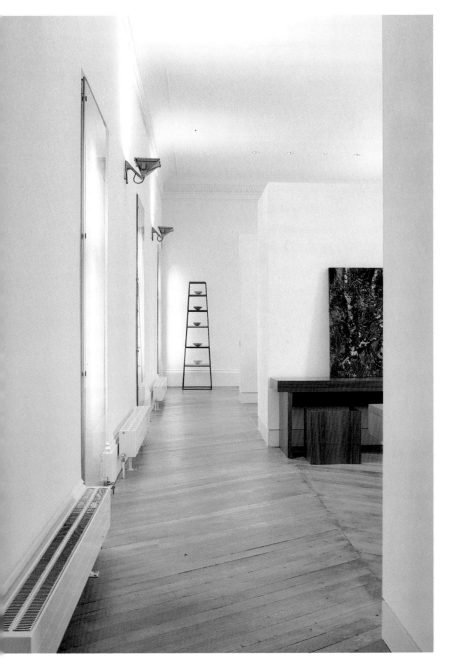

Optical Illusion

Gil Percal | © Gilles Gustève | Paris, France

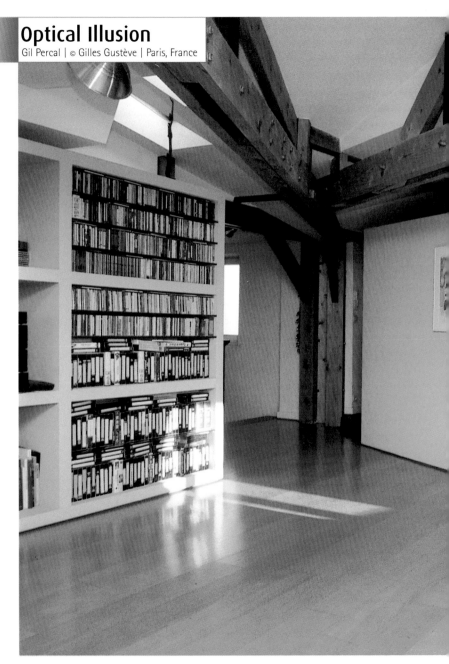

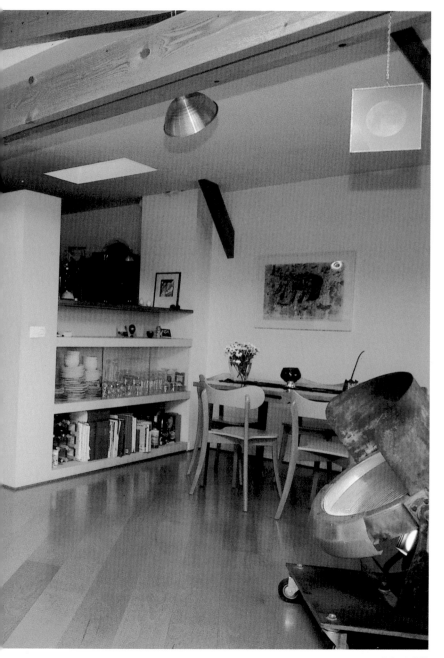

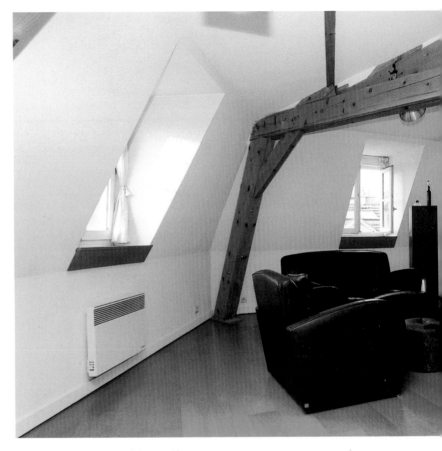

Before architect Gil Percal renovated the space, this
apartment in the third district of Paris consisted of
various spaces on the fifth and the sixth floors of the
building, without any communication between them.
Percal created access to the upper floor, uniting the
two levels and gaining space for an additional room,
which increased the surface area to 463 square feet.
The project's focal point was the union of the two
levels via a monumental staircase that occupies the
entire entrance to the apartment.

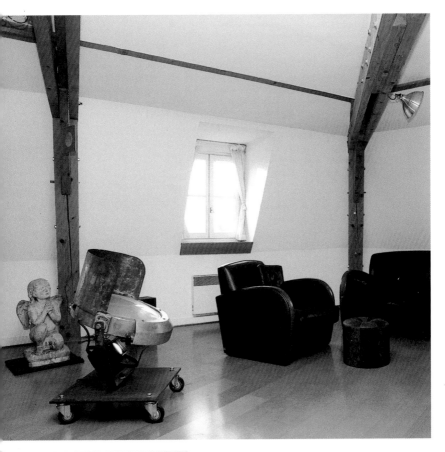

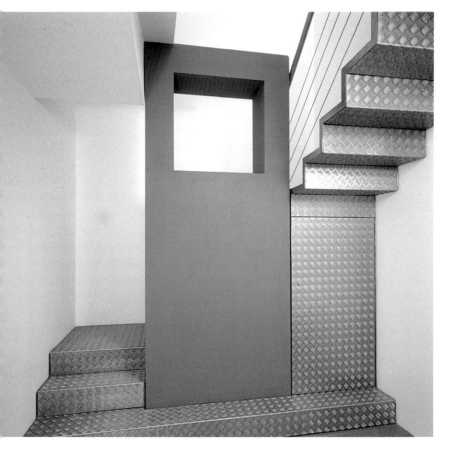

A studio on the fifth floor leads to the sixth floor via the staircase, which contains a blue element in the center. This item provides hidden support for the upper floor, concealing a metallic column on the left side. The aluminum texture of the stairs and the geometric play between this element and the space of the staircase creates an illusion of reversibility that alludes to drawings by M.C. Escher.

Loft in Milan

Laura Agnoletto & Marzio Rusconi Clerici | © Matteo Piazza | Milan, Italy

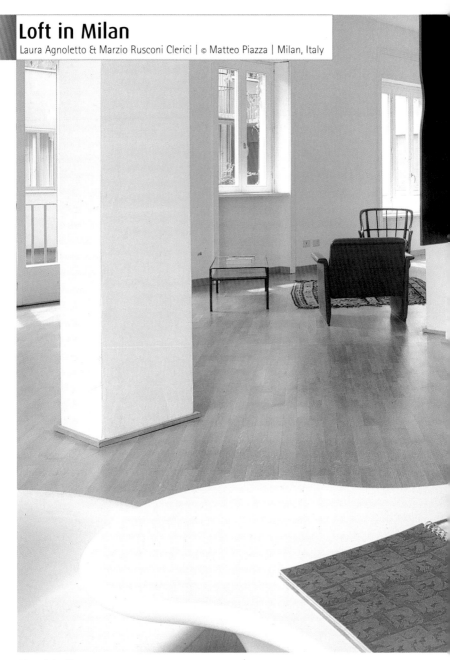

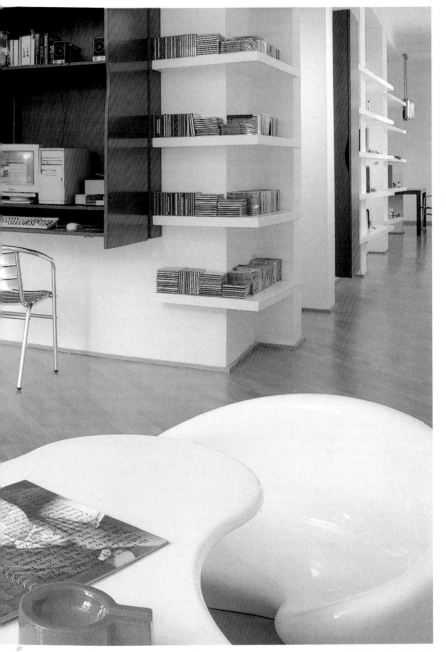

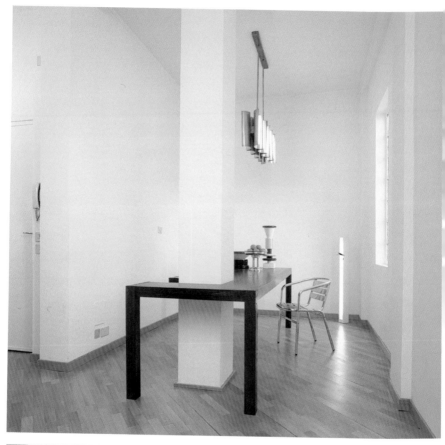

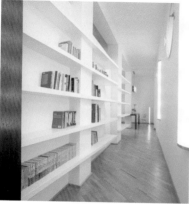

The entrance was planned as a small area off the passageway between the kitchen and the bath and leading to the dining room. At its widest point, beginning in front of a small table built around a column, it is an activity space more than a transit area.

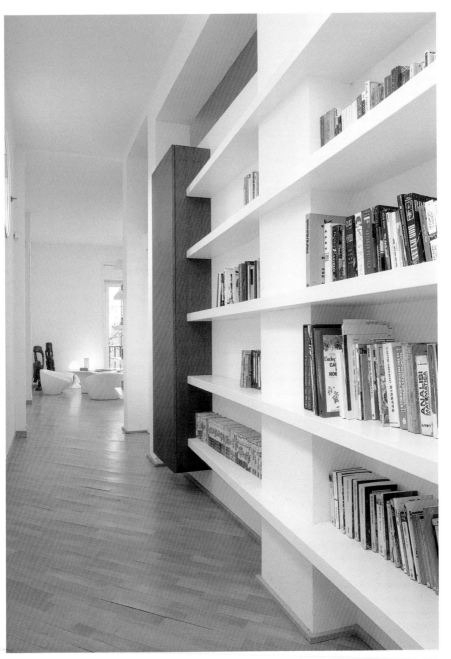

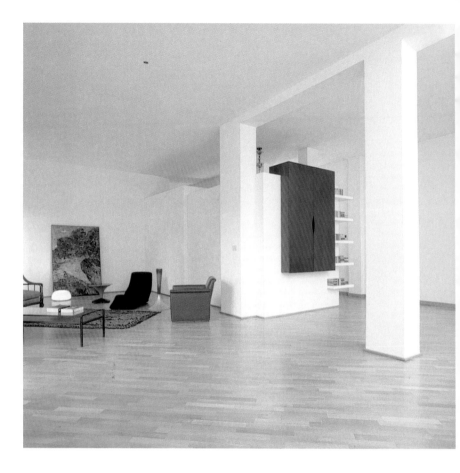

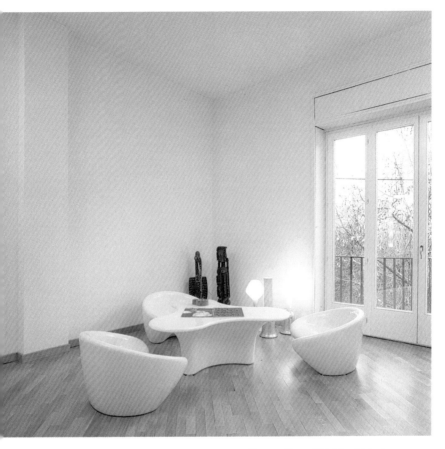

The newest image of this loft, which has been remodeled repeatedly through the years, merges past and present into a clear metropolitan identity. The development of the design offers a trip through the history of decorating fashion and creates spatial tensions that enrich the dwelling's spaces.

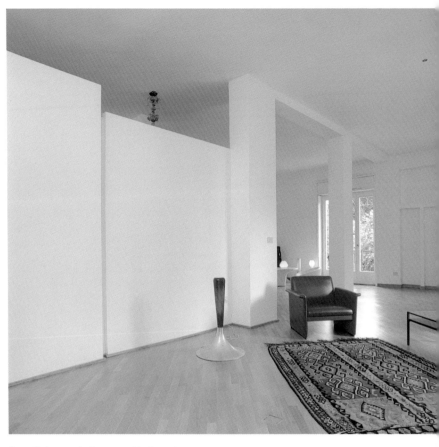

The corridor's perspective is accentuated by the openings
in the adjacent wall. The corridor contrasts with the
luminosity and spaciousness of the large living room.

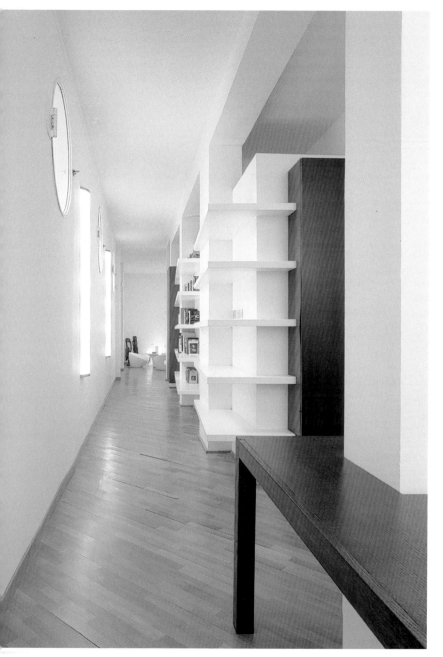

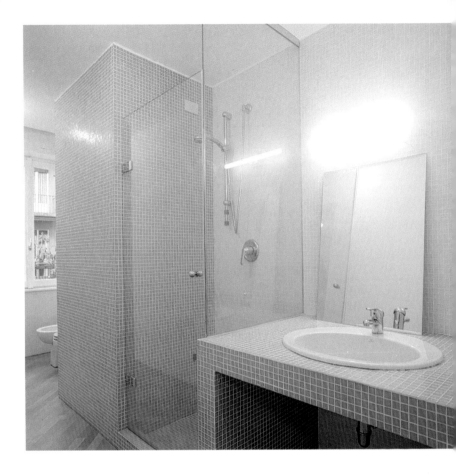

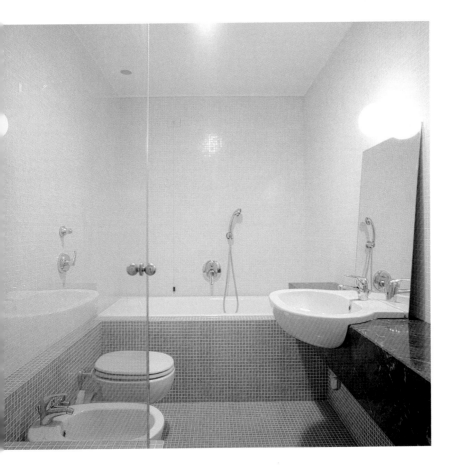

Loft in Wall Street

Chroma AD | © David M. Joseph | New York, NY, United States

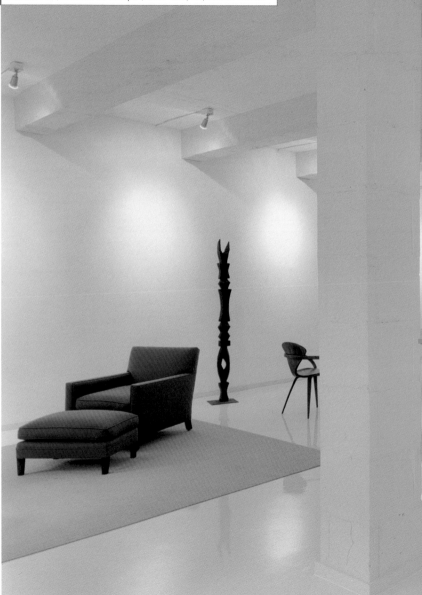

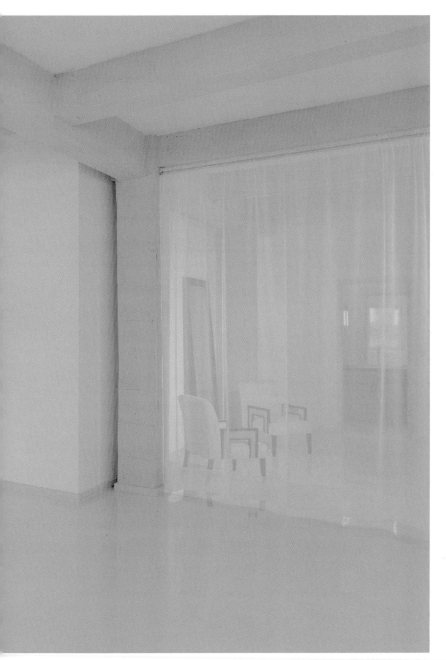

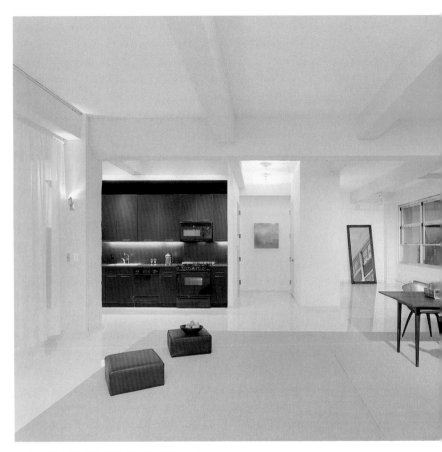

In 1995, New York's City Hall encouraged contractors to convert empty office buildings in lower Manhattan into homes. The city's revitalization plan offered tax incentives and flexible construction requirements. The real estate group Time Equities took advantage of the proposal and hired the architectural team Chroma AD to remodel a six-story building into 13 lofts.

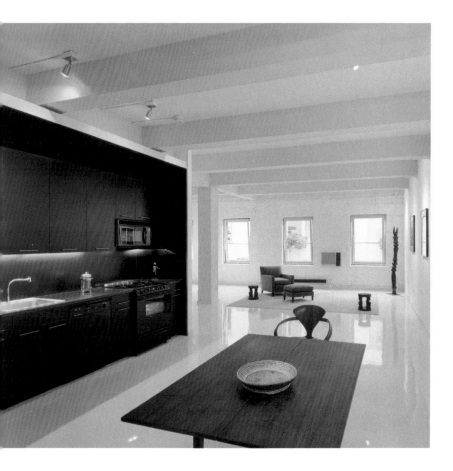

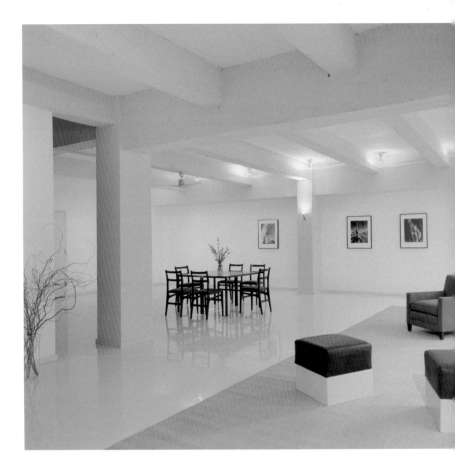

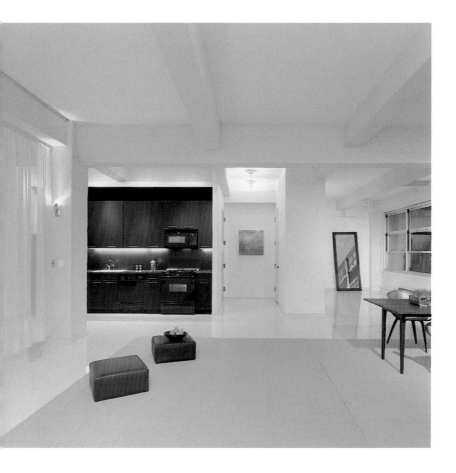

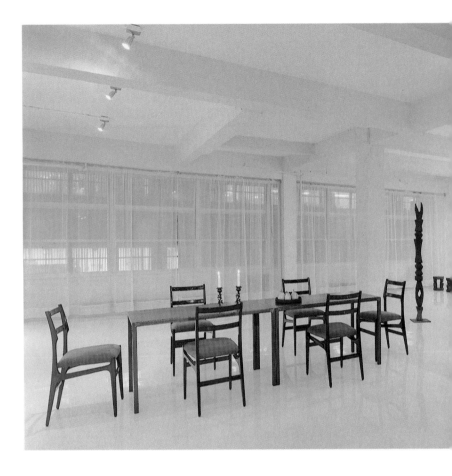

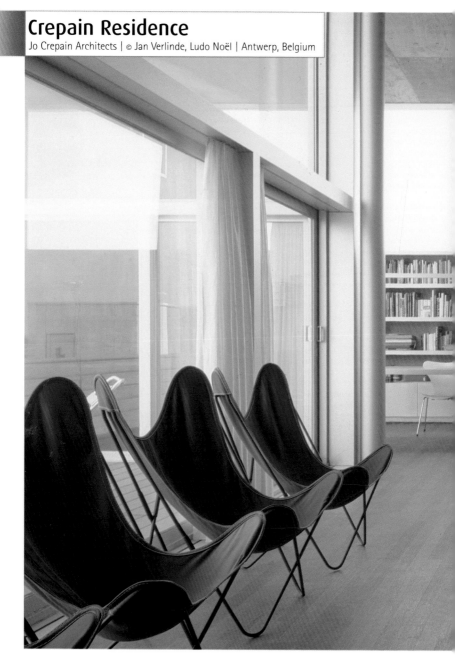

Crepain Residence

Jo Crepain Architects | © Jan Verlinde, Ludo Noël | Antwerp, Belgium

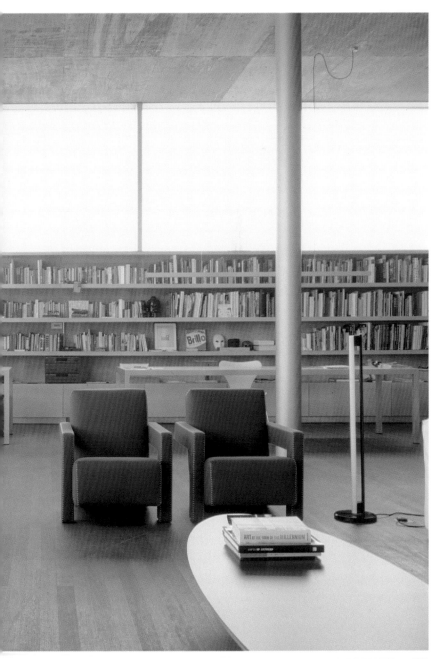

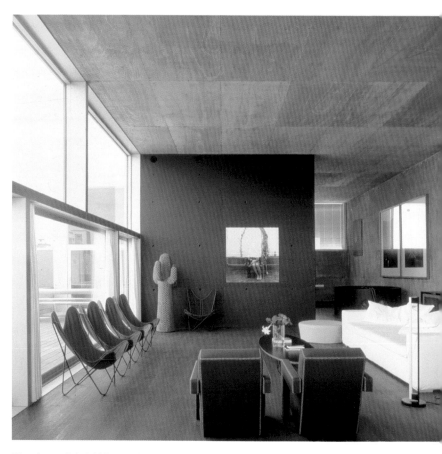

This project entailed refurbishing an industrial park in the center of Antwerp, Belgium. The architect converted an old, fin de siècle warehouse into a living space and office for his own use. At the same time, a 30-year-old office complex was demolished to allow the creation of a parking lot and a garden.

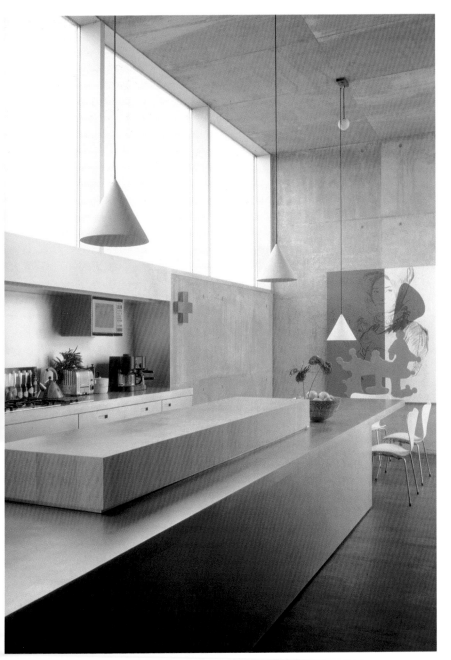

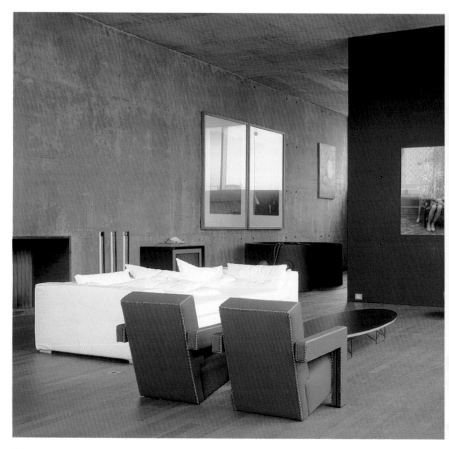

The symmetric forms created by most of the structure
are complemented by curved furniture and accessories
in bright primary colors. The ceilings reach 13 feet in
height and amplify the sense of space.

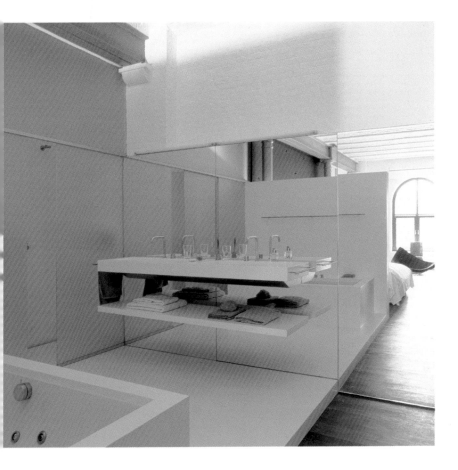

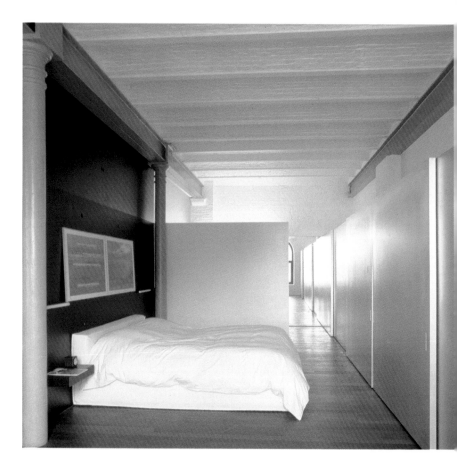

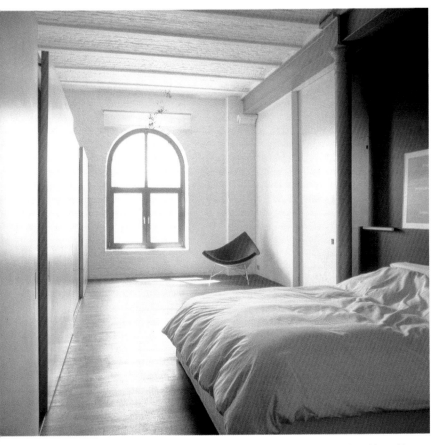

The bedroom area is separated by a white partition to provide privacy. The project is modern and fluid home whose use of concrete in combination with other textures and tones creates a warm, conforting and inviting space.

Choir Loft

Delson or Sherman Architects | © Catherine Tighe | Brooklyn, NY, United States

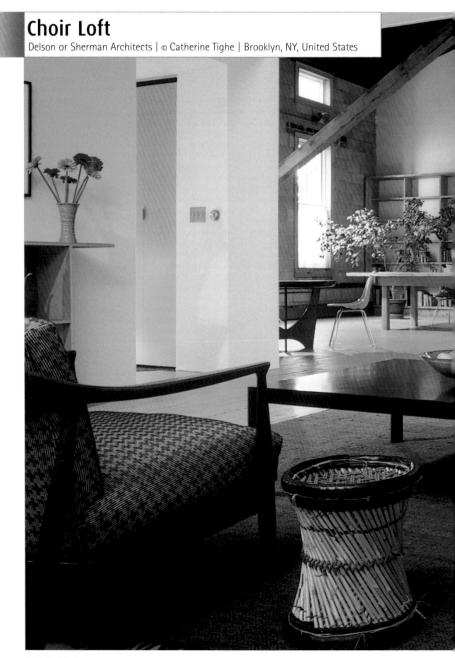

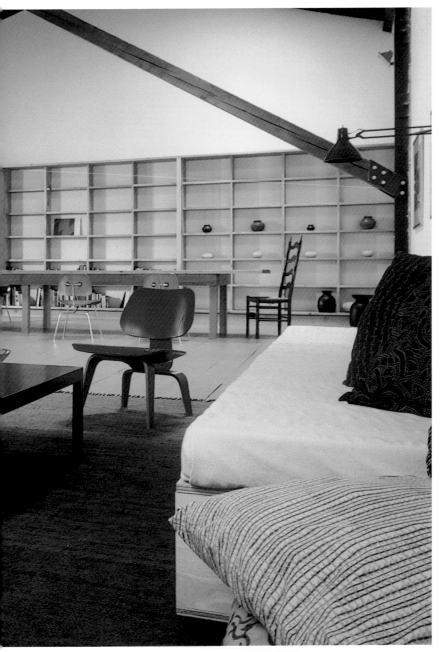

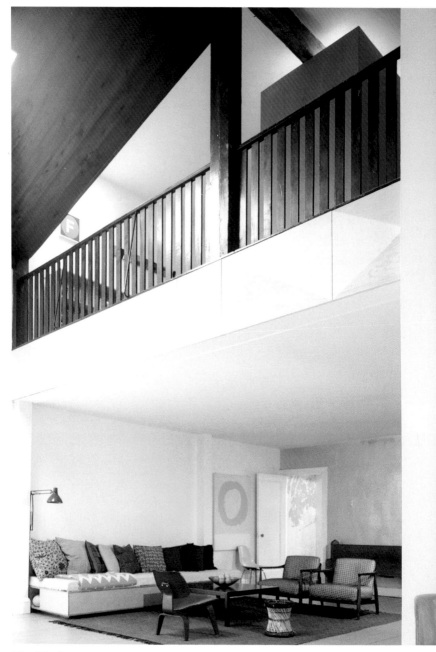

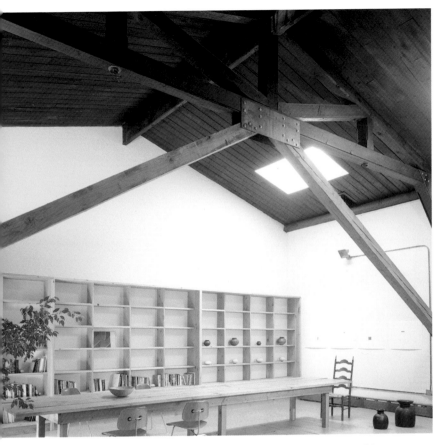

In order to emphasize the vastness of the two-story volume, a series of deep skylights that spill light into the space was installed into the ceiling. The room was furnished with a giant 20-foot table and long bookcases.

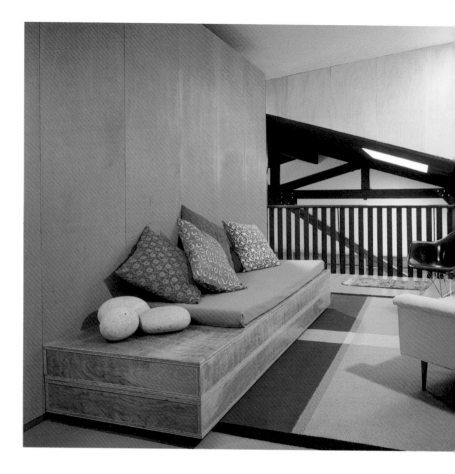

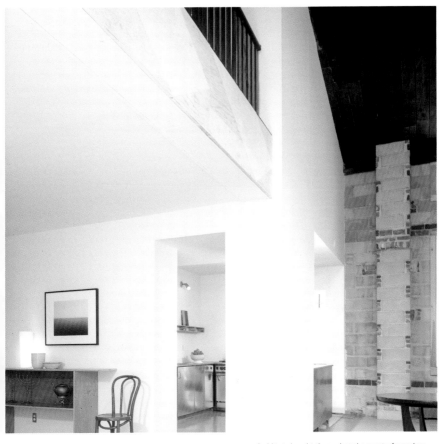

Architects bought the neglected property, formerly a
church, and transformed it into a home for a family of
four. The space was gutted, although even the shell was
in need of repair. Major structural work included
rebuilding an exterior wall and bolstering existing
trusses with new heavy-timber struts and steel plates.

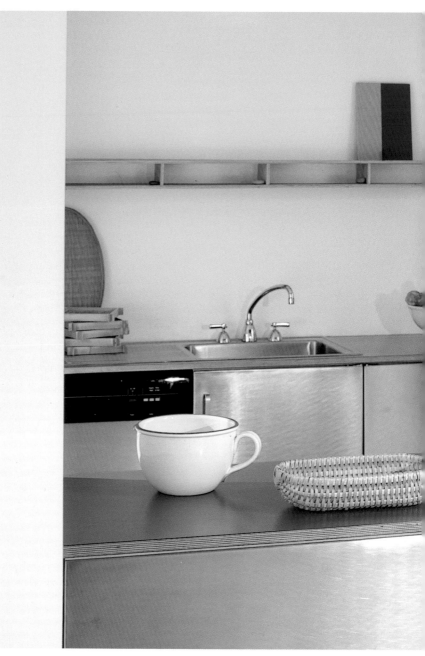

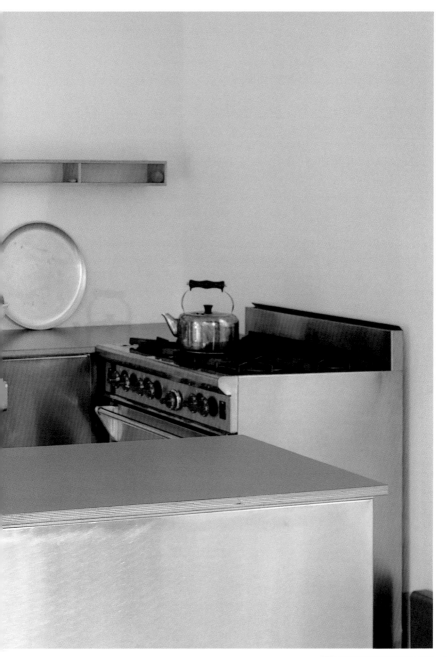

Rosenfeld Loft

Gluckman Mayner Architects | © Lydia Gould Bessler | New York, NY, United States

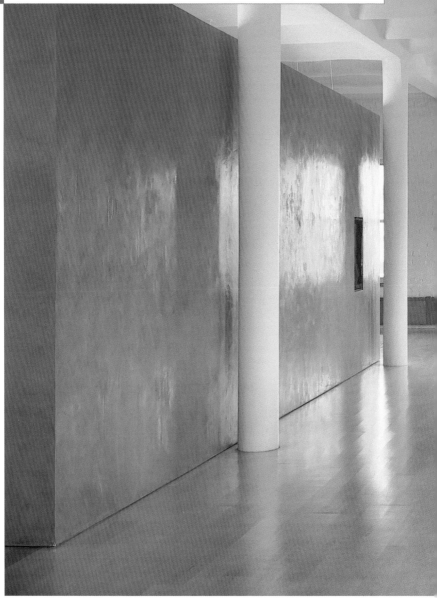

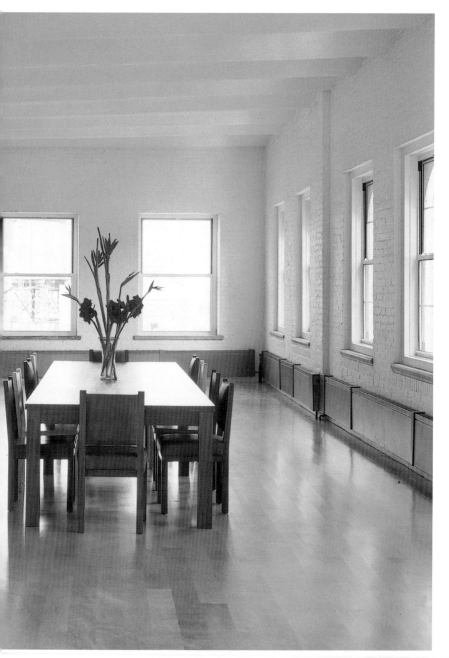

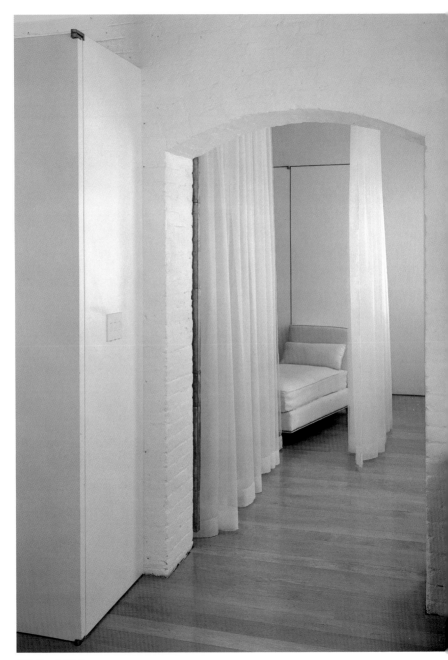

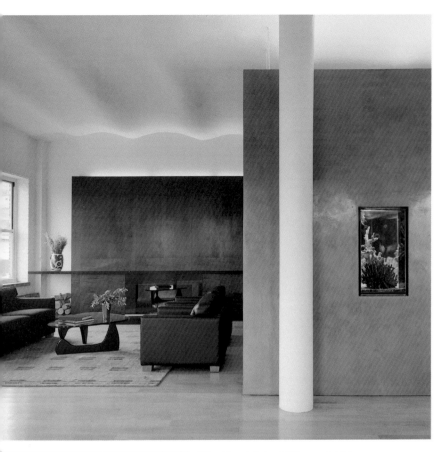

This residence includes a 1,800-square-foot living space, two bedrooms, an open kitchen, and a 400-square-foot outdoor terrace. A partition runs the length of the dining area to give privacy to the living areas. A small aquarium also acts as a window between the two spaces.

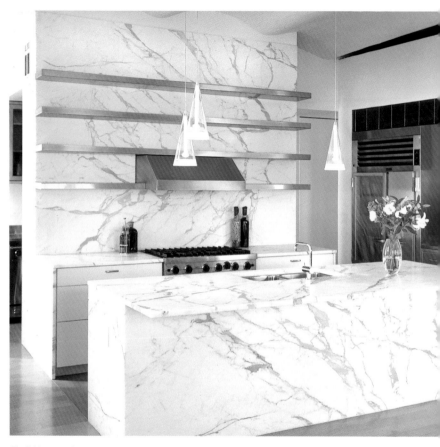

The finishes are refined: the original vaulted ceiling was
subtly altered to achieve a smooth, curvy effect; and
the brick walls and pillars were painted white to
maintain a sober color palette.

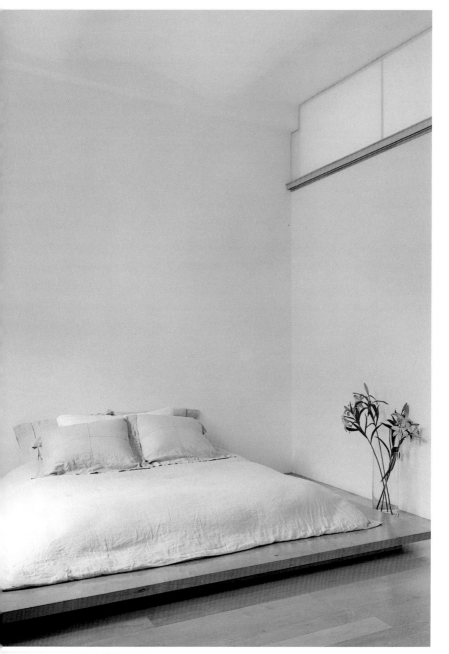

Potter Loft

Resolution: 4 Architecture | © Eduard Hueber | New York, NY, United States

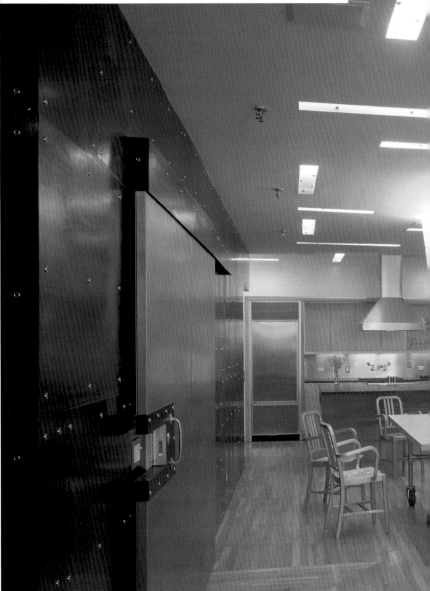

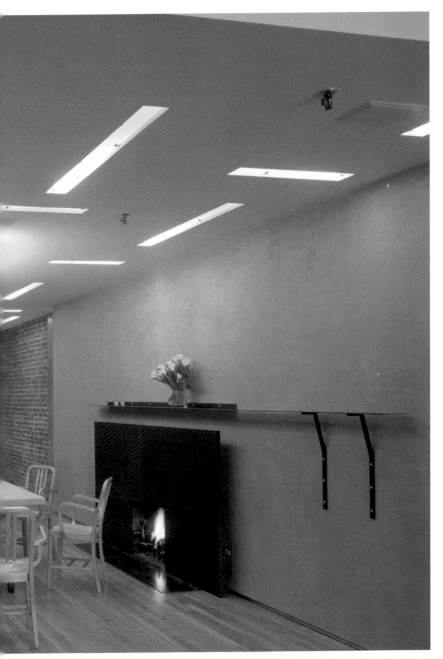

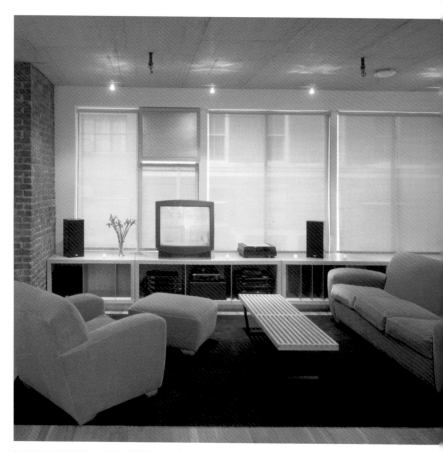

Located in New York's Chelsea neighborhood, this loft was refurbished in response to the client's simple lifestyle. The ground plan is distributed to afford open space that moves through the central kitchen, the baths, and the bedrooms at the back of the apartment. This room is surrounded by different types of surfaces that define the thresholds of the space.

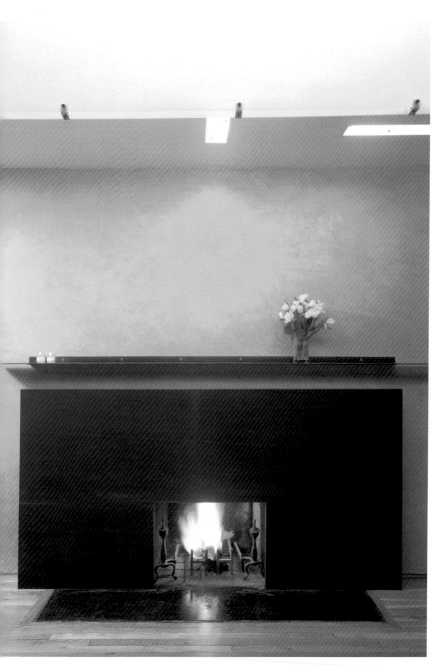

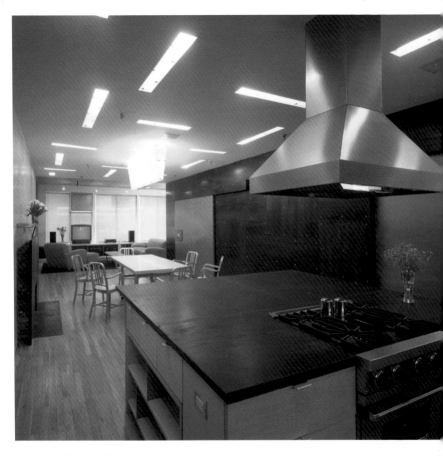

Together, both kitchen and dining room boast 20 bars
or segments of light connected to individual adjustable
controls. Border spaces open and close through the use
of movable elements that slide, pivot, or roll.
Constructed with a tailor-made metal panel, the sliding
door is the building's security door.

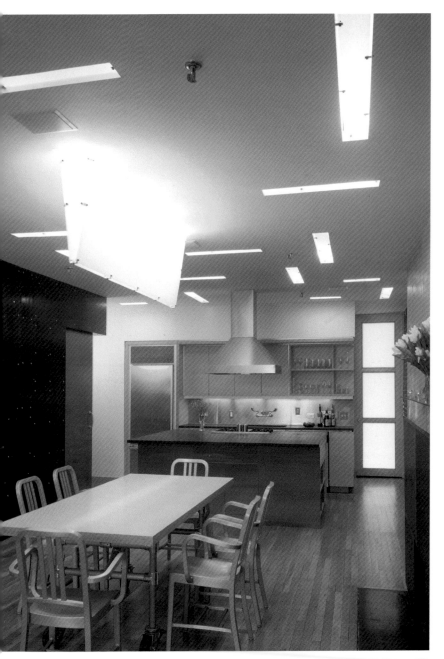

1310 East Union

Miller / Hull Partnership | © Ben Benschneider, James F. Housel, Craig Richmond |
Seattle, WA, United States

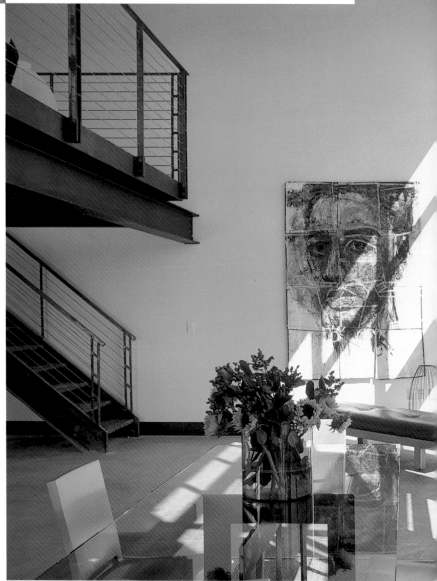

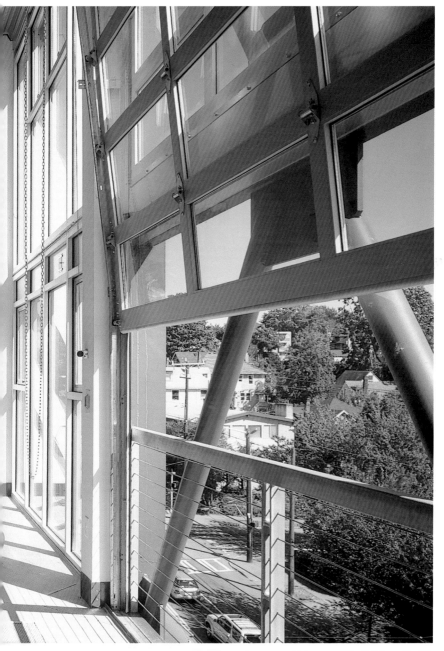

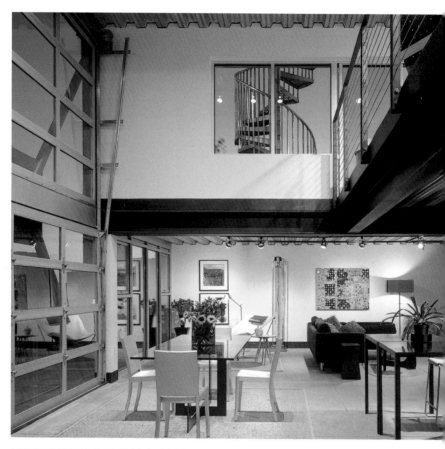

Located on Capitol Hill in Seattle, Washington, this loft-style condominium occupies a small 40 by 80 foot plot that was maximized by the architects' design plan. The duplex contains integrated living/dining/kitchen areas on the lower level, which looks out through a steel-framed glass façade with uninterrupted views of the city. Interior materials include concrete floors, exposed steel structural elements, steel railings, steel-plate baseboards, and modular metal kitchen casework that support the butcher-block counters. Patches of color liven up the space.

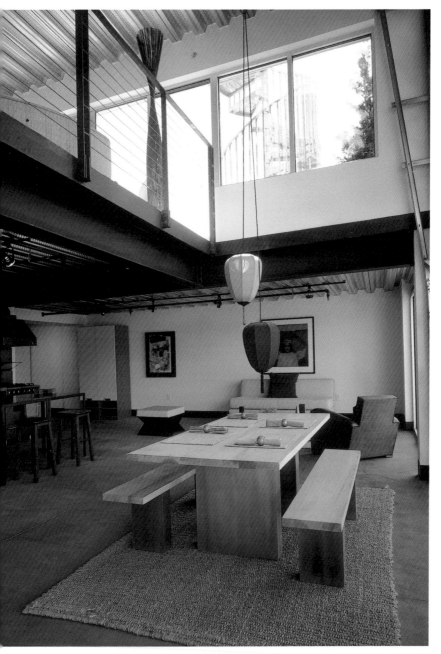

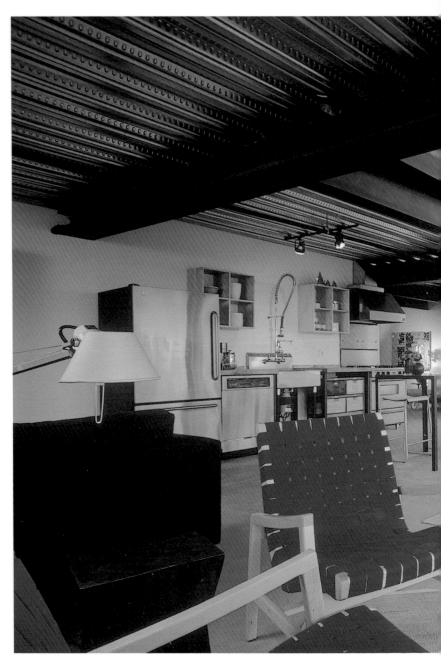

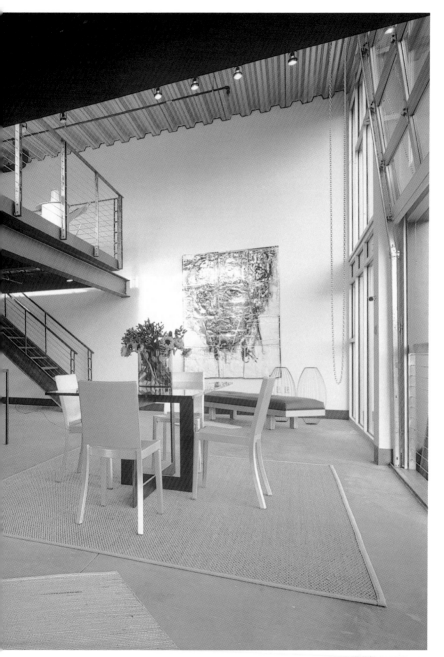

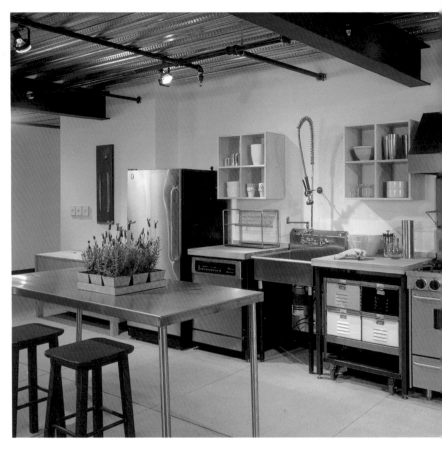

Each residential floor contains two loft units varying in size from 700 to 1,600 square feet. The top two floors contain duplexes, one of which is shown here, with west-facing balconies, mezzanines, and shared access to a private rooftop garden.

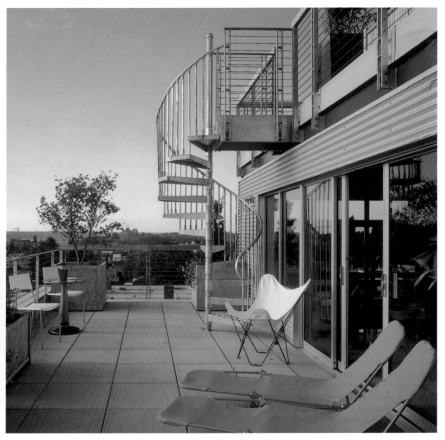

Wagner Loft

Michael Carapetian | © Andrea Martiradonna | Venice, Italy

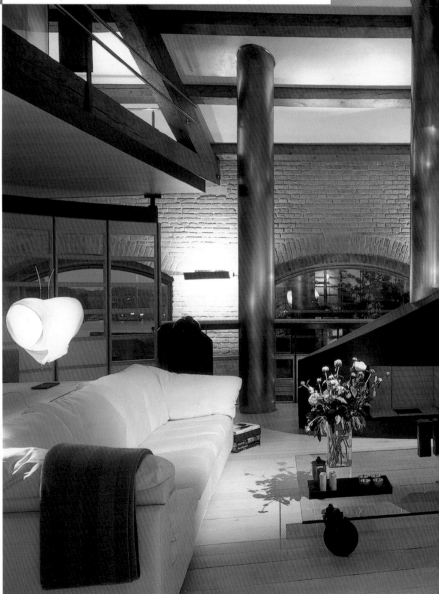

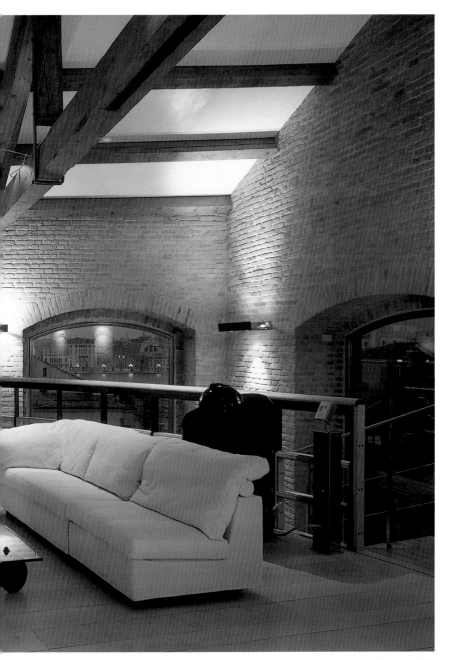

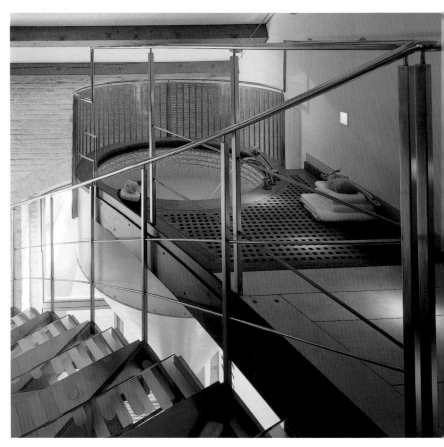

This residence was inserted into an industrial shell that was originally constructed in 1910. The terraces and the lowest level of the loft are raised by a suspended steel floor and a suspended steel-frame wall that divides the space from the rest of the enveloping structure.

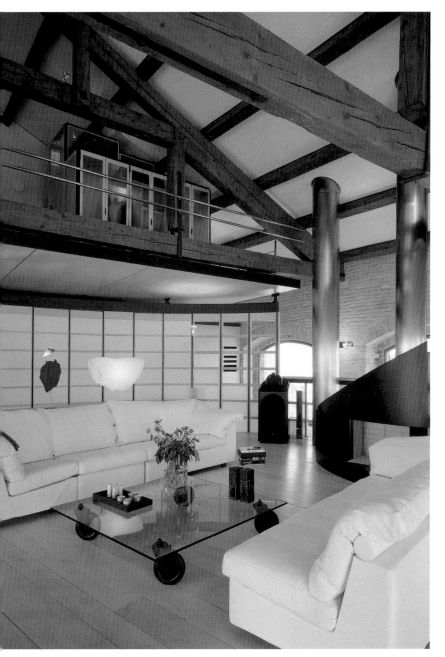

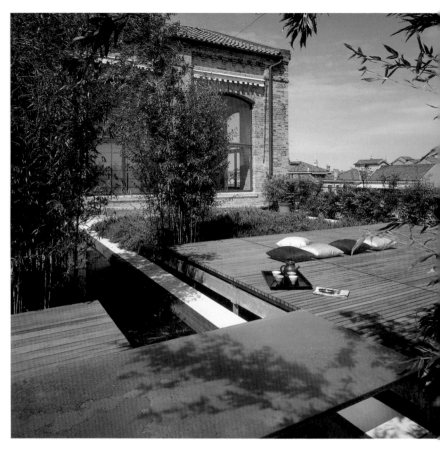

An elliptical-shaped wood construction is cantilevered
from two wood structural plates, taking up one-third of
the space. This ellipse, which makes reference to
conventional boat constructions, is composed of
prefabricated plywood box-beams. The architect aimed
to keep the structure intact by introducing new
surfaces to sustain the rooms without removing any of
the existing brick walls and wood trusses.

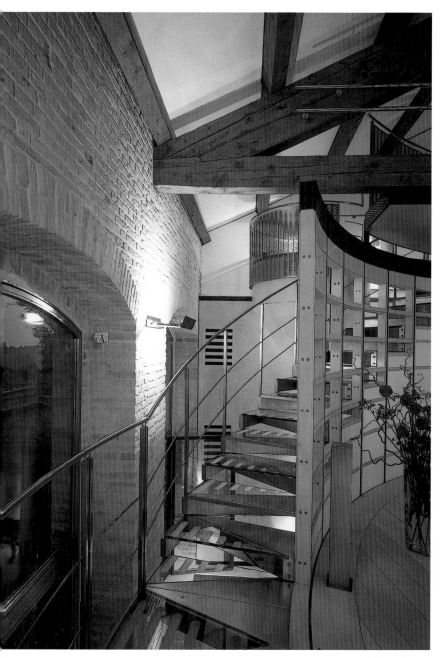

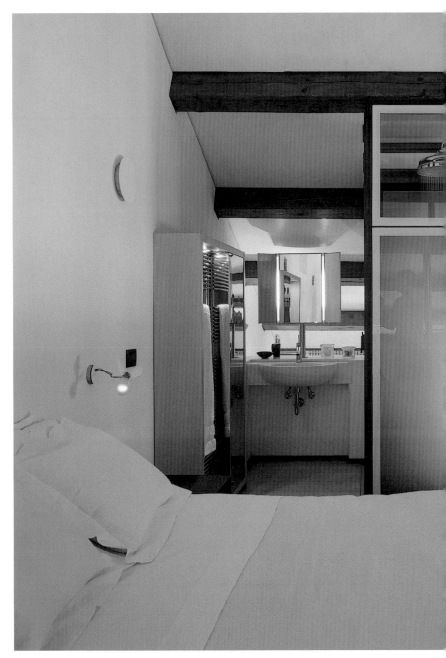

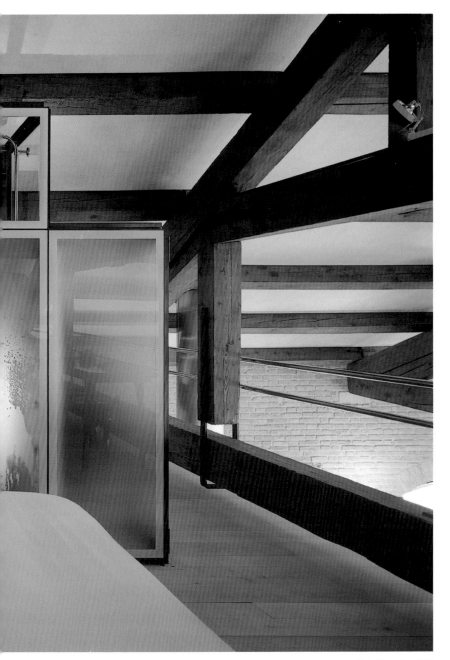

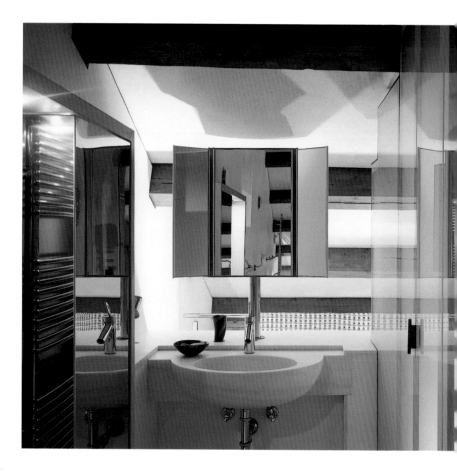

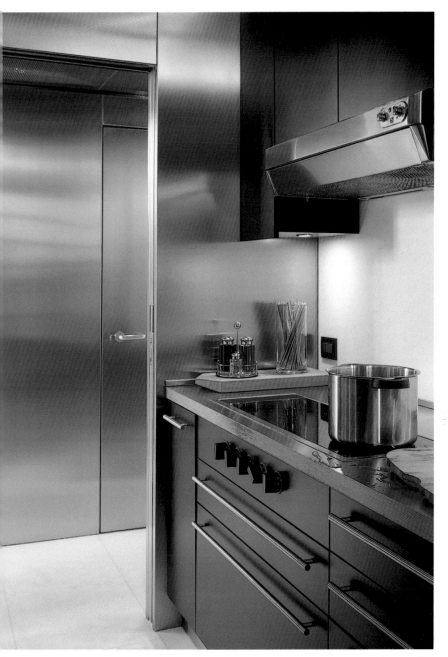

One Space inside Another

Alexander Jiménez | © Jordi Miralles | New York, NY, United States

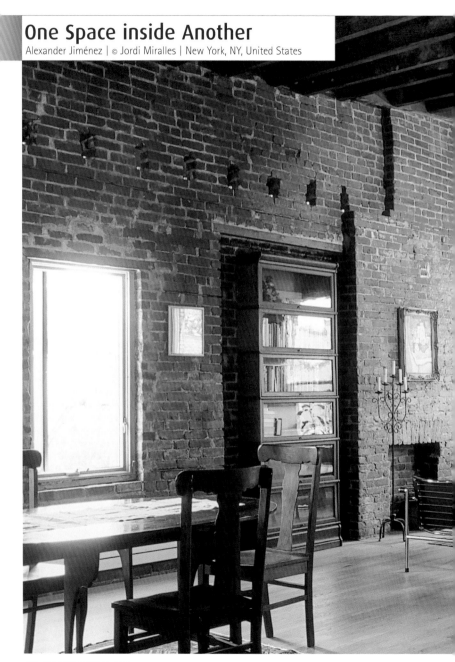

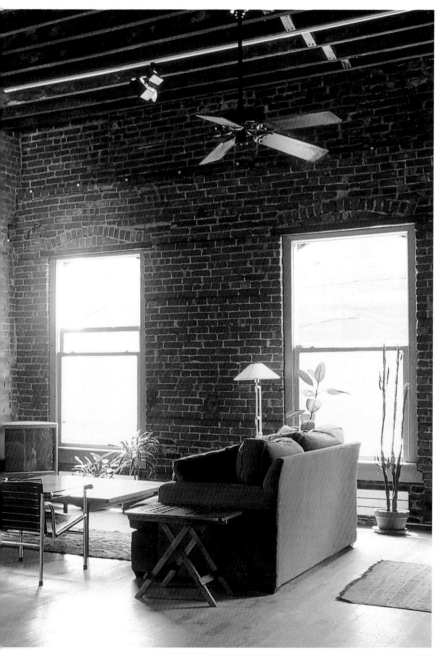

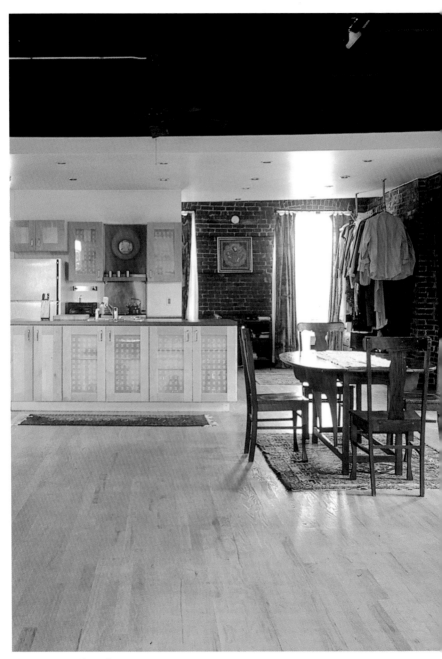

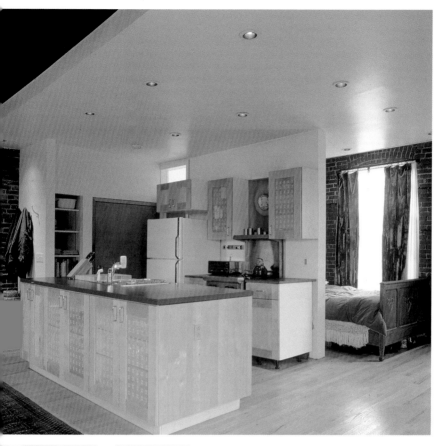

This loft has a rectangular layout and is situated in an old factory building in an industrial neighborhood in New York City. The goal of Alexander Jiménez's renovation was to maintain the industrial feel of the space, yet adapt it to provide modern comforts. In order to establish different zones, the architect used functional and constructive solutions that avoided having to break up the space with walls.

Flexible Integration

Siggi Pfundt / Form Werkstatt | © Karin Heßmann / Artur | Munich, Germany

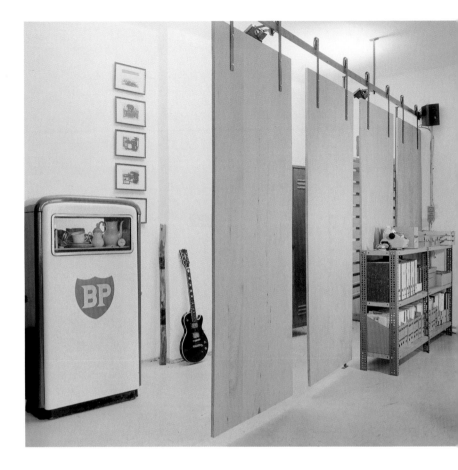

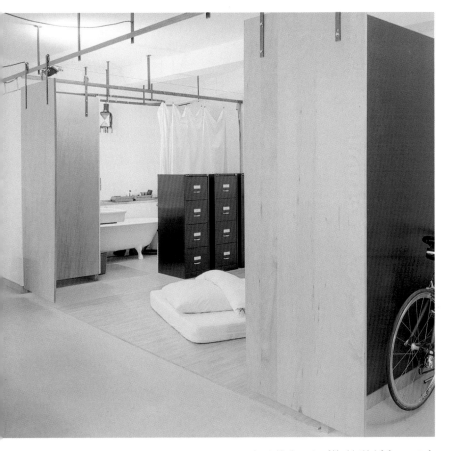

Located in the center of Munich, this loft forms part of what was previously a sewing machine factory in the city's old industrial area. The architect renovated the space as a private residence. The project had three goals: to give the space flexibility, to preserve its original character, and to employ basic, easily constructed materials and methods for the renovation.

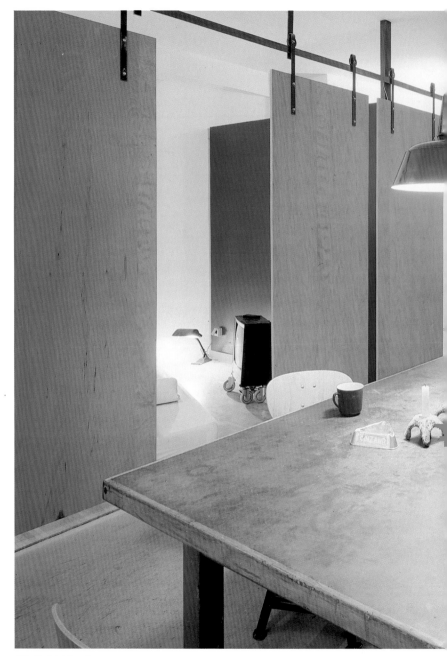

Home and Garage

A-Cero | © Alberto Peris Caminero | A Coruña, Spain

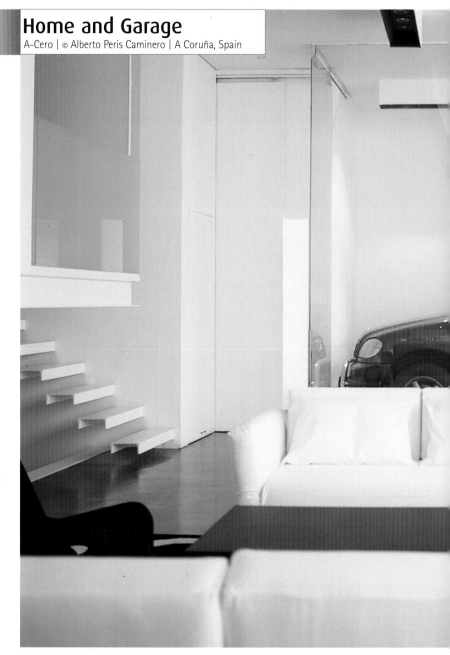

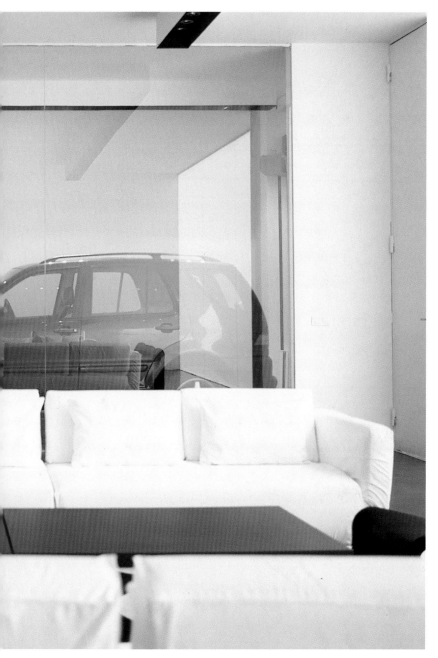

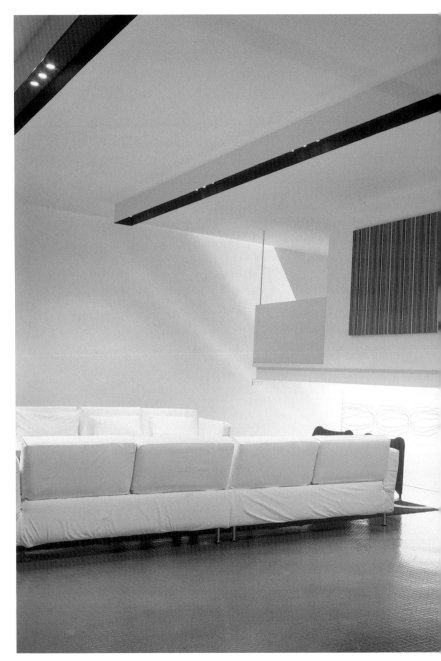

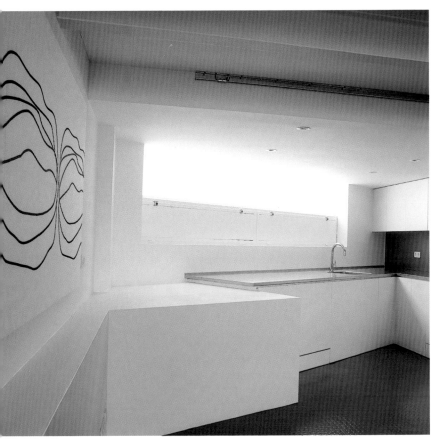

In addition to transforming an industrial space into an innovative dwelling, the purpose of this project was to explore the social significance of the automobile as a functional and aesthetic element of the home.

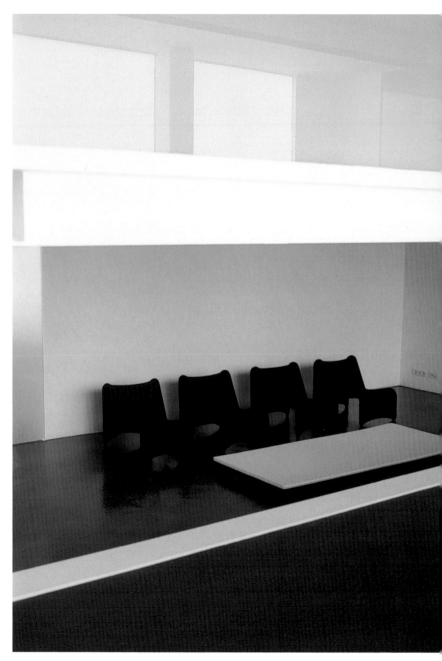

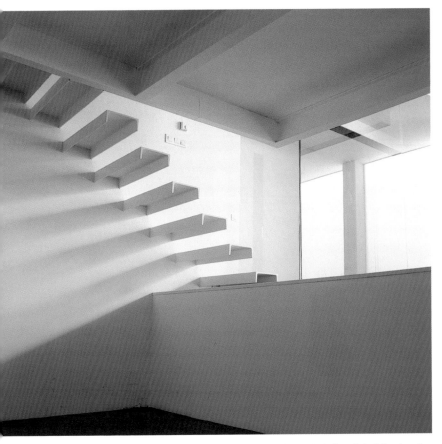

Different floor levels distribute the basic functions of this loft. The lower level contains the living and dining areas. The next level, distinguished by a taller ceiling, houses an integrated kitchen that can be closed off by a sliding opaque glass panel. The top level is accessed by a floating staircase that passes alongside a glass structure containing the main bathroom.

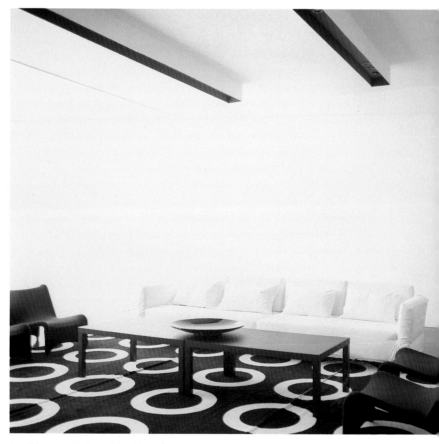

In addition to transforming an industrial space into an innovative dwelling, the purpose of this project was to explore the social significance of the automobile as a functional and aesthetic element of the home.

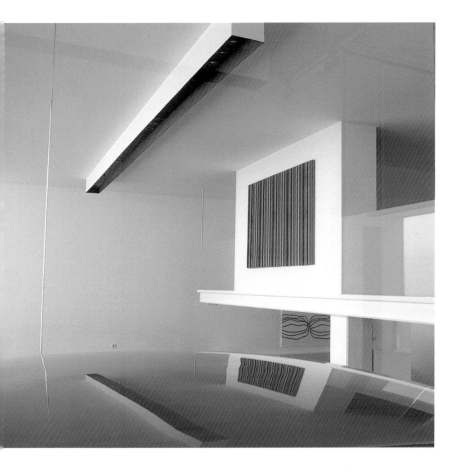

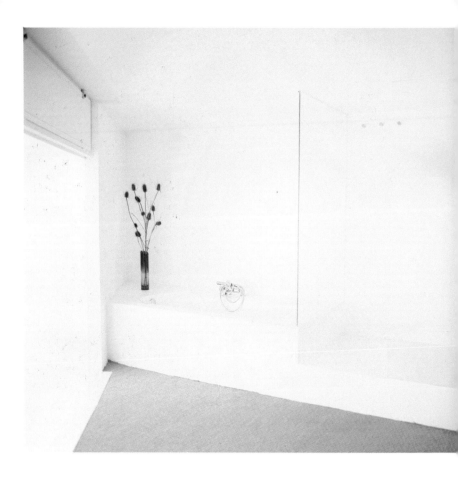

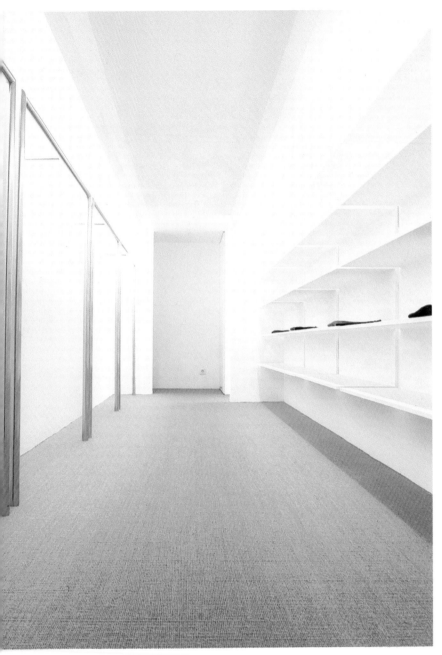

Park Avenue Loft

Ayhan Ozan Architects | © Björg Photography | New York, NY, United States

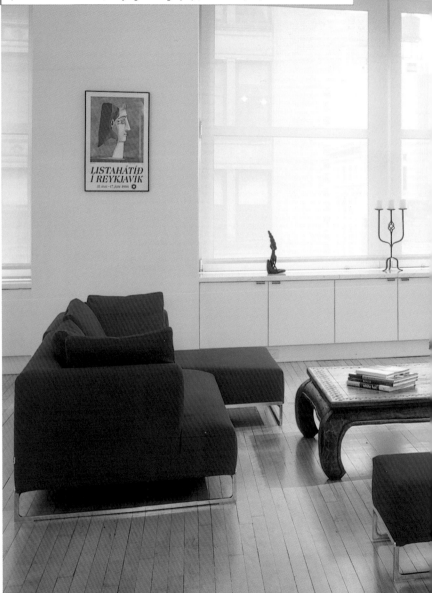

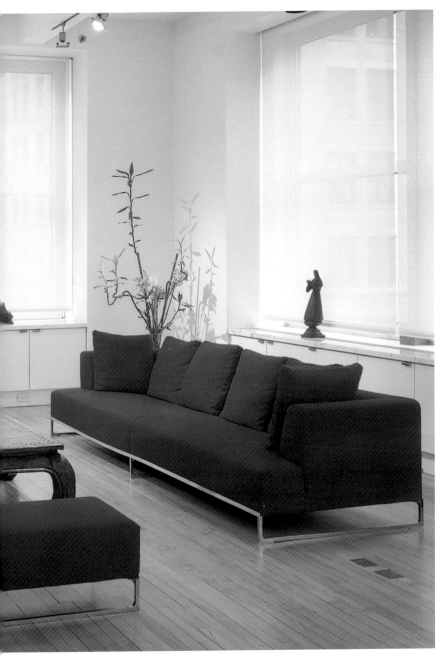

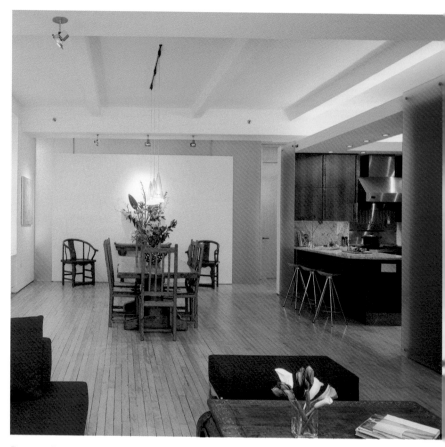

The concept for this loft was developed around an
open, sky-lit kitchen designed to enhance the feeling of
spaciousness and allow daylight to penetrate all areas
of the loft. To achieve this, no single wall reaches the
ceiling, and a select few are surrounded by glass.

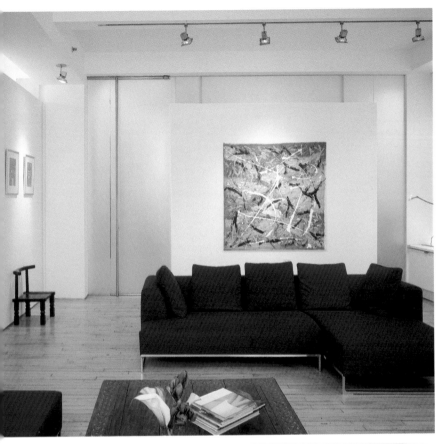

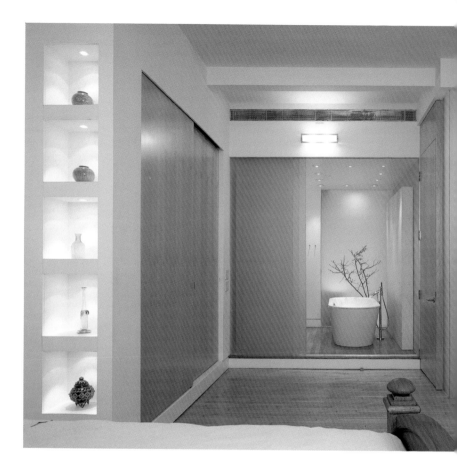

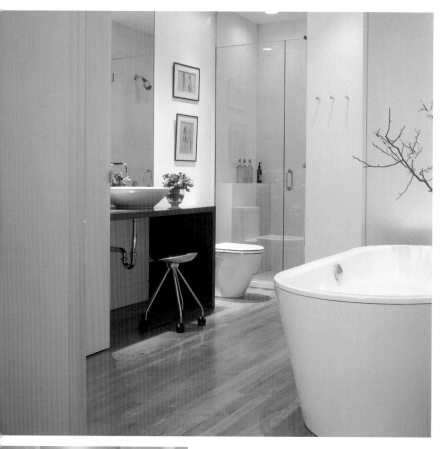

Courtyard

François Muracciole | © Morel M. Pierre / ACI Roca-Sastre | Paris, France

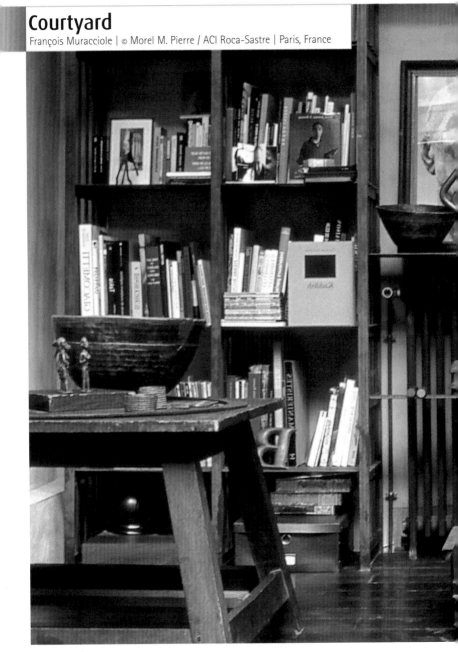

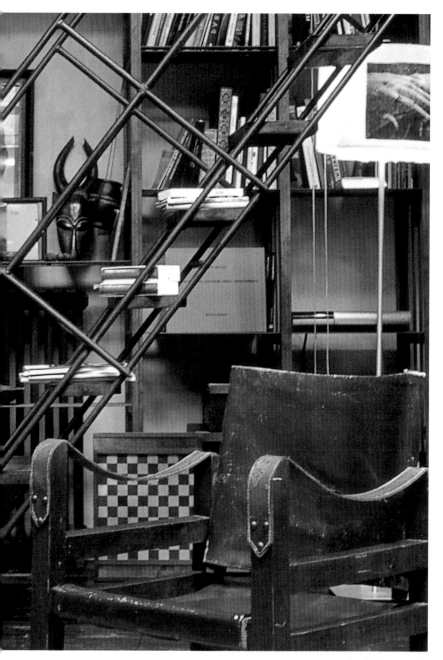

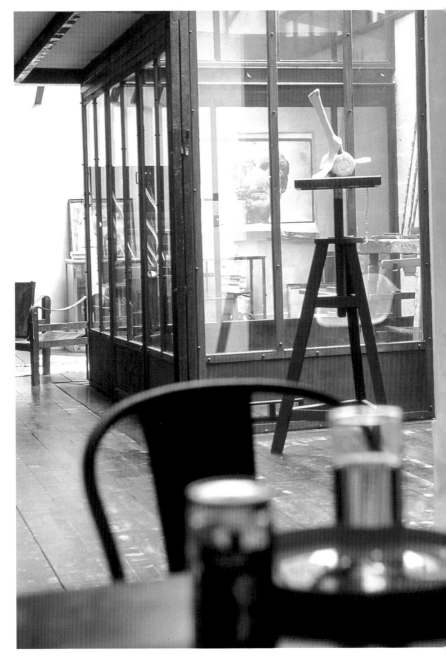

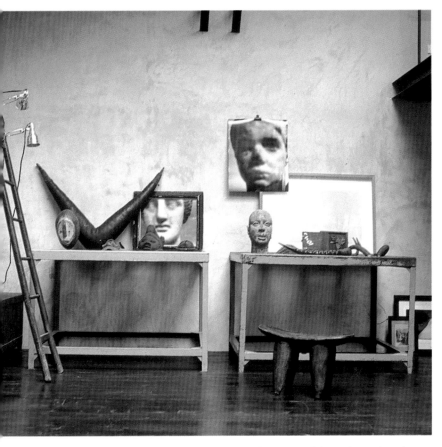

This project entailed converting a workspace into a comfortable, well-lit dwelling. The idea was to take advantage of the elements that contributed to the space's original character and alluded to the workshop that was once located there. The patio, located in the center of the space, was hidden by a plastic ceiling. By eliminating this ceiling, the sun illuminates the entire space, including the bedrooms situated in the old warehouse.

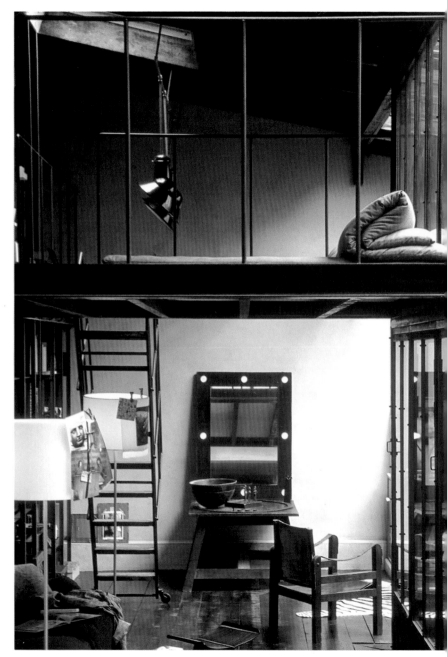

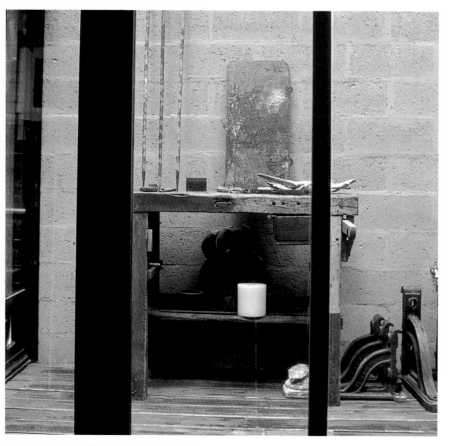

This old workshop is situated at the end of a small patio in the popular Belleville neighborhood of Paris. A young photographer and her husband commissioned the architect François Muracciole to transform the space. Since it was an old mechanical workshop, the rooms were somber, with chipping walls and industrial objects that were incorporated into the new design.

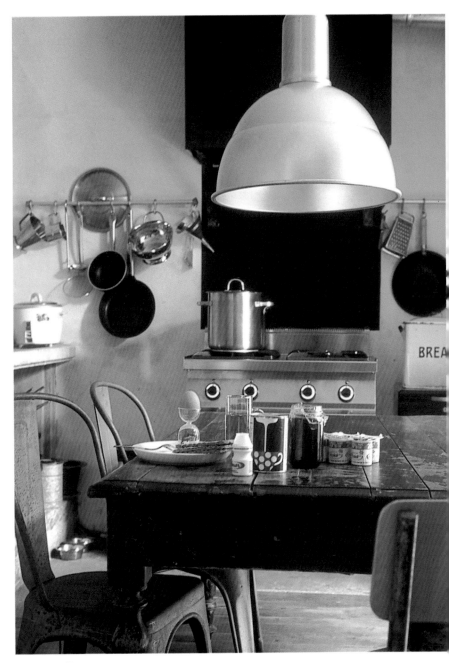

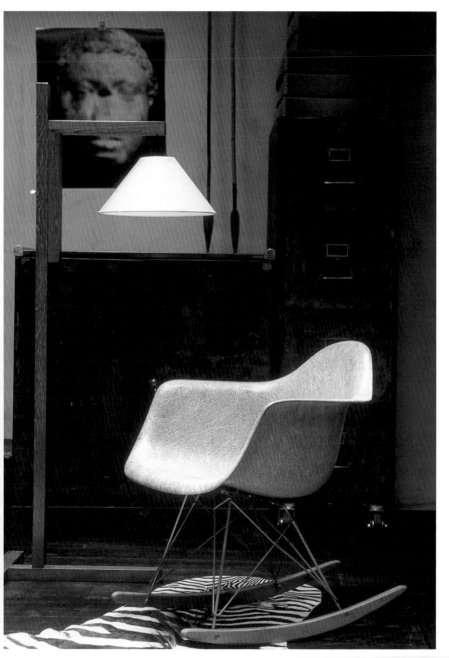

Space for Two

Guillermo Arias | © Carlos Tobón | Cartagena de Indias, Colombia

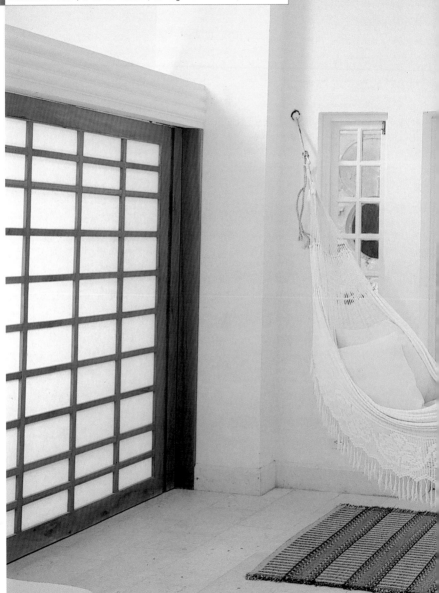

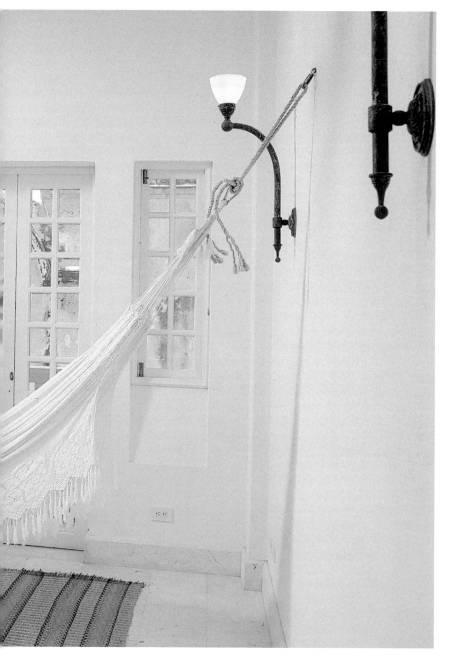

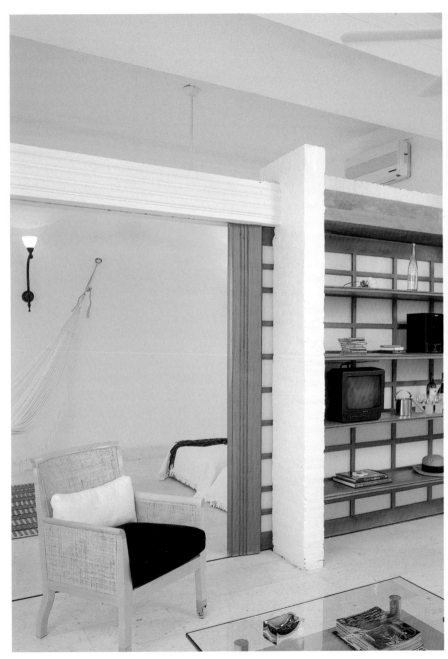

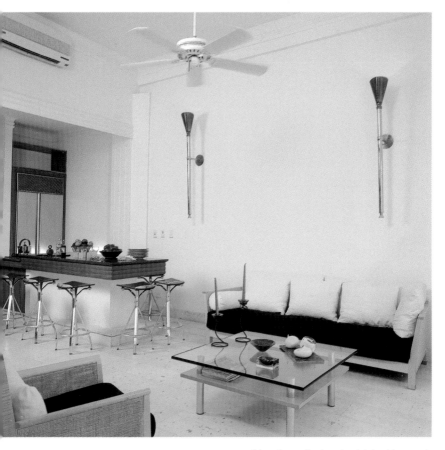

This small, recreational apartment designed for a couple occupies what were once two living rooms in an old residence in a 1930s building in Cartagena de Indias. The building is located in Santo Domingo Plaza, one of the most emblematic spaces in the city. Despite the apartment's splendid views of the plaza and the church, the interior was run-down and divided by a confusing and disorganized series of exposed beams.

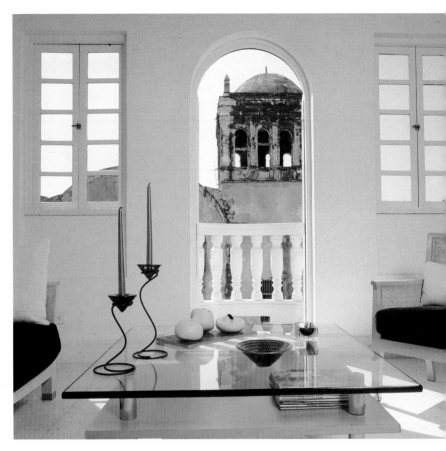

The first step was to reproduce the atmosphere that most likely existed in the original space, but with a contemporary feel. A series of large moldings define the general space, which is now uninterrupted and free of dividing walls. Various architectural elements make up the different areas and disguise the central column that forms part of the structure.

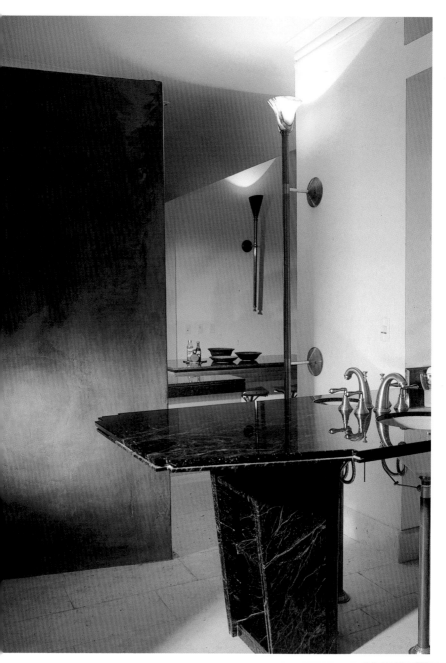

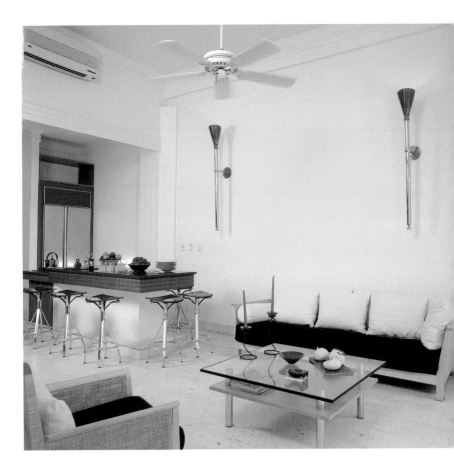

Natoma Street Loft

Jim Jennings | © Roger Casas | San Francisco, CA, United States

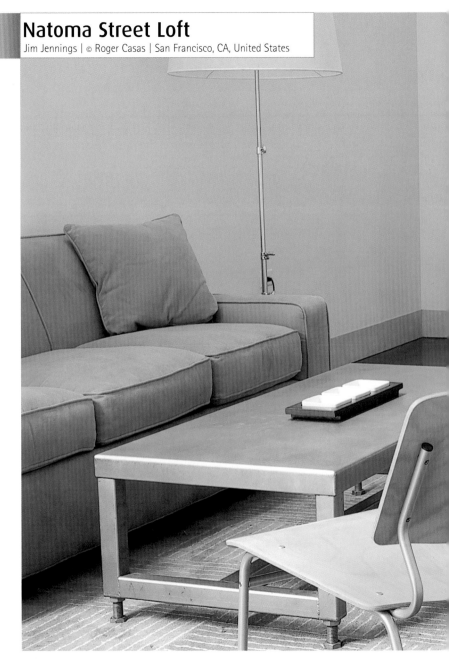

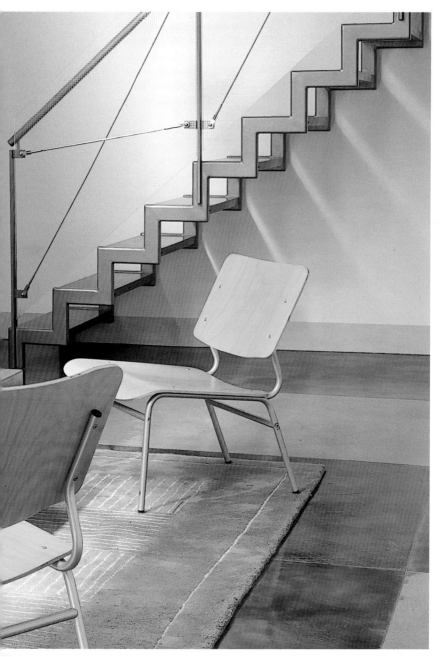

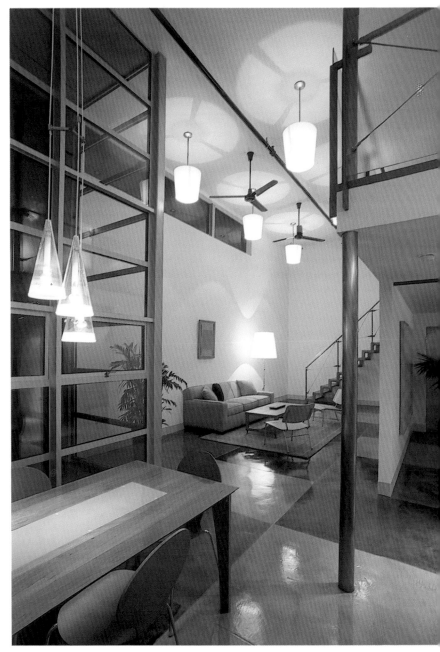

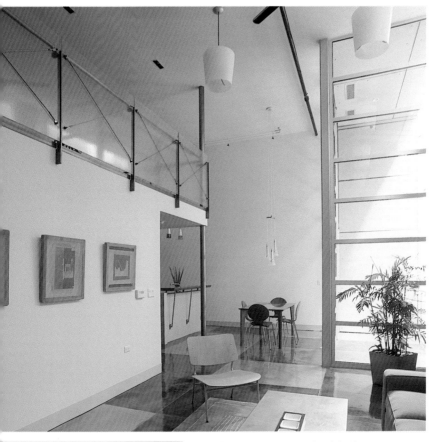

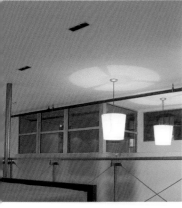

The original rectangular two-story volume led to the creation of a mezzanine level on which the bedroom is situated. A translucent glass balcony looks from the bedroom onto the living area underneath. Steel is one of the primary resources used in this project to accomplish a modern yet raw effect throughout the loft.

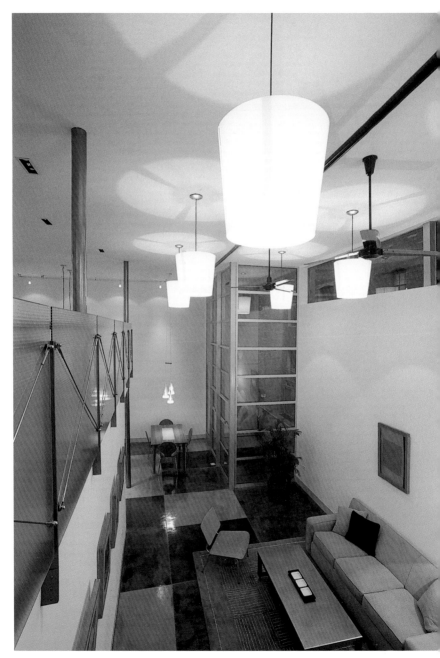

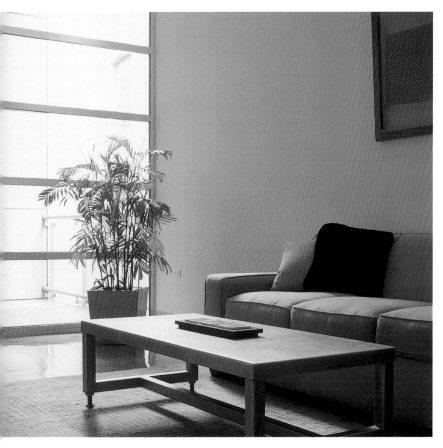

Apertures were made horizontally, in the form of
clerestory windows, and from floor to ceiling, along a
corner fashioned out of glass and steel.
The dining area faces the kitchen and is separated
by an island. The concrete floors and radiant heat
provide an efficient means of living comfortably within
this two-story space.

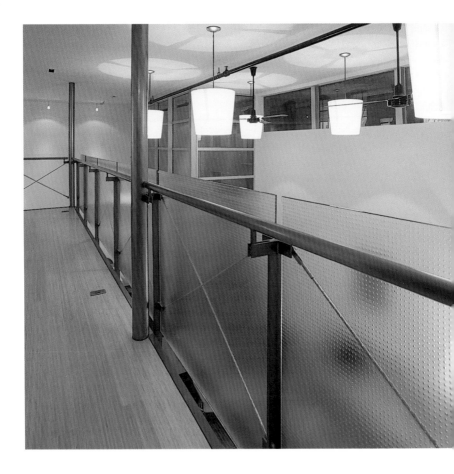

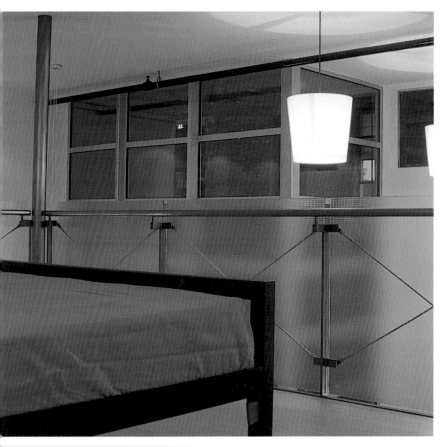

Loft in A Coruña

A-Cero | © Juan Rodríguez | A Coruña, Spain

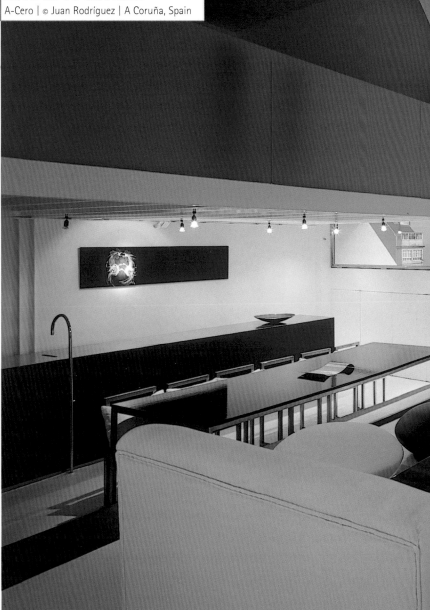

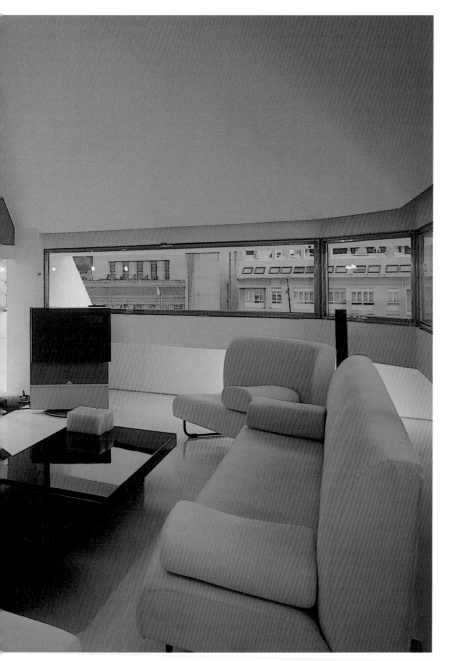

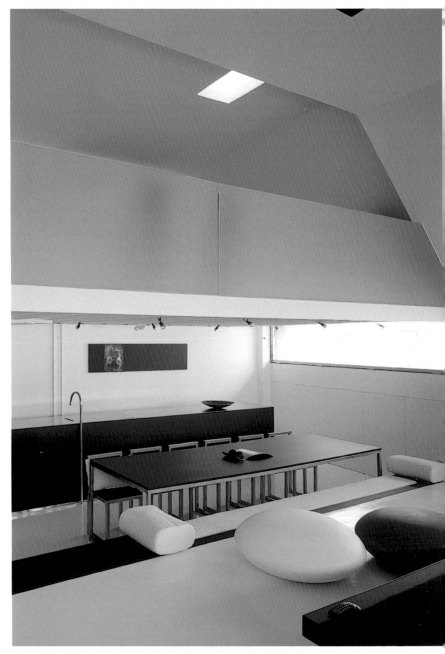

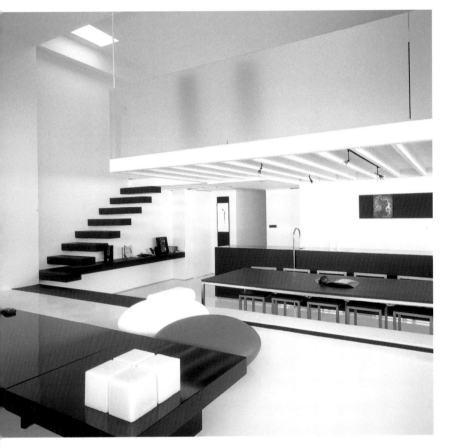

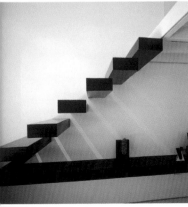

The existing mezzanine was preserved and modified slightly around the staircase, while elements were removed from the hall to provide a greater sense of space in the entrance. The column that previously supported the mezzanine was replaced by a tension rod to relieve the perception of heaviness. The public areas and domestic functions are divided by small differences in levels and materials along the floor and ceiling.

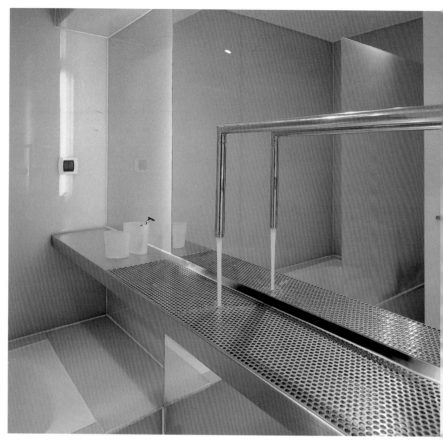

Stairs recessed in the wall lead to an upper level that
houses the bedroom, bathroom, and dressing room.
A translucent glass balcony subtly divides the two
levels and provides privacy for the private areas.

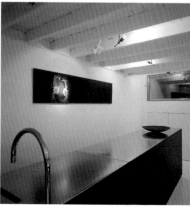

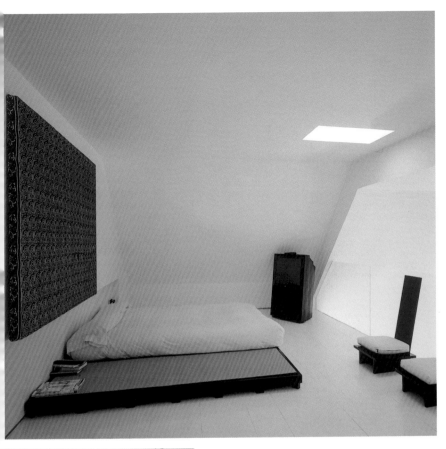

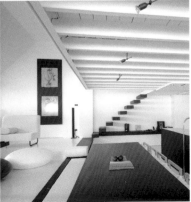

Horizontal Unit

Stephen Quinn & Elise Ovanessoff | © Jordi Miralles | London, United Kingdom

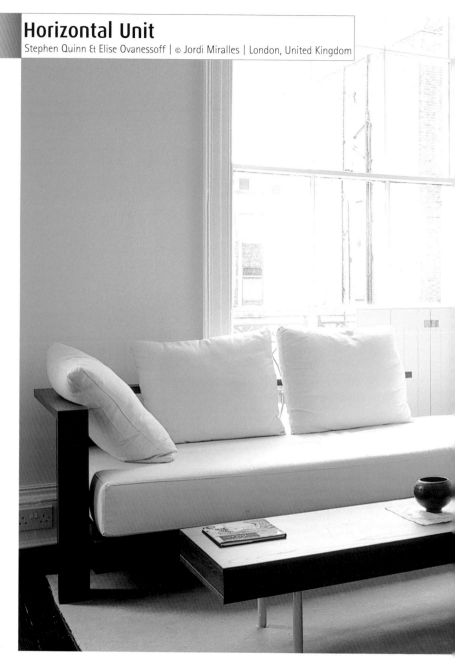

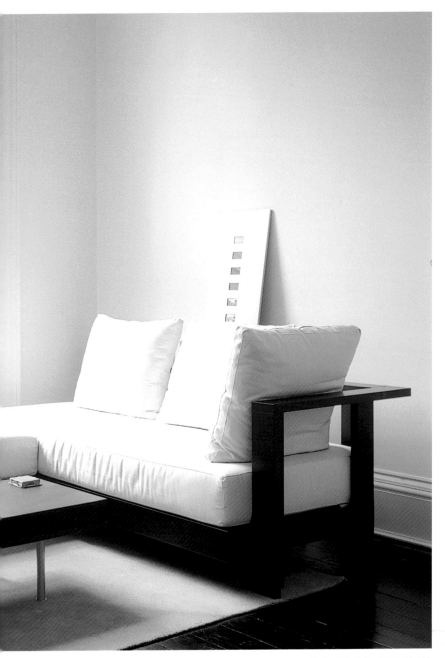

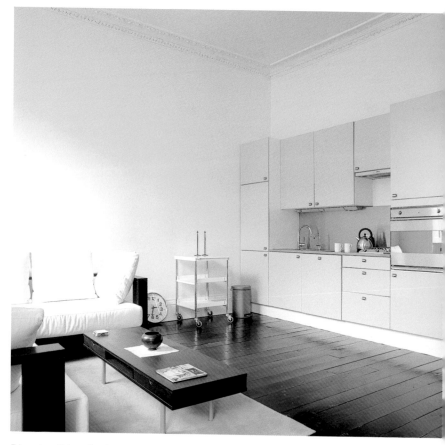

This apartment is located on the first floor of a typical four-story Georgian house in the neighborhood of Marylebone in central London. This project entailed remodeling the first floor, which was originally a reception area. Previous renovations were of poor quality, so the architects decided to recreate the original space and adapt it to a new, more efficient use.

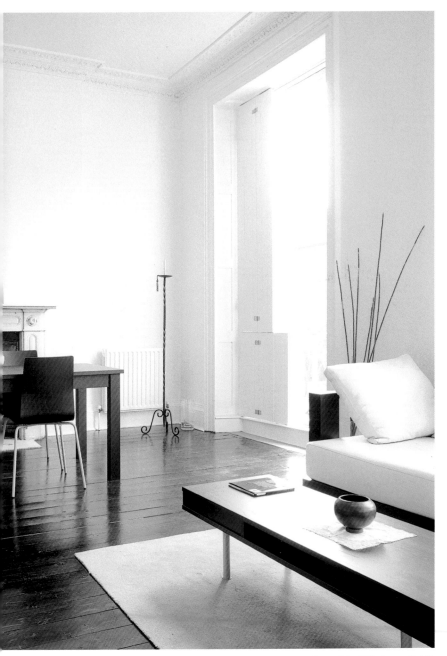

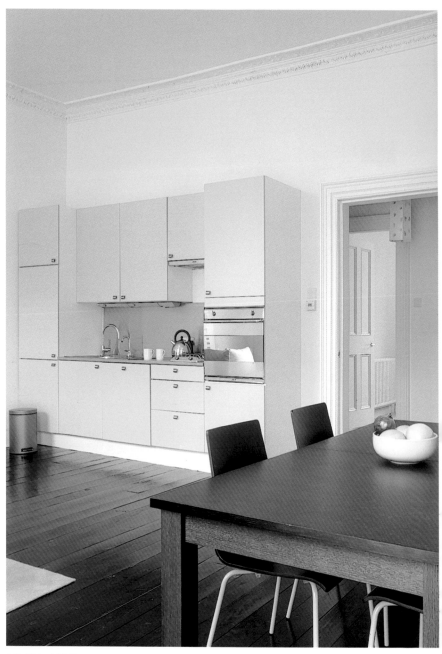

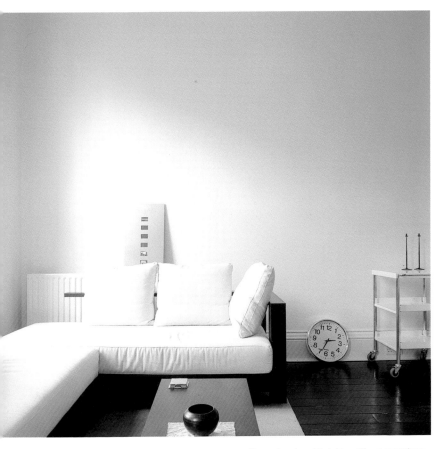

The apartment consisted of two different atmospheres connected by steps. The architects first restored the large room at the front to its former size and then moved the kitchen to a more convenient location.

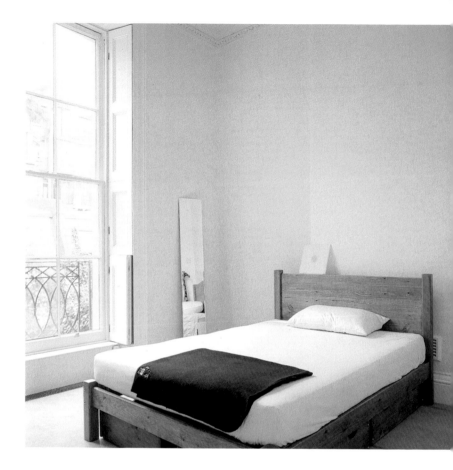

The bedroom is located in the back and leads to a walk-in closet with a sliding door painted with green and blue stripes.

Two Atmospheres and One Box

Mónica Pla | © José Luis Hausmann | Barcelona, Spain

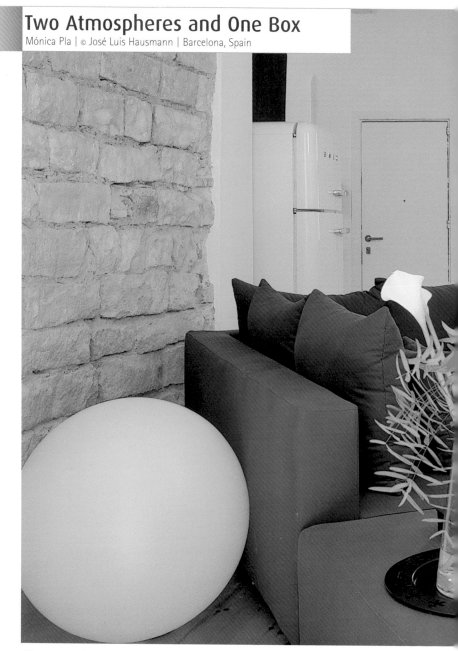

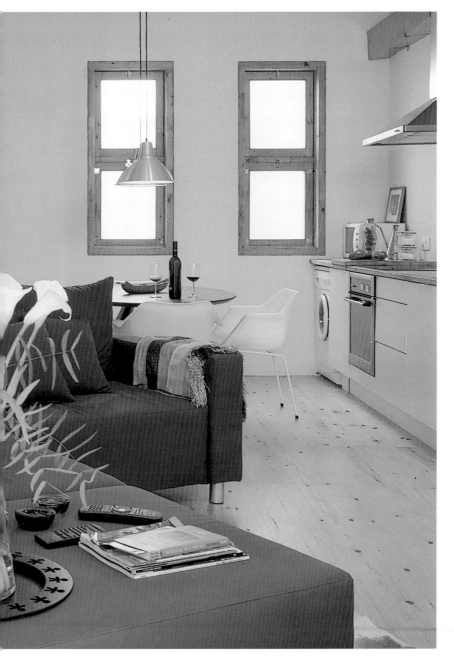

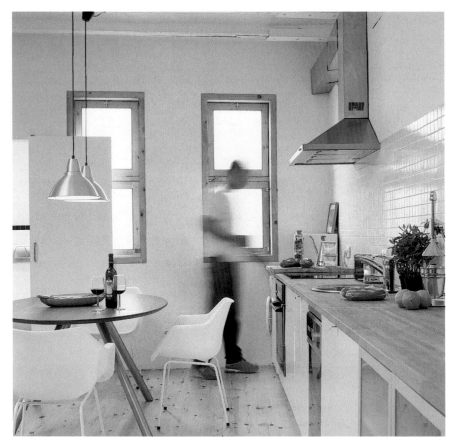

Before it was renovated, this old apartment, located in
Barcelona's Ciutat Vella quarter, featured many rooms
and little natural light. The deteriorated and neglected
space was transformed with the goal of creating a
luminous and spacious residence in just one environment.

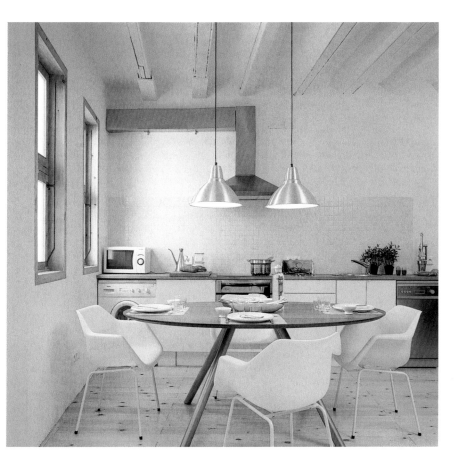

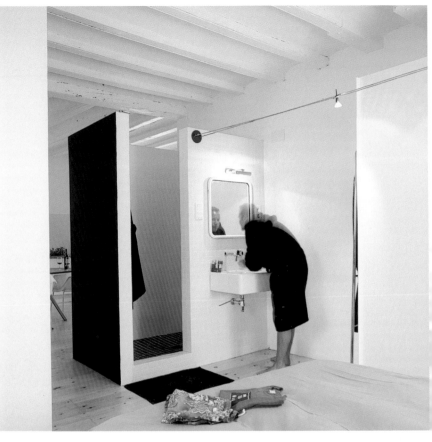

The first step was to tear down various walls and to open up—frame permitting—a variety of windows so that natural light could flow in. Even though there were no walls to separate the space, the designer managed to provide intimacy in the bedroom and to differentiate between the kitchen and the living area.

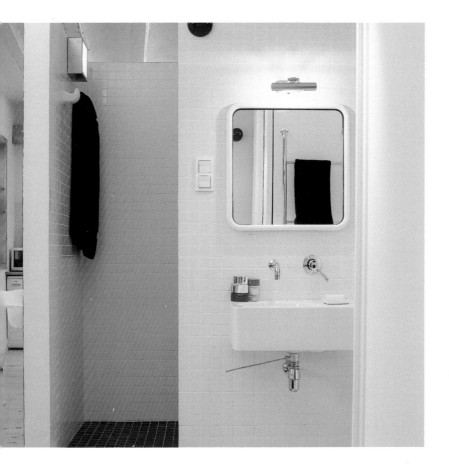

Loft within a Loft

Studio A | © Andrea Martiradonna | Milan, Italy

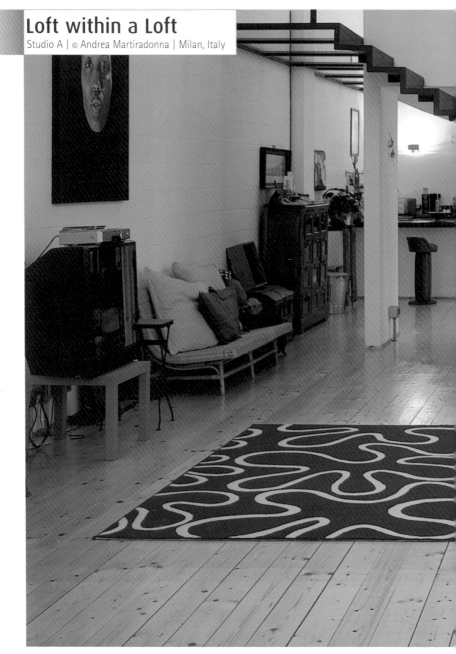

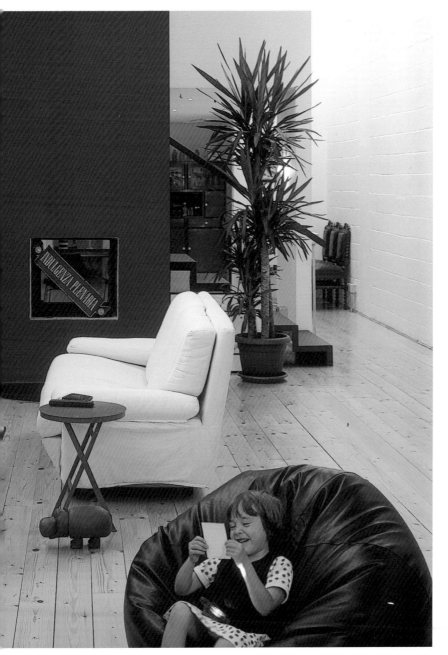

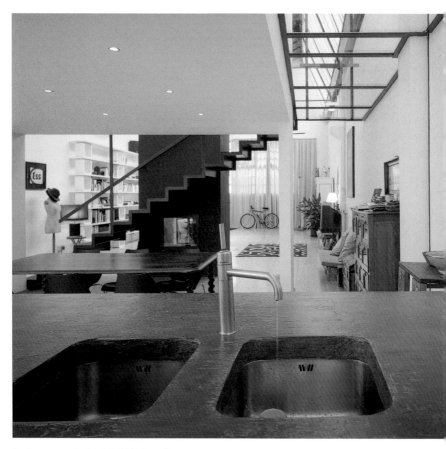

In what was once the site of the Schlumberger factory, this attic space was rehabilitated into a living space for a young professional. A chimney that pierces the ceiling delineates the kitchen and dining areas, which rest underneath a lowered ceiling that stops short of either side to let light from the skylight pass through.

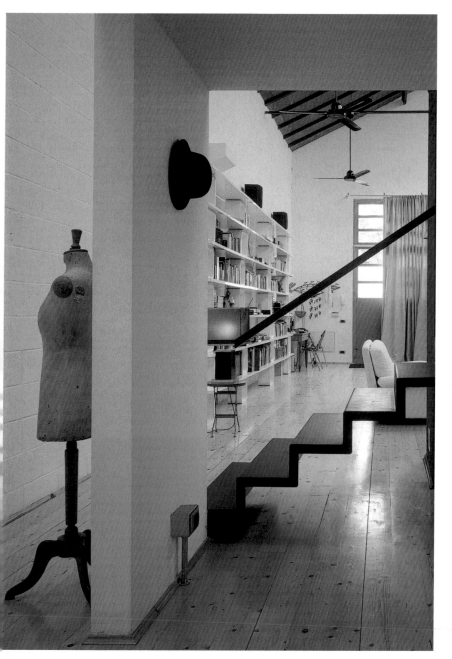

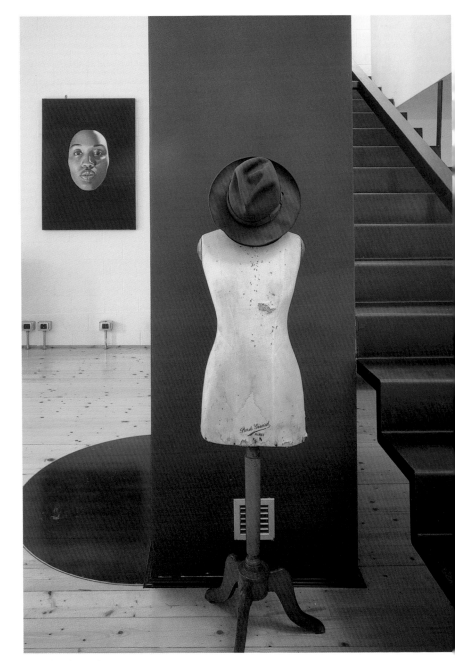

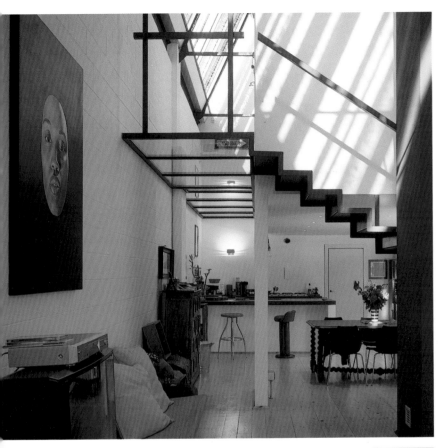

The rectangular space has a 23-foot-high ceiling. The entrance is located at one extreme, and though there is only one façade, the loft receives abundant light from a pitched glass ceiling. The vertical void above the kitchen is intersected by a glass panel that serves as a walkway on the upper level of the attic.

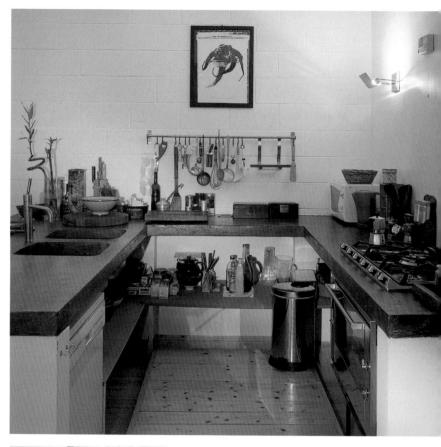

466 Loft within a Loft

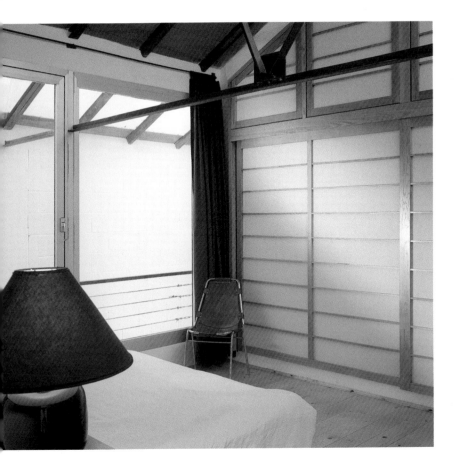

Windmill Street

Guillaume Dreyfuss | © David Pisani and Kurt Arrigo | Valletta, Malta

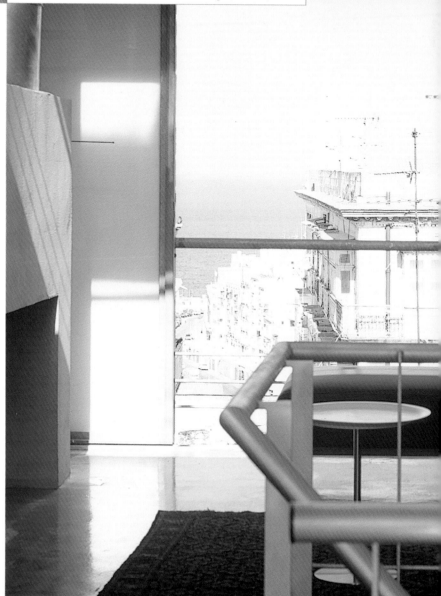

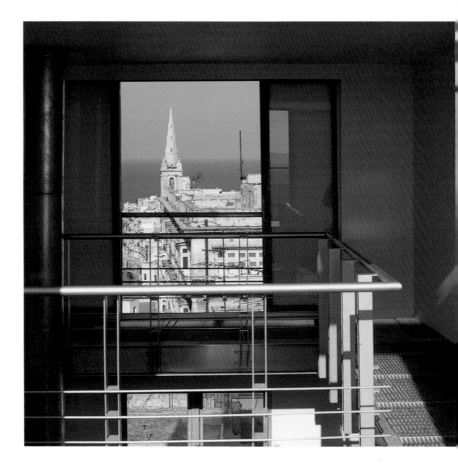

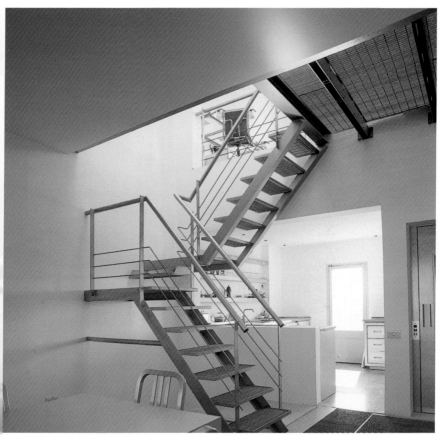

The public zones are paved in a monolithic, self-leveling concrete and resin floor, and are characterized by the steel and expanded metal stairs and landings that divide the floor horizontally into two areas.

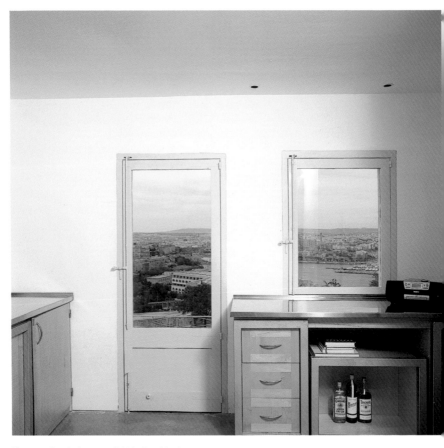

The more private bedroom area is laid with solid and resilient materials like gray terrazo. A floor-to-ceiling closet and mosaic tile surface delineates the master bathroom.

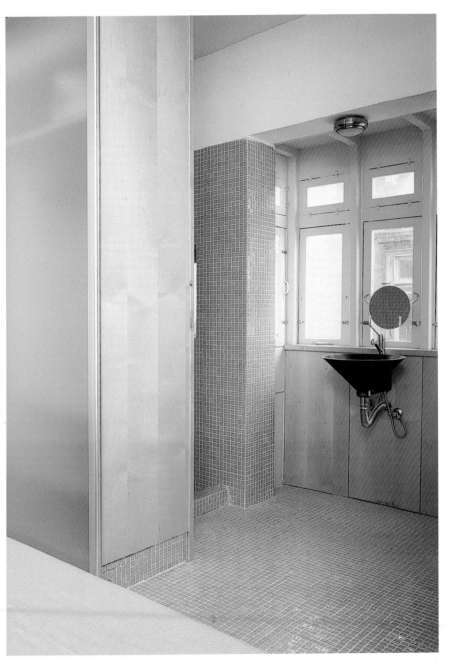

Structural Loft

Attilio Stocchi | © Andrea Martiradonna | Bergamo, Italy

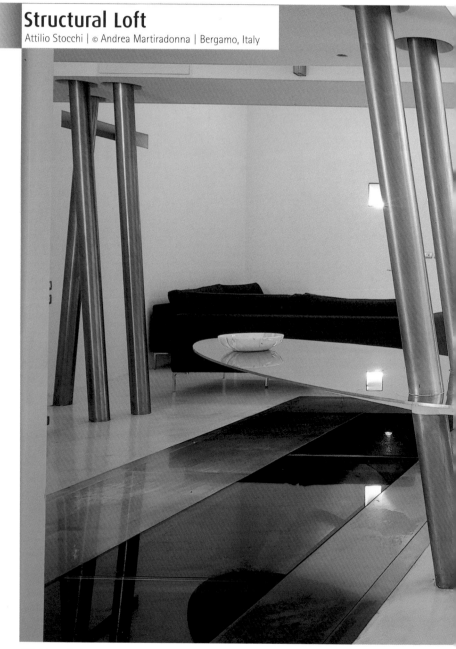

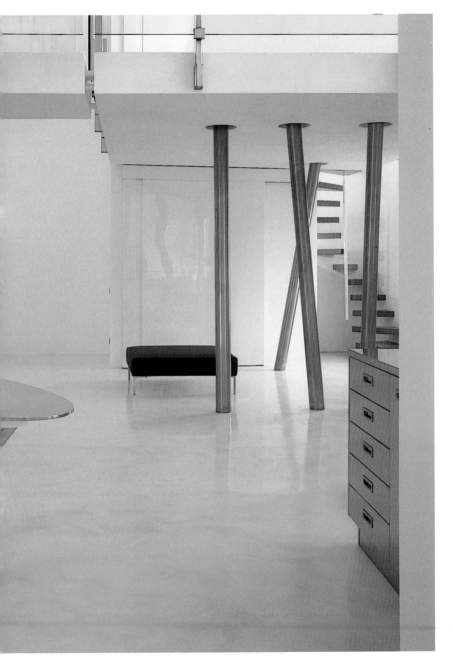

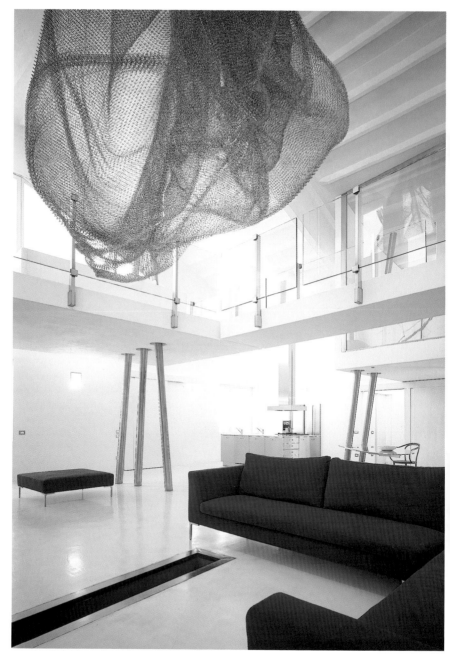

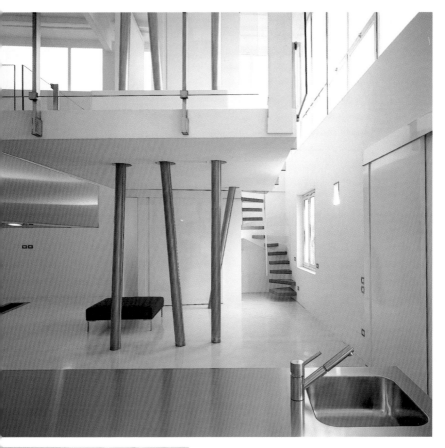

The architect decided to take advantage of the extraordinary height of the ceilings in this space by incorporating an additional level. The public zone was allocated to the lower level, while the private zones were lifted onto the upper structures. Two slanted posts puncture an oval glass dining table and continue through a suspended structure that contains a bathroom.

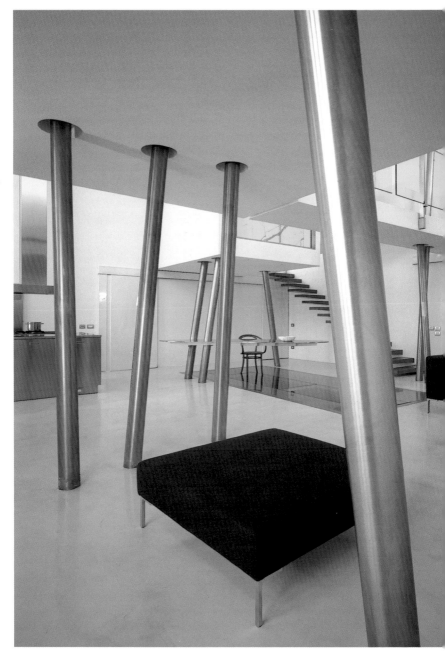

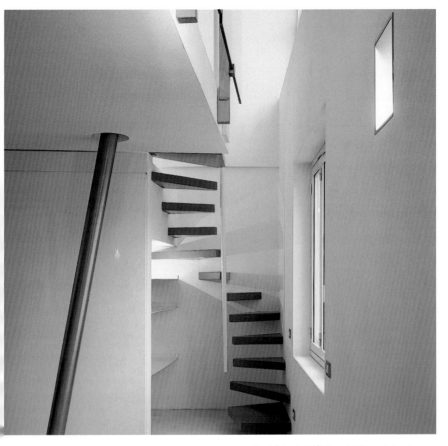

The loft is articulated through thirteen steel posts distributed in asymmetrical clusters around the space. These posts support the horizontal planes system to create the sensation of instability, piercing through what comes in their way in an arbitrary manner.

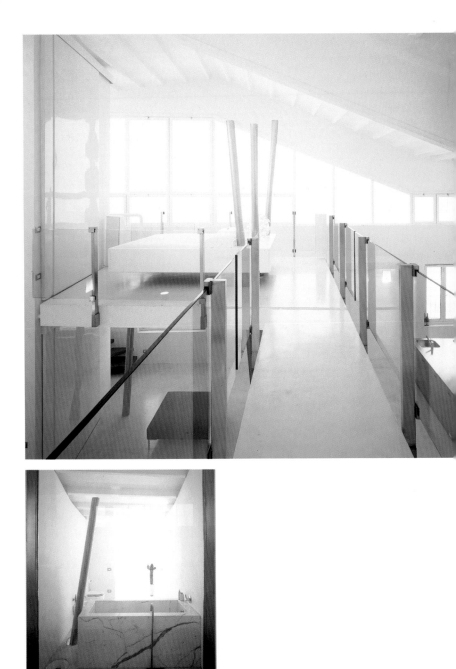

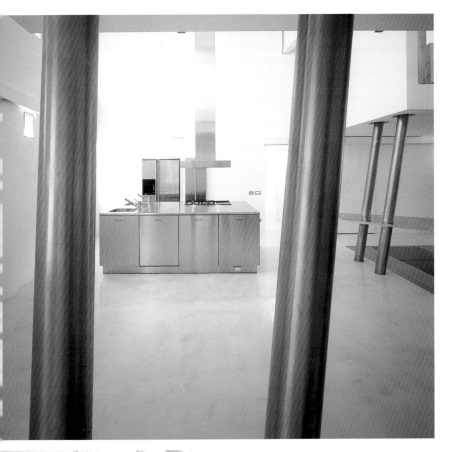

Home and Atelier

Luis Benedit | © Virginia del Guidice | Buenos Aires, Argentina

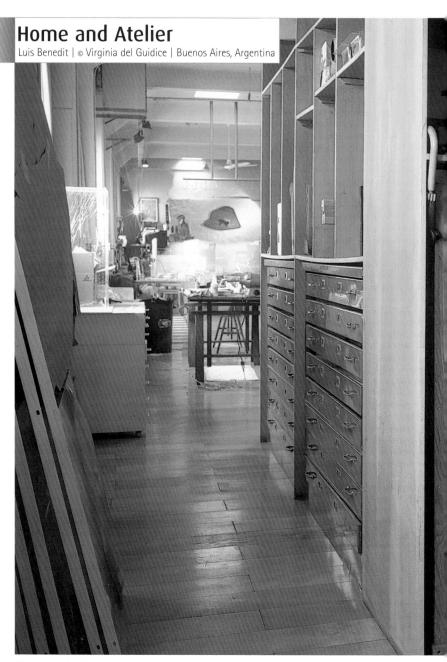

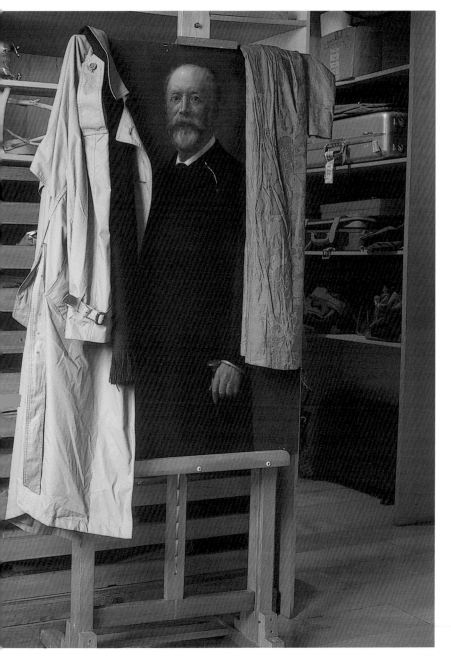

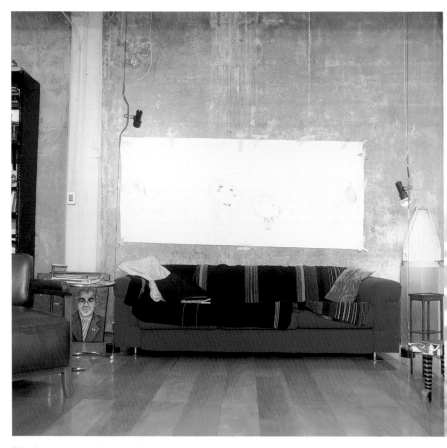

This loft was previously a bakery shop that was part of
an old market. It belongs to Luis Benedit, a well-known
artist and architect who has exhibited his work in New
York's Museum of Modern Art and the Contemporary
Art Museum in Sydney, Australia. He decided to buy the
1,830-square-foot space and transform it into his own
living and working space.

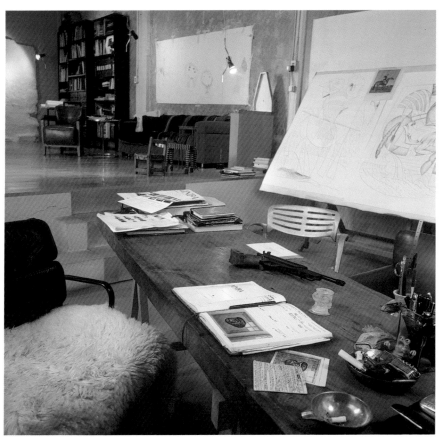

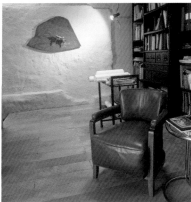

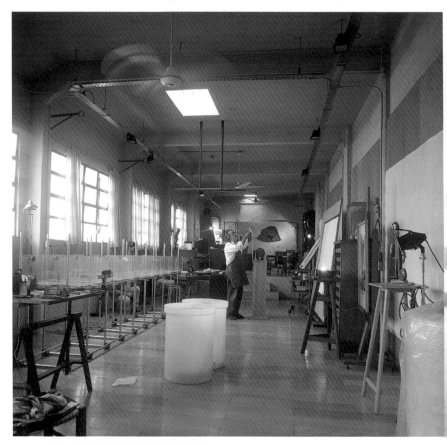

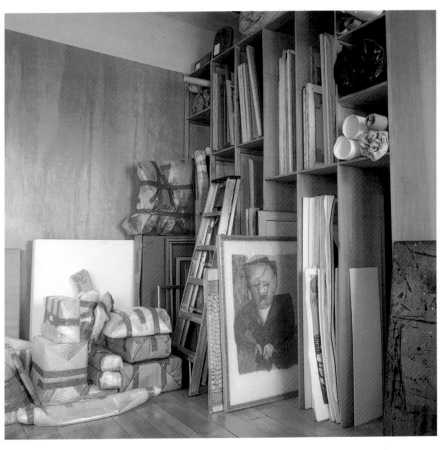

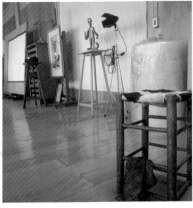

To create a more homely atmosphere, the owner coated the walls with panels of Guatambú wood. He also introduced a quartz lighting system along the industrial ceiling grill.

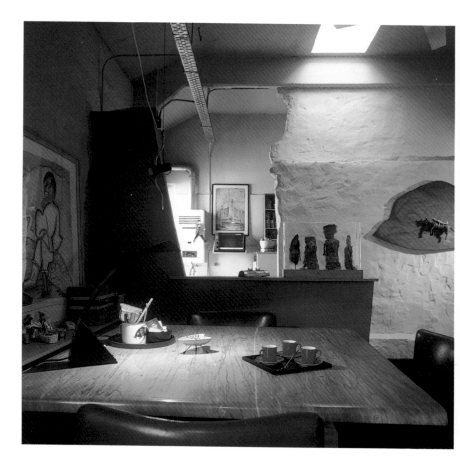

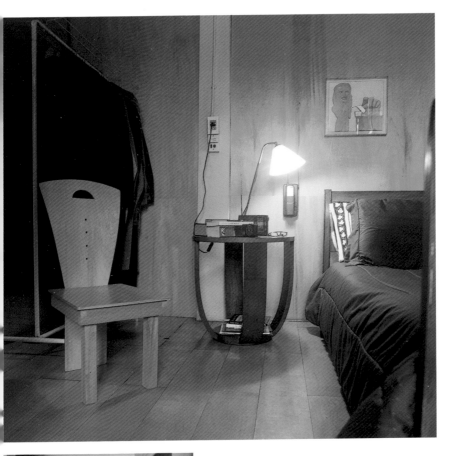

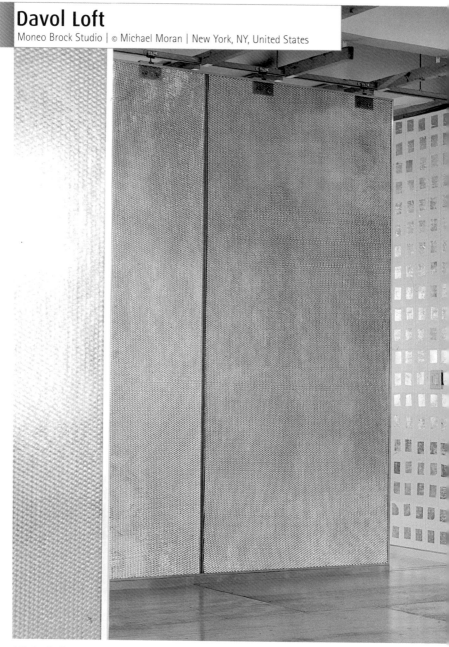

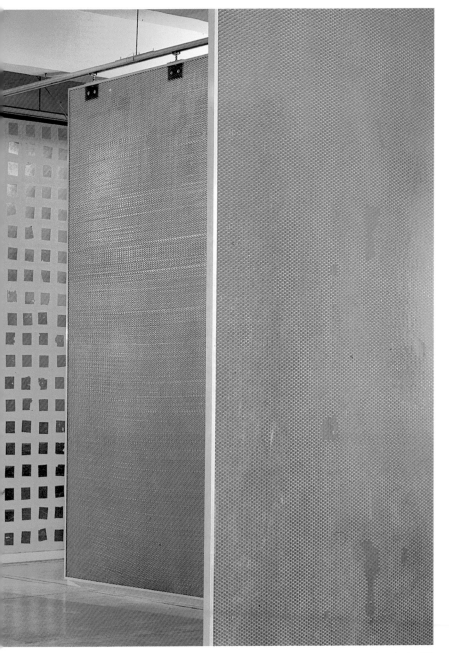

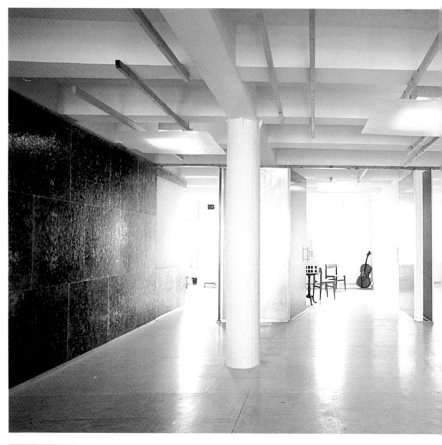

This project began with an empty rectangular box with the typical characteristics of a loft (columns down the center, enormous windows, and a ceiling more than ten feet high) in a former industrial warehouse.

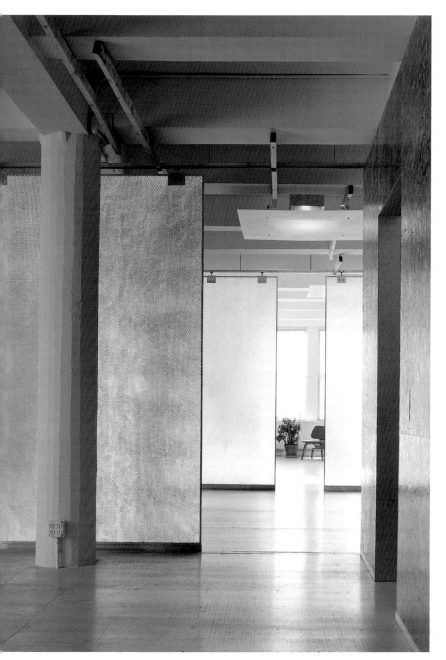

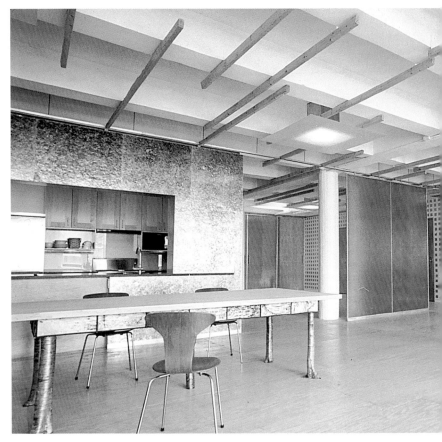

The architects placed the service areas against the windowless north and south walls. They avoided total visual separation of these rooms from the rest of the loft, treating them like modules inserted into the container. The walls of the rooms do not reach the ceiling and iridescent materials are used, creating magnificent reflective patterns that accentuate the lightness of the components.

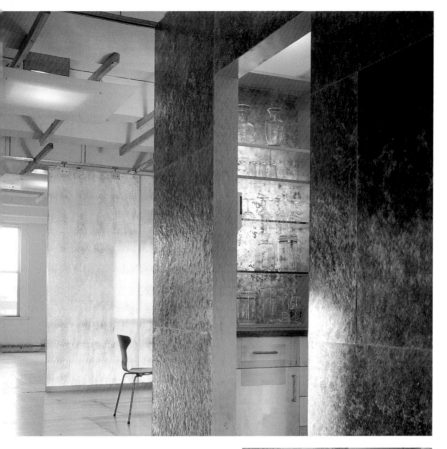

Conversion of an Old Factory

Child Graddon Lewis | © Jonathan Moore | London, United Kingdom

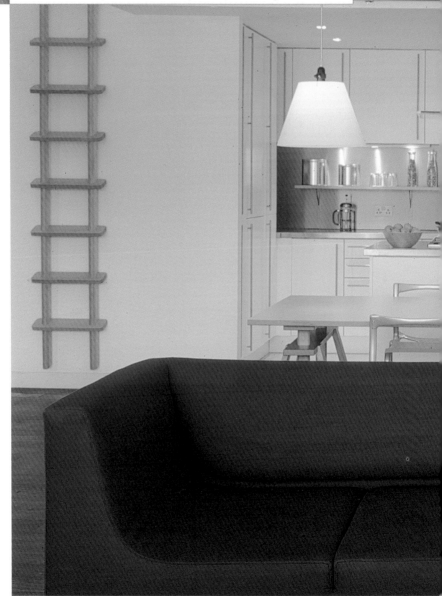

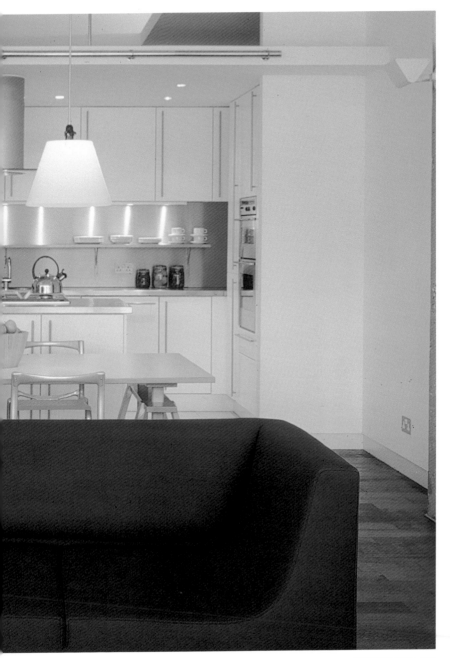

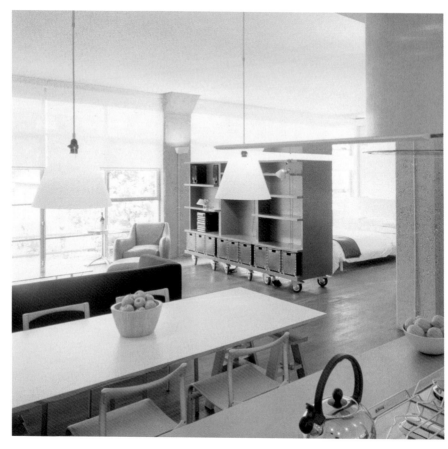

In these apartments, the installations were centralized, leaving the rest of the area free for rooms that do not need running water, such as the bedrooms, the living room, and the studio. The electrical installations were left uncovered to facilitate the arrangement of the plugs and switches.

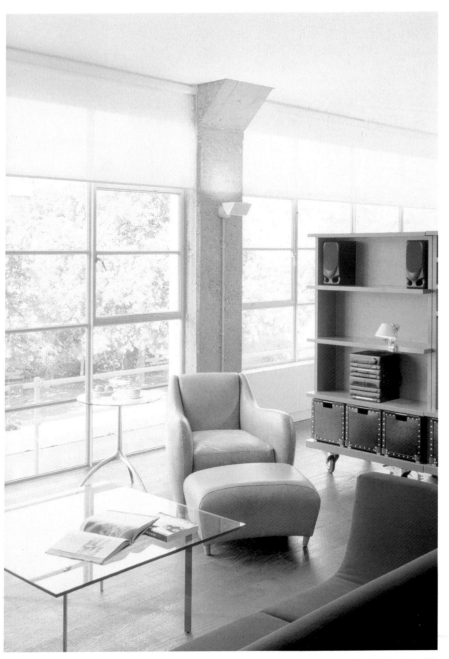

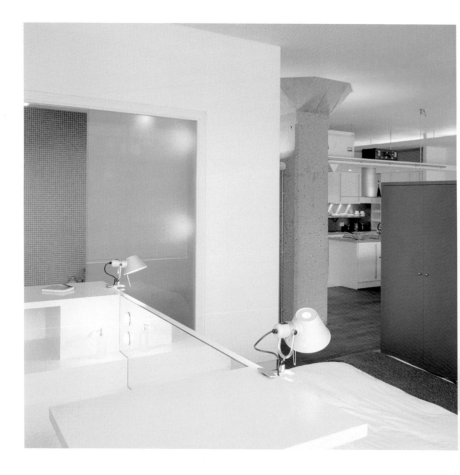

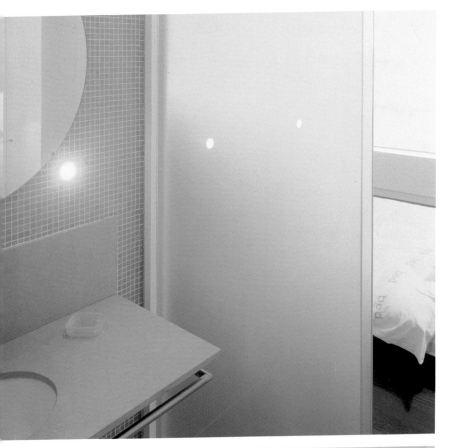

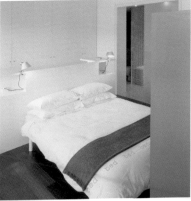

Home and Studio

Helena Mateu Pomar | © Jordi Miralles | Barcelona, Spain

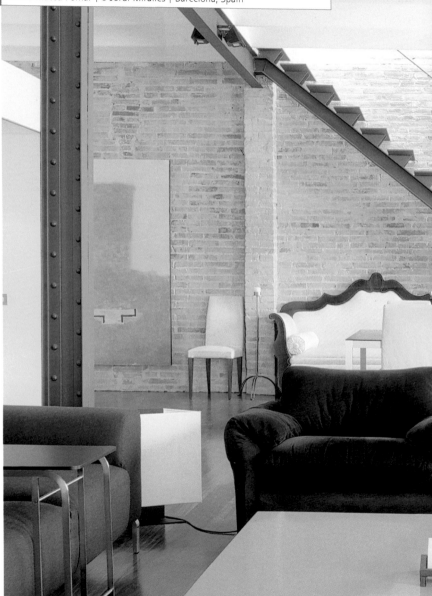

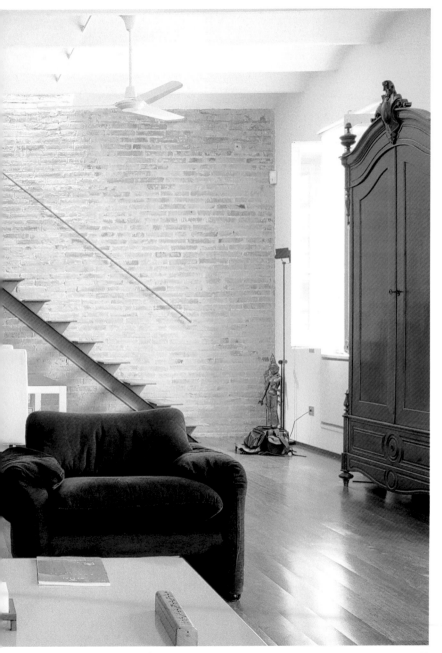

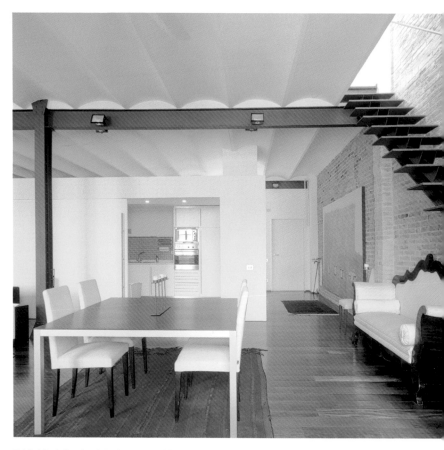

This building in Barcelona's Gracia area was originally a factory specializing in electrical material. The loft occupies the building's top floor, a privileged space since it enjoys private and direct access to the rooftop terrace.

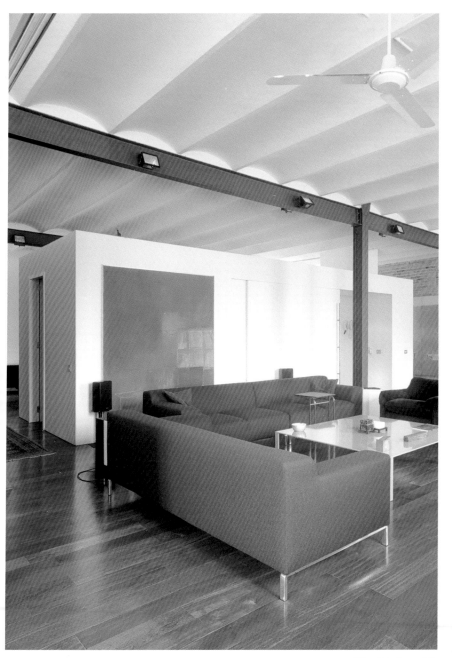

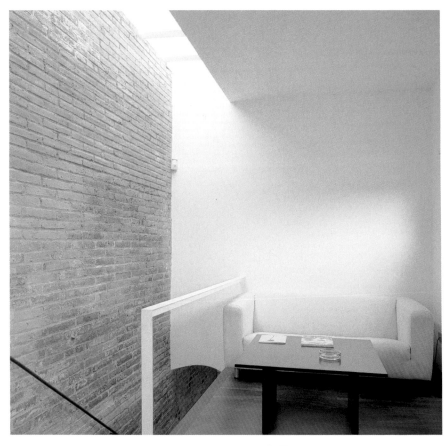

It was important to assure closure of most private
rooms and the storage spaces in order to keep them
independent of the other rooms while maintaining
spatial continuity. Independent boxes were designed to
contain the baths, the kitchen, and the cupboards. The
living room, the office, and the bedrooms surround the
boxes. This keeps the natural light flowing into the
dwelling's main spaces and allows it to filter into the
floor plan's most inner zones.

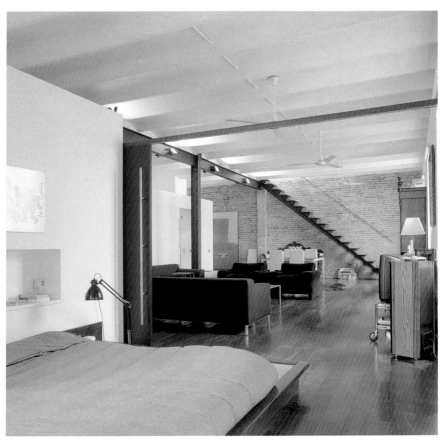

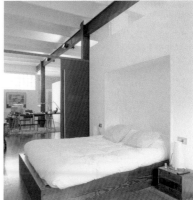

Ocean Drive

DD Allen | © Pep Escoda | Miami, FL, United States

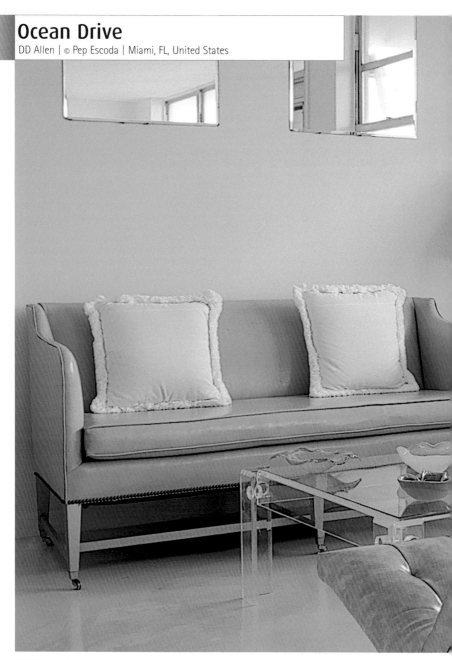

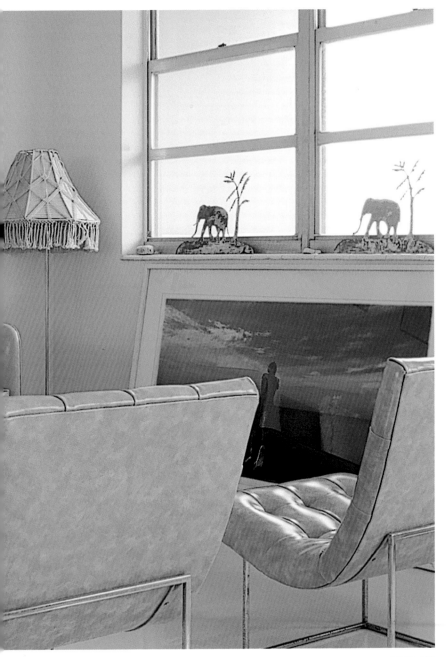

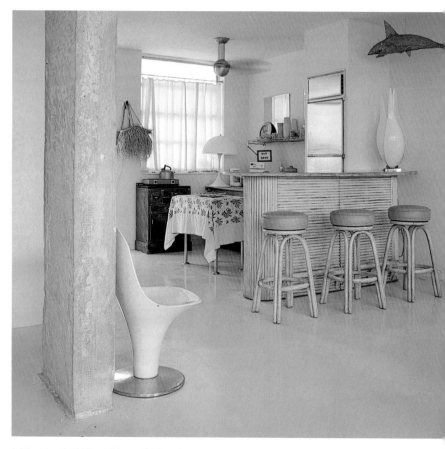

In this project, the dividing wall that previously marked off the bedroom was removed, and only the reinforced concrete column was left exposed, acting as a sculptural element in the loft. The bed, fully integrated with the rest of the space, sits on top of a platform shaped like a grand piano, and has direct views of the ocean. The column and the platform are the visual dividers between public and private space.

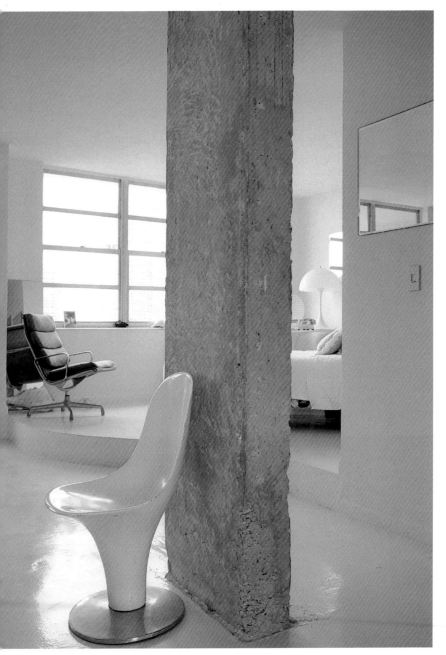

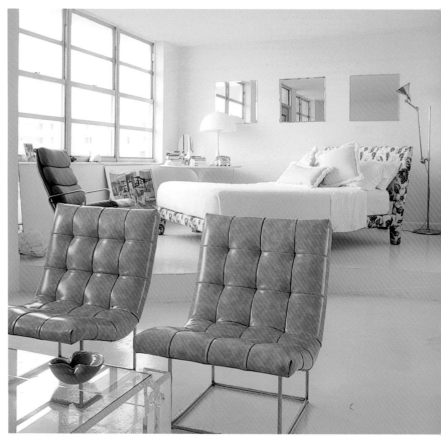

Designed for short stays, the kitchen was reduced to a
stovetop, built-in refrigerator and a bar that doubles as
an eating table. A minimal number of elements and a
light color palette create a peaceful and fresh
atmosphere.

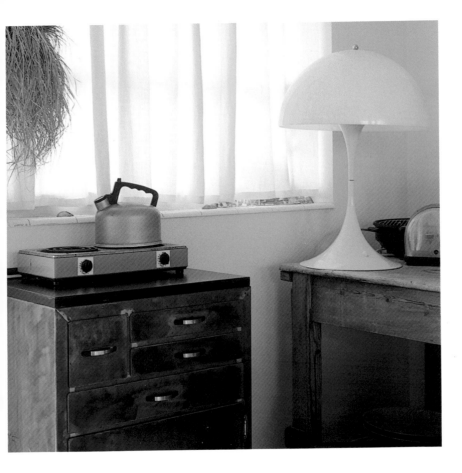

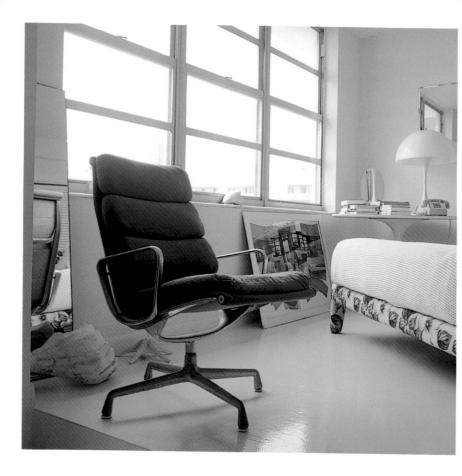

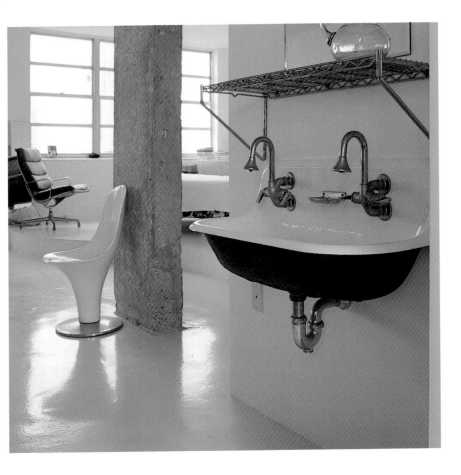

Orange and White

Pablo Chiaporri | © Virginia del Guidice | Buenos Aires, Argentina

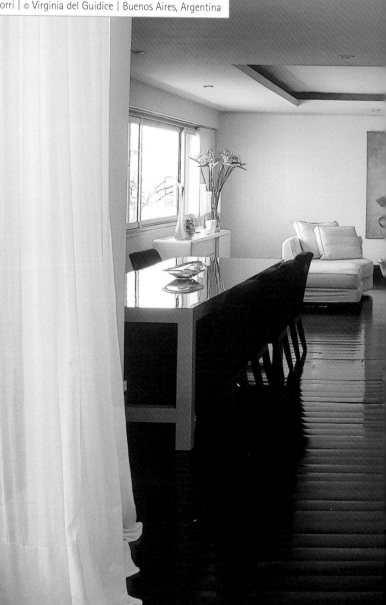

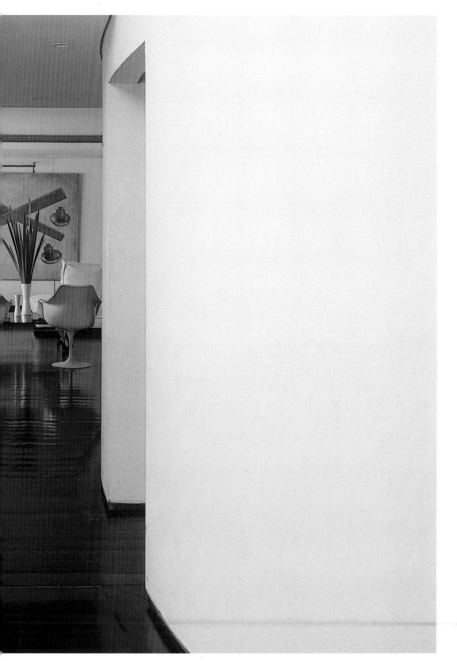

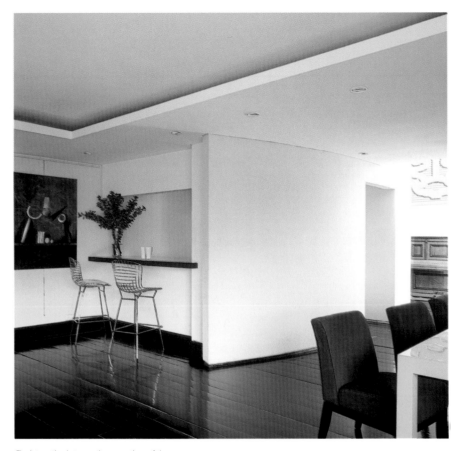

The interaction between the proportions of the
horizontal spaces and the vertical voids, as well as the
amount of natural light that fills the space, are the
main resources that were used to generate the
individual areas of the loft. Dark woods, natural stone,
steel, and translucent fabrics in different textures are
the most prominent materials.

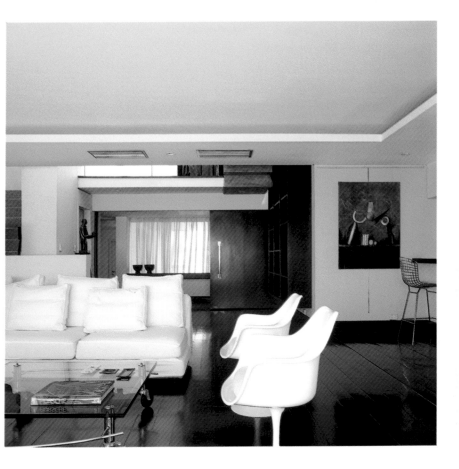

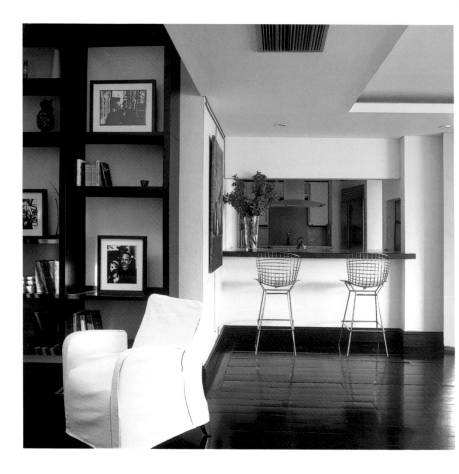

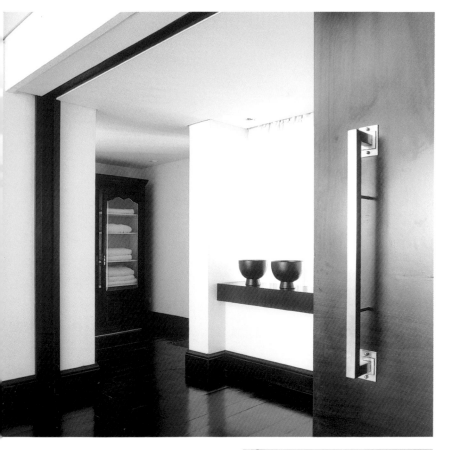

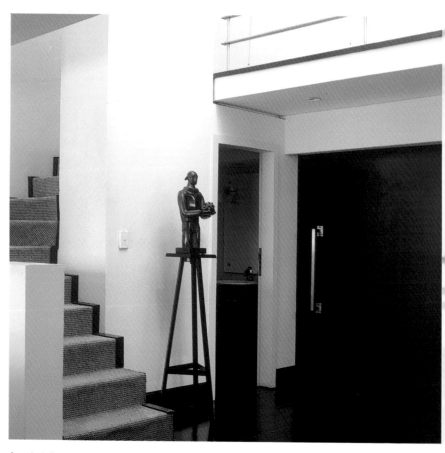

Comprised of comfortable furniture and bright tones of
white and orange, the living area leads to the upper
level, which contains the bedroom suite.

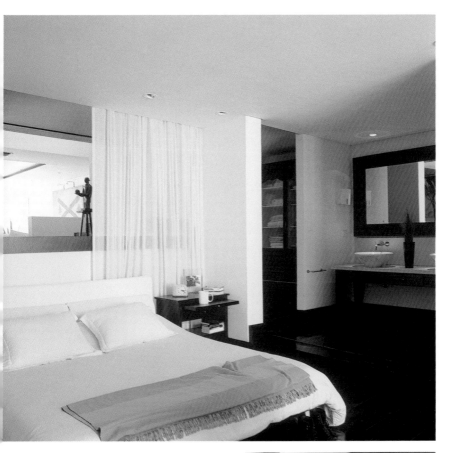

Everything in a Cabinet

Guillaume Terver and Fabienne Couvert | © Vincent Leroux / ACI Roca-Sastre | Paris, France

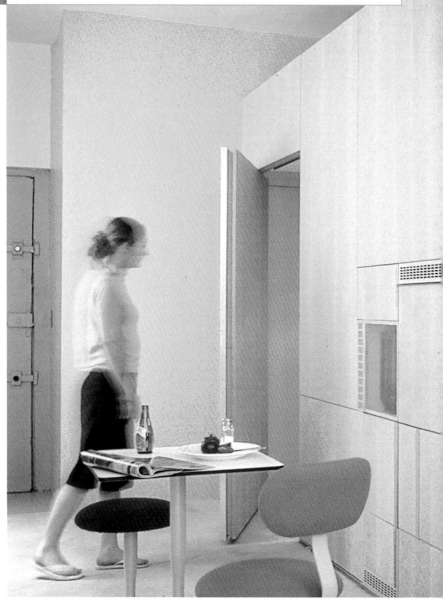

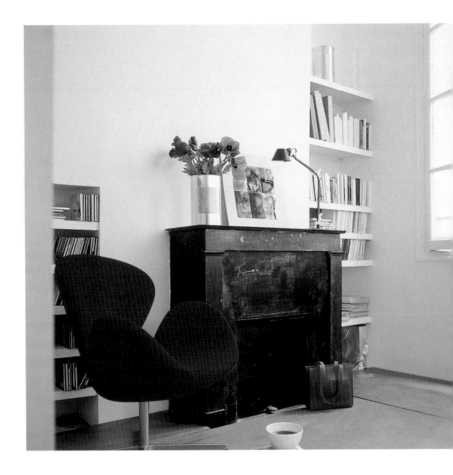

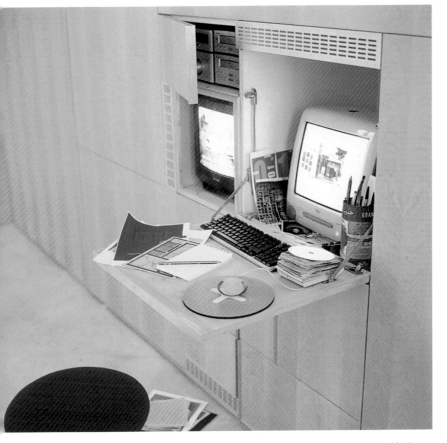

This loft in Paris centers on a single piece of furniture that contains all of the elements necessary for a pleasant living space. It consists of a square, wooden box on which the architects secured sycamore panels.

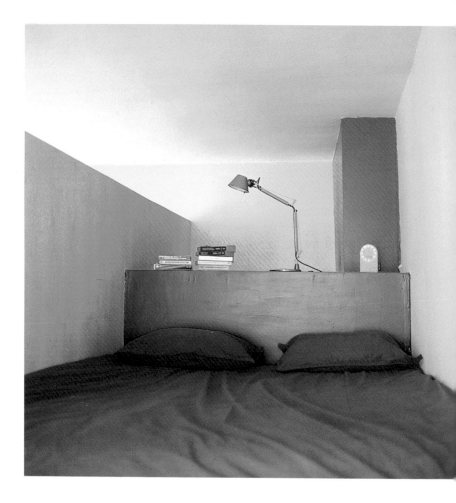

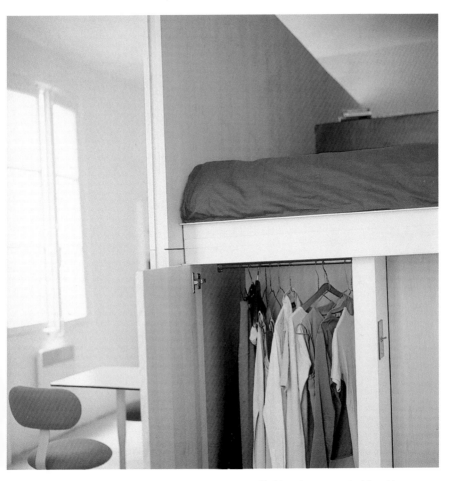

All of the various components of the residence are contained in the box: the bed in the upper part, a door underneath that leads to the kitchen, a closet at the end, and a glass space for the television.

Loft in Madrid

Caveda Granero Romojaro Architects | © Maite Gallardo | Madrid, Spain

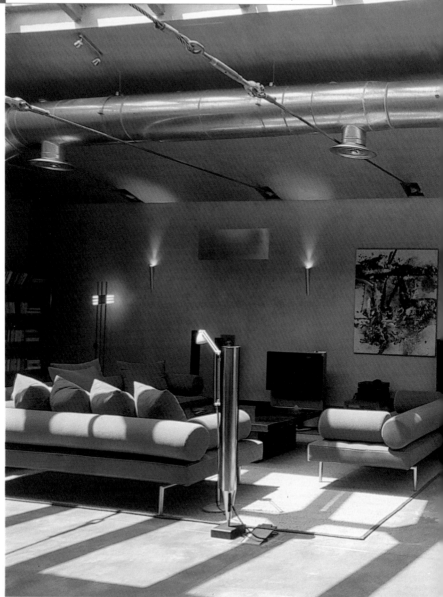

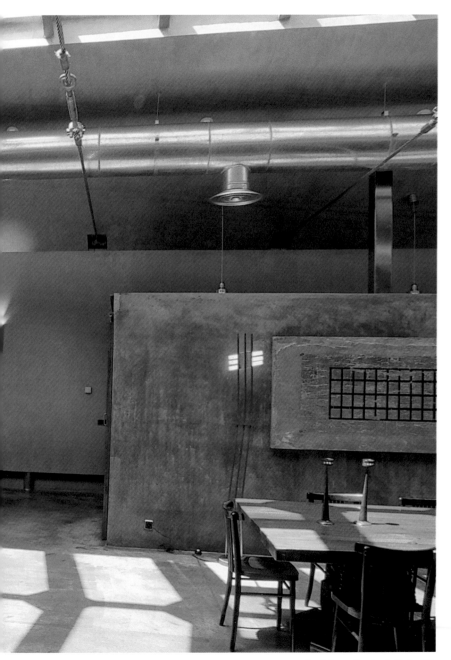

This loft is located on the ground floor of a detached block of apartments. Its front wall is 12 feet high, and the wall at the opposite end of the large, well-lit gable-roofed bay is 18 feet high.

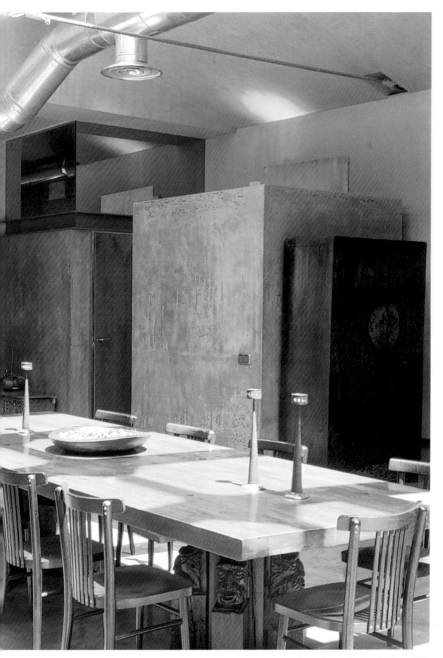

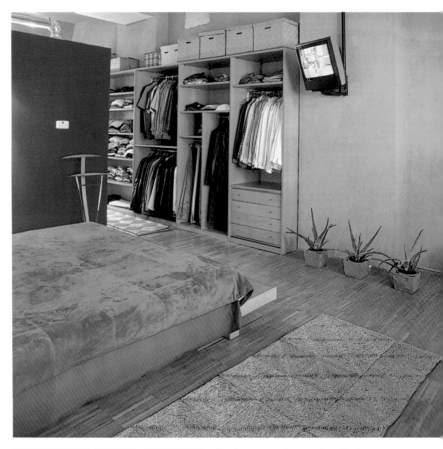

Entry from the street is by way of an offset in the façade that incorporates an interior/exterior patio. This arrangement places the bedroom off the back hall, with ample lighting and ventilation coming through the intermediate space. Privacy is achieved by way of a metal screen between the street and dwelling, as well as the use of reflector glass in the windows.

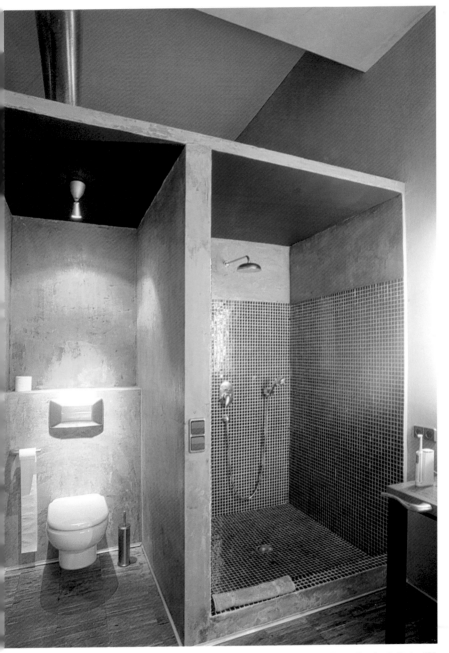

Calypso Hill

Non Kitsch Group | © Jan Verlinde | Oostduinkerke, Belgium

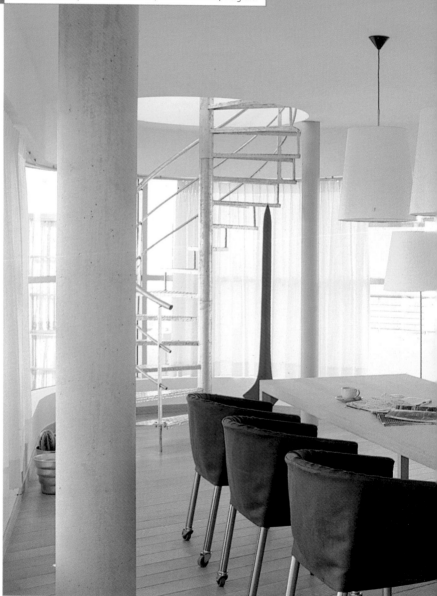

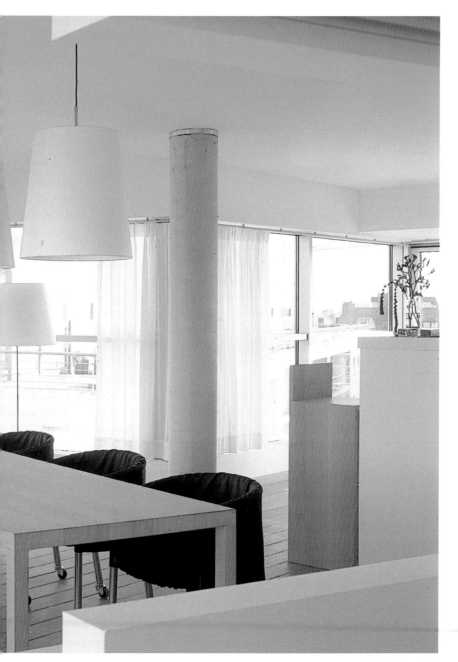

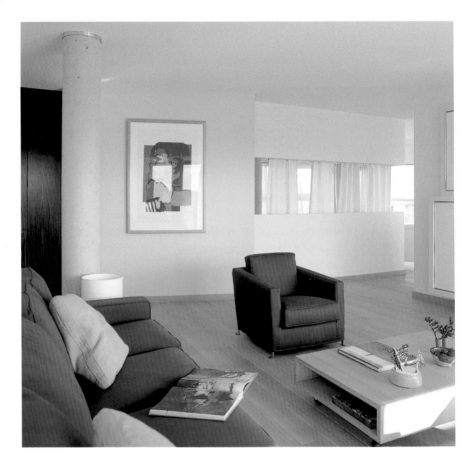

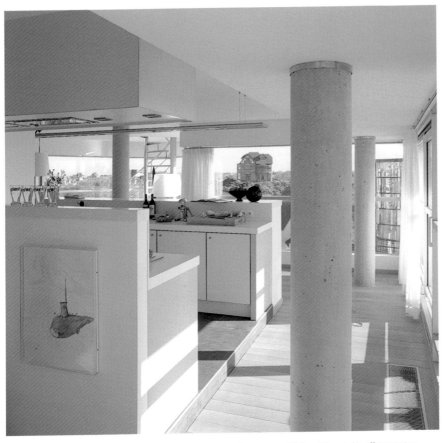

The promoter of Calipso Hill wanted to offer a new type of apartment, an original dwelling in harmony with postmodernist architecture. The loft's oval plan was entirely dominated by a 118-foot glass façade, which made many clients apprehensive. They were accustomed to compartmentalized dwellings closed to the exterior.

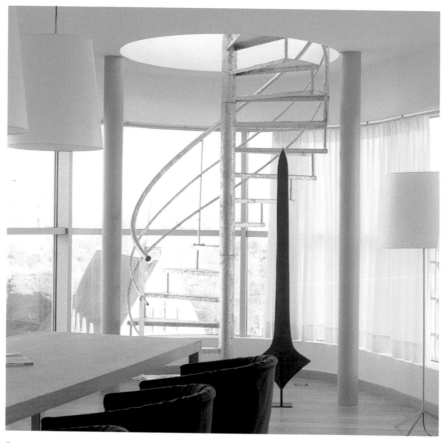

The upper-level terrace is accessed by way of a spiral
staircase at one end of the apartment. This element includes
a load-bearing column, a series of thin rungs, and a handrail,
forming a stylized whole that avoids interrupting the
splendid views seen through the large windows.

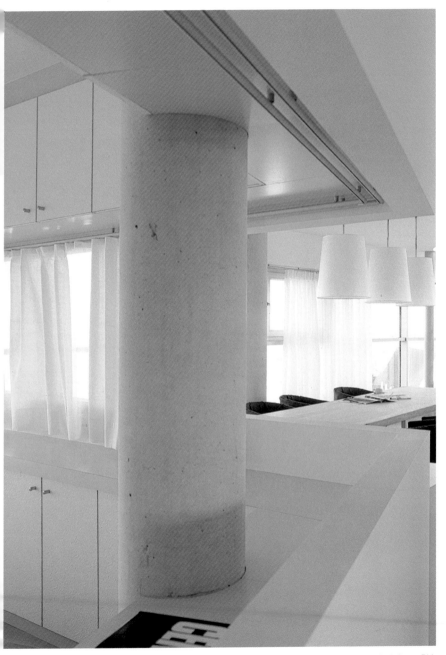

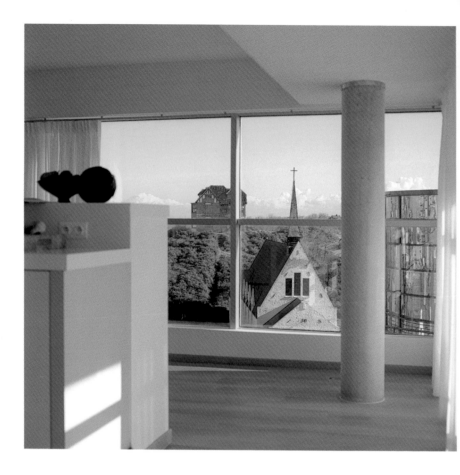

Light and Dark

Karin Léopold & François Fauconnet | © Vincent Leroux / ACI Roca Sastre | Paris, France

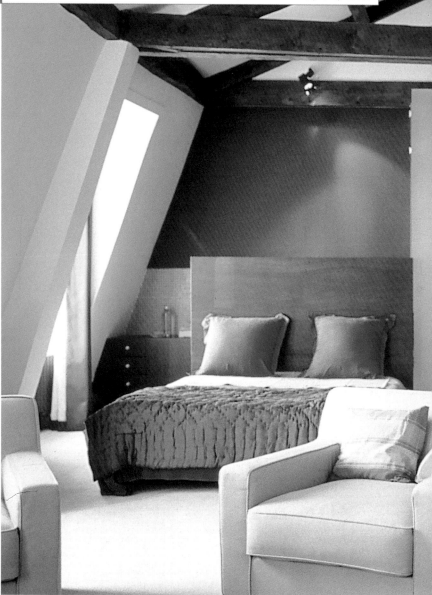

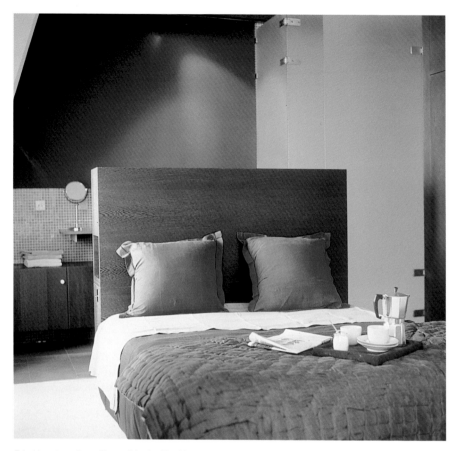

This old apartment, located in a traditional residential
building in Paris, consisted of a small, subdivided attic
that was in a state of disrepair. The roof features the
pronounced incline so typical of the top floor of a
Parisian building, and the windows offer splendid views
of the city and the Eiffel Tower. The apartment's
restoration included incorporating the interior's
charming elements while freeing the space of the
cramped sensation of only 322 square feet.

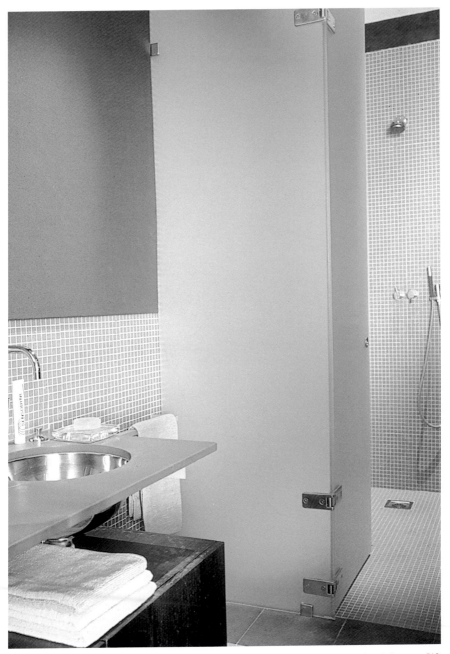

Painter's Studio

Agnès Blanch / Elina Vila (MINIM Arquitectura Interior) | © José Luis Hausmann | Barcelona, Spain

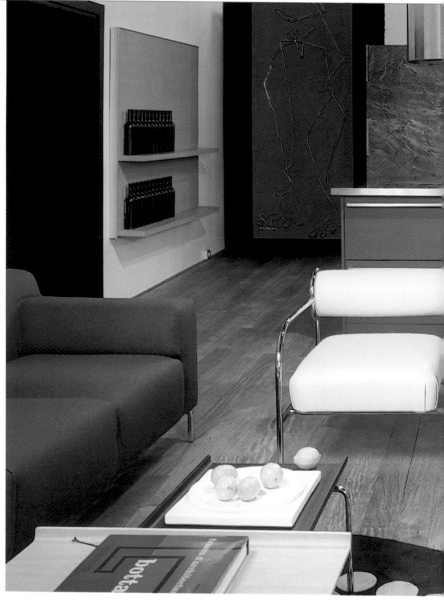

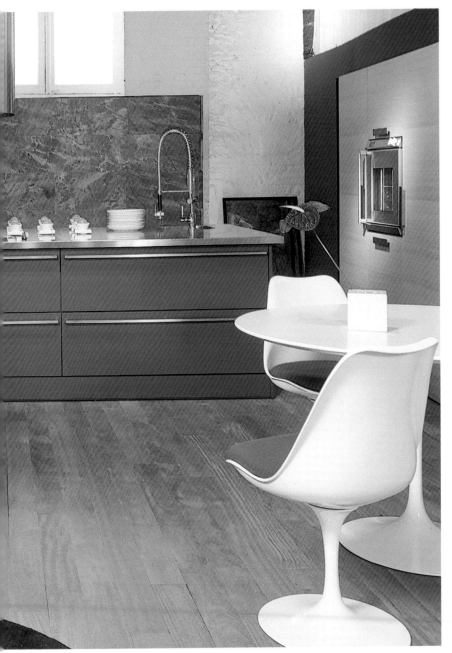

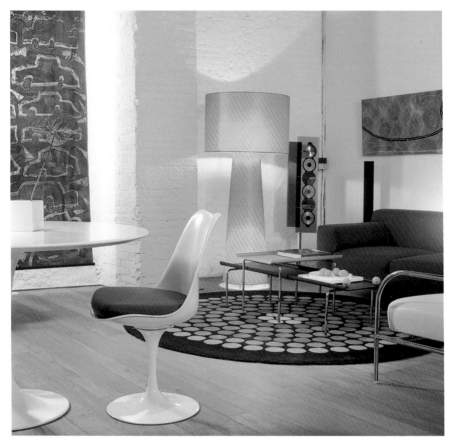

This loft was created for a multimedia artist whose colorful works add life to the space. The kitchen became the center of attention; a freestanding island with a stainless steel countertop faces the living area, flanked by a wall of cabinetry.

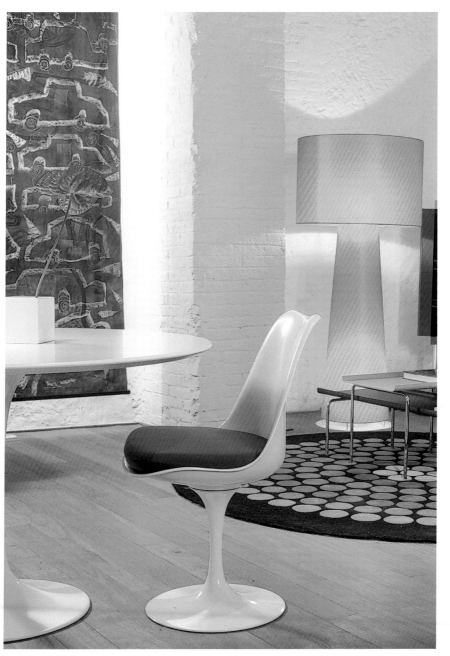

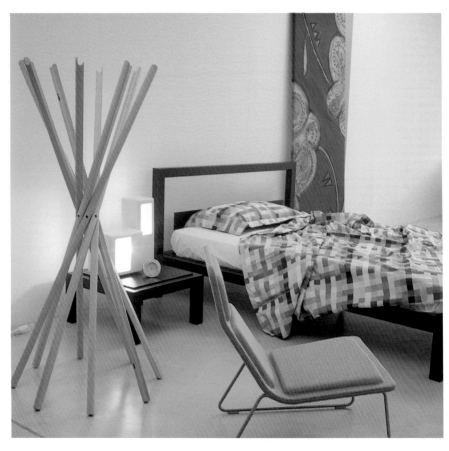

The philosophy of these interior designers springs from the perception of minimalism as a series of concepts that value simplicity, austerity, and elegance, rather than a passing aesthetic trend.

Luxurious Cell

Johnson Chou | © Volker Seding Photography | Toronto, Canada

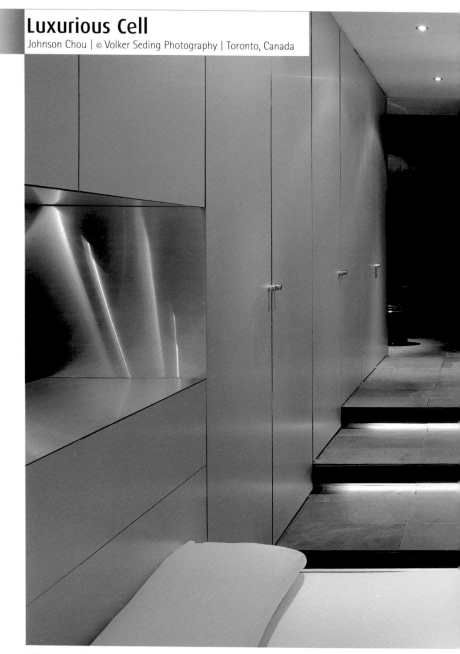

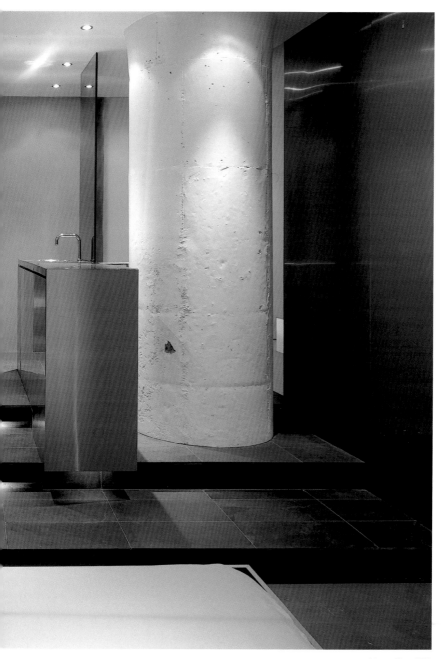

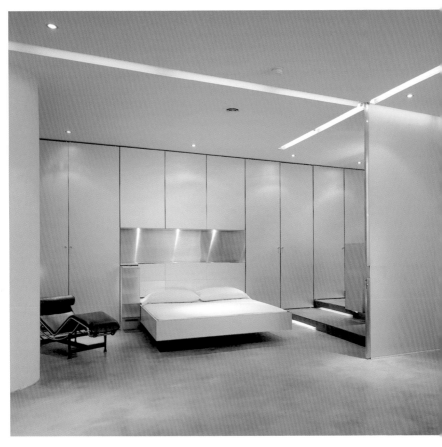

In the bedroom, an aluminum-clad king-size bed
cantilevered from the wall floats before a wall of floor-to-
ceiling aluminum closets that span the length of the room.

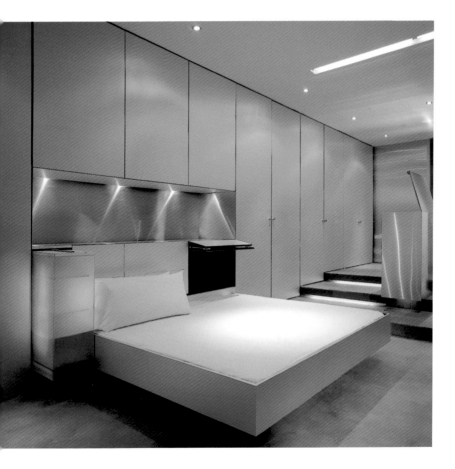

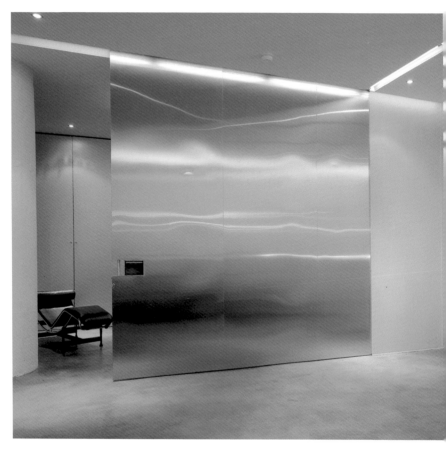

Chou began by removing all nonstructural walls and introducing a large 30-foot sandblasted screen to divide the main space. In addition, he layered the space with sliding partitions, the largest a dramatic 16-foot section of stainless steel that separates the bedroom from the living area.

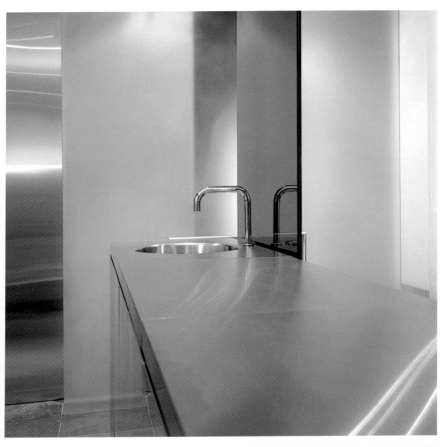

Four Level Loft

Joan Bach | © Jordi Miralles | Barcelona, Spain

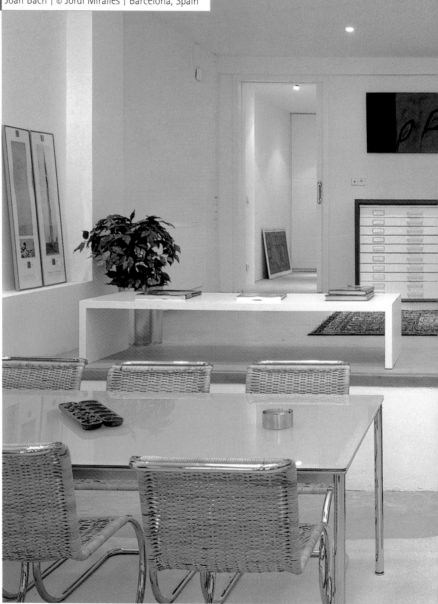

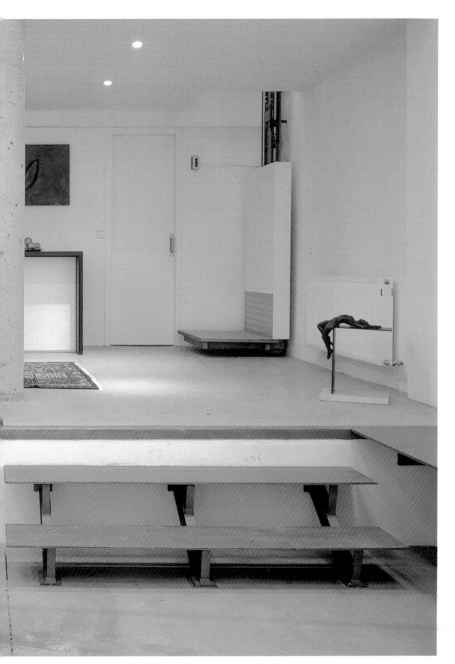

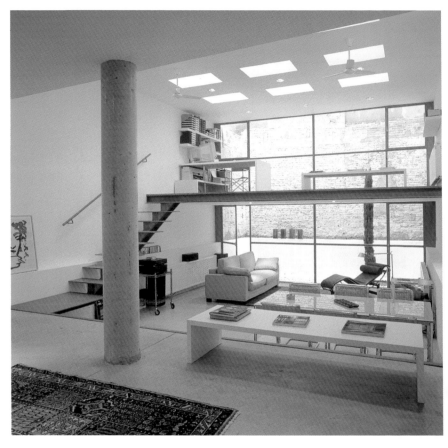

The uniqueness of this loft apartment lies in the creation
of four differentiated levels that contain a space for each
function without the use of walls. Except for the baths, the
rooms are, at least partially, interconnected.

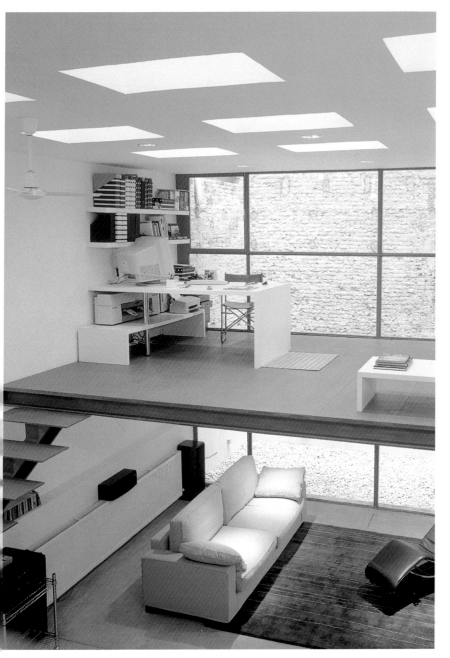

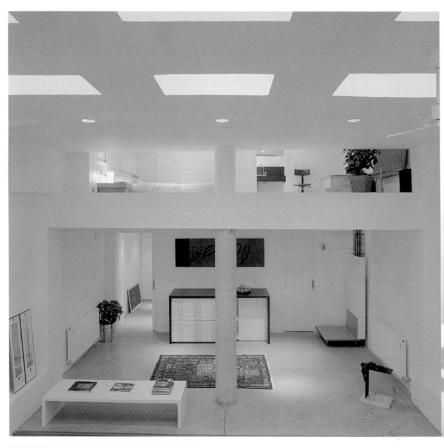

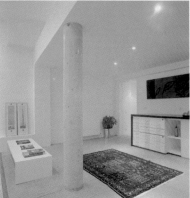

The ground floor houses the entranceway, a small reception office, and a bathroom. Use of a mechanically operated metal platform provides access to the bedroom and to the bathroom, which are located above the hall.

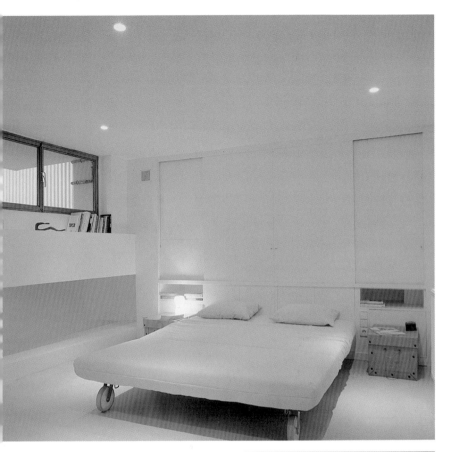

Renaud Residence

Cha & Innerhofer Architects | © Dao-Lou Zha | New York, NY, United States

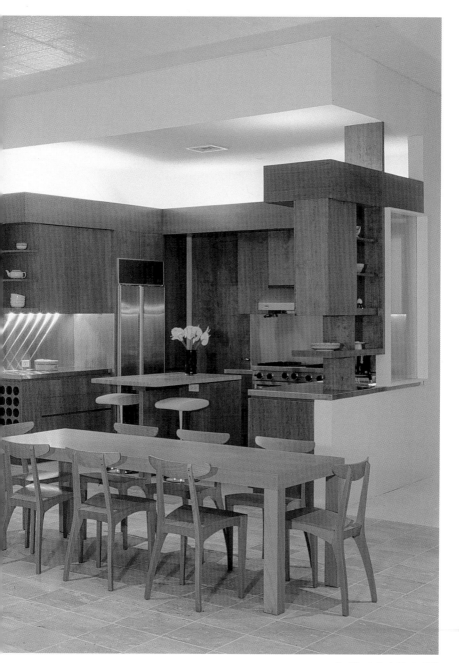

This 4,000-square-foot loft in New York's Soho district
is the home of a young banker. The architectural
remodeling job turned it into a quiet domestic space
inside a thriving social center.

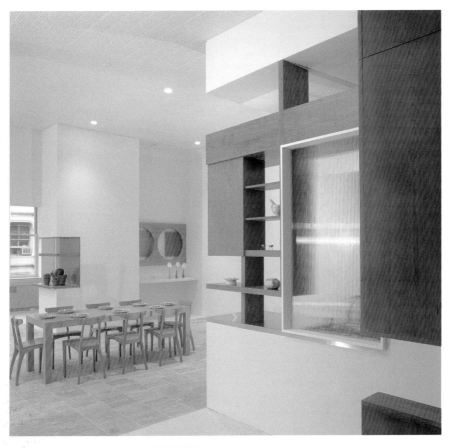

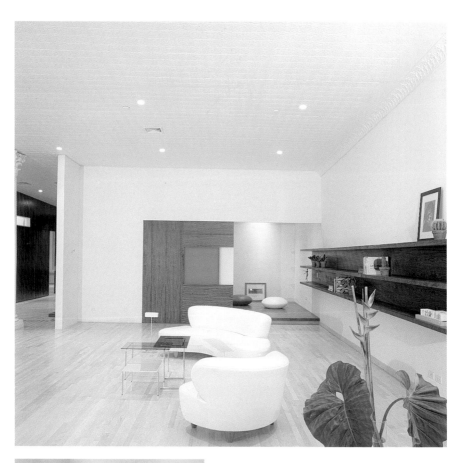

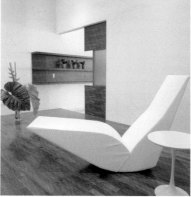

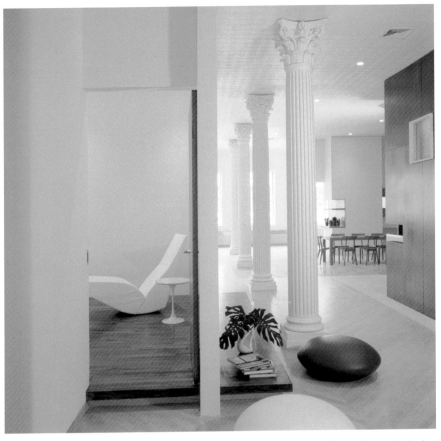

The space reflects the character of the neighborhood, where the peace and quiet of a residential zone merges with the bustle of the stores and galleries.

Functional Folds

Stéphane Chamard | © Vincent Leroux / ACI Roca-Sastre | Paris, France

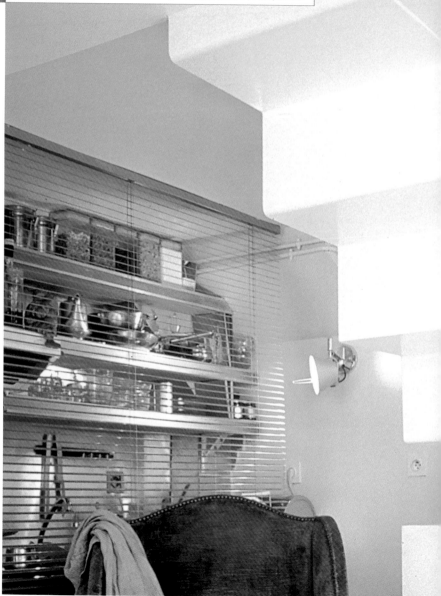

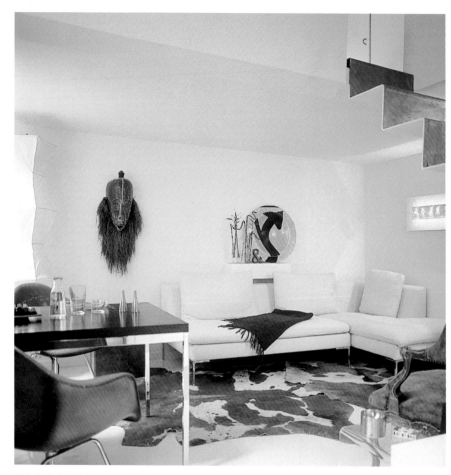

At the back of a patio in the sixth district of Paris, a
city renowned for its small living spaces, is this old,
172-square-foot doorman's room. The young architect,
Stéphane Chamard, transformed the tiny quarters into
a luminous interior in which to live and work.

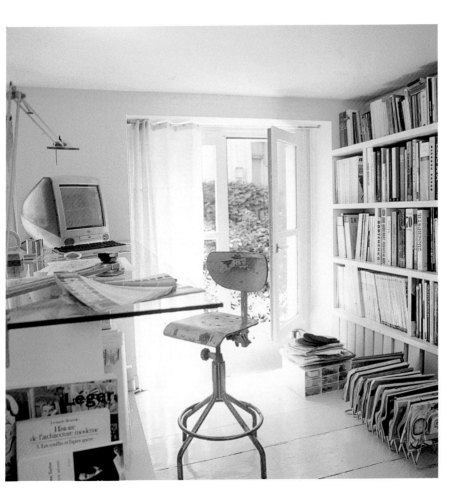

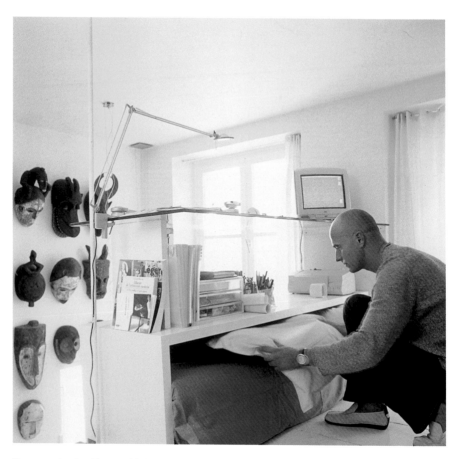

The area consists of a cubic space with high ceilings, which permitted the architect to create two floors. Chamard used every last inch, making the most of the room and its exterior openings by giving them a functional character.

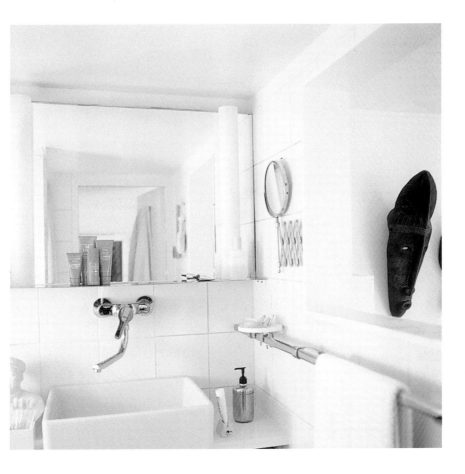

Greenberg Loft

Smith-Miller & Hawkinson Architects | © Matteo Piazza | New York, NY, United States

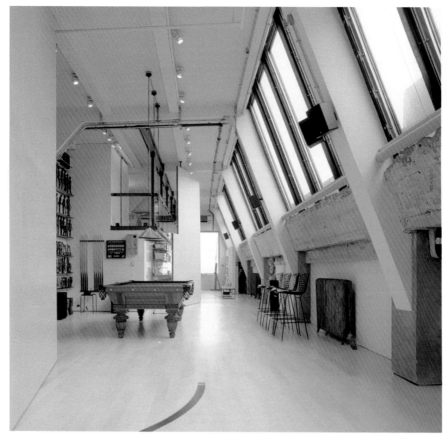

The Smith-Miller & Hawkinson team were charged with
refurbishing this loft to accommodate a dwelling and
an art exhibition area. Since the client, a collector,
wanted these two functions to coexist without strict
borders, the architects developed dual programs that
merge the gallery with the private spaces.

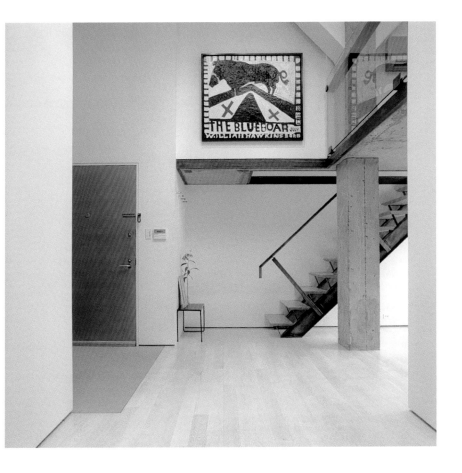

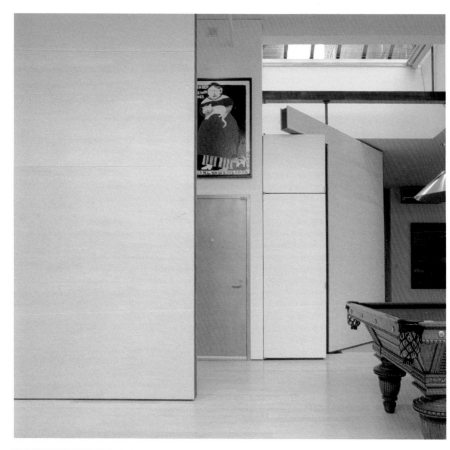

584 Greenberg Loft

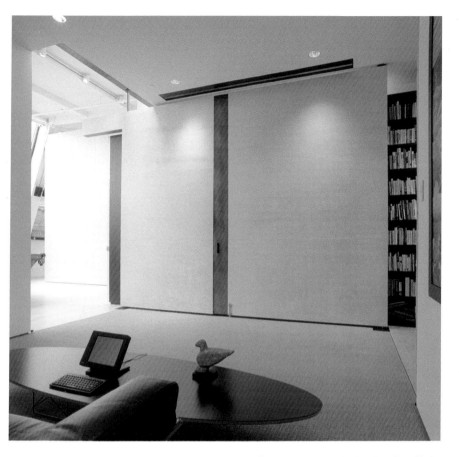

The duplex arrangement includes a lower floor with the master bedroom, the living room, the dining room, the kitchen, the projection room, a painting studio, a storeroom, and a large terrace.

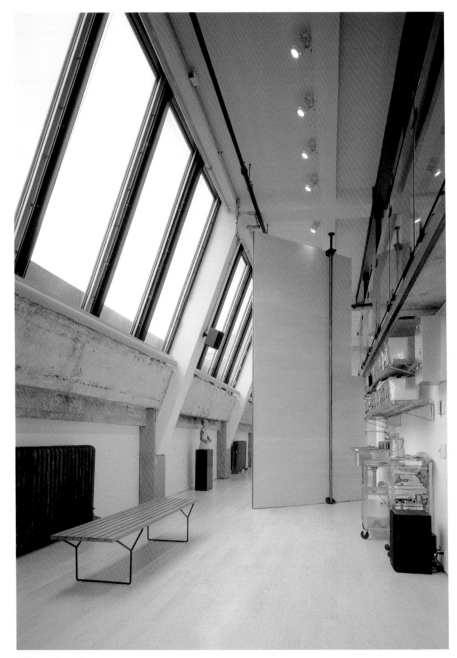

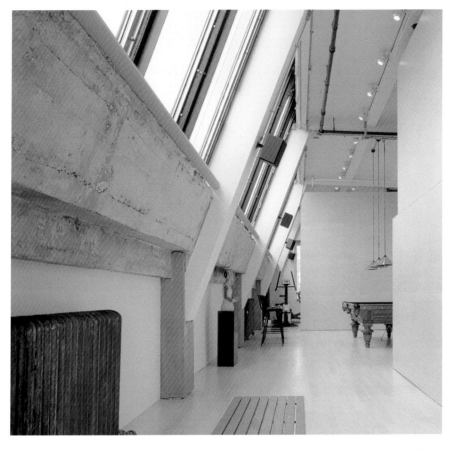

Concrete was used on the upper floor in some columns
and facings. In general, however, the architects chose
white plaster for the dividers and a birchwood floor.

Loft in Chelsea

Kar-Hwa Ho | © Björg Photography | New York, NY, United States

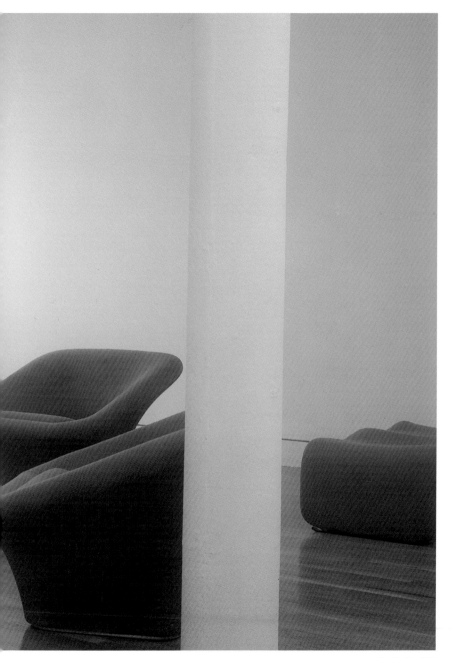

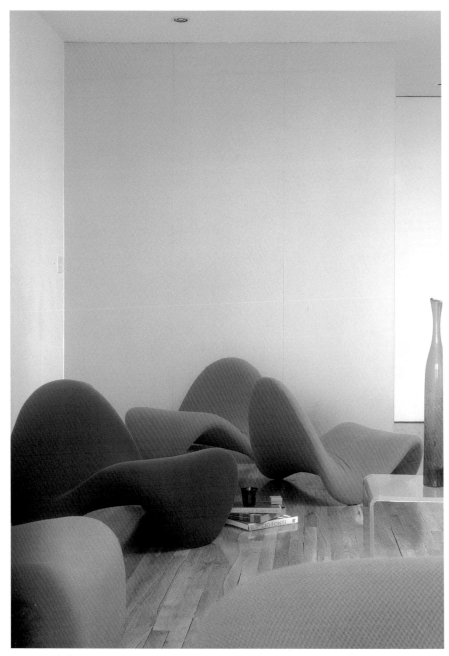

The architect's use of only a few materials brings a uniformity to the dwelling. The flooring is wood parquet, and the walls are plastered. In the kitchen, stainless steel combines with the painted white wood of the cupboards.

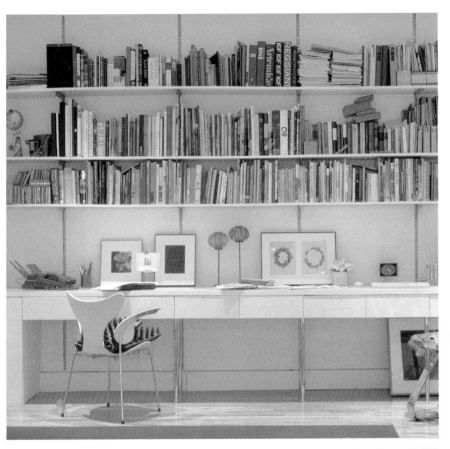

O'Malley Residence

Carpenter Grodzins Architects | © Chun Y. Lai Photography | Avoca, PA, United States

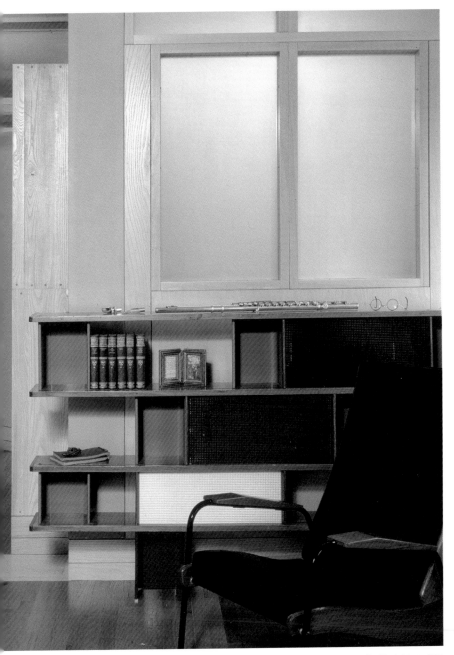

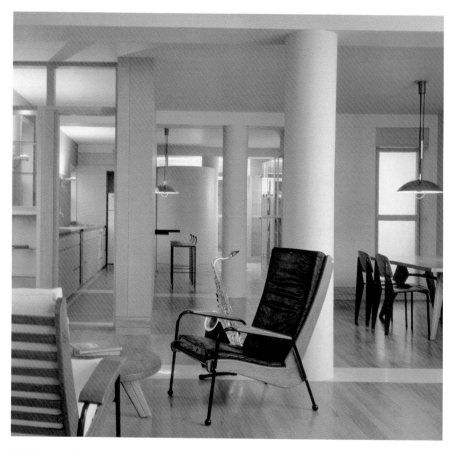

This loft in the small Pennsylvania town of Avoca was originally a warehouse. The building's perimeter was demolished, but the structure of columns, beams, and walls that once made up the virtual mass remains standing. The casual order suggested by the marble bands in the oak platform marks off the different areas, such as the dining room, the living room, or the bedroom, without using vertical partitions that would interfere with the diaphanous, open space.

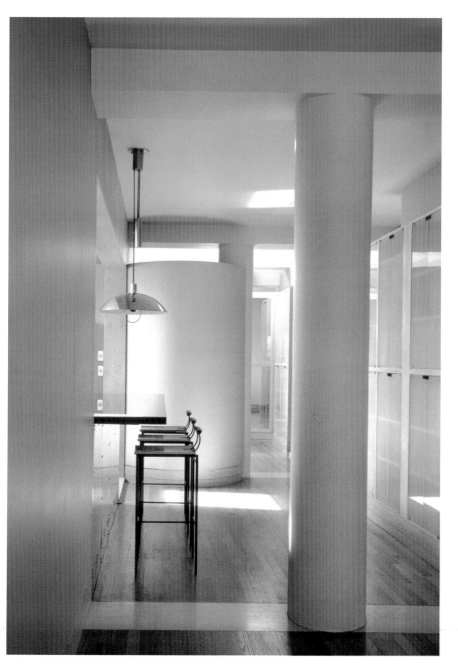

The 1,500-square-foot dwelling was rehabilitated for
the needs of a single occupant whose main
requirement was conserving as much space as possible
by incorporating important storage units.

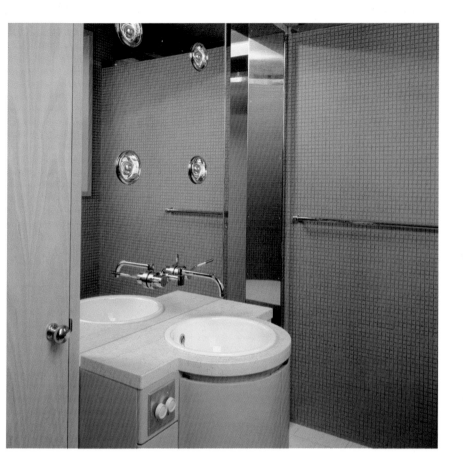

Roof under Roof

Barbara De Vries & Alastair Gordon | © Gilles de Chabaneix / ACI Roca-Sastre |
New Jersey, NJ, United States

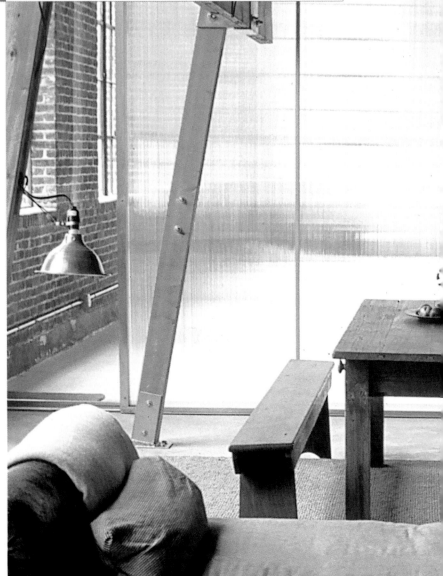

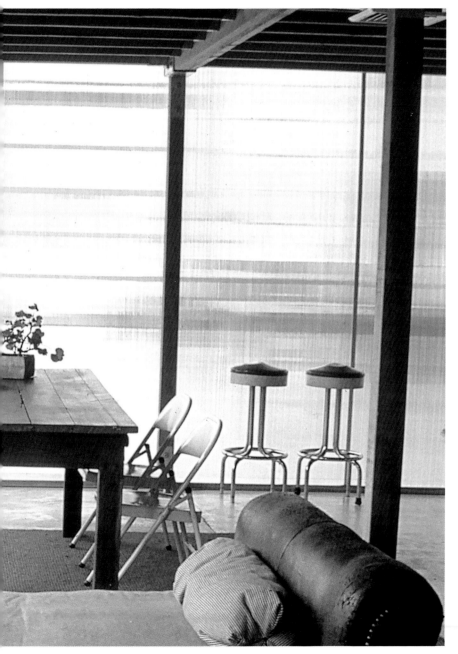

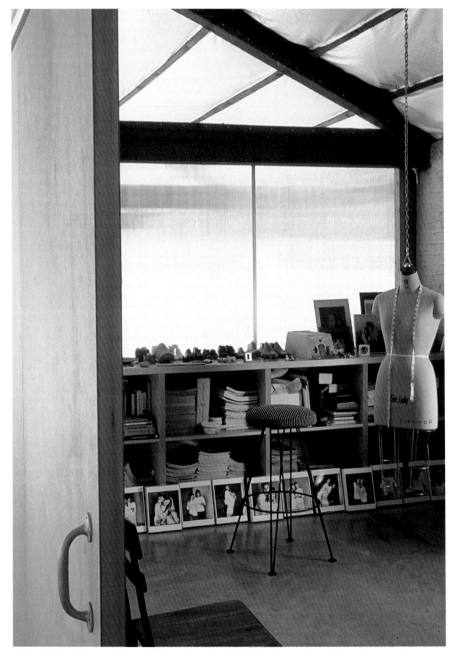

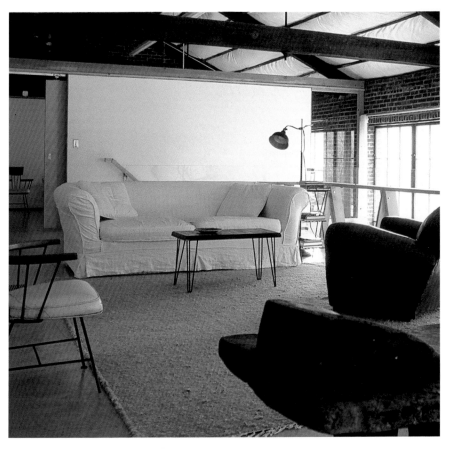

This loft is hidden in the forest, at the edge of a canal in New Jersey. A fashion designer and a journalist/writer discovered the building—an old, abandoned brick factory—and decided to remodel it into a place to live and work.

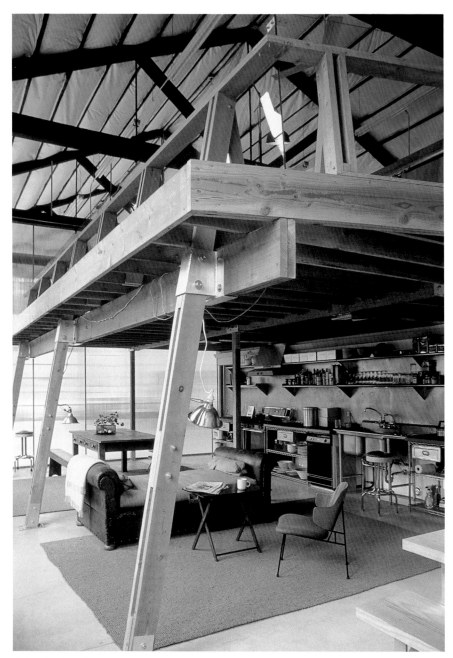

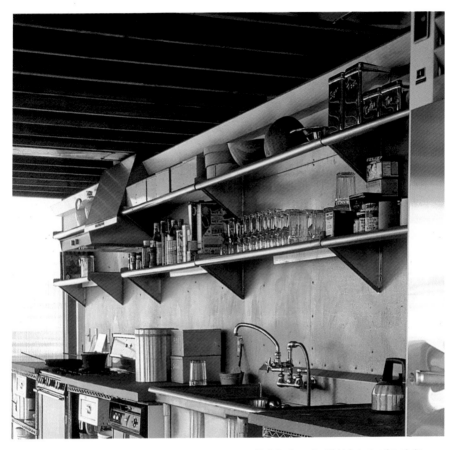

The loft enjoys natural light that enters through the windows and from below. This is especially important because the structure is isolated from the perimeter of the space. Sliding doors link the various rooms of the loft.

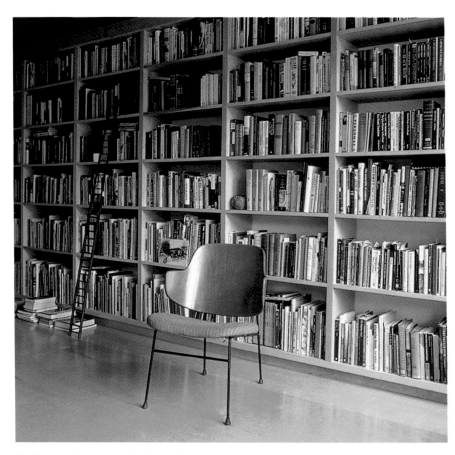

The clients wanted to preserve certain elements and
adapt them into their new home: the industrial style,
the brick walls, the immense windows, the open ceiling,
and the cement floor.

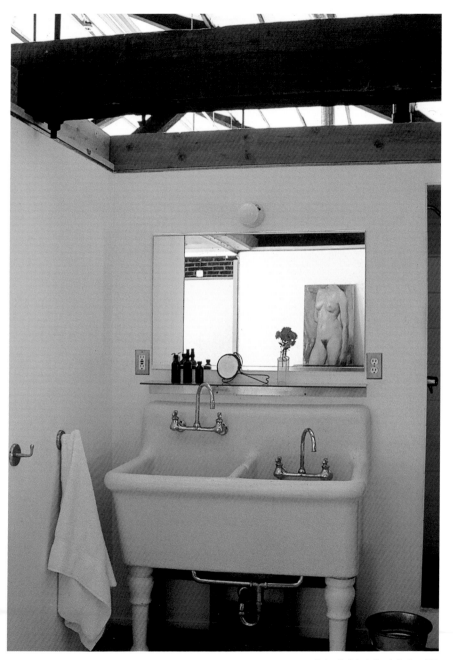

Loft in Plaza Mayor

Manuel Ocaña del Valle | © Alfonso Postigo | Madrid, Spain

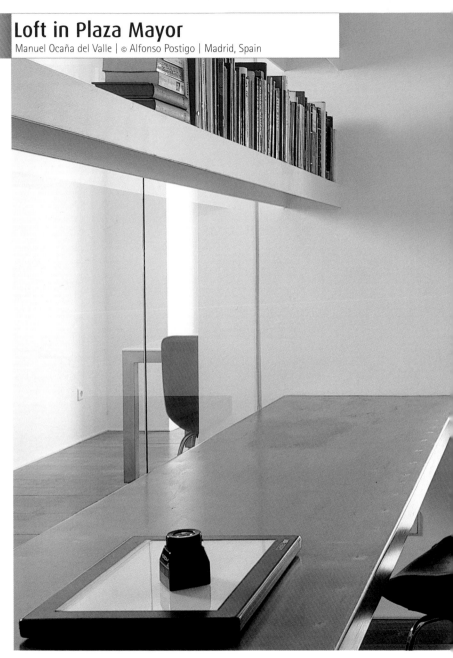

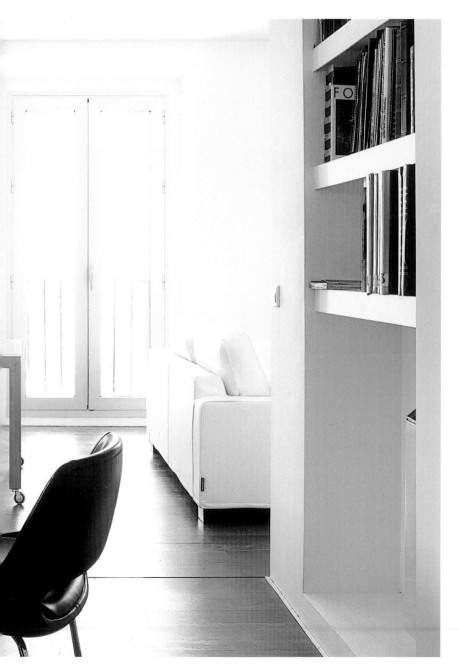

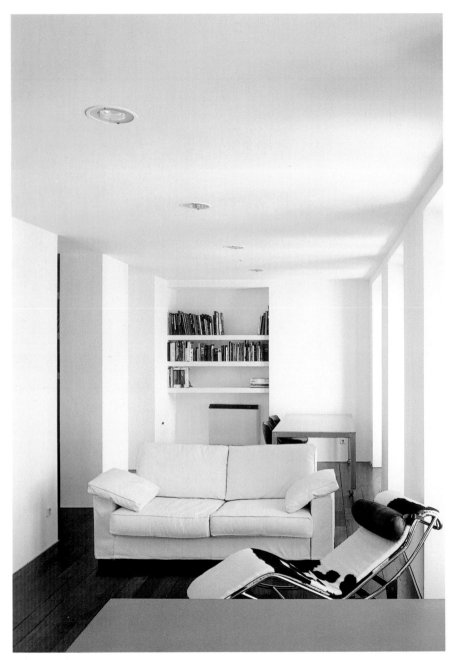

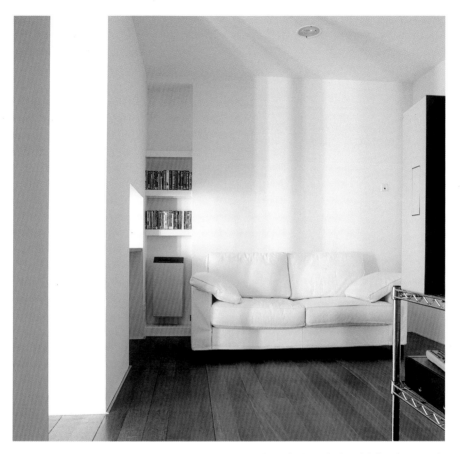

This project involved an irregularly formed apartment in an old building located in the center of Madrid. The structure was disorganized and had suffered significant damage and numerous "patch" renovations. The load-bearing walls were wide and presented variable strokes. The passageways were badly defined, and there were angles and projections that made it difficult to move around in a space with such great depth.

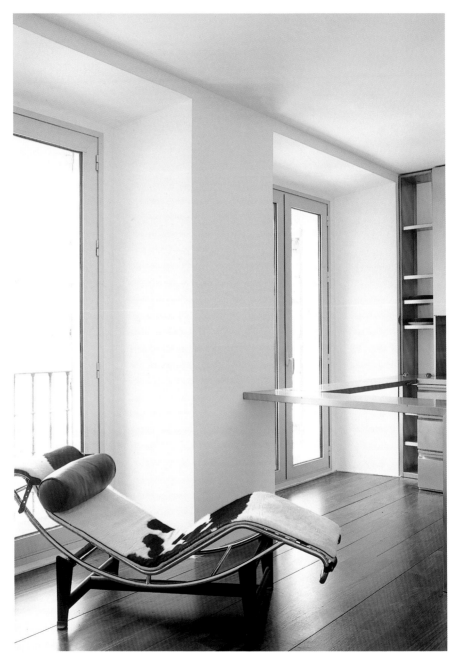

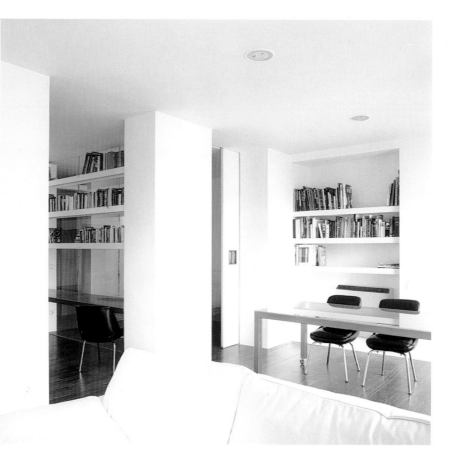

Even though some elements of the original space were preserved, such as the dark wood platform, new materials transformed the character of the space by giving it a contemporary image. Designer furniture, like the chaise lounge by Le Corbusier upholstered in cowhide, complements the atmosphere.

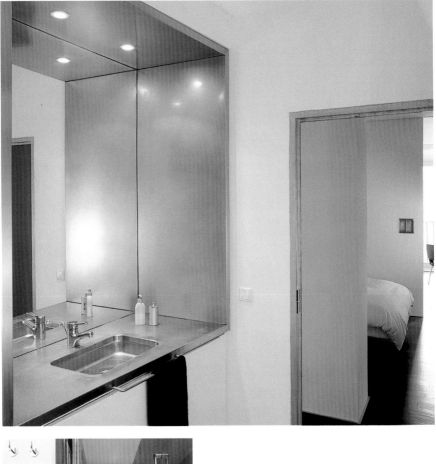

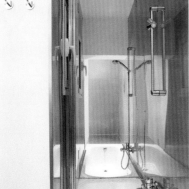

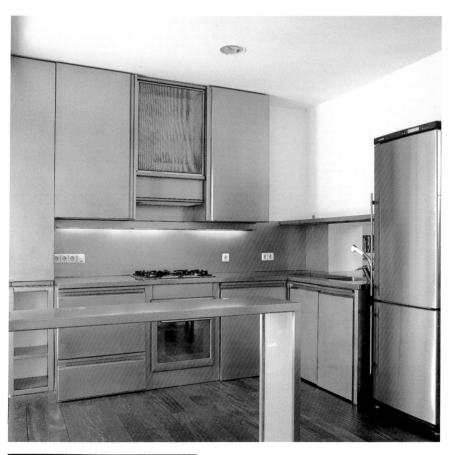

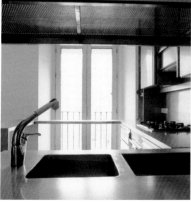

Minimal and Austere

Sandra Aparicio & Ignacio Forteza | © Eugeni Pons | Barcelona, Spain

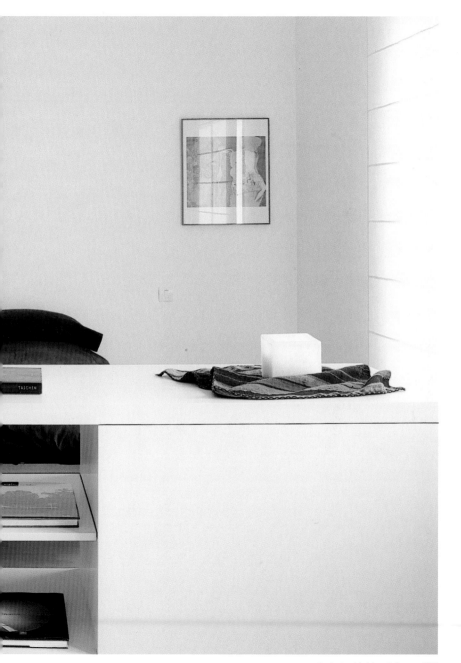

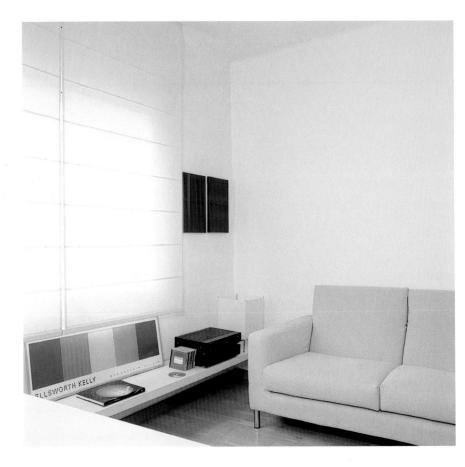

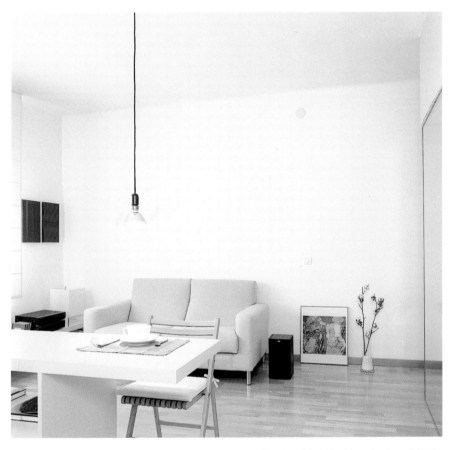

The reformation of this small apartment was designed for a client who lives in the country but needs a space to spend the night in the city. The project entailed creating an apartment that carefully covers basic living functions but with a minimum of extraneous elements.

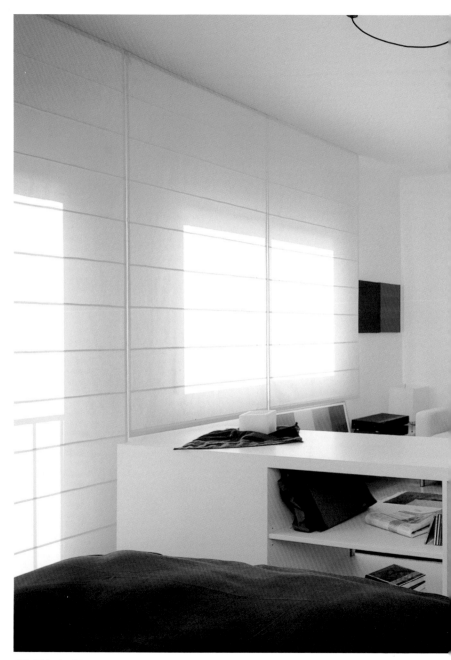

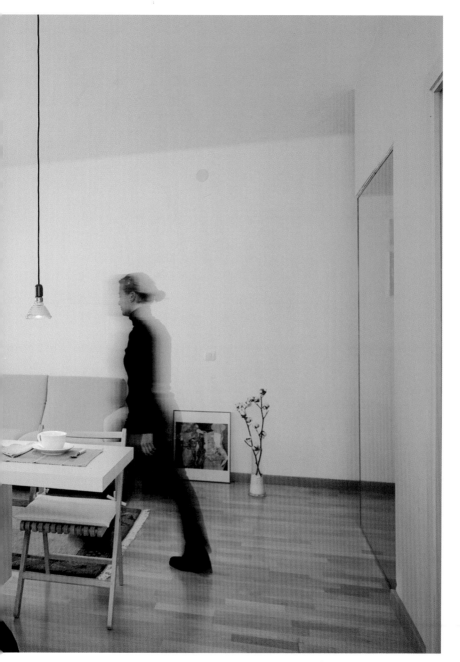

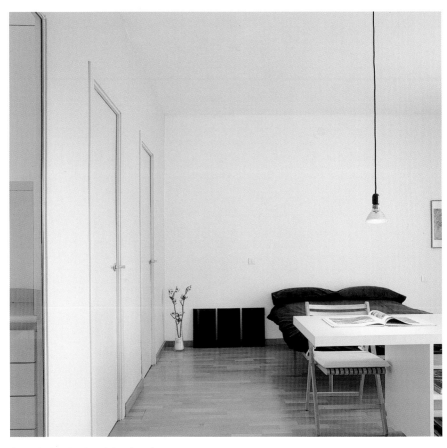

A natural color palette is used throughout the
apartment and the furnishings to accentuate the unity
of the space.

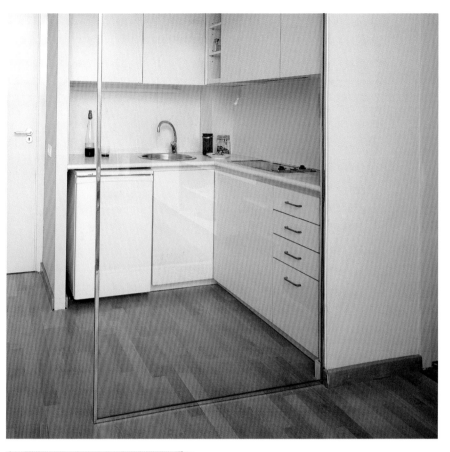

Residence in Toronto

Cecconi Simone Inc. | © Joy Von Tiedemann | Toronto, Canada

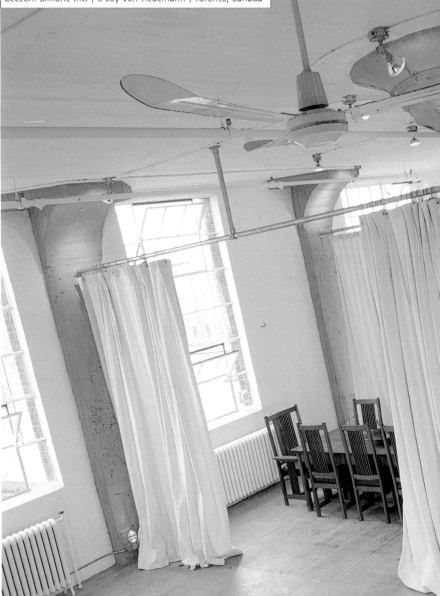

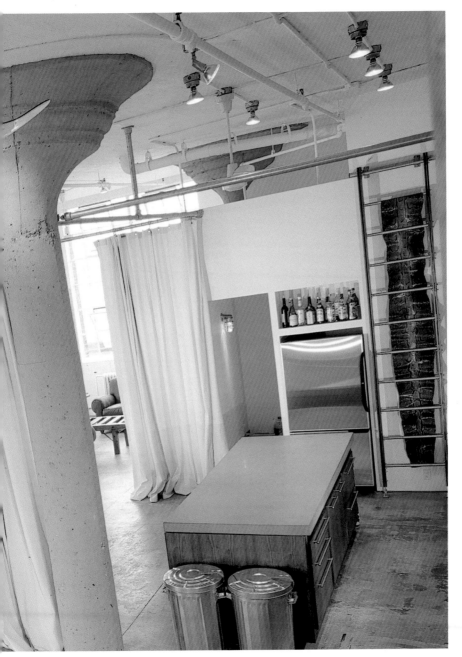

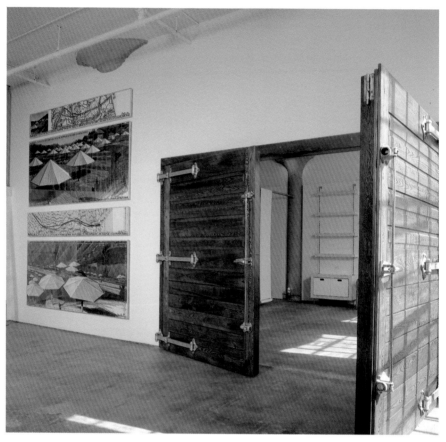

This residence is located in an old industrial
neighborhood on Toronto's east side. The goal of the
designers was to create a space in which the original
structure and the intervention's elements would
complement each other.

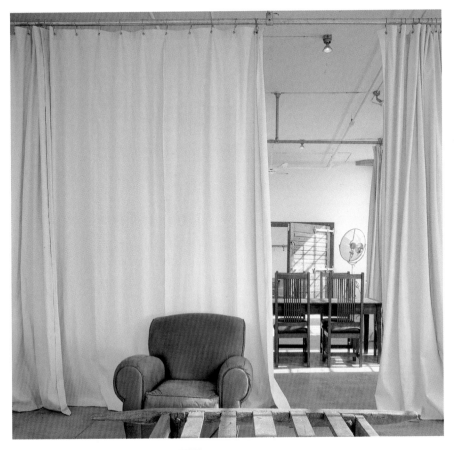

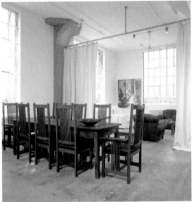

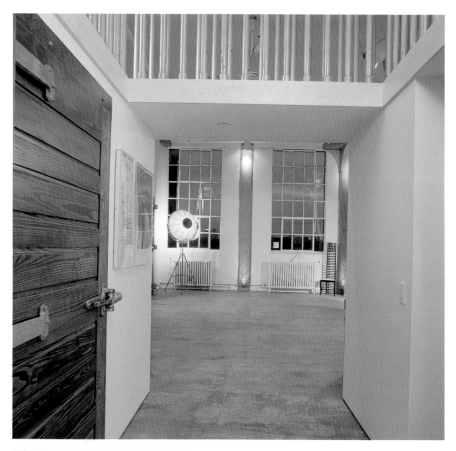

628 Residence in Toronto

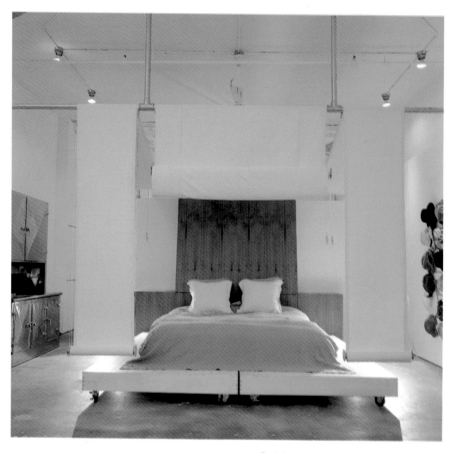

The loft was originally divided into two locales that merged into a single cohesive space. The old truss system was preserved, and the floors and columns were newly installed to recover the original color and texture and to create a rustic effect.

Home and Studio in London

Blockarchitecture | © Chris Tubbs | London, United Kingdom

The design of this London loft demonstrates
Blockarchitecture's interest in redirecting experience,
space, and materials—all of the process conditioned by
an unwavering commitment to our contemporary "snip
and cut" cultural context.

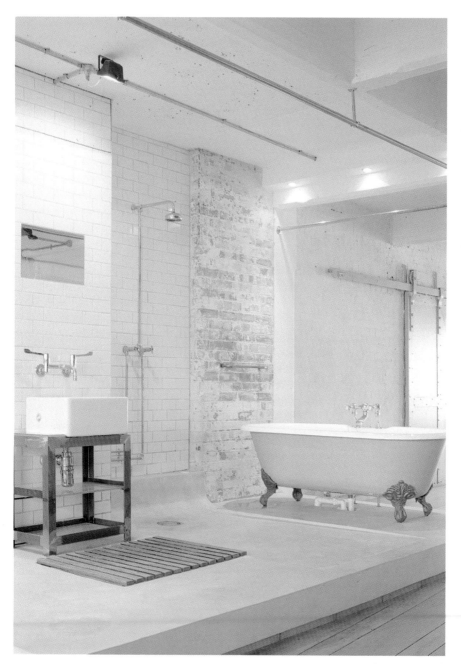

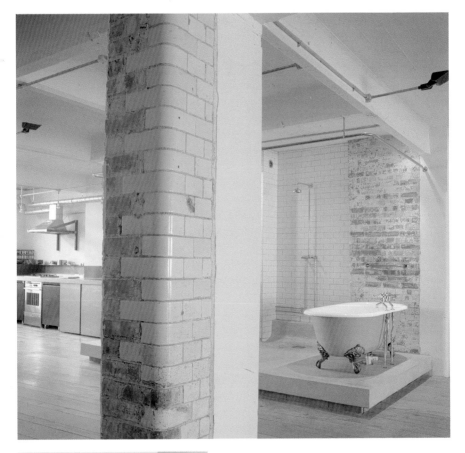

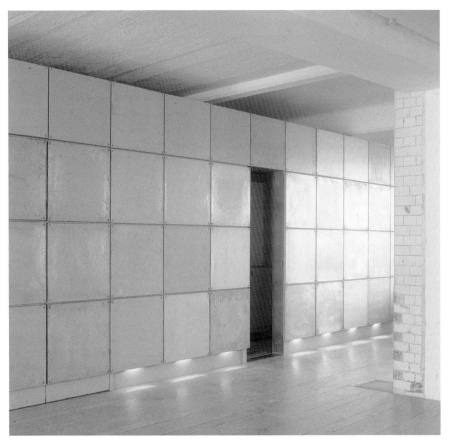

A part of the apartment's lighting installations was focused on the ceiling to highlight the restoration work on the support beams.

Siegel Swansea Loft

Abelow Connors Sherman | © Michael Moran | New York, NY, United States

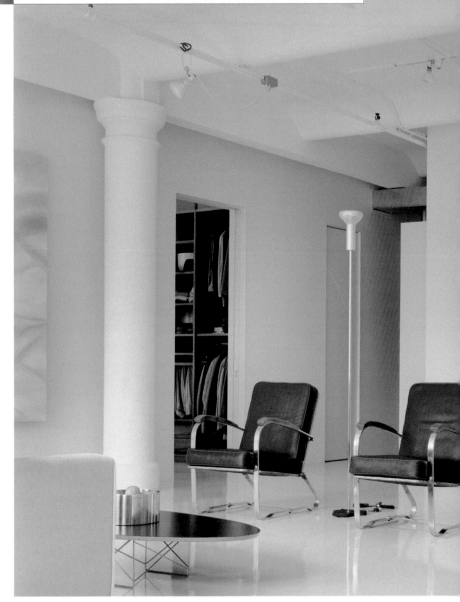

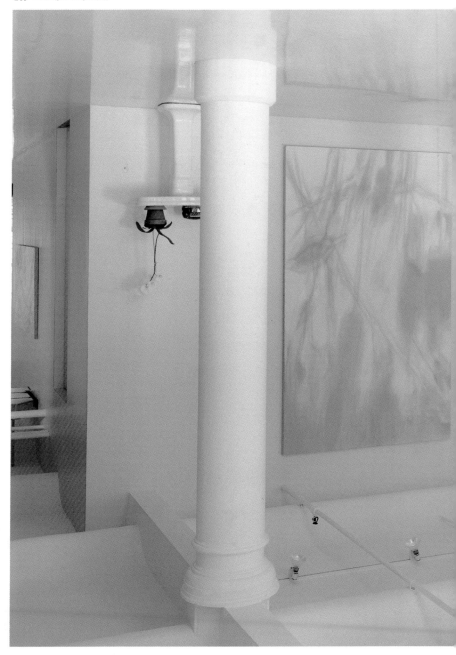

Writer Joel Siegel and his wife, painter Ena Swansea,
bought this New York City loft to create a space where
they could both live and work. From the outset, the
original character of the building, an early twentieth-
century factory, was respected. Vaulted ceilings,
plastered walls, and industrial details were retained.

The original floor was covered with an epoxy-urethane compound. The vertical partitions were left unpainted. Instead, a product normally used as a filler was applied. These specifically chosen materials created a grayish, neutral balance in which the works of art can be properly viewed.